Picturing Old New England

Picturing Old New England
Image and Memory

Edited by William H. Truettner and Roger B. Stein

with contributions by Dona Brown,
Thomas Andrew Denenberg,
Judith K. Maxwell, Stephen Nissenbaum,
Bruce Robertson, Roger B. Stein,
and William H. Truettner

NATIONAL MUSEUM OF AMERICAN ART
SMITHSONIAN INSTITUTION

YALE UNIVERSITY PRESS
NEW HAVEN AND LONDON

THE NATIONAL MUSEUM
OF AMERICAN ART
GRATEFULLY ACKNOWLEDGES
A GENEROUS GRANT FROM
FIDELITY INVESTMENTS
THROUGH THE
FIDELITY FOUNDATION
IN SUPPORT OF THIS BOOK

Picturing Old New England: Image and Memory

Edited by William H. Truettner and Roger B. Stein
with contributions by Dona Brown, Thomas Andrew
Denenberg, Judith K. Maxwell, Stephen Nissenbaum,
Bruce Robertson, Roger B. Stein, and William H. Truettner

Chief, Print & Electronic Publications: Theresa Slowik
Designer: Steve Bell
Editor: Kathy Preciado
Associate Editor: Timothy Wardell
Editorial Assistant: Tami Levin

National Museum of American Art
Smithsonian Institution
Washington, D.C.

Published on the occasion of the exhibition *Picturing Old
New England: Image and Memory,* organized by the National
Museum of American Art, Smithsonian Institution, and
shown at National Museum of American Art, Smithsonian
Institution, Washington, D.C., April 2–August 22, 1999.
©1999 National Museum of American Art, Smithsonian
Institution. All rights reserved.

NMAA also maintains a World Wide Web site at
www.nmaa.si.edu. For further information, send email to
nmaainfo@nmaa.si.edu.

Library of Congress Cataloging-in-Publication Data

Picturing Old New England: Image and Memory / edited
by William H. Truettner and Roger B. Stein;
with contributions by Dona Brown ... [et al.].
 p. cm.
 "Published on the occasion of the exhibition Picturing
Old New England: Image and Memory, organized by the
National Museum of American Art, Smithsonian Institu-
tion, and shown at National Museum of American Art,
Smithsonian Institution, Washington, D.C."–T.p. verso.
 Includes bibliographical references (p.230) and index.
 ISBN 0-300-07938-9 (cloth)
 ISBN 0-93-731148-0 (pbk.)
 1. New England–In art–Exhibitions. 2. Art, American–
New England–Exhibitions. 3. Art, Modern–19th century–
New England–Exhibitions. 4. Art, Modern–20th century–
New England–Exhibitions. I. Truettner, William H. II.
Stein, Roger B. III. National Museum of American Art (U.S.)
 N8214.5.U6 I42 1999
 704.9'49974041'074753--ddc21
 98-40097
 CIP

The National Museum of American Art, Smithsonian Insti-
tution, is dedicated to the preservation, exhibition, and
study of the visual arts in America. The museum, whose
publications program also includes the scholarly journal
American Art, has extensive research resources: the databases
of the Inventories of American Painting and Sculpture, sev-
eral image archives, and a variety of fellowships for schol-
ars. The Renwick Gallery, one of the nation's premier craft
museums, is part of NMAA. For more information or cata-
logue of publications, write: Office of Print and Electronic
Publications, MRC 230, National Museum of American
Art, Smithsonian Institution, Washington, D.C. 20560.

Photo Credits: Fig. 13: Photograph by Richard Walker.
Fig. 25: Photograph by Will Brown. Fig. 36: Photograph
by Malcolm Varon. Fig. 38: Photograph by Michael Tropea,
Chicago, Illinois. Fig. 44: Photograph by Mark Gulezian.
Fig. 51: Photograph by David Bazinet, Elite Photography,
Vero Beach, Florida. Figs. 55, 56: Photographs by Thomas
E. Marr & Son. Fig. 58: Photograph by Melville McLean.
Fig. 66: Photograph by Jerry L. Thompson, Amenia, New
York. Fig. 67: Photograph by Jeffrey Nintzel, Grantham,
New Hampshire. Fig. 69: Photograph by James H. Smith
and William J. Miller. Figs. 78, 79, 84: Photographs by
Amanda Merullo. Figs. 80, 81, 83: Photographs by Penny
Leveritt. Fig. 97: Photograph by Brown Brothers. Fig. 100:
Photograph by Erik Gould. Fig. 108: Photograph by Noel
Rowe. Figs. 118, 140: Photographs by David Stansbury.
Figs. 123, 131, 132, 178: Photographs by Lynn Rosenthal,
1998. Fig. 167: Photograph by Michael Agee. Fig. 208:
Photograph by Bill Finney. Fig. 215: Photograph by George
Holmes. Fig. 218: Photograph by Lee Stalsworth. Fig. 202:
Photograph by Marie and Hugh Halff.

Title page: Rockwell Kent, *Maine Coast* (detail), 1907, oil on
canvas, 86.7 x 112 cm (34 1/8 x 44 1/8 in.). © The Cleveland
Museum of Art, 1998, Hinman B. Hurlbut Collection
(1132.1922).

pp. iv–v: Alice Schille, *White Houses,* ca. 1916, watercolor, 44.5
x 52.1 cm (17 1/2 x 20 1/2 in.). Courtesy of The Canton Mu-
seum of Art, James C. and Barbara J. Koppe Collection.

Front cover: N. C. Wyeth, *Island Funeral,* 1939, tempera on
panel, 111.8 x 132.1 cm (44 x 52 in.). Art Collection of the
Hotel duPont, Wilmington, Delaware. Photograph courtesy
of the Brandywine River Museum, Chadd's Ford, Pennsylvania.

Back cover: Marion Post Wolcott, *Corner of Main Street, Center
of Town, after Blizzard, Battleboro, Vermont,* 1940, gelatin silver
print. Library of Congress, Prints and Photographs Division.

Contents

Foreword

Picturing Old New England: Image and Memory sifts eight decades of art to discover the essential themes that make up our mental image of Old New England. The authors bring various approaches to bear, relating this art to history, social structures, literature, and popular culture. No one method would suffice, for the larger project here is to trace the construction of a national myth about the American founders' values, timelessly enshrined in a regional landscape and people.

Carlos Fuentes has said that creativity means "calling into existence a world." The comforting world that these New England artists called forth drew deeply on national memory, a collective history that subtly filters out some aspects of life while magnifying others. Those filters vary from one decade to the next, for they are the way that an ever-shifting present reshapes the past to meet its own needs.

America's best creative talents between the Civil War and World War II offered a strong, reassuring image that tells the story of striving individuals and supportive communities. Tradition, inheritance, bloodlines, stability, courage, endurance—these provided the balance against forces of social change that seemed to accelerate out of control during the same decades. The small region where the country's early heroes and nameless yeomen lived was invested with immense psychic gravity and weight, as if to stabilize a nation undergoing uncontrolled geographic, demographic, and commercial expansion. New England was like a buttress supporting a dizzying arch being extended across the continent. The New England people emerged as a kind of archetypal folk, a kindred people defending a common culture against external forces of change.

If we believe that the present reinterprets the past to answer its own questions, then it's fair to ask why the myth of Old New England is a timely topic now. In fact, as we close the twentieth century, we confront the pressures of another vast expansion. Everywhere we hear about the "global village"—a global economy, worldwide telecommunications network, multi-cultural and trans-national population. National values are again under stress, threatened by fears of a New World Order on the one hand and of ethnic tribalism on the other. Where today can we find an anchor strong enough to stabilize our culture? What images would provide the unifying effect that the pictures of Old New England did for decades past? Today, movies, television, and advertising are sources to which the vast majority of citizens look; pop music may be the most broadly shared cultural experience of all.

The authors in this book suggest that the New England myth was too exclusionary and limited to meet the needs of a rapidly diversifying nation, blinding people to essential realities. Still, it's possible that the simple clarity of the New England image gave the immigrant, freed slave, aspiring laborer, or frontiersman an easy way to identify as an "authentic American." In any case, a mythology appears when it's needed and cannot be willed into existence, so while we can seek to understand the way it works, no judgment can be rendered.

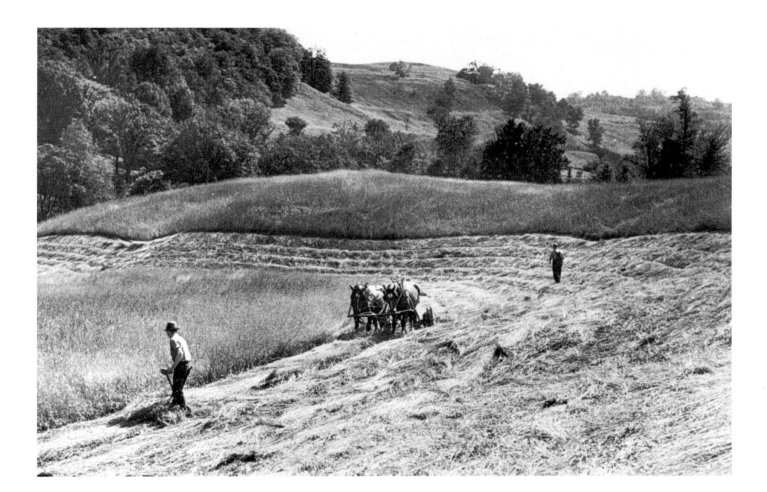

Arthur Rothstein, *Cutting Hay, Vermont*, 1937, gelatin silver print. Library of Congress, Prints and Photographs Division.

The authors of *Picturing Old New England* examine in detail just how various categories of images work on the imagination to create national culture. By bringing this process into such sharp focus, they offer a much richer understanding of the eighty years under review, which set the stage for this "American Century." Equally important is the way they inspire thoughts about our own present and the kind of past we need to sustain us.

Elizabeth Broun
Director
National Museum of American Art

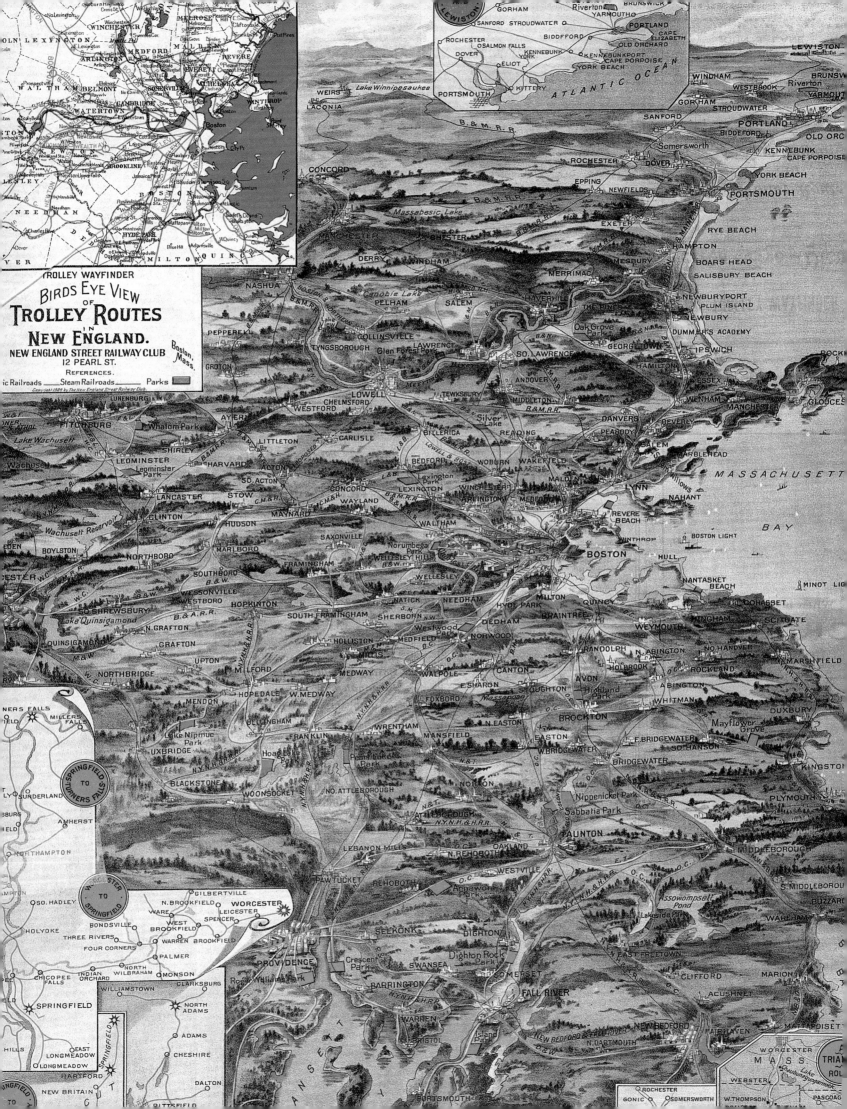

TROLLEY WAYFINDER

BIRDS EYE VIEW
OF
TROLLEY ROUTES
IN
NEW ENGLAND.

NEW ENGLAND STREET RAILWAY CLUB
12 PEARL ST.

Boston, Mass.

REFERENCES.

Electric Railroads.　Steam Railroads.　Parks

Copyright 1904 by The New England Street Railway Club.

Preface and Acknowledgments

Most readers of this book will be familiar with the term "old New England." It brings to mind a number of images, many of which convey the sense of a present deeply tinged with age and tradition—a present, in other words, that has been comfortably aligned with the past. There are occasional challenges to this alignment: Augustus Saint-Gaudens's *Shaw Memorial* on Boston Common (*see* Fig. 67), a monument to the white leader of a famous black regiment in the Civil War, testifies to New England's continuing and often troubled search for moral and political redemption. But the more common aim of these images is to offer the past as a handsome, old-fashioned, and morally sound version of the present. So successful are most of them in carrying out their mission that viewers take them as encounters with an authentic old New England, or at least with a place that remains largely untouched by a willful and chaotic present.

Images of New England are not alone in effecting this sleight-of-hand. What is remarkable about them, however, is that they carry it off so convincingly. Simply put, they claim that old New England has not disappeared from every corner of the region, that some part of it remains, ready to accommodate travelers from the present. Accommodation proceeds more easily, of course, when these travelers disregard New Englands other than the one they have in their mind's eye. That New England, not surprisingly, is usually drawn from images that carefully balance past and present. Such images function both internally and externally; they are as much an exercise in wish-fulfillment as they are representations of an actual place. Old New England, we suggest, is found somewhere between; it is neither fantasy nor reality but an ideal past, continually reinvented over the last two centuries.

If old New England images describe the present in terms of an ideal past, they are nevertheless focused in the way they represent shared cultural beliefs at different times in history. Images such as John Rogers's *Fugitive's Story* (*see* Fig. 1), and Edward Hopper's *House by an Inlet* (*see* Fig. 202) speak in different artistic languages to different audiences, but the story this book tells is of the links connecting the two, not only as New England subjects but as subjects that expand regional issues into ones of national import. Indeed, New England subjects performed this primary role through much of the nineteenth and twentieth centuries, and were fashioned by each new generation of Americans into a tried-and-true alternative to the present. This more or less predictable routine also eased old New England into the role of old America. It was (and still is) the region to which Americans most often turn to locate the nation's past— a past that stands in sharp contrast to the so-called "lost" pasts of the ante-bellum South or of native peoples. The New England past is presumed to be a continuous past, a repository of ideas and values that have endured, unbroken, for almost four centuries.

The time frame for this study runs from 1865 to 1945. We could have begun earlier; long before the Civil War a self-consciousness about the region and its past was part of national art and literature. Our starting date, however, falls after the war, with a new,

Bird's Eye View of Trolley Routes in New England (Boston: Geo. H. Walker & Co., 1904). Courtesy of Harvard Map Collection, Harvard College Library.

more urban and industrial New England. As the nation approached the twentieth century, images of New England seemed to retreat further into the past. Read against the historical overview by Dona Brown and Stephen Nissenbaum, the disparity between what the images show and the direction in which the nation was heading reveals some degree of cause and effect, though clearly they are neither a mirror of nor an obstinate response to the times. As active instruments, as shaped perceptions, images give form to cultural ideas, to moral and social norms, and hence—especially over this span of years—they need to be read with care, not for "hidden meanings" but as the visual language of an earlier era, which requires some translation on our part.

The contexts of these images may be sweeping— issues of urbanization, industrialization, and cultural diversity touch on almost every object illustrated in this book. But these objects are also associated with more circumscribed historical matters, such as post-Civil War tourism, the role of centennials and expositions in commemorating the past, preserving the colonial at the turn of the century, local effects of the depression, changing conditions in the New England fishing industry, and the growth of New England art colonies. Images associated with these and other phases of New England history constitute a series of responses, varying over time and place, to the physical, social, and economic transformations of the region. In doing their cultural work, the images reveal both continuities and dissonances, though the dissonances are surprisingly fewer than one finds in the literature of the period (the corrosive rurality of Edith Wharton's *Ethan Frome* is a well-known example). The result is a remarkably similar pattern of image construction, of borrowings and repetitions, across media, and over extended periods of time.

The six chapters divide the period between 1865 and 1945 into roughly chronological units, and treat themes and subjects that can be read against a variety of historical issues, some already outlined. The first pair of chapters acknowledges the devastating effect of the war and the new social and industrial landscape that confronted New Englanders. "After the War" leads off with images of rural New England, not because rural New England was flourishing but because post-war Americans were moving to urban areas and developing new patterns of consumption. At the same time, they sought to hold on to a stable, pre-industrial past, idealized in paintings such as Eastman Johnson's *Old Stage Coach* (*see* Fig. 5), genre sculpture, photographs, and prints. These were complemented by a "Scenic Rural"— views of the White Mountains and the seashore— by Winslow Homer, George Inness, William S. Haseltine, and others. The two locations offered refuge from urban life and association with a richly layered past. By the late 1860s, the White Mountains were regarded as both a New England and national shrine, and seashore views included such venerable and geologically important formations as the rocks at Nahant.

Chapter two covers roughly the same period as chapter one, but reaches back to three specific historical pasts, each of which was instrumental in reasserting New England's moral and spiritual leadership. The first, a seventeenth-century, or Puritan, New England, is explored through works such as George Henry Boughton's *Pilgrims Going to Church* (*see* Fig. 35) and Augustus Saint-Gaudens's formidable *Puritan* (*see* Fig. 53). The second features stirring Revolutionary War scenes by Howard Pyle and N. C. Wyeth, painted during a decade when American imperialist ambitions ran high. The third, and most recent, past is represented by Brahmin portraiture. Tradition is closely inscribed in the dress and demeanor of the sitters, as well as in obvious tributes to art-historical precedent.

Chapter three moves on to turn-of-the-century images and objects that recreate a colonial past more distinctive for its refinement than for precise historical markings. This past, carefully set on a few small stages—towns like Deerfield, Massachusetts, and Old Lyme, Connecticut, and an occasional Boston drawing room—was constructed almost exclusively from old or newly made colonial artifacts, both thought to embody

the aims and ideals of old-stock New Englanders. Paintings by Childe Hassam and Edmund Tarbell of historic churches or interiors furnished with heirlooms, and photographs by the Allen sisters of colonial villages, represented the New England worth preserving—in contrast to a present that lacked grace, style, and an established social order. Chapter four acts as the homespun successor to chapter three. Set in Vermont, New Hampshire, or Maine—rural northern New England—the images can be understood both as a response to the depression and as a search for a place (imaginary more than real) untouched by a malfunctioning social and economic system. Northern New England, of course, was not alone in being singled out as an imaginary retreat; new images of community also favored the rural Midwest and a verdant, sunny California. But those made of New England—by Norman Rockwell, Maxfield Parrish, Grandma Moses, and a group of extraordinary Farm Security Administration photographers—were thought to have a special virtue, born of the region's long-standing reputation for independence and self-sufficiency.

Chapters five and six explore artistic and social issues particular to coastal New England. The antithesis of the well-bred New England towns painted by the impressionists was the rugged, masculine world Winslow Homer created on Prout's Neck. Homer's marines reduced the Maine coast and its inhabitants to a sobering contest with the sea, in which survival seems always in question. Following Homer in this approach were George Bellows and Rockwell Kent, each of whom painted strong, distinctive sea pictures in the starker terms Homer had defined. On the New England coast during some of the same years, a group of modernists—Edward Hopper, Marsden Hartley, Stuart Davis, Marguerite Zorach, and Yasuo Kuniyoshi, among others—were testing new compositional and color strategies on familiar subjects. Each was a tourist of sorts, both accepting and rejecting traditional subjects and styles, ultimately attracted to and suspicious of the authority of the past. The darker implications of Homer's vision arguably reach into this section, recasting some of the work in a more subversive, "grotesque" mode. The benign and picturesque New England seen in many previous images is overturned to expose another strain in the region's past, manifest in beliefs and institutions that were sometimes as rigid and uncompromising as they were nurturing.

If there are many old New Englands, as the authors of this book claim, there are also many ways of reading the images and objects that appear on the following pages. We have chosen to focus on the process by which New England's regional identity was transformed visually into a compelling national language. That language, over the time of rapid and persistent change we were examining, was largely conservative, and consistently used imagery as a means to contain and control, restricting retrospectively the character and makeup of the region and nation. But in its most eloquent form, it also stressed critical moral issues, those on which the nation was founded and that continue to promote absorbing social and political debate. Americans have struggled to achieve independence, religious freedom, and social justice. But the significance of our actions, as understood through images, is the subject of constant interpretation. We offer our reading of old New England images as a lead to further studies, exploring how the past can be seen to sustain and illuminate the present.

Picturing Old New England was produced over a period of three years, a relatively short time to investigate such a complex subject and to select works that conveyed telling ideas about old New England. Friends and colleagues, subjected to repeated requests for information as the exhibition took shape, responded with unfailing promptness and courtesy. Lenders, artists, dealers, independent scholars, and those in institutions outside NMAA who were consulted frequently are: Warren Adelson, Adelson Galleries; Jo Blatti, Hartford, Connecticut; Michael Wentworth and Sally Pierce, Boston Athenaeum; John Atteberry, Boston College Libraries; Theodore E. Stebbins, Jr., Erica

Hirshler, Carol Troyen, and Jeannine Falino, Museum of Fine Arts, Boston; Stephanie L. Taylor, Boston University; Lerphus T. Brown, Charlottesville, Virginia; Virginia Herrick O'Hara, Brandywine River Museum; Jeffrey Garner, University of California, Santa Barbara; Jay Cantor, New York; Judith McCulloch and Sharon Worley, Cape Ann Historical Museum; Judy Barter, Art Institute of Chicago; Jackie Cox-Crite and Allan Rohan Crite, Boston; Jere R. Daniell, Dartmouth College; Gerald Carr, University of Delaware; Philip Zea and Kenneth Hafertepe, Historic Deerfield, Inc., and Suzanne Flynt, Angela Goebel Bain, and Shirley Majewski, Pocumtuck Valley Memorial Association; Susan C. Larsen and Pamela J. Belanger, William A. Farnsworth Library and Art Center; Jeffrey W. Andersen and Jack Becker, Florence Griswold Museum; Frederic Woodbridge Wilson and Annette Fern, Harvard Theatre Collection; Sandra Grindlay, Harvard University Portrait Collection; M.P. Naud, Hirschl and Adler Galleries; Phyllis Rosenzweig, Hirshhorn Museum and Sculpture Garden; Susan Hobbs, Arlington, Virginia; Randall Griffey, University of Kansas; Vance Jordan, Vance Jordan Fine Art; Stuart M. Frank, Mary Malloy, and Michael P. Dyer, Kendall Whaling Museum; Linda Ayres, Sandy Lawson, and Jim Higgins, Library of Congress; Theresa Reismeyer, Litchfield Historical Society; Janet Headley, Loyola College; Lance Mayer, Lyman Allyn Art Museum; Donna Cassidy, University of Southern Maine; Peter Drummey and Chris Steele, Massachusetts Historical Society; Kimberly Alexander Shelland, MIT Museum; Stephen May, Washington, D.C.; Mr. and Mrs. Anthony Mitchell; Edward L. Deci, Monhegan Historical and Cultural Museum Association; Nicolai Cikovsky, Jr., Franklin Kelly, and Heidi Applegate, National Gallery of Art; Donna Belle Garvan and Hillary Anderson, New Hampshire Historical Society; Elizabeth Hutchinson, University of New Mexico; John W. Coffey and Michael Klauke, North Carolina Museum of Art; Mary Jean Blasdale, Old Dartmouth Historical Society; John W. Payson, Vero Beach, Florida; Daniel R. Finamore, Peabody Essex Museum; Peggy M. Baker and Karin Goldstein, Pilgrim Hall Museum; Jacques Amblard, Hotel du Pont; Annetta Gregg, du Pont/KGuns; Jessica Nicoll and Jessica Skwire, Portland Museum of Art; Sue Rainey, Charlottesville, Virginia; Maureen Hart Hennessey, Norman Rockwell Museum at Stockbridge; John H. Dryfhout, Saint-Gaudens National Historic Site; Sloane Stephens, Shelburne Museum; Leigh Culver, Smith College; Rodris Roth and Helena Wright, National Museum of American History, Smithsonian Institution; Lorna Condon and Melinda Linderer, Society for the Preservation of New England Antiquities; Thomas Southall, High Museum of Art; Ira Spanierman and Betty Krulik, Spanierman Galleries; Marianne Richter, Union League Club; Alfred J. Walker, Boston; Beth Venn, Whitney Museum of American Art; and Roger Stein's students at the University of Virginia and Stanford University, from whom, as always, he learned much.

Special thanks are due Elizabeth Kornhauser, chief curator of the Wadsworth Atheneum, who was a strong and early advocate for the exhibition, and to Stephen T. Bruni, executive director of the Delaware Art Museum; Laurene Buckley, director of the New Britain Museum of American Art; Doreen Bolger, director of the Baltimore Museum of Art; Russell Bowman, executive director of the Milwaukee Art Museum; Patricia Hills, professor of art history, Boston University; Teresa Carbone, curator, American painting and sculpture, Brooklyn Museum of Art; and Thomas W. Barwick, Seattle, Washington, who helped us negotiate particularly important loans. We are also deeply indebted to other lenders, private and institutional, who made available works to *Picturing Old New England*. Your generosity continues to make exhibitions such as this one possible.

Initial support for *Picturing Old New England* came from the Smithsonian's Scholarly Studies Program. Roberta Rubinoff, her colleagues, and reviewers Kevin D. Murphy, Patricia Hills, and others who remain anonymous provided us with good advice and generous travel and research funds. With the latter we toured New England and began preparing the publication. Selecting images for inclusion meant culling from our large

storehouse, and for every image or artifact finally chosen there were many others which might equally have claimed our attention. The manuscript for the catalogue went to anonymous readers and to others who reviewed essays at the request of the authors. The latter were Sarah Burns, Richard Candee, Wanda Corn, Gary Kulik, Elisa Cohen Tamarkin, Alan Wallach, and Sandra Zagarell. This process brought forth challenging commentary and a mid-course correction.

Many within NMAA also put forth extraordinary effort. At the top of the list must go the library staff. Cecilia Chin gave over extensive work space to the curators, who used it to review exhibition images. Patricia Lynagh, who cast a wary eye over this proceeding, nevertheless tracked old New England references with admirable skill, imagination, and good humor. Katrina Brown, Stephanie Moye, and Kimball L. Clark also diligently answered a daily barrage of questions. Chief curator Jacquelyn Serwer and deputy chief curator Lynda Hartigan smoothed our administrative path from the beginning to the end of the project. Registrar Melissa Kroning, and Patti Hager, Laura Prochnow, Alison Fenn, Annie Brose, Eugene Young, Michael Fisher, Lynn Putney, and Denise Wamaling were consistently generous with time and support. And Michael Smallwood, who specializes in gathering objects from far away places, again managed to have everything on hand at the right moment.

John Zelenik, chief of Design and Production, gave us a basic gallery plan and refined it in stages, with a keen eye and understanding of our needs. Kathleen Preciado took on a manuscript still unruly in many places and gave it much careful polishing, and Steve Bell made it into an elegant and satisfying book. At the same time, Timothy Wardell's editorial skills and good counsel helped keep the publication on schedule. Annie Storr, an excellent judge of museum audiences, gave a final, careful critique of the gallery texts. Katie Ziglar, Tracy Felker, and Michelle Foster of the NMAA development office never gave up hope, even when time was short and the odds were growing longer. When funds from the Fidelity Foundation and from Betty and James Sams arrived, they seemed like an answer to our prayers. We are also grateful to William S. Talbot and Marjorie and Henry Zapruder for directing us to other possible funding sources.

The hard core of Team New England consisted of Thomas Andrew Denenberg, the exhibition coordinator; Judy Maxwell, chief biography researcher and writer; Michelle Meade Dekker, indefatigable image sleuth and the compiler of the original checklist; Louise Reeves, who capably took over the reins after Tom Denenberg served out his term; and Sandra Levinson, who helped process illustrations and text for publication. Curatorial colleagues Merry Foresta, George Gurney, Virginia Mecklenburg, Richard Murray, Jeana Foley, and Ellen Miles gave us many good suggestions. And early in the project, Samantha Helman, Martha Norton, and Adam Greenhalgh performed valuable research, writing, and clerical tasks. The dedication and energy of the entire group considerably buoyed the spirits of the co-curators.

Tom Denenberg deserves a special commendation. Time and again his knowledge, judgment, and familiarity with New England collections provided us with answers and objects. His imprint can be found on almost every aspect of the exhibition. The exchange among the six authors throughout the project also proved to be a helpful way of rethinking and refining our objectives. Deepest thanks to Stephen Nissenbaum, Dona Brown, Bruce Robertson, and Tom Denenberg for coming through with thoughts, suggestions, and words of encouragement when we needed them most. Our final tribute is to Jenny Strauss Clay, generous with her support, and to our families, who from time to time gently reminded us that we were fathers and grandfathers as well as harried curators. We look forward to a few free weekends and to seeing all of you more often.

William H. Truettner & Roger B. Stein

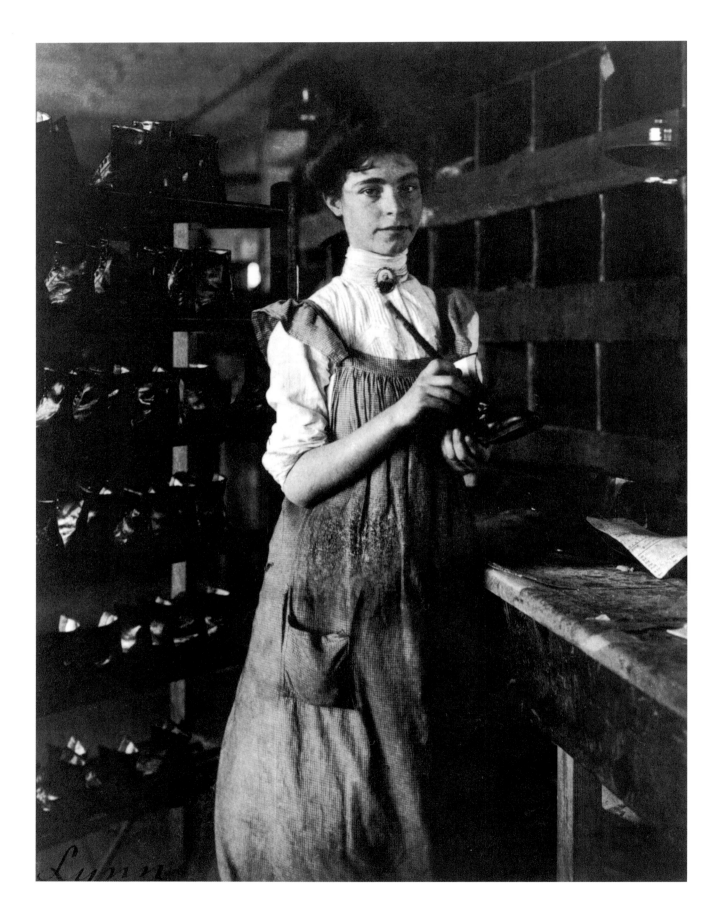

Changing New England: 1865–1945

DONA BROWN & STEPHEN NISSENBAUM

This book examines some of the ways New England has been represented during the period between the Civil War and World War II. Those eighty years span the decades in which the modern United States took shape and when New England came to look like "New England." A wide chasm separates these two historical developments, however. The modernization of American society evokes a vision of cities, factories, and mass culture. It is a tale of unending change, turmoil, divisiveness. A very different set of terms is needed to describe most of the images you will encounter in this book: calendar-perfect villages and rugged seacoast, a place of steadfast tradition, serenity, cohesion.

America in flux, New England at rest—the tension created by the gulf between those two stories is the subject of this book. The rift between the two does not mean that the images of New England described here are false. It does mean that images and realities cannot be easily disentangled. The pictures we hold in our mind's eye often determine not only what we see but what we do, whether as painters, as tourists, or as citizens. In that way, images can reshape external facts, even the very contours of the landscape.[1] The interaction between images and other kinds of reality has played a powerful role in the history of New England and the nation as well.

New England Transformed

As the Civil War ended in 1865, New England was triumphant. The region's writers—Emerson, Hawthorne, Longfellow, Lowell, Whittier—were being established as representatives of an American national culture. Its reformers, once dismissed as radical extremists, were now embraced as heroic figures who helped bring about the abolition of slavery. The Republican Party, barely a decade old but now in firm control of the federal government, was driven by New England-based principles of individualism, order, and self-control. Looming behind it all, New England's industries supplied consumer goods to the nation and the world beyond. For forty years and more, such new mill towns as Lowell and Lawrence, Massachusetts (built along the Merrimack River in 1823 and 1845, respectively, and named for two prominent investor families), had been a tremendous source of regional pride. (New England's industrial dominance was linked to its cultural flowering. Abolitionist poet James Russell Lowell belonged to the family known for its dominance of the textile industry, and his Harvard colleague Henry Wadsworth Longfellow married into another industrialist clan, the Appletons.) During the 1860s the wartime economy led to an astounding 61.8 percent increase in Massachusetts's manufacturing output—the single greatest increase that the state had yet seen (or would ever see again).[2] It seemed as if New England had won it all.

Frances Benjamin Johnston, *Mill Girl* (Shoe Factory, Lynn, Massachusetts), 1895, photograph. Library of Congress, Prints and Photographs Division.

1

But New England also emerged from the Civil War a troubled and transformed region, and its difficulties stemmed from the roots of its triumph. The Republican Party was beset by division. Abraham Lincoln, its first president, had fallen to an assassin's bullet. Andrew Johnson, his successor, proved so controversial that he was impeached by the House of Representatives. He was followed by a president who would become mired in scandal and corruption. By the end of Ulysses Grant's first administration in 1873, the party had split into irreconcilable factions. Antislavery allies divided over how far to extend equal rights to the newly freed slaves (and how to win back the loyalty of their former masters).

New England's industrial development gave the very landscape of the region an unfamiliar look. By 1865 New England had become the most highly urbanized region of the United States. Rhode Island was the single most densely populated state, with Massachusetts coming in a strong second. By 1875 more than half the inhabitants of Massachusetts lived in cities. Furthermore, the region was filling up with people of swarthy complexion and strange languages—with more immigrants and more Roman Catholics than the rest of the country. Back in the 1830s and 1840s industrialization seemed to go hand in hand with moral and social improvement. It had been possible then to believe that the new factories would bring prosperity without also bringing ethnic and class divisions, unskilled and ill-paid foreign workers, or strikes, lockouts, and violence. But now, after 1865, such hopeful prospects were clouded, and it seemed that New England would not avoid the class struggles that had long beset industrial Europe.

Over the next fifty years, in the half-century ending with the outbreak of World War I, these trends intensified and expanded into new parts of the region. In 1890 Fall River, Massachusetts, now the world's largest producer of printed textiles, surpassed Lowell as the American city with the greatest number of industrial corporations. Far to the north of the industrial centers of southeastern Massachusetts, the Amoskeag Manufacturing Company's massive textile mills dominated the northern Merrimack River and the city of Manchester, New Hampshire. Maine's industries started late, but they grew to giant proportions. By 1871 Lewiston, Maine, contained seventeen large factories, and eighty percent of its population came from French Canada. Maine's greatest period of industrialization was still to come, between 1880 and 1910, when great conglomerates built hydroelectric plants on the state's rivers. The new kilowattage enabled these corporations to construct the paper mills that would dominate the state's economy for many decades. One of these corporations, the Great Northern Paper Company, created the new city of Millinocket almost overnight in 1900, complete with hydroelectric plant, paper factory, and tenement housing for thousands of French Canadian workers.[3]

Prosperous New Englanders were inclined to celebrate these regional triumphs, to congratulate themselves on the ingenuity and character that had produced such amazing technological and economic progress. But dark clouds loomed on the horizon. Although New England's industries were thriving in the last quarter of the nineteenth century, a sharp-eyed observer could have noted that the industries of other regions were expanding even more rapidly. New England was no longer in the economic vanguard.

More important, many native-born middle- and upper-class New Englanders were not entirely happy with the byproducts of industrialization. For some, the great cities filled with immigrants were more disturbing than gratifying. These New Englanders were prompted to ask serious questions: What if the hard work and sobriety of their New England ancestors had inadvertently created a place where individual actions were lost in the industrial grind, where the search for money replaced honesty and integrity, and where (as they saw it) slovenly Italians and shiftless French Canadians replaced hard-working Yankees?

Worse still, the transformation of the region was not confined to the tenements and factories of the new industrial centers. What had meant growth for New England's cities meant crisis for its countryside. Actually, for decades before 1865 New England farms had been competing with new lands opening to the west, and New England farmers had been losing the fight. After the Civil War rural people found it more difficult to keep their children at home on the farm. Between 1860 and 1910 the population of America's largest cities (those with a population of more than one hundred thousand) grew by almost seven hundred percent. Much of that growth came from the countryside. The population of most small towns hit its peak in 1830, declining in many places for the next eighty years. The frontiers of Maine continued to gain population (the vast Aroostook area did not open as a potato-growing region until the 1890s), but most small towns in northern New England lost ground. For example, between 1850 and 1900, about forty percent of all those born in Vermont moved out—in each decade.

The forces pulling people away from the hinterlands dramatically transformed the rural economy. In the 1850s few New England villages had been without their woolen mills, their furniture factories, or their broom-making establishments. Local artisans and manufacturers had served and employed the farm families of New England. Now cheaper goods from the growing industrial centers (the same inexpensive cotton prints and cheap shoes that were making manufacturing centers out of New Bedford and Lynn, Massachusetts) replaced locally made goods, and young men and women followed their jobs to the cities. Small-town New England economies were significantly less diverse in 1900 than they had been half a century earlier.[4]

The cities and villages of coastal New England suffered a similar long, slow decline. In some places the great seafaring enterprises that had made New England famous in the eighteenth century had begun to suffer even before the Civil War. Nantucket's dominance of the international whaling industry was fading even before the market for whale oil was threatened by the discovery in 1852 that kerosene could be used for lighting. The island's harbor was too small for the increasingly large ships employed in the whaling trade, so that Nantucket was losing out to its nearest competitor, New Bedford. Moreover, through the end of the nineteenth century whaling was becoming less and less profitable because of a dramatic decline in the population of sperm whales, which made it necessary to launch ever lengthier and wider-ranging expeditions.

A similar fate overtook the deep-sea fishing industry that had shaped so many coastal communities. At the beginning of the Civil War more deep-sea fish were caught off the coast of Maine than anywhere else in the nation. Within a generation, the state's share of the industry had declined to a point of insignificance. Hit hard by Civil War disruptions and price increases, the deep-sea fishery faced even more difficulties in the years afterward, when technological innovation and financial pressures pushed the industry toward increased centralization. By 1880 more than half of all fish caught by New Englanders was shipped from Boston. By then, competition from the fisheries of the American West and the Gulf states also worked against New England fishing. More important, salted cod, mackerel, and herring—long the staples of the poor—could not compete with fresh meat, newly inexpensive and shipped by rail from the West. As deep-sea fishing declined and became centralized, working conditions worsened dramatically. By the end of the century eighty percent of Maine fishers worked not in the high-risk, high-profit, deep-sea enterprises but in small-scale coastal industries, fishing for sardines caught near shore and, increasingly, trapping lobsters, an industry supported by the three hundred thousand tourists who came through Maine in 1900. In Massachusetts only three towns still relied chiefly on fishing for their livelihoods at the end of the century: Provincetown and Chatham, both on Cape Cod, and Gloucester, on Cape Ann.

The Uses of Decline

In the eyes of some observers, rural New England's decline was not completely negative. In fact, it seemed like an answer to their prayers. Before the Civil War articulate New Englanders had emphasized the countryside's progressive characteristics—the bustling commerce of the small towns, the high literacy rates, the embrace of progressive reforms, even the presence of rural industry. These characteristics set small-town New England far above rural culture elsewhere in the nation (and especially the South). To be sure, some parts of the antebellum countryside, especially in its furthest reaches, remained culturally backward, and New Englanders reacted with embarrassment or even hostility to the fact. Now, in the decades following the Civil War, those outlying places began to seem attractive and the very "backwardness" of the countryside became its most valued attribute.

Writers heralded this change. Some of New England's most prominent authors conspicuously disengaged themselves from the problems of social reform, retreating with astonishing speed into the quiet pleasures of country life. The Quaker poet John Greenleaf Whittier had won fame in the antebellum decades for his impassioned antislavery verse. By 1866, one year after the end of the war, Whittier achieved even greater fame with a very different kind of poem, *Snow-Bound,* an elegiac evocation of childhood and family life in the New England countryside. An even more striking example is found in the career of New England's most celebrated writer, Harriet Beecher Stowe. Stowe had made her name as the author of *Uncle Tom's Cabin* (1852), the most influential and widely read antislavery work ever written. By 1860 she had abandoned the theme of political reform and begun to produce homespun novels about life in old-time rural New England, novels whose very titles evoked nostalgia: *The Minister's Wooing* (1859); *Old Town Folks* (1869); *The Pearl of Orr's Island: A Story of the Coast of Maine* (1862).

By the 1880s a full-scale movement of New England "local-color" literature had been fashioned, largely by women writers, including Rose Terry Cooke, Elizabeth Stuart Phelps Ward, Mary Wilkins Freeman, and Sarah Orne Jewett. In their writing, rural New England took on a new texture. The bustling small towns boasted of by antebellum writers were replaced by villages, where, as Jewett wrote, "all the clocks and all the people with them, had stopped years ago."[5] In local-color stories New England sometimes encountered modernity—but not often and not easily. Now New England villages were increasingly portrayed as a national repository of everything industrial society was leaving behind—pastoral scenery, quaint Yankee customs, rural simplicity. This literary transformation required some fictional sleight of hand. As Jewett wrote her beautifully turned stories about rural isolation for the *Atlantic Monthly,* she could hear the factory bells calling women to work at the Portsmouth Manufacturing Company down the street. But mills and workers rarely appeared in her stories.

Outside of books, in the actual landscape, promoters of tourism fashioned a self-consciously antiquated New England as an antidote to modernization. Entrepreneurs in many farm towns and seaports saw an opportunity to put their dilapidated buildings and grass-grown streets to work as waves of tourists set out in search of a nostalgic New England experience. Old, out-of-the-way places passed by in the surge of industrialization began to look attractive. For people fatigued and stressed by the rush of business, the ghostly quiet of rural backwaters like Deerfield, Massachusetts, now felt serene. For those who feared the corrupting influence of luxury and ease produced by industrial society, there was reassurance to be found in the hardy fisherfolk who lived tucked away in coastal villages.

Signs of Nantucket's commercial failure—its rotting wharves and empty factories—were recast for tourists as symbols of a Yankee heritage and the island's historic virtues. Even the lost whaling trade itself became a source of interest, as pro-

moters celebrated the last representatives of a sturdy race whose bravery and vigor had once been known around the globe—the "boldest and most enterprising mariners that ever furrowed the seas."[6] Quaint old seafaring men, retired from their dangerous and exciting work, provided a unique attraction to tourists, who hoped to be regaled by harrowing tales of hardship and courage.

Nantucket promoters claimed to offer an environment reassuring in another way. For people frightened by unfamiliar faces and languages, New England's backwaters now seemed ethnically "pure"—populated by people who were coming to be called "Anglo-Saxons." As an Old Colony Railroad pamphlet put it, "Nantucket's population [was] not increased, nor has it ever been, by . . . discordant elements from varying climes and nationalities."[7] This statement was patently untrue: Native American, African-American, and Portuguese sailors had long worked on Nantucket's whaling ships since the days of their glory. The claim that Nantucket was ethnically "pure" was necessary, however, if the people of Nantucket were to be linked with New England's ancestral past.

Other New England communities were shaped by vacationers with a somewhat different approach to the past. The summer communities near the city of Portsmouth, New Hampshire, for example—York, Ogunquit, and Kittery in Maine, the Isles of Shoals and New Castle in New Hampshire—attracted visitors who yearned for a return not to primitive simplicity but to the grace and elegance of "colonial" days. For these wealthy summer people, the "colonial" architecture of the old seaport towns symbolized a return to a world where the order, stability, and hierarchy they associated with the past still held sway—a place where their own ancestors had held unchallenged authority and where working people had been deferential and contented. "Colonial" vacationers worked hard to recapture the power of that vision, by restoring old houses, digging for treasures in antiquarian libraries and antique stores, and founding historical societies.

They also photographed, sketched, and painted re-created colonial landscapes. Many summer people were not simply vacationers. They were also professional artists, working in various genres and styles. Arthur Little included several York houses in his groundbreaking collection of architectural drawings, *Early New England Interiors* (1878). Edmund C. Tarbell, cochair of the School of the Museum of Fine Arts in Boston, bought a summer home in New Castle and transformed it by adding remnants of eighteenth-century buildings scavenged from nearby towns. He used that setting for many of his paintings.

For visual artists as well as for tourists, isolated rural communities and quiet, deserted seaports offered new opportunities. By the turn of the twentieth century artists' colonies closely linked with vacation communities thrived in many parts of New England. One of the oldest was in the White Mountains, where North Conway's splendid views of Mount Washington had attracted artists since the 1840s. Later colonies sprang up in Dublin and Cornish, New Hampshire; Old Lyme, Connecticut; Gloucester; and perhaps the best-known artists' haven, Provincetown, Massachusetts. Such places had several things in common. They were rural, they were isolated, and they were in obvious decline—fishing shacks no longer in use, wharves rotting, cemeteries grown up to weeds.

In the Maine village of Ogunquit, not far from Jewett's home in South Berwick, Charles Woodbury, Boston painter and art teacher, established a summer art school in 1898. A few years later in the same village, Hamilton Easter Field opened another school, this one oriented more toward New York and modernism. In the same neighborhood Childe Hassam painted at the Isles of Shoals (just off the coast); and a few miles to the south, Russell Cheney worked in Kittery Point, as did Tarbell in New Castle.

Painters in Ogunquit were attracted to the rugged landscape and to the marks

left by history on that landscape. (They also liked the inexpensive but picturesque fishing shacks they could use for studios.) Painters of a more modernist bent were particularly attracted by the objects created by old-time farmers and fishers. At his Ogunquit school Field displayed a collection of local folk art as evidence of an unbroken link between contemporary art and the indigenous traditions of the past. In nearby York, photographer Emma Coleman (*see* Figs. 9, 16) made a similar connection between her own work and that of local crafts people by photographing staged scenes of individuals engaged in traditional tasks.[8]

Escape into the world of historical reenactment was not enough for many old-stock New Englanders. The writer Thomas Bailey Aldrich was another literary figure associated with the cluster of summer resorts around Portsmouth. He achieved fame with *The Story of a Bad Boy* (1870), a charming memoir about his youth, when the "ghost of the old dead West India trade" dominated the landscape and no new businesses and few new people disturbed the peace of the city. Aldrich was not content merely to write elegies mourning the loss of that quiet and stable New England. He also produced an openly political poem, "Unguarded Gates" (1895), employing the classic elegance of a sonnet to argue for legislation to stem the flow of immigrants from southern and eastern Europe. Aldrich preferred the Portsmouth of his childhood, where immigrants were few and old Yankee characters dominated the landscape. "Wide open and unguarded stand our gates," began his poem, "and through them presses a wild motley throng." Aldrich was a proponent of newly emerging racial theories that divided humanity among some two dozen "races" of Slavs, Celts, Hebrews, Teutons, with the "Anglo-Saxon" race at the pinnacle. Aldrich's sonnet warned of the gathering power of darker races incapable of cherishing freedom, bringing with them "unknown gods and rites," "strange tongues," and "tiger passions." The poem concluded with a warning against "the thronging Goth and Vandal" who had once "trampled Rome": "Liberty, white goddess, is it wise / to leave the gates unguarded?"[9]

The Empire Strikes Back

Aldrich was not satisfied with simply writing poems. He also joined the Immigration Restriction League, founded at Harvard in 1894, and worked with its members to close those gates of immigration permanently. League rosters include many venerable names of New England's most powerful families—Abbott Lawrence Lowell, president of Harvard; Henry Lee Higginson, a founder of the Boston Symphony Orchestra; Henry Cabot Lodge, brahmin politician. Not all old-stock New Englanders shared Aldrich's nativist politics, however. Others of similar background—native-born Yankees who deplored the changes that had come over New England—responded quite differently to the region's transformation. Henry Lee Higginson's own cousin, Thomas Wentworth Higginson (*see* Fig. 60), held to the egalitarian ideas that had shaped his earlier years as a radical abolitionist, suffragist, and colonel of the first black regiment in the Union army. A Unitarian minister, this Higginson spoke out against immigration restriction and racial and religious discrimination. Similarly, Caroline Emmerton of Salem and her architect, Joseph Everett Chandler, used their discomfort with the changes overtaking New England to create a fusion of old and new values. They restored the House of the Seven Gables (setting of the Hawthorne novel) for use as a settlement house, where Emmerton taught the children of Salem's Italian immigrants (*see* Fig. 88).

In Aldrich's generation, too, a new crop of experts diagnosed the problems of the countryside. By the end of the nineteenth century the perilous state of rural New England had been noticed far outside the region, in the halls of academia and among muckraking journalists. Popular magazines like *Harper's* and *Atlantic Monthly*—and progressive journals like *The Nation*—filled their pages with such ar-

ticles as "Broken Shadows on the New England Farm" and "Is New England Decadent?" (A contributor to the *Atlantic Monthly* accused one western Massachusetts town of harboring tribes of incestuous half-wits, "pests and delinquents and dependents and defectives and degenerates.")[10] Literary images of decline emerged in the same local-color writing that was shaping a nostalgic vision of New England. Stowe's loving depictions of village society were more and more replaced by visions of a New England filled with hopelessness and grinding poverty. For sheer grimness, perhaps no description of New England has ever matched Edith Wharton's novella *Ethan Frome* (1911).

Progressive reformers tackled rural problems by organizing the Country Life Movement. Entirely new fields of academic expertise arose to confront the problems of the countryside. Rural sociologists studied the structure of farm families, and agricultural extension agents promoted new crops and fertilizers. Country Life leaders like Massachusetts Agricultural College's Kenyon Butterfield and Cornell's Liberty Hyde Bailey promoted a complex agenda—consolidate rural schools and churches to promote greater efficiency, teach agricultural and home economics courses, advise farmers on labor-saving machinery and cost-accounting methods— all in an effort to remove the last vestiges of self-sufficiency and to promote participation in the marketplace: husbands as producers, wives and children as consumers.

Such experts found nothing appealing in the backwardness of rural culture. The "best and the brightest" were leaving the countryside because existence there lacked the challenge and zest of modern life in the city. Country life also lacked the competitive Darwinian "winnowing forces" that encouraged progress. To promote those forces, Country Life experts worked to make farms as efficient as factories. To be sure, such efficiency would require fewer rural workers and would thus drive thousands of people off the farms. But many Country Life advocates saw this process as both inevitable and desirable. As University of Illinois agricultural scientist Eugene Davenport argued, "Many individuals will be crowded out as agriculture exacts more knowledge and skill. . . . Progress is not in the interest of the individual, and it cannot stop because of individuals."[11]

By the 1910s many rural (and urban) reformers were beginning to think that these competitive processes were not enough to weed out the unfit. Maybe the magazines had been right when they talked about "degenerates" and congenital deformities. Many experts came to think that intractable social problems were fundamentally genetic rather than economic. The 1920s witnessed a dramatic rise in the popularity among progressive reformers and scientists as well as old-guard reactionaries of what would today be called genetic engineering. In 1925, for example, University of Vermont Professor Henry Perkins launched a Eugenics Survey to identify the chief causes of "defect, dependence, and degeneracy" in Vermont. (Perkins, a biologist, had become convinced that something was terribly wrong with rural life when he learned that the draft board during World War I had found that Vermont had the highest percentage of any state of mental and physical "defectives.") The Eugenics Survey called for greater regulation of marriage, an increase in state care for the "feeble-minded," and a statewide law permitting sterilization of the "socially inadequate." Such a law was passed in 1931.[12]

These scientific programs, designed to improve the population through breeding, existed alongside a resurgence of older styles of racial politics. The infamous trial of Italian immigrants Nicola Sacco and Bartholomeo Vanzetti began in Dedham, Massachusetts, in 1921. Their execution in 1927, on the basis of flimsy evidence, reflected great hostility toward immigrants and radicals of all kinds. On a national level, the Anti-Immigration League won its final victory. In 1924 it succeeded in influencing Congress to cut the massive flow of European immigrants down to a trickle. In that same year the Ku Klux Klan claimed fifty thousand members in Maine.

The Rise of Labor

By 1920 more than two-thirds of the Massachusetts population consisted of first- or second-generation immigrants. Control by old-stock Yankees over the economy and politics of New England was in jeopardy. The stage was set for a series of battles between Yankees and second-generation immigrants—at the factory gates, in the voting booths, and in the culture wars.

Workers had been organizing since the mid-nineteenth century, but their position was strengthened with the establishment of the United Textile Workers in 1901. The power of the growing labor movement was tested in the very heart of the old elite Yankee dream of a painless Industrial Revolution—in Lawrence, Massachusetts, where by 1890 forty-five different languages were spoken. In 1912 Lawrence workers pitted their power against the great textile corporations in a strike that made headlines all over the country. The International Workers of the World, an umbrella union known as the "Wobblies," struck a brilliant blow with its appeal for an Exodus of Children into supportive communities and out of harm's way. The victory in Lawrence, although modest (a one-cent an hour raise and recognition of the right to organize), marked a turning point for labor in New England.

Signs of political change were in the wind, too. The Republican Party, symbol of New England's Civil War victory, had become in the late nineteenth century the advocate of elite control and untrammeled capitalism. Republicans held unchallengeable sway in most of New England through the early twentieth century, but there were hints of a new attitude. In Massachusetts even firmly Republican governments found themselves forced to pass laws protecting public health and recognizing the right of labor to organize as well as mandating a ten-hour workday and limiting the working hours of women and children. In 1928 Republican hegemony in New England began to crumble. Democrat Al Smith received the majority of Massachusetts votes for president that year, inaugurating an occasional but notorious Massachusetts tradition of voting against the presidential tide.

The Long Recession

These victories for Democrats and labor unions were far from decisive. The 1920s saw not only racial backlash but also the collapse of New England's two most important industries. Textile and shoe production was heavily concentrated in a few places. For example, 82 percent of New Bedford's workers and 78 percent of those in Fall River worked in textiles; while in Haverhill 84 percent of the work force labored in boot and shoe factories. By the beginning of the twentieth century these industries had already been weakened, but they had been temporarily buoyed by the production demands of World War I. Now, during the 1920s, the bottom fell out. Between 1919 and 1929 Massachusetts lost 154,000 jobs in manufacturing, most in its two biggest industries. New England suddenly found itself "deindustrialized."

In 1924 the Borden family of Fall River moved its textile mills to Tennessee. In 1933, in a moment of great symbolic power, the Appleton Company, founding giants of New England's textile might, moved to Alabama. Business leaders who made these decisions could cite the lower cost of doing business in the South, where textile mills would be closer to their sources for cotton. What they rarely pointed out was that production costs were lower in Alabama and Tennessee because those states had no unions and no child-labor laws. Many business leaders had made the decision years earlier not to reinvest their profits into modernizing and maintaining their factories in New England. A few parts of New England actually benefited from this development. In some areas of Maine non-unionized labor was so cheap during the 1920s that Massachusetts shoe companies moved there

instead of to the South. Maine's powerful combination of hydroelectric power and pulp mills continued to grow into the 1920s. But there was worse yet to come: the Great Depression of the 1930s.

The depression hit hard everywhere. The weakened textile and shoe industries were decimated, and the cities dependent on them were devastated. In 1936 the Amoskeag Manufacturing Company, after years of layoffs and declining wages, declared bankruptcy and closed its doors, throwing thousands of people out of work and bringing disaster to the city of Manchester. Even in the more diversified economy of Boston, nearly twenty percent of workers were unemployed; in some of the city's ethnic neighborhoods, unemployment reached forty percent. The countryside in general fared better, but only because farm families could return to the subsistence production discouraged earlier by the new agricultural experts. Products dependent on outside consumer markets—like milk—were hit heavily. By the spring of 1932 income in Vermont from milk checks had dropped fifty percent from 1929 levels.

New England's New Deal

New England developed a reputation for resisting the New Deal and the Roosevelt administration in the name of a bred-in-the-bone loyalty to the party of Lincoln. That reputation is based partly on fact. Massachusetts had fallen to the Democrats in 1928, but the rest of New England was still solidly Republican. In the dark year of 1932, every New England state, except Massachusetts, voted Republican, against Roosevelt and for Hoover. Even in 1936, when Connecticut, New Hampshire, and Rhode Island joined the New Deal, Maine and Vermont held out in a legendary minority vote against Roosevelt—the only two states in the United States to do so.

Even in these last bastions of rock-ribbed Republicanism, there were signs of change. When Maine went for Hoover in 1932, the state simultaneously elected a Democratic governor and two Democratic congressmen. And in 1936, when Vermont's voters resoundingly rejected Roosevelt, they also elected George Aiken as governor. Aiken was a Republican, but a new kind, pro-labor and pro-union in his sympathies. "Today the Republican Party attracts neither the farmer nor the industrial worker," Aiken lamented in a national radio speech in 1938, arguing that the party's leaders had become rubber stamps for business interests. (During his final term in the United States Senate, in the midst of the Vietnam War, Aiken made the wry proposal that became his best-known legacy: the United States government should simply declare victory in Vietnam and then withdraw its troops.) A vote for George Aiken was anything but a decisive rejection of liberalism.

Even if the voters of northern New England rejected the politics of the New Deal, they accepted its offers of help. Vermont and Maine received the largest portion of New Deal aid in New England. One week after the passage of the bill creating the Civilian Conservation Corps, the first CCC camp opened in Vermont. By 1934 eighteen camps were operating in Vermont. (Rural Republicans found work programs such as the CCC easier to accept than so-called direct-relief programs, since the work programs encouraged and rewarded hard work—usually outdoors—and did not appear to undermine personal independence or traditional notions of manliness.)[13]

New Deal programs had the greatest impact on northern New England's growing tourist industry. The CCC built Maine's section of the Appalachian Trail and also the campgrounds in Acadia National Park. Perhaps even more important, both state and federal governments invested heavily in the development of the skiing industry, which would come to dominate the economy of northern New England. In the winter of 1930 the Boston and Maine Railroad brought out the first of its "snow trains," which within five years had carried sixty thousand passengers to ski the

mountains of New Hampshire (*see* Figs. 154–157). By the 1930s tourism had become Maine's number one industry. In Vermont tourism produced more than twice as much revenue as quarrying, formerly the state's largest industry.

Tourism in New England depended on a vision of the region that had been forged in the Gilded Age of the previous century. New England (at least the tourist's New England) was a place of retreat, of nostalgic forgetfulness. *Yankee* magazine, founded in 1935, provided powerful reinforcement for this vision and for the tourist economy. But all those ski lifts and hiking trails put a new twist on the old image. For generations vacationers had been going into the wilds of Maine or New Hampshire to hunt or fish, but by the turn of the century many of them had begun to seek out a new self-consciously "wild" experience. Such wilderness vacationing was most often associated with the Adirondacks of New York and with the great expanses of wild country in the West, but even in relatively tame New England a new interest in "roughing it" had emerged by the turn of the century. Wilderness societies like the Appalachian Mountain Club and the Green Mountain Club actively promoted a new vision of outdoor recreation—rest for the jaded businessman and perhaps even for his exhausted wife. For the children, the summer-camp experience soon became a defining feature of New England: by 1920 Vermont had 75 summer camps, New Hampshire 85, and Maine an astonishing 230.

Many Americans now had become convinced that their salvation lay in new kinds of physical exercise—in hunting, hiking, camping, and skiing. Theodore Roosevelt's pronouncements on the "unhealthy softening and relaxation of fibre" among native-born Americans hit a raw nerve for some vacationers. Taken together, these cultural currents led many middle- and upper-class Americans to embrace a wide range of activities designed to bring overcivilized men (and some women) back into contact with the primitive. Skiing, along with other such college sports as rowing and football, was thought to toughen America's youth, to make them more like their hardy colonial ancestors. As early as 1910, when the Dartmouth Outing Club was founded, college students were beginning to ski in the White Mountains. The sport had become widely popular by the 1930s.

A Liberal New England?

Much had changed since New England was first transformed by the Industrial Revolution. Factory towns had filled up and emptied out. Generations of people of Italian, Irish, and French descent had lived and died, built churches and schools, learned English, and formed voting blocs. Labor unions, fostered by the New Deal, had established a foothold in the regional economy. Democrats or progressive Republicans held control of state governments that took some responsibility for the education and welfare of their citizens.

It is possible that all these changes might have taken place without altering the much-loved "New England" of calendars and vacation posters. All that was really necessary was to add a few photographs of winter scenes to bring the old images up to date. For some culture brokers, however, the 1930s offered a greater opportunity: to resolve the region's ethnic, class, and political conflicts by revising the very definition of New England. For example, take the guidebooks to the New England states written during the mid-1930s under the sponsorship of the Works Progress Administration (WPA), a New Deal agency that put unemployed writers to work on cultural projects. In the hands of these committed liberals, the heritage of the region became at once more inclusive, more egalitarian, and more democratic. The Massachusetts WPA guide, for example, was careful to include colorful ethnic celebrations along with the standard descriptions of eighteenth-century houses. (The customs of Portuguese fishing communities were a favorite.) The WPA writers were criticized for their extensive discussions of the Boston police strike of 1919 and the

Sacco and Vanzetti case. One critic even counted the lines devoted to Sacco and Vanzetti—forty-two—and noted that only nine lines were devoted to the Boston Tea Party.

But most important, the writers of the Massachusetts WPA guide attempted to capture the history of the region as their own. They described labor organizers as latter-day "frontiersmen" who came to the "defense of democracy" much as the Minutemen had done in earlier times.[14] These writers reframed the history of the state as a story of successive uprisings caused by a periodic "salty breeze" that "blows through this most conservative of commonwealths": a breeze that caused the American Revolution, that impelled the Lowell mill girls to strike, and that only died "to a flat calm at the beginning of the twentieth century."[15] Boston, in their view, owed its "color, its hope, and its unquenchable vitality" in the midst of the depression not to its old Yankee families but to its "newer stocks."[16]

By 1937, when the poet Conrad Aiken wrote a sketch of Deerfield (site of a famous Indian attack) for the Massachusetts WPA guide, both the old conventional ethnic prejudices and virulent new genetic theories were coming under concerted criticism, as Nazi racial ideology became increasingly repugnant to the American public. In one of the most beautiful passages in any WPA guidebook, Aiken wrote that the "strange air of unreality" pervading the silent houses of Deerfield whispered a painful message: "the wilderness haunts me, the ghosts of a slain race are in my doorways and clapboards, like a kind of death."[17]

But the WPA guidebook writers remained loyal to a vision of New England deeply rooted in its Puritan and English heritage, even as they attempted to universalize that heritage and make it play a progressive role. WPA guidebooks continued to suggest that small-town New England represented rural independence. Populated by self-sufficient, resilient folk, these villages would have no need of the New Deal. The writers of the WPA guides were hardly political conservatives, but when it came to their deepest cultural assumptions even Roosevelt liberals could continue to cherish the old ideas.

The paintings of Norman Rockwell, the most important American public artist of the 1940s, were similarly ambiguous. Rockwell's famous *Saturday Evening Post* covers from this decade worked on several levels. They were an assertion of Yankee individualism and a hymn to American traditions, but the small-town world they portrayed was also deeply egalitarian. In Rockwell's hands, the New England tradition was democratic down to its core. Although the conventional interpretation is that his art expressed antigovernment "individualist" values, Rockwell's major work from this period tacitly supported the New Deal. His series "The Four Freedoms" (*see* Figs. 129, 143), based on a famous Roosevelt speech, provided important cultural backing for FDR's internationalist agenda.

Epilogue: New England in 1945

War changed New England once again. Much as the Civil War had done eighty years earlier, World War II fueled the growth of industries and wealth. New England emerged from the war once again poised for economic resurgence. Government contracts led to the rapid expansion of research and development in weapons, electronics systems, and eventually computer technology. Cambridge, Massachusetts—home of Harvard University and Massachusetts Institute of Technology laboratories—was at the center of the new expansion, but other places also benefited: Portsmouth's naval shipyards; General Electric factories in Lynn and Pittsfield; research facilities in Woods Hole, on Cape Cod; and Groton, Connecticut, home of Electric Boat Company, builder of the nation's nuclear submarine fleet. The roots of the late-twentieth-century "Massachusetts miracle" were to be found here, in the expansion of industry created by World War II. Two decades of

war and cold war would add fuel to this military technology boom.

Because of industrial expansion, much of southern New England enjoyed the full-employment economy that has made the postwar period look in retrospect like a sweet dream. Fourth-generation immigrant families found themselves lifted out of factory jobs and into an increasingly white-collar, service-oriented economy. Ripples of the same economic transformation were felt in rural New England, too, as many previously overlooked places were transformed into new tourist destinations to meet the vacation demand of newly leisured workers. On Cape Cod, for example, a postwar building boom catered to a new Boston market, families who had only recently acquired sufficient prosperity and security to take a two-week vacation or buy a modest vacation home. Retirees, too, took advantage of the Social Security program and other New Deal-era pension plans to move to Cape Cod in large numbers during the 1950s.

But the battle for New England's heritage was not over. The end of the war generated an explosion of interest in making American history more widely available to the public. During the immediate postwar years, a number of "history theme parks" sprang up to meet both the demand for vacation entertainment and burgeoning public interest in historical New England. Six major museum villages were founded in New England, each inspired in part by two great prewar multimillion-dollar projects located outside the region: John D. Rockefeller's Colonial Williamsburg in Virginia, founded in 1926, and Henry Ford's Greenfield Village in Dearborn, Michigan, founded in 1929. Old Sturbridge Village, a re-created New England village of the early nineteenth century, opened to the public in 1947. Plimoth Plantation, founded in 1947, was committed to re-creating the life of the first generation of Plymouth settlers. Historic Deerfield, Inc., opened officially in 1952, as did Electra Havemeyer (Mrs. J. Watson) Webb's eccentric collection of buildings called the Shelburne Museum, in northern Vermont. Strawbery Banke, an assemblage of colonial-era buildings in Portsmouth, welcomed its first visitors in 1958. Mystic Seaport, a re-created seafaring town in Connecticut, had already opened on a very small scale in 1930.[18]

At their inception, the postwar village museums enshrined a vision of New England forged in the nineteenth century. In the years to come, they would be transformed by a new emphasis on historical accuracy informed by powerfully revisionist discoveries about the lives of ordinary people in early New England. But when they began, their interpretive roots lay firmly in the late-nineteenth-century model of old New England—rural, homogeneous, preindustrial. Historical interest in New England's ethnic and industrial past still remained a thing of the future. For a visitor to the postwar village museums in the early years, New England would be a place populated by hardy sailors (Mystic Seaport), rugged pioneers (Historic Deerfield), self-reliant farmers (Old Sturbridge Village), elegant colonial gentry (Strawbery Banke), and pious Pilgrims (Plimoth Plantation), with a penchant for antiquated spelling.

In these museums the old ideas about New England seemed more central than ever in the postwar years. With the rise of Hitler and the gradual alignment of American politics to resist Nazism, the outspoken racial theories of the Immigration Restriction League and the eugenics movement had become untenable. (Of course, immigration restriction had also done its work. After 1924 few immigrants were coming to the United States, and second-, third-, and fourth-generation Europeans were well on their way to assimilation.) If aliens and immigrants no longer seemed so threatening, they were replaced in the postwar period by another foreign enemy hovering over Europe and threatening to sap the loyalties of Americans: the specter of Communism. In 1952 the founder of Historic Deerfield noted: "our

young and powerful nation finds itself engaged in an ideological conflict with Communism." Under these circumstances the living history of "a New England village can be the most eloquent response to the strident falsehoods poisoning the air today."[19] In such a highly charged atmosphere the dawn of the "American century" would enlist the old image of New England in a new struggle.

Notes

1. Historians have recently been making effective use of the idea that regional identity does not stem simply or inevitably from such intrinsic circumstances as those of geology, climate, or the ethnic composition of the region's population, but that such identity is also created and transformed by cultural images "invented" to meet particular cultural, economic, or political needs. Examples of this approach include Axelrod, ed., *Colonial Revival in America;* Giffen and Murphy, eds., *"Noble and Dignified Stream";* Edward L. Ayers et al., *All over the Map: Rethinking American Regions* (Baltimore: Johns Hopkins University Press, 1996); Brown, *Inventing New England;* and William Robert Taylor, *Cavalier and Yankee: The Old South and the American National Character* (New York: Braziller, 1961). For the general theme of "invented traditions," see Hobsbawm and Ranger, eds., *Invention of Tradition;* David Lowenthal, *The Past Is a Foreign Country* (New York: Cambridge University Press, 1985).
2. Wilkie and Tager, eds., *Historical Atlas of Massachusetts.* All statistics about Massachusetts's economy come from this book.
3. Judd, Churchill, and Eastman, eds., *Maine.* All statistics about Maine's economy come from this book.
4. For a study of this process, see Barron, *Those Who Stayed Behind.*
5. Jewett, *Deephaven,* 71.
6. D. H. Strother, "A Summer in New England," *Harper's* 21 (November 1860): 745.
7. *The Old Colony: or, Pilgrim Land, Past and Present* (Boston, 1887), 66–67.
8. Openo, "Artistic Circles and Summer Colonies."
9. Aldrich, *Writing of Thomas Bailey Aldrich,* 2: 71–72.
10. Rollin Lynde Hart, "A New England Hill Town," *Atlantic Monthly* 83 (April 1899): 571–72.
11. Quoted in Danbom, *Resisted Revolution,* 40.
12. The Vermont project was initially aimed at the native-born rural population. In time it came to target a wide variety of people who were enmeshed in the web of charity programs. Its more brutal provisions probably fell most heavily on the Abenaki Indians, who lived along the margins of Vermont society. See Gallagher, "Perkins and the Vermont Eugenics Movement."
13. Judd, *New Deal in Vermont.*
14. Federal Writers' Project, *Massachusetts,* 65.
15. Ibid., 3.
16. Ibid., 145.
17. Ibid., 223.
18. For information about these museums and much else, see Michael Kammen's magisterial book, *Mystic Chords of Memory.*
19. Flynt and Chamberlain, *Frontier of Freedom,* 1.

After the War: Constructing a Rural Past

ROGER B. STEIN

In 1869 John Rogers, Jr., began selling from his manufactory in New York City copies of a small sculptural group in plaster entitled *The Fugitive's Story* (Fig. 1). It is a paradigm of its particular moment, suggesting the history of imaging New England for the nation. Four years after the Civil War, Rogers reaches back into the past for his story, juxtaposing an anonymous fugitive slave and her baby against portrait images of the New England abolitionists John Greenleaf Whittier, Henry Ward Beecher, and William Lloyd Garrison. The white male leaders of the antislavery movement in the prewar years have become in this postwar image emblematically, as poet, preacher, and publicist, the active receivers and transmitters of "the fugitive's story." The barefoot black woman stands with head bowed, her belongings in a sack at her feet; the well-dressed and booted men gather around a handsome period desk and chair.

Hindsight teaches us some of the larger truths of this image. She is overwhelmed, outclassed, and outnumbered in gender and race by these spokesman for the dominant culture. Her narrative will be appropriated and her image refashioned, verbally and visually, morally and poetically. The radical achievement of her courageous act as fugitive and as mother and the subsequent emancipation of her people become in this parlor sculpture material for a rather genteel tableau.[1] The moral and political struggles of abolitionist idealism were being domesticated and turned into a narrative of the past.

Although *The Fugitive's Story* was produced in New York and intended for a national audience, the sources of the image lay clearly in New England. Rogers's family genealogy combined shipowners, ministers, and Harvard presidents, but his own education had been artisanal and technological rather than academic and his family's recent entrepreneurial fortunes had been shaky indeed. Young John, Jr., remembered his boyhood in Northampton, Massachusetts, as "the happiest part of my life."[2] Then his career diverged from the old New England pattern: he went not to Harvard but to Boston English High School, trained in machine shops and at the Amoskeag mills in Manchester, New Hampshire, and worked for the railroad in Hannibal, Missouri, before settling on a professional life as a sculptor. After a successful career that culminated in New York where he produced popular images in multiple replicas, many of definably New England subjects for a large national middle-class audience, he retired to New Canaan, Connecticut.

The men portrayed in *The Fugitive's Story* also had deep New England roots. Henry Ward Beecher, the famous preacher, son of the leading orthodox Congregationalist minister of Litchfield, Connecticut, was centrally engaged in creating a liberal faith for postwar Americans. His Brooklyn, New York, church attracted twenty-five hundred on a Sunday to hear his sermons, and was appropriately named "Plymouth." As an abolitionist image, he was also clearly an alternative to his sister

John Whetten Ehninger, *October* (detail), 1867, oil on canvas, 82.0 × 137.6 cm (32 1/4 × 54 1/8 in.). National Museum of American Art, Smithsonian Institution, museum purchase.

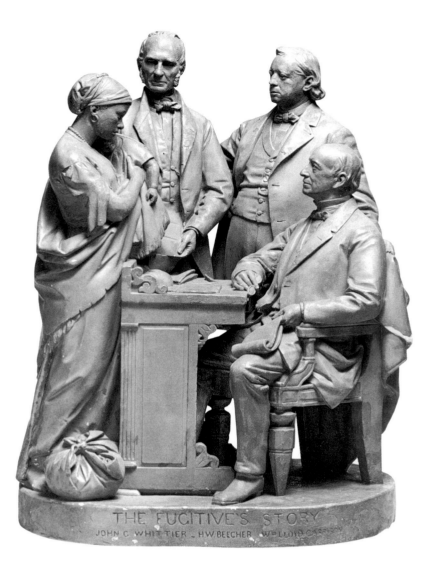

Harriet Beecher Stowe. In these years she turned the subject of her fiction from *Uncle Tom's Cabin* to the households of rural New England. William Lloyd Garrison edited *The Liberator* from Newburyport, Massachusetts. He had, however, dissolved that key abolitionist periodical in 1865, declared the task done, and turned to free trade. Finally, and most centrally for our story, John Greenleaf Whittier, the prewar Quaker romantic radical from Haverhill, Massachusetts, was just becoming, through the publication of *Snow-Bound* in 1866, perhaps the greatest postwar avatar of retrospective New England rurality.

These changes suggest a deflection of the great moral energy crystallized in the abolitionist efforts and the Civil War itself, of a national effort every bit as powerful as the Revolution or initial establishment of a "city upon a hill." The black mother and child stand before these white men, who are now listening to other voices. Her story will be quietly erased, made genteel, and then disregarded. The outrage of slavery, her attempt to reunite her broken family, and even her woman's voice, must be placed against the image of comfortable domesticity,

1. John Rogers, *The Fugitive's Story*, 1869, painted plaster, 55.8 × 38.5 × 28.2 cm (22 × 15 × 11 in.). Yale University Art Gallery, Mabel Brady Garvan Collection.

literally swaddled in the whiteness of Whittier's *Snow-Bound*.

Before turning to that poem, we must note that *The Fugitive's Story* is also a touchstone in the transmission of a vision, the marketing of the image. Many images of New England which we will be examining here were initially produced by individual artists for a wealthy circle, in and out of New England, but the larger history of this imagery is of cooperative ventures aimed at extended regional, national, and international audiences. John Rogers, in one contemporary reviewer's phrasing the "Whittier of American sculptors," was also the entrepreneur who organized the production of these sculptures and then marketed them for five, fifteen, or, in this case, twenty-five dollars each. Their dissemination is a major part of our story: how individual images of New England found their varied audiences. Indeed, the old quip about Melville criticism replacing whaling as a major New England industry applies more generally. The visual and literary imagery of old New England became a national commodity, successfully marketed by a powerful publishing industry, a cultural elite of critics and editors closely allied with their artists and writers, both inside and outside the region, for a hundred years and more.

The Old-Fashioned Rural

The poem *Snow-Bound* emerged, at least in one version of the story, as Whittier's response to a request for his boyhood reminiscences from his Boston publisher, Ticknor & Fields, for their new juvenile magazine. It turned instead into a book-

length "Winter Idyl" of some fifty-two pages, published first in early 1866. Taking off from both a fragment of occult philosophy and Ralph Waldo Emerson's stunning lyric poem, "A Snow Storm" (1841), Whittier weaves a tale of the effect of a winter storm on his rural household as family and guests are driven inward. They gather around the fireside to tell the story of their lives and concerns. The binding force of memory cuts across time and space, deepening family attachments, to create social and spiritual communion (the fire standing for the Quaker "inner light"). A clearing of the weather leads this reconsecrated unit to shovel its way first to the barn and then out into the larger world. The final address posits the poem's readers as urban:

> Dreaming in throngful city ways
> Of Winter joys his boyhood knew;
> And dear and early friends—the few
> Who yet remain—shall pause to view
> These Flemish pictures of old days;
> Sit with me by the homestead hearth,
> And stretch the hands of memory forth
> To warm them at the wood-fire's blaze!

In the year after the end of the Civil War Whittier has taken quite literally his Emersonian motto about being "enclosed in a tumultuous privacy of storm." The passionate abolitionist reaches over (and to some extent through) conflict, tension, and the death of loved ones, reaches around the changing urban world of New England, to find the stability of memory and art as genre scenes played out at the rural hearth.

The "pictures of old days" are more than vague metaphors. A frontispiece portrait and pair of vignettes are included in the first edition of the poem.[3] By 1868 the work was published in a fully illustrated edition of some sixty-five pages. The specific images of Whittier's Haverhill birthplace as well as other Whittier homesteads near the Massachusetts coast north of Boston were to appear repeatedly in articles on Whittier and in oil paintings, calendars, and woodcuts.[4] The imagery of *Snow-Bound* reappears even when the literary reference is not explicit and gives emotional and historical resonance to images as diverse in time as Winslow Homer's *A Winter Morning—Shovelling Out* (Fig. 2) of 1871 and N. C. Wyeth's oil painting of about 1929, a memorial of his grandfather shoveling snow. Would it be a mistake to think that Currier and Ives, those popular printmakers who carefully negotiated between nostalgia and up-to-date presentation of the latest natural disaster or speeding conveyance, had Whittier's poem in mind when they produced their image of men shovelling out a locomotive, entitled *American Railroad Scene—Snow-Bound* (1871)?[5]

The long-standing appeal of this finely crafted poem in its illustrated versions may be illuminated by an 1893 story from Harry Fenn, *Snow-Bound*'s first illustrator. According to Fenn, it was the publisher James T. Fields who encouraged Whittier to continue expanding the poem and who "thrust the first pages of 'Snow-Bound' into my hand," remarking,

2. Winslow Homer, *A Winter Morning—Shovelling Out*, 1871, wood engraving, 22.8 × 30.0 cm (8 7/8 × 11 13/16 in.), from *Every Saturday* 2 (14 January 1871). National Museum of American Art, Smithsonian Institution, The Ray Austrian Collection (Gift of Beatrice L. Austrian, Caryl A. Austrian, and James A. Austrian).

3. Harry Fenn, *Old Kitchen Fireplace in the Whittier House*, from "The Story of Whittier's 'Snow Bound,'" *St. Nicholas: A Monthly Magazine for Boys and Girls* 20 (April 1893), New York: The Century Co. Bowman Gray Collection, Rare Book Collection, The University of North Carolina at Chapel Hill.

4. *New England Kitchen*, Centennial Exposition, Philadelphia, 1876, from *Leslie's Illustrated* (June 10, 1876).

"'What do you think of that for a Christmas book? There is a picture in every line.'" Fenn then went to Amesbury to visit the poet, who was reluctant to send him to the house in Haverhill because it was "guarded by a dragon, and a very untidy dragon at that, and thee will not find the old fireplace that is described, but a modern Yankee cooking-stove, and a general commonplace air." Fenn nevertheless goes, finds the "dragon" to be a "foreigner," pulls the stove and fireboards out, exposing the original hearth—fireplace, cranes, and hooks—and then recovers from the attic other pieces—"remnants of old spinning-wheels, chairs, and tables"—with which to refurnish the room for his illustrations (Fig. 3). In sum, to the joy of Whittier, who cries out, "Tis just as we knew it near a half-century ago!" Fenn erases both the immigrant tenant and the modernized kitchen of the present and returns his audience back in time to the old New England to receive, in Whittier's final line, "the benediction of the air."[6] The reconstruction captures for its post-Civil War audiences the grace of the past.

This dynamic is central to an understanding of the art of the period: the collaboration of artist, writer, and publisher in creating and then marketing a rural past for old New England. Families shattered by wartime losses, scattered to the cities—in 1866 Haverhill itself was a major textile manufacturing center—and to the West, and confronted by a multicultural population were in these images and texts reconstituted as memory and as value, as social and spiritual ideals. It would be an erroneous simplification to believe that this process began only after the war. In the 1850s Winslow Homer, for example, was already creating for the new illustrated periodicals, whose audiences were primarily urban and suburban, images of Irish immigrants landing at Boston's Constitution Wharf and of remembered rural rituals (*Husking the Corn in New England*). Other genre painters mined the same vein, for pastoral as a literary and visual mode is by definition an ideal rurality created as escape and haven by urban consciousness.[7] This search for stable values in the past, as a specifically historical inquiry, predates the Civil War (one has only to recall Nathaniel Hawthorne's Puritan New England or Robert Weir's huge painting *Embarkation of the Pilgrims at Delft Haven*, installed in the rotunda of the U.S. Capitol in 1843).[8] The boundaries between a pre- and post-Civil War recapturing of old New England were, like the lines between the pursuit of the old-fashioned rural and the historical recovery of an earlier time, permeable, not rigid.

Furthermore, anyone who examines this material becomes aware that the time frame of "the past," "old-time New England," "Puritan," and indeed "the colonial" was fluid and flexible. Events commemorating the battles at Concord and Bunker Hill did take place in 1875, and displays at the Philadelphia 1876 Centennial Exposition, marking the one hundredth anniversary of the Declaration of Independence, looked both backward and forward. The past was recalled in many images in the art sections and displays of individual states—the New England kitchen (Fig. 4) being the most notable—but the great Corliss steam engine in the Hall of Machines proclaimed progress and the future at a moment when the trade balance of the United States was shifting from imports to exports.

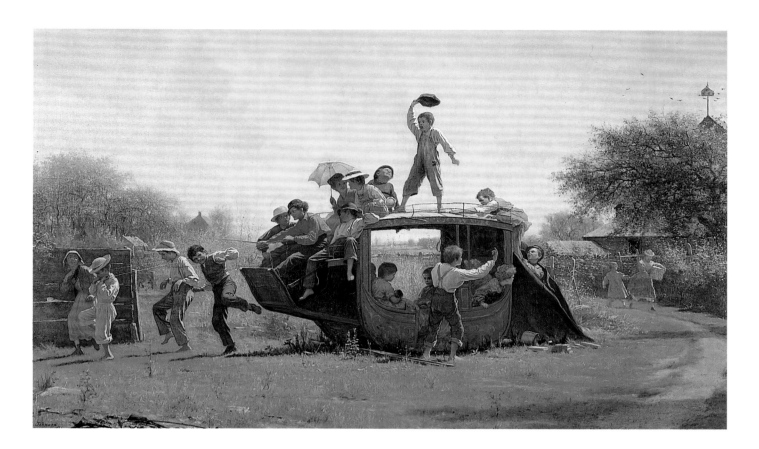

5. Eastman Johnson, *The Old Stage Coach*, 1871, oil on canvas, 92.1 × 152.7 cm (36 1/4 × 60 1/8 in.). Milwaukee Art Museum, Layton Art Collection, Gift of Frederick Layton.

"Old New England" became a way of encoding values, a language for a lost way of life, imputed to an earlier America either as a form of nostalgia or as a protest against the present. Artists and writers who could meticulously copy specific forms or events for their evocative or historicized images and texts were also flexible and argued for the "imaginative truth" of their presentations. Under their direction, "the colonial" could thus stand for anything dating from the 1620 landing at Plymouth Rock to the 1830s and 40s—just before the deeper effects of industrial growth and large-scale immigration were felt. "Old" was always a relative term, but artists used it strategically as a means of distancing themselves from the present.

The art of Eastman Johnson makes this clear. After years of training in Düsseldorf, Germany, and a trip to the West, Johnson produced his first major success, *Negro Life at the South* (1859), a "picturesque" slave-quarter scene set in Washington, D.C. The painting became known almost immediately to some as *Old Kentucky Home*, its urban identity sacrificed for the connection to Stephen Foster's nostalgic effort to enshrine a mythical, idyllic era. This process of dehistoricizing, blurring the painting's specific urban slave context, continued after the war.[9] Johnson also reached back through the tragedy of Lincoln's assassination to re-create *The Boyhood of Lincoln* (1868). (In both pictures the hearth functions as a central retrospective symbol of home values.) Other images portray an ideal New England. *The Old Stage Coach* (Fig. 5) offers its viewers the imagery of rural youth. Gender roles are carefully differentiated: boys act as horses and as drivers on top; girls sit in the coach or tend the young in the distance. The inclusion of black children is emblematically hopeful of the new postwar society. This image also engages its viewers in a game of retrospection. The wheelless stagecoach can go nowhere except historically and emotionally backward: the name over its door is "Mayflower." The painting's first purchaser, George Whitney, manufactured wheels for railroad cars. Two years before the painting was finished the spike linking East and West through the Central Pacific Railroad had been driven at Promontory Point, Utah; and in 1871 Mark Twain published *Roughing It,* his parody of the romance of western stagecoach travel. In *The*

9:45 Accommodation, Stratford, Connecticut (Fig. 6), Edward Lamson Henry carefully juxtaposed the new train, the station, and the passengers rushing past the coaches that would take them from the old "colonial" white houses for their journey into the city—a depiction of old New England already becoming a suburb of New York.

Henry would become one of the painters and great collectors of old-fashioned coaches. In the late nineteenth century in New England, they would increasingly be used as tourist conveyances at places like Mount Washington and the Crawford House in the White Mountains of New Hampshire or as tallyhos on the Massachusetts North Shore, frequently to carry passengers from railroad depots. They would also be used by Howard Pyle in explicitly historical images of the Revolutionary War in which French officers are handing in local ladies at Newport, Rhode Island (*see* Fig. 48).[10]

The emotional weight of naming, the directional significance of the label "Mayflower," should not be underestimated. The stationary coach painted by Eastman Johnson may perhaps be paired with the sleek yachts designed in the 1880s by Edward Burgess, the North Shore naval architect. Burgess's *Puritan* was followed by the *Mayflower*, both winners of the transatlantic America's Cup race. At the other working extreme one could turn back to the brig *Pilgrim* on which the young Bostonian Richard Henry Dana, Jr., sailed to California, described in his famous *Two Years before the Mast* (1840) or forward to the model of a fishing schooner, the *Puritan*, chosen to commemorate the 250th anniversary of Gloucester, Massachusetts, in a diorama at the 1893 World's Columbian Exposition in Chicago. According to an 1893 Baedeker guidebook, steamers working the New York–Fall River line were named *Puritan, Pilgrim, Plymouth,* and *Providence.* Stasis and speed, land and sea, work and play, all insisted on the memory of their colonial past.[11] The complex strategies of retrospection suggested by Johnson's *Old Stage Coach* would appear in countless variations in the decades to come.

6. Edward Lamson Henry, *The 9:45 Accommodation, Stratford, Connecticut*, 1867, oil on canvas, 40.6 × 77.8 cm (16 × 30 5/8 in.). The Metropolitan Museum of Art, Bequest of Moses Tanenbaum, 1937 (39.47.1). All rights reserved, The Metropolitan Museum of Art.

7. Eastman Johnson, *Sunday Morning*, 1866, oil on canvas, 61.6 × 91.4 cm (24 1/4 × 36 in.). Collection of The New-York Historical Society, The Robert L. Stuart Collection, on permanent loan from The New York Public Library, 1944.

A second less well-known Johnson painting suggests another shape of postwar retrospection. In 1866 the artist sold to the New York sugar refiner and art collector Robert L. Stuart a work entitled *Sunday Morning* (Fig. 7). Although derived from a series of 1863 studies involving a black man by a hearth, the postwar composition substitutes three generations of a white family gathered around a central, elaborately furnished, old hearth.[12] Across from the well-dressed gentleman with his back to us sits the grandfather with open book—clearly a Bible, as the painting title indicates. In his *Book of the Artist* (1867) Henry T. Tuckerman praised the composition as "a scene so deeply associated with Peace, and yet as truly native to the land." Displayed at the 1876 Centennial, the painting was also translated into an engraving entitled *The Emigrants' Sunday Morning.* Johnson produced other versions, one in collaboration with Worthington Whittredge, with just two old people in a hauntingly empty room, entitled *Sunday Morning, New England.*[13]

The shifting titles of the Johnson versions of the hearth scene are not regionally limited, but all the images combine signifiers of the past. The last third of the nineteenth century saw a proliferation of New England-based versions of the old hearth, stimulated by re-created New England kitchens, sometimes with costumed characters in colonial dress, that appeared

8. J. A. Scholten, *Sanitary Fair, Saint Louis, Missouri* (New England Kitchen with Some Historically Costumed Characters), 1864, stereophotograph. Missouri Historical Society, St. Louis.

9. Emma Coleman, *A Kitchen Hearth, Deerfield, Massachusetts,* ca. 1883–86, photograph. Society for the Preservation of New England Antiquities.

at various expositions: in 1864 at the Brooklyn, Saint Louis, and Indianapolis Civil War sanitary fairs (Fig. 8); in 1876 at the Centennial (*see* Fig. 4); and in 1893 at the Columbian Exposition. All were dutifully reported and illustrated in the newspapers, the weekly magazines, and various fair souvenir books and histories.[14] Oil paintings on the hearth theme included an old couple, *Second Childhood* (1879), before the Deerfield hearth of artist James Wells Champney, exhibited at the Boston Art Club in 1880, or the younger couple in colonial costume before the fireplace in *Sparking* (1881–82) by the Portland, Maine, artist Franklin Stanwood, or a genteel older woman in *A Cup of Tea* (1901) by Enoch Wood Perry.[15]

By the 1880s painted images centered on the hearth had begun to compete with the work of photographers like Emma Coleman, who collaborated with her companion, the historian Alice Baker, on a series of images of Old Deerfield, Massachusetts (Fig. 9). In one photograph Baker is posed in mobcap, shawl, and old dress, a spinning wheel by her side. By 1891 these photographs record period interiors which had become museum settings at places like Memorial Hall in Deerfield.[16]

During the period the spinning wheel was itself another of the repeated signifiers of old-time New England, the female-gendered equivalent of the blacksmith's forge. Given the critical importance of the New England textile mills during these years,

the spinning wheel was clearly a pre-industrial marker of old New England, with or without its specific quasi-historical Pilgrim literary associations to Priscilla Mullins in Longfellow's *Courtship of Miles Standish* (1858). The imagery appears repeatedly in various media—paintings, graphics, bas reliefs, sculptures, shop signs, whirligigs, embossed cloth bookbindings, and spinning-wheel furniture (*see* Figs. 85, 87). Some look backward in time, like the Allen sisters' Deerfield image of a spinner before an old hearth (ca. 1900). Others look to the present, as in Emma Sewall's 1890s photographs of working-class women standing before walking wheels in rooms wallpapered with aesthetic designs.[17] Photographs like these won prizes in competitions sponsored by the Boston Camera Club, which elicited the best images of "old-fashioned New England interiors."[18]

Sewall's *The Village Blacksmith* (Fig. 10) won another of these prizes, for Most Artistic Merit in 1896 and for Best Figure Composition the following year. Although this craft was pre-industrial in the era of Bethlehem Steel and of the Homestead and Pullman strikes and was canonized by Henry Wadsworth Longfellow in his 1840 poem "The Village Blacksmith," blacksmithing and horseshoeing remained a part of rural life into the 1930s. After this time apprenticing began to take place at

10. Emma Sewall, *The Village Blacksmith*, before 1896, from Abbie Sewall, *Message through Time: The Photographs of Emma D. Sewall 1836–1919* (Gardiner, Maine: The Harpswell Press, Tilbury House Publishers, 1989).

11. Albert Fitch Bellows, *The Village Elms, Sunday Morning in New-England*, 1878, engraving, 63.5 × 91.5 cm (25 × 36 in.). Society for the Preservation of New England Antiquities.

newly established outdoor rural museums like Old Sturbridge Village, Mystic Seaport, and their equivalents elsewhere, from the Henry Ford Museum in Dearborn, Michigan, to Colonial Williamsburg in Virginia. As this suggests, Longfellow's inspiration was not confined to New England. Thomas Hovenden claimed a Longfellow source for his Pennsylvania version of *The Village Blacksmith* (1880) as did James Van Der Zee when he photographed two young African-American blacksmiths in a shop in Phoebus, Virginia, in 1908.[19] A parallel market for paintings and prints by and after David Chalfont, John Joseph Enneking, and others was part of the story of this heroicized figure of rural life, who, like the Yankee peddler, represents small-scale village life interacting with the larger world.

This alternation between withdrawal and engagement was another distinctive note in the art of post-Civil War America. One feels the pulling back into an earlier era, into an old-time New England insulated from the pressures of modernization, with hopes for not only a social but a spiritual centeredness apart: in Whittier; in Johnson's versions of *Sunday Morning;* and in photographs of old folks reading Bibles at the fireside or by candlelight.[20] The outdoor version of this coming together appeared in a watercolor-and-gouache image of 1876, which was turned into a large engraving two years later. Albert Fitch Bellows's *Village Elms, Sunday Morning in New-England* (Fig. 11) offers its viewers two allées back into space, divided by

12. Alfred Cornelius Howland, *Fourth of July Parade*, ca. 1886, oil on canvas, 66.0 × 113 cm (26 × 44 1/2 in.). Private collection.

magnificent elms. At the end point of each walk is a church spire. Villagers proceed in a genteel parade toward the left. As the title indicates, the ancient elms share with the shaded churches a central role in this quiet Sunday ritual, a perfect equilibrium among nature, religion, and the gathering families.

A rather raucous version of the community's secular encounter with the past, by contrast, takes form in Alfred Cornelius Howland's *Fourth of July Parade* (Fig. 12). The main event—a group of costumed men marching pompously, with the American flag prominent, a commander of sorts on a whitish (Washingtonian) nag, and another distinguished figure being pulled in an old barouche—is illuminated by a brilliant slash across the middle of the painting. A comic chorus of barefoot boys observes the proceedings. Off to the left, comfortably in the shade, the middle-class audience also watches. Where and who are we, the observers of this image? Are we urban viewers of a quaint rural scene? Are we the well-dressed sophisticates standing apart from the rubes, the yokels, the old fogies, the young whippersnappers of our own rural community? What an easy condescension ignores, by playing only across the two bands closest to the picture plane, is the village context: the stately row of elms, the classical brick structure to the left, the old inn with its long veranda, and, squarely in the center, the meeting house or church, traditional locus of rural community values, however much in dispute they were during the late nineteenth century.[21] Lovingly rendered here is a natural and architectural past, an old-time New England (modeled on Howland's specific sense of the town of Walpole, New Hampshire). Howland lets us have our comic remembrance of the local ritual but allows us to be more sophisticated in our understanding of the past. For the middle-aged generation looking on at the side, however, "the War" was the horrific conflict from which many of their generation did not return to the village, and the American War of Independence could be—as we will see here in chapter 2, "Gilded Age Pilgrims"—reconfigured to shape the values of the present.

In different images one feels more explicitly the intersection of the old and the new as a framing perspective and one which also reads in class terms the divide between the rural working farmer and the gentrified middle class which is more

13. Thomas Waterman Wood,
The Village Post Office, 1873,
oil on canvas, 91.4 x 119.4 cm
(36 1/4 x 47 1/4 in.). New York
State Historical Association,
Cooperstown.

14. John Rogers, *Checkers
Up at the Farm*, 1876, painted
plaster, 51.9 x 44.6 x 32.2 cm
(20 1/8 x 17 7/8 x 12 3/4 in.).
National Museum of American
Art, Smithsonian Institution,
Gift of John Rogers and Son.

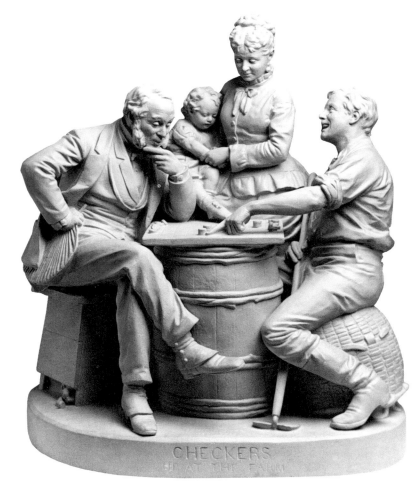

15. John Whetten Ehninger,
October, 1867, oil on canvas,
82.0 × 137.6 cm (32 1/4 × 54
1/8 in.). National Museum of
American Art, Smithsonian
Institution, museum purchase.

closely connected to urban culture. Thomas Waterman Wood's Vermont version of rurality, *The Village Post Office* (Fig. 13), clearly brackets the space between the drygoods clerk and his lady customer on the left and the elderly postmaster and his nicely costumed female client on the right; between them he places a farm group and some cronies arguing a checkers game in the background. John Rogers's parlor sculpture *Checkers Up at the Farm* (Fig. 14) turns this into a comic tableau, with mother and child at the apex and the older, nattily dressed man contrasted to the younger shirt-sleeved farmer. A pleasant rural triumph over the city, but without tension and rancor, the work sold some five thousand copies, but surely not to the rustics waiting in line in the Wood painting (that work was chosen for replication as an engraving in George Sheldon's 1879 *American Painters*).[22]

John Whetten Ehninger's post-Civil War harvest scene, *October* (Fig. 15), glows with autumnal colors. A few workers in the center—including a black man in the oil painting—load the waiting wagon, while a young woman lounging in the left foreground converses with a neatly dressed young man holding a pumpkin. Created for exhibition and sale to a wealthy patron, the oil painting is quite general in its title, *October*. Its less elegant, more narrative graphic version in *Harper's Weekly* defines the scene as specifically "in New England," in contrast to a facing picture of grape harvesting "on the Hudson" River in New York. The graphic image substitutes a stronger emphasis on family (rhyming passages of a human family and a pair of horses with foal) against a more mountainous background.[23]

Finally, we may mention Eastman Johnson's own New England harvesting scenes, one of his primary visual territories after the Civil War. One sequence focused on cranberry picking on Nantucket, where the New York-based artist had established a summer studio and invested in real estate to capitalize on the developing tourist trade. Also at Nantucket he did a second series in the 1870s on cornhusking, one version of which went into the Chicago collection of the elegant philanthropist Mrs. Potter Palmer. An earlier series in the 1860s pictured winter scenes of maple sugaring in the woods near Fryeburg, Maine. All show very specific re-

gional agricultural products that were marketed nationally, but the pictorializations look benevolent rather than commercial and are from the point of view of visiting urban tourists (who are explicit characters, especially in some of the sugaring scenes).[24]

In the 1880s Emma Coleman, working in Maine, produced a group of photographic images: *A Yankee Sower*, *Husking Corn*, *Grinding Spice*, *Gathering Kelp in an Oxcart*, and *Yoke of Oxen and Cart*.[25] Stark, simple, and boldly configured, *A Yankee Sower* (Fig. 16) is key to understanding the group. It most obviously reads as straight out of Jean-François Millet's Barbizon paintings of the 1850s. Enormously popular among Americans, especially Bostonians, thanks to the efforts of Millet's New England pupil William Morris Hunt, Millet's images heroicize the dignity of the rural worker. Endlessly reproduced, these French models offered to American artists and writers another distanced language for the preindustrial past, into which the materials of New England rurality might be poured. As a language recently hallowed by art, it was thus aestheticized, collected, and exhibited, especially by discerning New Englanders.[26]

The Scenic Rural: The White Mountains

The artistic forms examined thus far have been primarily figural or genre, the art of the everyday, rather than grand heroic images or history paintings more directly engaged in the interpretation of the past. During the nineteenth century, however, literature and art were often focused on nature as the romantic site of individual growth, of spiritual search and transcendence, of social and national exploration, and of economic and ethnic exploitation. The "sublime" snow storm drives Whittier's family inward. Its blow out causes the group to reestablish a link to the outside world. Plowing paths in the snow, the group reconnects with the larger community. If the exploration of the incommensurate sublime continued in New England in the later work of artists like Winslow Homer by abolishing the position of the coastal viewer of those who are lost on the Grand Banks (*see* Fig. 166) or shrinking the human figures to dinky little dabs in *High Cliffs, Coast of Maine* (*see* Fig. 161), for most artists of New England (including Homer), the viewer's framing position was a central concern.

We see this most explicitly in Otto Grundmann's *Interior at the Mountains* (Fig. 17). A German recruit to the directorship of the new School of the Boston Museum of Fine Arts in 1876, Grundmann rapidly acquired friends, patrons, and invitations to Whitefield, New Hampshire, which was becoming a major resort area, with views of the Presidential, Franconia, and Kilkenny mountain ranges.[27] Mirror Lake appears in the foreground of this painting, but what is most striking is the elaborate framing of the view. The form of the windows looking toward the bay, the raised shades with fringed pulls, the maroon crocheted screen, the viewing deck beyond with its plantings, the awning, the table with its binoculars, and, of course, the

17. Otto Grundmann, *Interior at the Mountains*, 1878, oil on canvas, 45.7 × 68.6 cm (18 × 27 in.). Mr. and Mrs. Jeffrey R. Brown.

comfortably cushioned wicker bench for the viewer—all direct our attention specifically to the processes of observation. Furthermore, the "nature" of New Hampshire to be observed directly is multiply contrasted, through the map and framed prints, to Europe and to Rome (the Temple of Fortuna Virilis at upper left) and other classical sites and images, including the little winged figure plucking a harp—an aeolian harp? Art vies with nature, even in the leaf forms in the rug and wallpaper, and summer versions of the aesthetic style are contrasted to the vernacular hooked rug.

This witty triumph of the artful over the merely natural emerges from a tradition stretching back at least half a century, when Thomas Cole came to the White Mountains. After the Civil War the traveler's journey was smoothed in countless ways, and artists were collaborators with the tourist industry. The large chromolithograph by J. H. Bufford (Fig. 18), the Boston firm for which Winslow Homer had apprenticed a decade earlier, not only announces summer timetables for the railroad and steamer, it surrounds these with a garland of images. Connecting a Native American and a Union soldier, the national eagle spreads its wings over Profile House. Other famous sites pictured include the Old Man of the Mountains and Lake Winnipesaukee as well as various notches and falls (with an emblematic Neptune thrown in for good classical measure). Most important are the vignettes of five or so large "houses" catering to the burgeoning tourist trade.

In 1866 *Burt's Illustrated Guide of the Connecticut Valley* was published in Springfield, Massachusetts, with descriptions of sites ranging from Mount Holyoke to Quebec and including the White Mountains. Guide books and souvenirs hawking the benefits of the great resorts proliferated. The year 1865 saw the founding of the Kilburn Brothers firm in Littleton, New Hampshire, which became the world's largest producer of stereographic views. Individual tourist places sold stereographic prints as souvenirs—natural wonders and genre scenes of old codgers or maple sug-

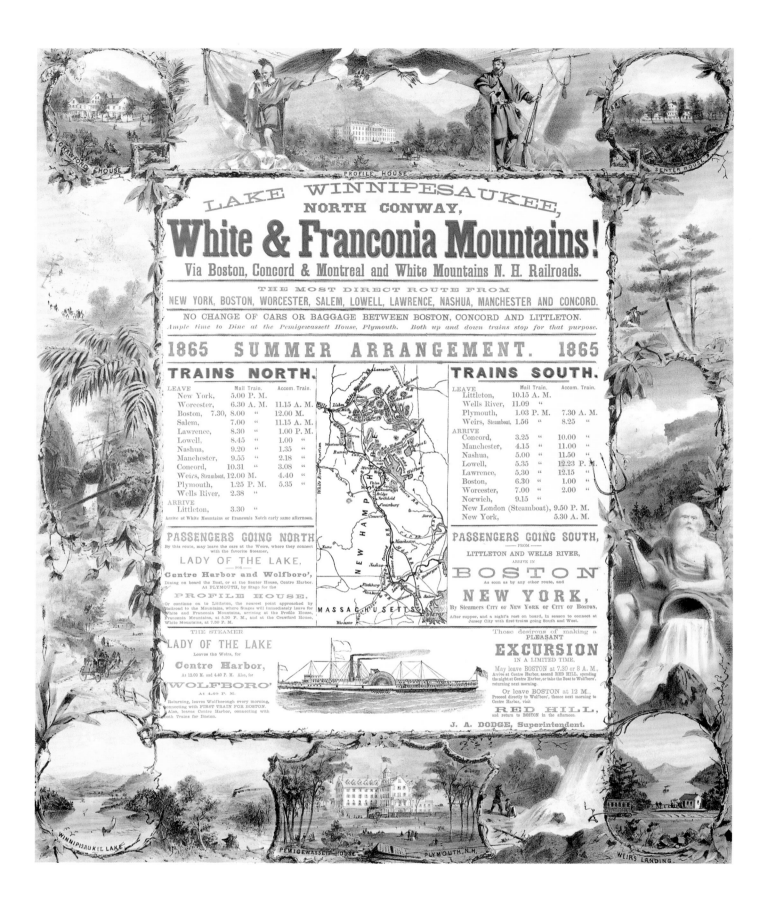

18. J. H. Bufford, *Lake Winnipesaukee, North Conway, White & Franconia Mountains!*, 1865, chromolithograph, 51.8 × 62.9 cm (20 3/8 × 24 3/4 in.). Boston Athenaeum.

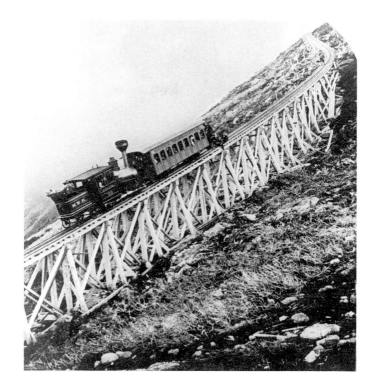

19. Benjamin West Kilburn, *Mount Washington*, ca. 1870, stereograph, 10.2 × 15.9 cm (4 × 6 1/4 in.). New Hampshire Historical Society, Concord, New Hampshire (F4643).

aring—which were marketed nationally by competing firms. One could thus take the sublime or the picturesque as well as the wonders of human construction into one's own parlor in three dimensions.[28]

Perhaps the most famous technological marvel amply recorded by Kilburn and others was the trestle bridge for the cog railway to the top of Mount Washington (Fig. 19). Its name was "Jacob's Ladder," both droll Yankee tongue-in-cheek and sacramentalizing in its allusion to the biblical sources of sublime seeing. The shift we are describing is characteristic of "the scenic rural." In the older dynamic, human observers stood in awe before the sublime. Their experience of the transcendent was radically different from their material struggles in the world of commerce and industry. These new works, however, set out to tame for touristic consumption the grandeur of the White Mountains. Many visitors were wealthy travelers, denizens of the nation's cities, although contingents of local working people were also attracted to these places.[29] The commodification of the New England mountain landscape in stereophotographs, lithographs, engravings for the many or oil paintings for the few has its roots in the work of artists in the years immediately after the close of the Civil War.

One observes the process in the paintings and graphics of Winslow Homer, that bellwether of the popular image in his early work. In the same year the cog railway was built, Homer completed his more decorous image of horseback travel on Mount Washington, to be sold as a small oil painting to Shadrack H. Pearce of Boston, recast both as a wood engraving for *Harper's Weekly* and as a major exhibition oil painting of a single figure, entitled *Bridle Path, White Mountains.* The shift in point of view in each is telling. Homer's interest (and that of his presumptive audiences) lies not in the sublime peak of Thomas Cole, which is not visible, but in the visitor's experience. In the small oil owned by Pearce (Fig. 20), for example, while tiny figures trudge off into the distant clouds, in the middle ground two women sit sidesaddle, two men stand nearby, and a guide leads the way, at the right side of the image. That leaves one extra horse. Could it possibly be ours, the viewer's, who is now looking over these angled rocks just at the picture plane? It is part of the game of seeing, and that is the point.[30]

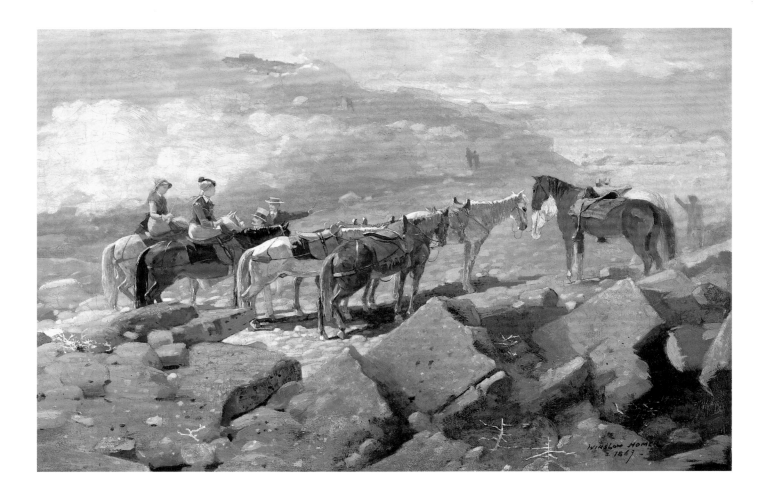

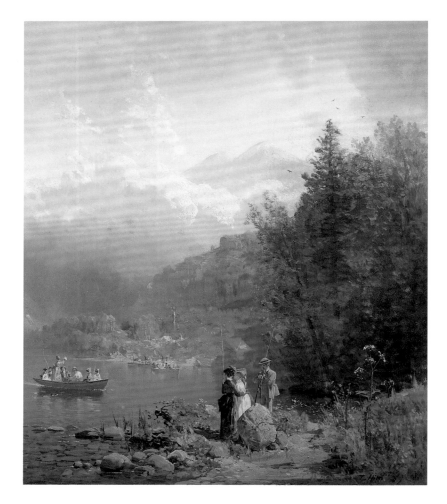

20. Winslow Homer, *Mount Washington*, 1869, oil on canvas, 41.3 × 61.8 cm (16 1/4 × 24 5/16 in.). Gift of Mrs. Richard E. Danielson and Mrs. Chauncey McCormick (1951.313). Photograph © 1998, The Art Institute of Chicago. All rights reserved.

21. Thomas Hill, *Fishing Party in the Mountains*, ca. 1872, oil on canvas, 61.3 × 51.4 cm (24 1/8 × 20 1/4 in.). Fine Arts Museums of San Francisco, M. H. de Young Memorial Museum purchase (46.1).

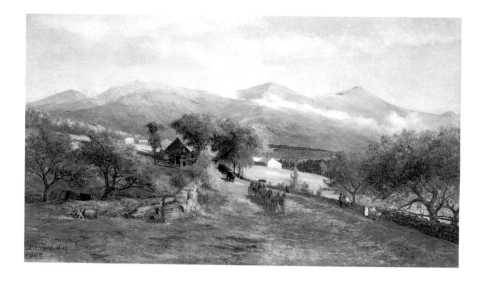

Or take the *Fishing Party in the Mountains* (Fig. 21) by Thomas Hill. Thomas's brother Edward, who lived and worked in New Hampshire, produced his own large images, like *The Presidential Range* (Fig. 22), with its coach bearing travelers to the mountains from the foreground on a visual ramp into the deeper space of the mountains beyond. The modest "wood study" produced by Thomas in the White Mountains is not "about" that sublime upper region. The spotlight instead falls on the lower edge, our easy point of entry to join the well-dressed fishing party and the boats stretching out toward the far shore. Friendly intercourse is the order of the day—not the "fishing" but the "party."

In the summer of 1875 George Inness traveled to North Conway. There he worked on a dynamic scene, *Kearsarge Village* (Fig. 23), which moves in space from the near hillside to the valley, with cattle, a line of wispy poplars, and a mountain rising into the clouds beyond. No insistent pastoral gazers intrude. The turbulence of the sky, roughly brushed in, and the lowering clouds rolling toward us and obliterating the horizon at upper left create a dynamic that engages the viewer, making us slightly threatened participants rather than passive consumers of the view. Inness's atmospheric drama illuminates the more typical achievement of "the scenic rural" in the White Mountains.[31]

The Scenic Rural: The Seacoast

In what sense can the New England seacoast be thought of as the site of "the scenic rural"? It seems almost a contradiction in terms, given the associations of the sea and New England with the initial voyaging, the "vast and furious ocean" of William Bradford, or with Melville's Ishmael setting out from New Bedford and Nantucket

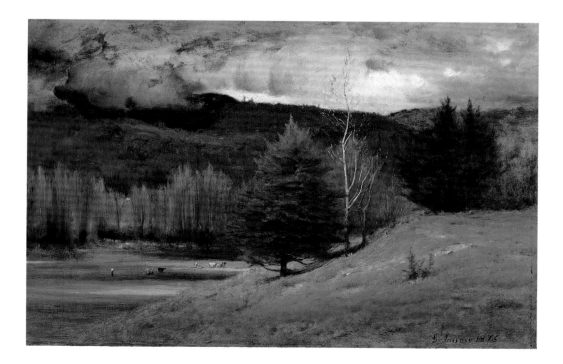

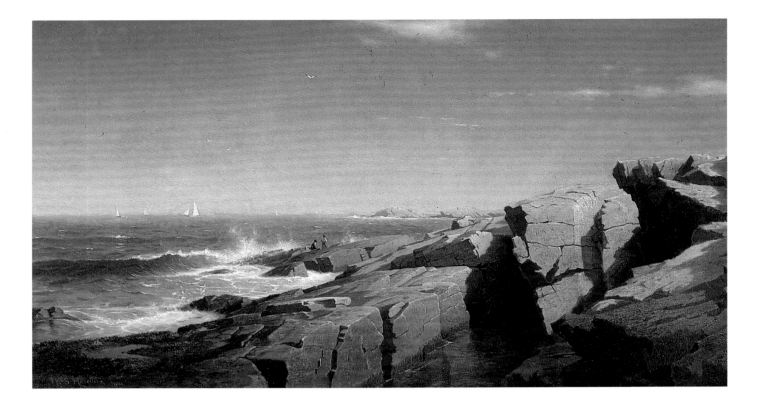

24. William Stanley Haseltine, *Rocks at Nahant*, 1864, oil on canvas, 56.2 × 101.9 cm (22 1/8 × 40 1/8 in.). Brooklyn Museum of Art, Dick S. Ramsay Fund, A. August Healy Fund, and the Healy Purchase Fund B.

in pursuit of the sublime Moby-Dick or the crashing waves that swept the coast of Thomas Doughty's *Shipwreck* (1834) or the Mount Desert or Grand Manan of Frederic Church in the 1850s and 1860s. Yet one dominant role of the New England seacoast following the Civil War is as a site for vacationers. Like the White Mountains, it was a place of escape from urban crowding, from the obvious costs of industrialization and an increasingly mechanized culture. The vacation tour to mountains or coast was calibrated to the health needs of a population worried about neurasthenia and other nervous disorders. Such vacationers sought in the rural—mountain or coastal—a renewal of energies as well as a fulfillment of desires for the natural, the geological, the aesthetic, and at least remnants of the spiritual.[32]

The escape to the rural or coastal was also calibrated by class. The poor gathered in large popular beaches near the city, while the wealthy (divided between older wealth and new money) clustered in enclaves set apart, although still connected to the city by rail. William Dean Howells mapped this territory deftly in his *Rise of Silas Lapham* (1885). In it the old Corey family of Beacon Hill, Boston (their name linked to seventeenth-century Salem), is financially down in its fortunes and has had to give up its summer house at Nahant, on the near North Shore, although the mother and children still vacation at Mount Desert Island on the Maine coast. The nouveau riche Lapham family is building on the newly filled Back Bay in the city, and they summer just south of Boston in Nantasket at a boarding house and then a hotel. The mother and daughters stay on, while Silas commutes daily by boat from his paint-factory office in the city.

William Stanley Haseltine's *Rocks at Nahant* (Fig. 24) gives no hint of these complex social and spatial dynamics. Nahant was early in pasturage, then replanted: "willows and poplars seemed to have thriven best on its wind-swept turf." Its farmhouses became retreats where William Hickling Prescott and John Lothrop Motley wrote their histories and Longfellow composed a part of *The Song of Hiawatha* (1855). It was also a center of geological study by Louis Agassiz, who had a summer home there.[33] Haseltine, whose family had come from Whittier's Haverhill, was a member of the Natural History Club at Harvard in the 1850s.[34] The three main sites of his American imagery—Mount Desert Island, Rhode Island's

25. Alfred Thompson Bricher, *On the Shore, Newport*, ca. 1885, oil on canvas, 61 × 102.2 cm (24 × 40 1/4 in.). Diplomatic Reception Rooms, U.S. Department of State, Washington, D.C.

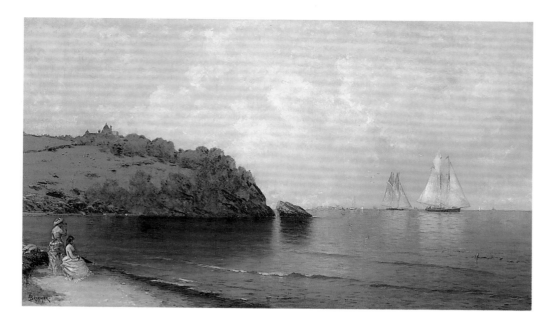

Narragansett Bay, and Nahant—were all outstanding both for their rock formations and burgeoning tourism after the Civil War. Haseltine's production of multiple images of these three locales attests to their popularity.[35] With its piercing blue skies and strong earth tones, the Brooklyn Museum version of *Rocks at Nahant* reduces our experience to a few simple elements: the bold but precisely readable geology of the massive rock forms, the sea washing up, the distant jutting of another spit of rocks. No city of Boston at a distance, no trees or land forms, only a couple of tiny people on the rocks and barely a cloud in the sky. Nothing disturbs the purity of nature, the healthy experience sought by the patrons of these pictures.

Nor was patronage limited to those who could purchase the paintings. In the early 1870s *Appleton's Journal* ran a series that became the period's greatest coffee-table book: *Picturesque America* (1872–74). Chapters were profusely illustrated with engravings after the leading artists of the day. The first volume opened with "On the Coast of Maine." Other chapters include "The White Mountains" and "Providence and Vicinity," with Haseltine contributing the original for the steel engraving *Indian Rock, Narragansett*. Among the wood engravings were images of the city of Providence, old houses, bridges, and woods as well as large mills on the Blackstone River. The second volume included chapters on the Connecticut and Housatonic river valleys, Boston, Mount Mansfield, Vermont, and other coastal and mountainous New England locations, both rural and urban, and the tourism which it was encouraging.[36]

Vast numbers of "scenic-rural" paintings were marketed from the 1870s to the end of the century. Worthington Whittredge produced many coastal scenes of Newport and of Paradise Rocks, Berkeley's Chair, and other geological landmarks along the beaches, as had other artists from the 1850s on, including James Suydam, John Frederick Kensett, and John LaFarge.[37] A late upper-class scene by Alfred Thompson Bricher, *On the Shore, Newport* (Fig. 25), is undoubtedly a visual construction. Pieces of a cliffside walk and a Newport "cottage" have been brought together with the elegant ladies to the left, our surrogates as observers watching the yachts that race offshore.[38]

Another version of Rhode Island can be seen in a series of images entitled *A Home by the Seaside*, which Whittredge produced in the early 1870s. The version done in 1872 (Fig. 26) brings together the old rural New England with the sea. The gambrel-roofed house in the near right, before which an old woman bends in the kitchen garden, is clearly, like the old tree before it, a "colonial" remnant. Below, to

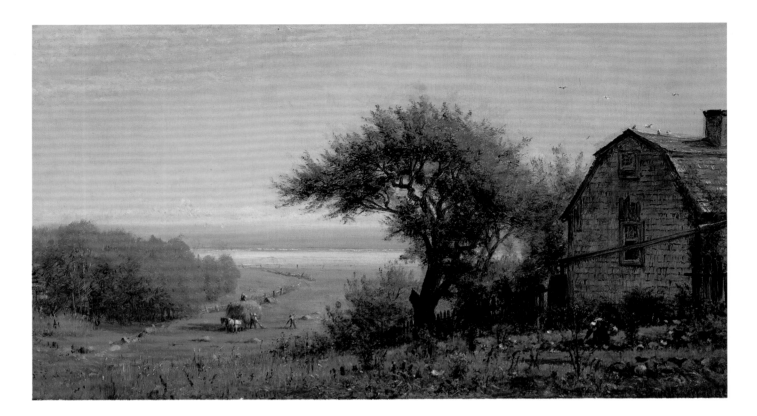

26. Worthington Whittredge, *A Home by the Seaside*, 1872, oil on canvas, 50.8 × 78.9 cm (20 × 30 1/8 in.). Los Angeles County Museum of Art, William Randolph Hearst Collection (46.45.1).

the left, men gather marsh hay from the field and beyond them are the curling waves of the open sea. By contrast to the sparkling colors of Haseltine, all is muted and carefully balanced, past against present, the old habitation against the sea from which Americans have come to harvest the New World. Even gender roles are balanced. The several versions of this image suggest that Whittredge had a market for such a vision.[39]

Artists summered both to the east and west of Rhode Island along the southern New England coast. In 1858 Albert Bierstadt, a native of New Bedford, Massachusetts, had done a historical image, *Gosnold at Cuttyhunk, 1602*, recalling early landings in the area around New Bedford. By the end of the century William Tryon and others were at the nearby town of Padanaram, and a whole group of artists gathered at Old Lyme, Connecticut, although their artwork tended to turn inward to the town rather than outward to the coast. But let us turn finally back north of Boston. This area attracted artists and patrons from the years before the Civil War up to the present. If Beverly, Manchester-by-the-Sea, and Annisquam are known more exclusively to those who have inhabited them, spatially and visually, Gloucester,

27. Louis Prang (after F. M. Knowles), *Gloucester Beach*, ca. 1876, chromolithograph, 12.7 × 17.8 cm (5 × 7 in.). Courtesy of the Boston Public Library, Print Department.

28. Winslow Homer, *High Tide*, 1870, wood engraving, 22.5 × 29.9 cm (8 7/8 × 11 3/4 in.), from *Every Saturday* 1 (6 August 1870), National Museum of American Art, Smithsonian Institution, The Ray Austrian Collection (Gift of Beatrice L. Austrian, Caryl A. Austrian, and James A. Austrian).

29. Winslow Homer, *Low Tide*, 1870, wood engraving, 22.5 × 29.9 cm (8 7/8 × 11 3/4 in.), from *Every Saturday* 1 (6 August 1870), National Museum of American Art, Smithsonian Institution, The Ray Austrian Collection (Gift of Beatrice L. Austrian, Caryl A. Austrian, and James A. Austrian).

Rockport, and Newburyport, Portsmouth and the Isles of Shoals, and ultimately Prout's Neck, Mount Desert, and Monhegan, had and continue to have a wide and varied appeal. This is not an accident but a function in part of the wealth of images created by artists and writers and how these places and these images have been sold to their audiences. Part of that story lies ahead of us, as does the historical story of Plymouth and the Pilgrim coastal imagery. The origins of their appeal were clearly pre-Civil War, but the big push occurred just after the war. It is apparent in the construction of summer homes and estates by important architects of the period—William Emerson (distant cousin of the poet), Arthur Little, and Peabody and Stearns—and of hotels and spas serving more transient visitors. Images of Gloucester Beach or Appledore, for example, were produced by lithographers like Louis Prang (Fig. 27) to attract clientele.[40] Writers and artists offered images of this life in various forms, and the periodical press marketed both images and texts to a wide public.

A few cases in point can suggest the story. The first takes us to the North Shore at Manchester-by-the-Sea in 1868. Annie Adams Fields, poet, classicist, and wife of publisher James T. Fields, noted the appearance of Winslow Homer and Winkworth Allan Gay sketching on the beach below her large cottage and invited them to tea.[41] The couple was presumably already owners of Homer's early large Civil War image of lounging Zouaves, *The Brierwood Pipe* (1864). Among the results of Homer's sketches at that time were two large oil paintings of bathers at Eagle Head, Manchester. Exhibited in 1870, the two pictures were then labeled as *High Tide* and *Low Tide* (Figs. 28, 29) for the 6 August 1870 issue of Ticknor & Fields's large-format magazine *Every Saturday*. *Low Tide* celebrates childhood at the beach, with a

30. Winslow Homer, *Swinging on a Birch Tree*, 1867, wood engraving, 14.9 × 9.2 cm (5 7/8 × 3 5/8 in.), from *Our Young Folks* 3 (June 1867). National Museum of American Art, Smithsonian Institution, The Ray Austrian Collection (Gift of Beatrice L. Austrian, Caryl A. Austrian, and James A. Austrian).

stable and serious pyramid of girls and a contrasting band of children frolicking in the background. *High Tide,* in its graphic as in its oil version, is more problematic: grouped in an unstable pyramid, three young women emerge from the surf, with distant tents (in the graphic version) or a somewhat menacing Eagle Head and a cowering puppy (in the oil). It has the kind of imaginative play that one finds in the near contemporary poem of Emily Dickinson, "I started early—took my Dog— / And visited the sea" (ca. 1862), a drama of female and male, of tensions between decorous social forms and passionate fantasy, and of potential violence in the imaginative encounter.[42] Dickinson is here, as always, on the edge: the old New England that is her rural Amherst, Massachusetts, grounding, a shaky relation to its older Congregationalist certainties, and a use of polite formalities to hold at bay the postwar world—in this poem configured as the male sea.

Dickinson's achievement remained private to all but a few friends and literary mentors like Thomas Wentworth Higginson. The work of other New England women who reshaped late-nineteenth-century understanding of the region was eminently public—again, especially through the auspices of James Fields's publishing house and its various journals. Sarah Orne Jewett, who became the lifelong companion of Annie Fields after the death of her husband James, began publishing New England stories in the 1870s, some of which were gathered as *Deephaven* in 1877. The book follows two young, wealthy Boston women who spend their summer on the coast, living in the beautiful old mansion of a dead aunt but visiting among the locals. Old Captain Sands sounds the keynote: "Everything's changed from what it was when I used to follow the sea." A dozen miles from the nearest railroad, Deephaven is an isolated backwater that never recovered from the embargo of 1809. Shipbuilding is a thing of the past, and women outnumber men, many of whom were drowned at sea (or killed in the Civil War?). The strength of *Deephaven* lies in its evocation of a fading world; its weakness lies in its point of view. The two rich outsiders are sympathetic to their subjects but forever tourists in their world, and the book teeters on the edge of a distancing, picturesque quaintness that was to sabotage so much local-color fiction of New England during this period.[43]

Women produced much of New England's local-color fiction. Linked in its later stages to the preservation and house-museum movement, this literature has its roots in Harriet Beecher Stowe's *Pearl of Orr's Island: A Story of the Coast of Maine* (1862) and its culmination in Jewett's *Country of the Pointed Firs* (1896). At some points veering toward a racial ideology of Anglo-Saxon origins—Jewett's historical romance, *The Tory Lover* (1901), for example—such fiction frequently erased the immigrant and mill factory from the old-time New England landscape. It offered these perspectives to a wide, especially middle-class readership and a context within which it could receive the visual images that are the focus of the present study.

Each writer made her specific contribution, her specific connections. Celia Thaxter, for instance, started out as a poet of "Landlocked" in the *Atlantic Monthly* in 1862 and was encouraged by Fields to produce prose reminiscences of her childhood on the Isles of Shoals. The resulting pieces, expanded and gathered into book form in 1873 (with a few illustrations by Harry Fenn, through the agency of her avuncular friend and neighbor John Greenleaf Whittier), became *Among the Isles of Shoals*. A passionate natural and cultural history, the book is shaped by Thaxter's childhood memories of life on the lighthouse island and her adult consciousness of a place that had become a tourist mecca, especially for New England intellectuals,

thanks to the hotel erected by her father on Appledore.[44] The book clearly served as a guidebook for those who traveled there for rest and renewal.

But one should not smooth out the story. The sea that beats on the rocks of *Among the Isles of Shoals* is ruthless and unforgiving, and people's lives are sometimes twisted by the isolation of the place. In Thaxter's *Island Garden* (1894), illustrated by Childe Hassam, slugs and frogs engage in a Darwinian struggle among the lovely flowers. The nightmare version of a summer vacation on the New England coast by Charlotte Perkins Stetson [Gilman], entitled "The Yellow Wall-paper" (1891), describes the horrific costs to a woman's consciousness—indeed, to her very life—of such a withdrawal from active life. The gardens and houses of old New England could be an aesthetic trap, although how much we feel this, the "grotesque" side of the story, in the visual evidence before us is an open question.

What needs final emphasis in this opening exploration of the art of New England during the post-Civil War decades is the degree to which its success and importance to the history of American visual culture depended not on single images, which today might number among the "masterpieces" of American art (though there are many of these), but on the transmission of these images to a broad national and international audience, the marketing of old New England through an extended network of social and professional relationships, between cultural producers and the publishing industry. In these ways old New England became a national memory bank. James Fields initially wanted *Snow-Bound* for his magazine *Our Young Folks,* although it "outgrew" that venue. Homer's *Swinging on a Birch Tree* (Fig. 30) was published in *Our Young Folks* in 1867 and reads today like an illustration for Robert Frost's "Birches," published in *Mountain Internal* (1916). Homer also produced a series of silhouettes for Ticknor & Fields's 1873 Christmas edition of James Russell Lowell's New England prewar vernacular *The Courtin'* (Fig. 31). A generation later, in 1891, Howard Pyle would illustrate Oliver Wendell Holmes's 1857 gentle satire on the failure of old Puritan theological orthodoxy, "The

Under the willows, Magnolia.

Deacon's Masterpiece; or, 'The Wonderful One-Hoss Shay.'" The reprocessing of old New England was a continuing literary-visual collaboration.

The same is true for the tourist's New England, and Ticknor & Fields was by no means the only publisher of this material. The popularity of coastal New England, for example, depended on a series of articles like "The Summer Haunts of American Artists," in New York's *Century* magazine.[45] The Boston firm of Little, Brown employed the writer-artist Edmund Garrett and brought out his *Romance & Reality of the Puritan Coast* (*Under the Willows, Magnolia*; Fig. 32) in 1897 as they had his historical *Three Heroines of New England Romance* (*see* Fig. 39) in 1894. Finally, we might note Winfield S. Nevins's "Summer Days on the North Shore," which appeared in September 1891 in *New England Magazine,* a journal, since its inception in 1884, devoted primarily to old New England materials. This particular volume included an essay on Salem witchcraft (also by Nevins); an article on old Newburyport (not as home of the abolitionist Garrison); an essay on Edward Burgess, the yacht designer; and the first printing of "The Yellow Wall-paper."

Notes

1. One is reminded of Harriet Brent Jacobs's struggle to maintain her identity as the author of *Incidents in the Life of a Slave Girl* (1861), for the history of which, see the introduction to the critical edition edited by Jean Fagan Yellin.

2. Quoted in Wallace, *Rogers,* 14.

3. By 1867 the work had sold twenty-eight thousand copies. For the details of the long publishing history of *Snow-Bound,* see Thomas Franklin Currier, *A Bibliography of John Greenleaf Whittier* (Cambridge: Harvard University Press, 1937), 98ff. The portrait in the first edition of *Snow-Bound* was "engraved by E. W. Smith from a photograph by Hawes" and is very close in feature, gesture, and clothing (in everything but the tie) to that in the Rogers *Fugitive Story.* It thus seems likely that Rogers used the same Hawes photograph or possibly even the E. W. Smith engraving as his source, since the Whittier figure in the sculpture looks *out* with that facial posture and not *down* at the black woman who is telling the story.

4. See, as just a sampling, the images in Richard Henry Stoddard, "John Greenleaf Whittier," *Scribner's* 18 (August 1879): 569–83; Harriet Prescott Spofford, "John Greenleaf Whittier," *Harper's* 68 (January 1884): 171–88. The 1892 edition of *Snow-Bound* was illustrated by Edmund Garrett; the 1906 edition has work by Garrett, Howard Pyle, and John Joseph Enneking, who also did oil versions, for which see *John Joseph Enneking: American Impressionist* (Brockton, Mass.: Brockton Art Museum/Fuller Memorial, 1974–75). At least one Prang souvenir with fringed cloth borders is dated 1884. When the Whittier birthplaces became museums, Samuel T. Pickard, Whittier's biographer, produced *Whittier-Land: A Handbook of North Essex* (1904), "designed to meet a call from tourists who are visiting the Whittier shrines at Haverhill and Amesbury in numbers that are increasing year by year." For photographic images, see (again as examples only) the Alfred Ordway images in *Whittier-Land.* See also Samuel Chamberlain, *Open House in New England* (Brattleboro, Vt.: Stephen Day, [ca. 1937]). Chamberlain comments in the caption, "the birthplace of the beloved New England poet. A poet might well grow out of such surroundings" (86).

5. The Homer engraving appeared in *Every Saturday* 2 (14 January 1871): 32. The Wyeth painting, entitled *Grandfather's House,* linked to a later Wyeth illustration for *Snow-Bound,* is reproduced in Christine B. Podmaniczky, *N. C. Wyeth: Experiment and Invention, 1925–1935* (Brandywine, Pa.: Brandywine Museum, 1995), see 27, 29, 31. The Currier and Ives image is number 187 in Frederick A. Conningham, *Currier and Ives Prints: An Illustrated Checklist* (New York: Crown, 1983). The later compilation is *Currier & Ives: A Catalogue Raisonné,* hereinafter cited by entry as Gale. The careful analysis of Currier and Ives images and how they function has never been carried out, although a few scholars have included these prints with other works in thematic studies. Most often they have been treated as flat "reflections" of their culture. In relation to the present inquiry into old New England, although many N. Currier or Currier and Ives prints are still undated and were created before our 1865 starting date, most of the landscapes, in order to reach a national audience, tend not to be regionally specific, although a few are labeled "New England," especially those created by George H. Durrie for lithographic reproduction, like *New England Winter Scene* (1861) and *Autumn in New England—Cider Making* (1866; Gale 1350), or Frances Palmer's *New England·Scene* (1866; Gale 4800), or some maple-sugaring scenes "in the North Woods" (Gale 0170, 4305).

6. Harry Fenn, "The Story of Whittier's *Snow-Bound,*" *St. Nicholas: A Monthly Magazine for Boys and Girls* 20 (April 1893): 427–30. Fenn defines the magazine *Our Young Folks,* for which *Snow-Bound* was originally requested, as a predecessor of *St. Nicholas.* It is important to note the shift in publishers from the Boston house of Ticknor & Fields to the New York Century Company.

7. See Stein, "Picture and Text," 34–36; and Burns, *Pastoral Inventions,* which cuts across the Civil War years in its exploration of the topic. For earlier explorations, see Marx, *Machine in the Garden;* and Poggioli, *Oaten Flute.*

8. The *Embarkation* appeared as an engraving on the anniversary of the landing at Plymouth Rock, coupled with another engraving of Plymouth Rock, "as it now appears," from a contemporary photograph (*Harper's Weekly* 11 [14 December 1867]: 797). Currier and Ives published many "Landing at Plymouth Rock" images, some dated to 1846 (Gale 3702–4) but one for the 1876 centennial (Gale 3705). Plymouth Rock as an historical, literary, and visual subject receives exhaustive treatment in John Seelye's book, *Memory's Nation: The Place of Plymouth Rock* (Chapel Hill: University of North Carolina Press, 1998).

9. For a brilliant historical analysis of the creation and reception of this work, see Davis, "Johnson's *Negro Life.*"

10. See Huntington and Pyne, *Quest for Unity,* 58–60. The Henry painting was engraved as "The Village Depot," in *Harper's Weekly* 12 (15 August 1868); for more on Henry, see Elizabeth McCausland, *The Life and Work of Edward Lamson Henry, N.A. 1841–1919,* New York State Museum Bulletin 339 (Albany, 1945). See also Forbes and Eastman, *Taverns and Stagecoaches of New England,* 2: 20–21; Nevins, "Summer Days on the North Shore."

11. For descriptions and visual images of Burgess's racing boats, see A. G. McVey, "Edward Burgess and His Work," *New England Magazine* 11 (September 1891). James E. Buttersworth made several paintings of these ships: *The Puritan and Genesta* (ca. 1885), *"Mayflower" Leading "Galatea"* and *"Mayflower" Leading "Galatea" around the Lightship,* from the America's Cup of 1886, and *"Mayflower" Racing off Sandy Hook Lighthouse* (ca. 1886). Currier and Ives also produced an inexpensive print version of the *Mayflower* crossing the bow of the *Galatea* in 1886 (Gale 4443).

12. According to Patricia Hills, the painting began about 1863 as an oil on paperboard study of a New England kitchen scene without figures. It became an image of a single black figure called *The Chimney Corner* (1863) before being transposed into the postwar picture of an old white man reading

the Bible (Hills, *Johnson*, 36–38). For a further discussion of these and related images, see Lesley Carol Wright, "Men Making Meaning in Nineteenth-Century American Genre Painting, 1860–1900," Ph.D. diss., Stanford University, 1993, 66–71.

13. New-York Historical Society, *American Landscape and Genre Painting*, 236. See Tuckerman, *Book of the Artist*, 469. For the Stuart collection of American painting, see Tuckerman, *Book of the Artist*, 626 and index; and Strahan, ed., *Art Treasures of America*, 2: 117–24, in which it is listed as *Sunday Morning, Reading the Bible*. By 1868 Stuart, the largest sugar refiner in New York with obvious connections to the South, also owned Johnson's *Negro Life at the South*. A strict Presbyterian, Stuart presented each of his workers with a Bible. See Davis, "Johnson's *Negro Life*," 84. I am indebted to Lesley Wright both personally and in her dissertation (cited n. 12 above) for material on Stuart. The *Emigrants' Sunday Morning* appeared as the only Johnson illustration in Sheldon, *American Painters*, facing 168. The Whittredge/Johnson *Sunday Morning, New England* was on the art market in the 1970s.

14. See Roth, "New England; or 'Olde Tyme' Kitchen Exhibit at Nineteenth-Century Fairs"; and Frye, "Beginning of the Period Room in American Museums," 159–85, 217–40.

15. *James Wells Champney, 1843–1903* (Deerfield, Mass.: Hilson Gallery, Deerfield Academy, 1965), 32 and no. 18; Edwards, *Domestic Bliss*, 81–82; Kornhauser, *American Paintings*, 2: 601–3.

16. Nylander, *Our Old Snug Fireside*, figs. 108, 111. Nylander argues convincingly that the collecting of "colonial" materials began in the pre-Civil War era.

17. See Monkhouse, "Spinning Wheel," 154–72; Sewall, *Message through Time*, no. 4 (*Mrs. Young*) and no. 6 (*Mrs. Coffee—Small Point*). The photograph by Frances Allen and Mary Allen of Deerfield (ca. 1900) is reproduced in Flynt, McGowan, and Miller, *Gathered and Preserved*, 10.

18. See Sewall, *Message through Time*, 99, no. 7; on the frame of her photograph of the 1636 Fairbanks homestead in Dedham is a clipping about the building's significance (ibid., no. 9).

19. Sewall, *Message through Time*, no. 17; compare the work, circa 1902 and 1920, of Chansonetta Stanley Emmons, another Maine photographer (Péladeau, *Chansonetta*, 23, 71). *Thomas Hovenden (1840–1895): American Painter of Hearth and Homeland* (Philadelphia: Woodmere Art Museum, 1995), 13; Braithwaite, *Van Der Zee*. Currier and Ives images of the Longfellow poem appeared early, with one dated 1864 by Frances Palmer that includes verses from the poem (Gale 6976; see also Gale 6977-78). In the same year Palmer produced for Currier and Ives another image from Longfellow's "The Wayside Inn" (Gale 7103).

20. Tuckerman made a point of singling out the Bible-reading old man in Johnson (Tuckerman, *Book of the Artist*, 469). For the photographic images, see Sewall, *Message through Time*, no. 1 (a prizewinner in 1898, at the Boston Camera Club and Photo-Club of Paris; no. 5 is a study for this); and Coleman, *Mr. Theodore Parsons Reading Bible in Sewall House, York, Me.* (Society for the Preservation of New England Antiquities [SPNEA], 18833–86, no. 7862-a).

21. For an acute sense of the critical role of the church during this period, see the rural tales of Mary Wilkins Freeman: "A Village Singer," "A Conflict Ended," "The Church Mouse," "A Village Nun," to mention but a few. All are included in Solomon, ed., *Short Fiction of Sarah Orne Jewett and Mary Wilkins Freeman*.

22. For the setting of *The Village Post Office*, Wood used his Vermont relatives and friends and a general store in Williamstown (see Lublin, *American Selections*, 162–63). Virginia M. Westbrook nicely compares the Wood painting to a contemporary view of the city of Burlington in Saunders, Westbrook, and Graff, *Celebrating Vermont*, 158–59. For a different dynamic in an exclusively male version of this setting, compare Homer's *Country Store* (1872); see Sheldon, *American Painters*, facing 109. For an illuminating discussion of the dynamics of the process, see Burns, *Pastoral Inventions*.

23. See "Grape Harvesting," in *Harper's Weekly* 11 (26 October 1867): 673–74 and images at 680–81. The Ehninger graphic image is also reproduced in Burns, *Pastoral Inventions*, 48. Ehninger, who had studied with Emanuel Leutze in Düsseldorf and with Thomas Couture in Paris, was interested in finding a method for reproducing his sketches for larger audiences. In 1859 he edited *Autograph Etchings by American Artists Produced by a New Application of Photographic Art, under the Supervision of John W. Ehninger, Illustrated by Selections from American Poets* (New York: Townsend, 1859). It included *The Puritan* by Leutze, another Puritan scene entitled *The Exiles* by Ehninger, and images by Eastman Johnson, F. O. C. Darley, and George H. Boughton.

24. See Simpson, Mills, and Hills, *Johnson*; for the context, see Brown, *Inventing New England*, chap. 4; for sugaring-off scenes, which never eventuated in a major oil painting, see Hills, *Johnson*, 49–51, 64–67; and the forthcoming Johnson exhibition catalogue (Brooklyn Museum).

25. The titles are not Coleman's but were added by SPNEA after they acquired them. For a discussion of the group, see Giffen and Murphy, eds., *"Noble and Dignified Stream,"* 118, 152–55. There are parallel images in the work of Emma Sewall, especially in the images of marsh haying (Sewall, *Message through Time*, nos. 28, 31–40). The role played by women photographers—Emma Coleman, Emma Sewall, Chansonetta Emmons Stanley, Frances Allen and Mary Allen, and others—is just emerging. Analysis of these images and their location within the lives of these women, the social roles played by these photographers, and especially their largely female support systems is a challenging new cultural and aesthetic territory.

26. For one cultural reading of the impact of Barbizon in the United States, see Meixner, *French Realist Painting and the Critique of American Society*.

27. For this and surrounding information on this work, I am indebted to the research of Jeffrey R. Brown of Brown/Corbin Fine Art, Lincoln, Massachusetts.

28. See the excellent study by Thomas Southall, "White Mountain Stereographs and the Development of a Collective Vision," 97–108. Southall makes the important point of the shared quality of the vision: what is privileged is not the uniqueness of an individual artistic voice but its confor-

mity to a type. He also notes that many pointed out in 1869 that both the cog railway and the spike in Utah that completed the transcontinental railroad were the accomplishments of New Hampshire men.

29. See Brown, "Accidental Tourists," 117–30; Brown, *Inventing New England,* 41–74.

30. For helpful discussion and illustrations of these and related images, see Cikovsky and Kelly, *Winslow Homer,* 72–78.

31. The territory was thoughtfully surveyed in McGrath and MacAdam, *"A Sweet Foretaste of Heaven"* (and exhibition); the earlier, Keyes, *White Mountains;* and the recent traveling exhibition *White Mountain Painters, 1834–1926,* organized by the Danforth Museum of Art, Framingham, Massachusetts, 1994–96.

32. The minister Thomas Starr King, for example, was orchestrator of the White Mountain tour in his famous guide books (King, *The White Hills: Their Legends, Landscape, and Poetry, with Sixty Illustrations* [Boston: Crosby, Nichols, Lee, 1860]).

33. Garrett, *Romance & Reality of the Puritan Coast,* 46–50.

34. Haseltine's ancestors were founders of Haverhill; and his father was born there in 1793. In 1817 the family moved to Philadelphia, where William grew up. His New England work is thus part of a vacationing "return." For biographical outlines, see Simpson, Henderson, and Mills, *Expressions of Place.*

35. "It is within three years that Mr. Haseltine has come into notice as a painter of coast scenes, and so marked has been his success, that his prominence and superiority in the portrayal of the rocky shores of Nahant and Narragansett are by all fully acknowledged. Agassiz pronounces the rocks of Nahant to be the oldest on the globe and that they are of volcanic origin. Mr. Haseltine fully conveys their character in his pictures, and no one who has wandered over these huge masses of rough red rock, and watched the waves breaking against them, could fail to locate, from his studies, the very spot he has delineated" ("Among the Studios," *Watson's Weekly Art Journal* 1 [8 October 1864]; quoted in Simpson, Henderson, and Mills, *Expressions of Place,* 171; see also 14–31).

36. For a thoughtful discussion of the project, see Rainey, *Creating "Picturesque America."*

37. For an excellent selection of these images, see Workman, *Eden of America.*

38. See William Kloss, in Alexander W. Rollins, ed., *Treasures of State: Fine and Decorative Arts in the Diplomatic Reception Rooms of the U.S. Department of State* (New York: Abrams, 1991), 456–57; for related Brichers, see Brown, *Bricher.*

39. Robert Workman tallies seven versions in his entry on the painting in *Eden of America,* no. 26. An engraving of *Home by the Sea* appeared in the *Art Journal* in 1876.

40. The catalogue *Prang's Chromo* (April 1869), 8, includes the chromolithographs *Late Autumn in the White Mountains* (after Alfred Thompson Bricher) and *The Crown of New England* (after George L. Brown) and sets of *Twelve Views of American Coast-Scenes.*

41. In partnership with James Ticknor, James T. Fields was Boston's leading publisher of the great generation of writers who had represented New England—Emerson, Hawthorne, Holmes, Longfellow, Lowell, and Whittier—as well as leading British authors, most notably Charles Dickens, whom he hosted on his American visits. For the early history, see Tryon and Charvat, *Cost Books of Ticknor & Fields;* Charvat, *Profession of Authorship in America;* and, most recently, Winship, *American Literary Publishing.*

42. Thomas H. Johnson, *Poems of Emily Dickinson* (Cambridge: Harvard University Press, 1955), no. 520. For a discussion of this and other Dickinson poems that refer to the sea, see Stein, "Realism and Beyond," 190–208, which also treats other materials in this chapter. For a perspective on a very different earlier imaging of this area, see Sarah Cash, "Singing Beach, Manchester: Four Newly Identified Paintings of the North Shore of Massachusetts by Martin Johnson Heade," *American Art Journal* 27, nos. 1–2 (1995–96): 84–98.

43. *Deephaven* was published first by the later incarnation of Ticknor & Fields, James R. Osgood & Company; by the ninth edition of 1881 the publisher's name had become Houghton, Mifflin & Co. In the mid-1880s Emma Coleman helped prepare with Jewett a photographic edition of *Deephaven* with tipped-in plates; it was not in general circulation. In 1893 a new illustrated edition appeared, with images by Jewett's South Berwick schoolmate Marcia Oakes Woodbury and her husband Charles, who was by then running a painting school in Ogunquit. The illustrated edition has been recently reprinted in a facsimile edition with a cover design by Sarah Wyman Whitman (*see* Fig. 57). See Giffen and Murphy, eds., *"Noble and Dignified Stream,"* 135–37, 180–82.

44. Jewett and Annie Fields were friends of Thaxter and served as literary executors of her estate after her death in 1894. Thaxter's portrait, by Otto Grundmann, hangs in the Portsmouth, New Hampshire, Public Library.

45. Lizzie W. Champney "The Summer Haunts of American Artists," *Century* 30 (October 1885): 845–60. The author was married to the painter James Wells Champney.

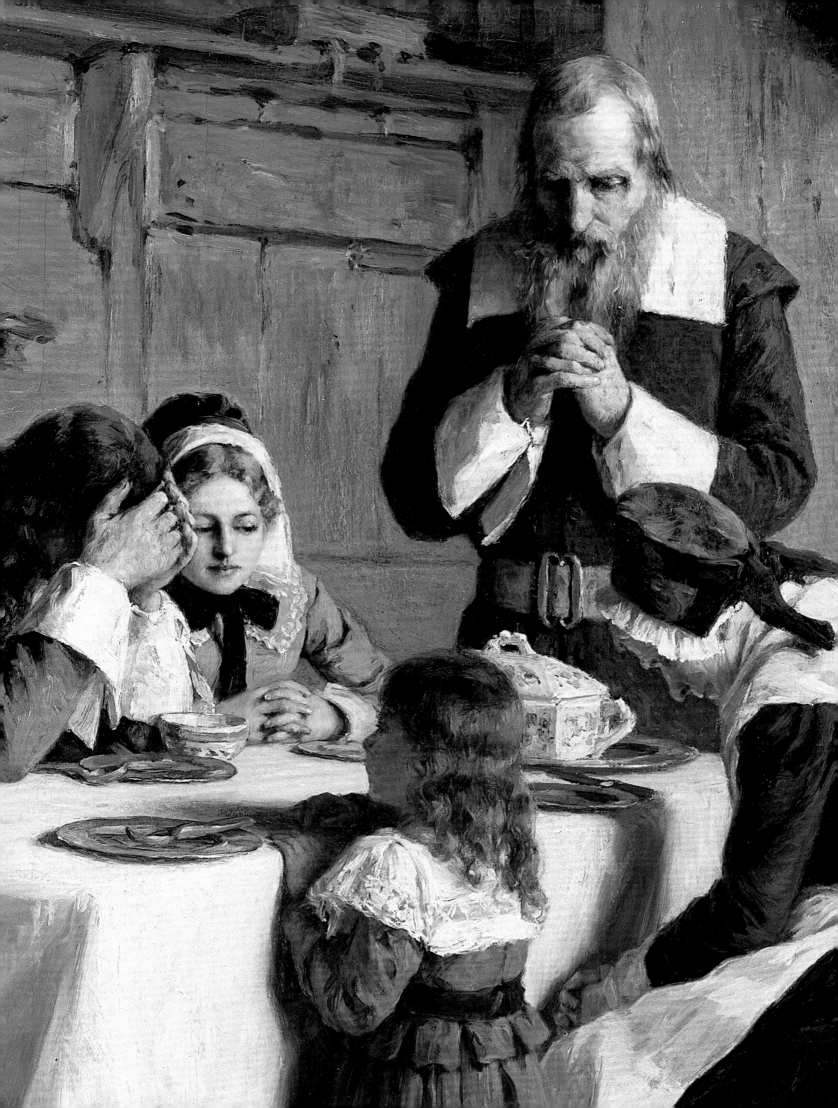

Gilded Age Pilgrims

ROGER B. STEIN

Historicizing the Past: The Return of the Mayflower

The reshaping of the New England rural past was one critical process that occurred after the Civil War. The more specific reexamination of New England history—of Americans' relation to their Puritan and Revolutionary War past—was another related process. The pictorial emphasis on a preindustrial rurality and a vacationers' haven in nature in the decades after 1865 and the marketing of this vision to a national audience were ways of reasserting the importance of older ideals and values in the face of a changing America. The historical recovery of the colonial past involved a parallel attempt to reassert the moral and social values of the founding (the Puritan seventeenth century), the making of the republic (the Revolutionary era), and the fulfillment of the ideal through the preservation of the Union and the freeing of the slaves (the Civil War). This was New England's claim to moral predominance and national leadership, and it reinforced the searching for historical roots, back to a British and, for some, an Anglo-Saxon racial heritage. After the devastation of the Civil War and the uncertainties generated by massive postwar immigration and by industrial, commercial, and urban development, such a strategy should not seem surprising.

Psychologically, the future is always an unmapped terrain, and our tendency is to read it in terms of past experience. Historically, William Bradford, who landed at Plymouth in December 1620, describes a landscape of loss facing those who had sailed on the *Mayflower:* "no friends to welcome them, nor inns to entertain or refresh their weatherbeaten bodies; no houses or much less towns to repair to, to seek for succor" and no biblical Pisgah from which to look down on a promised land.[1] Bradford's account was well known in its own time, and following generations drew on it to define the loss of the original Puritan piety, before the manuscript disappeared. Bradford's full text, *Of Plimoth Plantation,* was rediscovered in London in 1855, immediately copied, and published by the Massachusetts Historical Society the next year. It consequently became fully a part of the historical record that helped post-Civil War Americans define the meaning of their past.[2]

Of course the rereading of the New England past had been an ongoing process. Plymouth in 1620 and Massachusetts Bay in 1629 were critical locations in that process, but the Old Tower in Newport, Rhode Island, had suggested Viking origins to pre-Civil War writers like James Fenimore Cooper and Henry Wadsworth Longfellow;[3] and Frederic Church's career as a landscape painter began in 1846 with his historical canvas *The Hooker Company Journeying through the Wilderness from Plymouth to Hartford, in 1636.*[4] After the Civil War Celia Thaxter reminded readers of the *Atlantic Monthly* that the Isles of Shoals had been used as a base by fishermen as early as 1614, and *Among the Isles of Shoals* (1873) included fragments of earlier seventeenth- and eighteenth-century histories.[5]

Henry Mosler, *Pilgrims' Grace* (detail), 1897, oil on canvas, 98.4 x 131.5 cm (38 3/4 x 51 3/4 in.). Allentown Art Museum, Gift of Mr. and Mrs. Norman Hirschl, 1977 (1977.04).

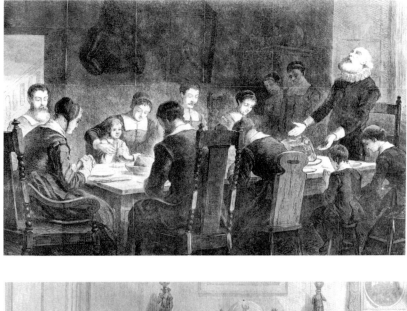

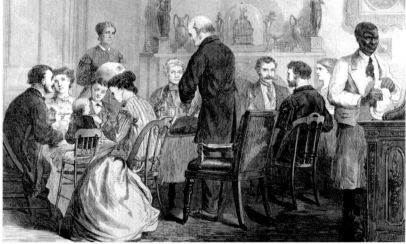

Nathaniel Hawthorne had been to the Shoals in 1852, just after finishing in quick succession *The Scarlet Letter* (1850) and *The House of the Seven Gables* (1851), his rereading of the Puritan past of Boston and Salem, as well as countless shorter tales like "Endicott and the Red Cross" or "The Maypole of Merrymount," which used fiction to critique the New England history he had read in the collections of Salem's Essex Institute and elsewhere.[6] Cotton Mather's *Magnalia Christi Americana* (1702) had appeared in a scholarly edition in the 1820s. Two years after Hawthorne's death and in the wake of the Civil War, the process continued. In 1866 Samuel Gardner Drake published an elegant edition of Cotton Mather's *Wonders of the Invisible World* (1693) and Robert Calef's sequel, *More Wonders of the Invisible World* (1700), under the title *The Witchcraft Delusion.* Drake then went on in 1869 to publish his own *Annals of Witchcraft in New England,* intended to set the record straight: that Mather was "unjustly singled out and held up to scorn," that witchcraft as a practice came from England, and that he was now putting the student "in possession of nearly all the Materials existing upon this deeply interesting, though humiliating, and in some respects, revolting Subject."[7]

That Drake's work, clearly directed to a limited audience, was part of a continuing attempt to recast the colonial evidence and to offer a more positive representation of the Puritans can be seen in two works of 1867. The first was by John Whetten Ehninger, whose large oil painting *October* (*see* Fig.15) had been published in a revised graphic version in *Harper's Weekly* on 26 October. Five weeks later *Harper's Weekly* published a lead article on Thanksgiving. According to the author, this festival, originating in New England, "has become a national affair," celebrated by all on the same day. The community of thanksgiving is "due to the war, and shows how firmly that struggle has bound together the different sections of our country. . . . Like many other Puritan ideas, it has been communicated to other States until it has become national." But having said this, the writer went on to indicate that this kind of festival and public praise of God had ancient origins and that the Puritans "had a darker theology—one of fear rather than of love. . . . The God of the nineteenth century is not the God of the sixteenth." What we are given here, thus, is at once a nationalizing of the regional, so that New England can stand for the nation—New England and Northern abolitionist idealism had, after all, just won the Civil War—and a critique of its "darker" past in the name of present, in this instance spiritual, values.[8]

The visual expression of all of this was available in a pair of plates: John Ehninger's *A Thanksgiving Dinner among the Puritans* (Fig. 33) and the accompanying *A Thanksgiving Dinner among Their Descendants* (Fig. 34). The first emphasizes the praying father

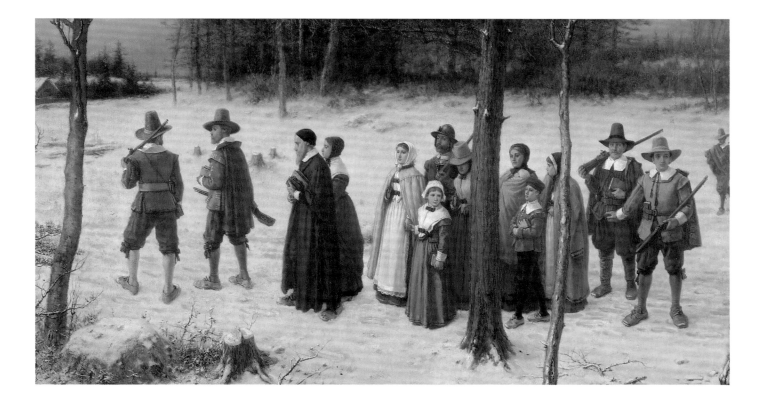

35. George Henry Boughton, *Pilgrims Going to Church*, 1867, oil on canvas, 71.8 × 130.8 cm (28 1/4 × 51 1/2 in.). © Collection of The New-York Historical Society, The Robert L. Stuart Collection, on permanent loan from The New York Public Library, 1944.

looking up to God, while others solemnly bow their heads. It is set in a rather elegant building, with ascending stairs, a set of armor on the wall, framed portrait, cabinet with jugs, and two servants bowing in the dark. In the companion piece, by contrast, the old man is carving, not praying, the decor and the clothing are not somber but fashionable, with vaguely classical motifs on the elegant mantle, and reminders of wartime: the scene is bracketed by the figures of the lighter-skinned serving woman and the black manservant who stares problematically out at us, his back to the seated Union officer with the empty sleeve. If the left side of the image expresses a gentle family love and the Victorian clutter at the center gives shape to postwar urban prosperity, the black servants express not only the "conspicuous waste and leisure" of what Thorstein Veblen would call "the leisure class"; they also stand as haunting reminders of the unfulfilled promise of equality of the Reconstruction era. Was a retreat into a Puritan past to become a way of evading those issues, another way of recasting "the fugitive's story"?

The year 1867 also saw the exhibition by George Henry Boughton at the Royal Academy in London of his now famous image originally titled *Early Puritans of New England going to worship armed, to protect themselves from Indians and wild beasts* (Fig. 35). In both his life and art, Boughton reached across the Anglo-American boundaries that had been so strained by Civil War politics to recast the image of the first Puritans/Pilgrims for the coming generation.[9] Indeed, the reverberations and replications of the Boughton painting extend well into the twentieth century. Fully the Anglo-American, Boughton was born in Britain but trained and exhibited first in New York at the National Academy of Design and then in France. He spent time in Brittany, painting pictures of the French peasantry, who represented, in an era of major agricultural conflict, sturdy self-reliant older ways for the Barbizon and Pont-Aven artists from the 1850s on.[10] Settling in London in the 1860s, Boughton became friend and sometime mentor to a generation of American expatriates, including Edwin Austin Abbey, James McNeill Whistler, and Henry James.[11] His paintings traveled back and forth across the Atlantic. *Early Puritans* was on exhibit in New York in early 1868 as *Pilgrims Going to Church*, and was purchased by Robert L. Stuart, who was at the same time accumulating Eastman Johnson genre scenes.[12]

36. N. C. Wyeth, *The Wedding Procession*, 1940–45, oil on canvas (mural for the employee lounge of Metropolitan Life Insurance Building, New York), 274.3 × 762.0 cm (9 × 25 ft.). The collection of the MetLife murals, the Metropolitan Life Insurance Co., New York.

Retitled *Pilgrims' Sunday Morning,* the painting became a notable part of the American art display at the 1876 Centennial Exposition. In graphic form the image appeared in magazines and books on American history over the next fifty years, was virtually plagiarized by Frederick Waugh for his *Puritans* (1890), and clearly served as the model for a scene in the Old Deerfield, Massachusetts, Historical Pageant in 1910, as photographs testify.[13] It continued to be a well-known print displayed in schoolrooms across the country well into our own time.[14]

The explicit source of the image was again Anglo-American. The passage cited by Boughton from William Henry Bartlett's *Pilgrim Fathers* (1853) describes the "dense forest" through which "the cavalcade proceeding to the church, the marriage procession, if marriage could be thought of in those frightful days, was often interrupted by the sudden death-shot from some invisible enemy."[15] Boughton eschews the melodrama of his textual source, except implicitly in the guarded look of the men bearing muskets. The pictorial design of the image does not stress the danger of Indians or wild beasts.[16] The tree stumps emphasize the act of clearing the large middle space for the stately parade. The foreground vertical trees are frames, not barriers, and the pairs of armed men bracket and quite literally safeguard the old minister (who looks like Elder Brewster), his mate, and a group of women, men, and children—in sum, a solemn, complex event is rendered, subdued in its color range and almost tonal in its palette.[17] The outward gaze of some figures induces the viewer to participate in this quiet ritual, to become a part of their community. Guarded at the edges, in a wintery New England, this image invites us to relive a history in which Pilgrim Plymouth becomes the sign for a more general Puritan New England. The further semiotic slippage, from "going to church" to "Sunday morning," is another such broadening and opening up of the meaning of a particular historical event for its late-nineteenth-century audiences and one which narrows the distance between seventeenth-century New England and the Sunday morning images of rural New England by Eastman Johnson, Albert Fitch Bellows, and others.

In the years after 1867 Boughton painted other images of Puritans, although none had quite the appeal of this first one. His *Landing of the Pilgrim Fathers* (1869) was an all-male grouping, more militant in armor and more rhetorical in gesture.[18] In 1869 he exhibited at the Royal Academy *The March of Miles Standish*, in which armed men follow the Indian guide Hobomek—the first of these Boughton images based on Longfellow. Several large scenes depict versions of the return of the *Mayflower,* again using Longfellow as source, with black-clad men and women gazing from the rocky shore at the retreating form of the ship—*Pilgrim Exiles,* as one is entitled—a motif that functions in two ways, emphasizing the bravery of these "pioneers" and their loss of the critical tie to the mother culture.[19] This double intent

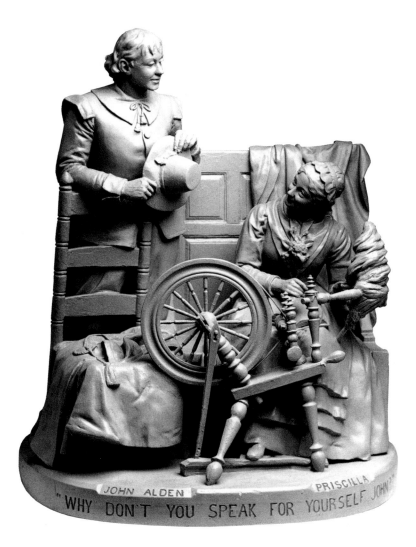

37. John Rogers, "Why Don't You Speak for Yourself, John?," 1885, painted plaster, 55.8 × 43.2 × 30.5 cm (22 × 17 × 12 in.). National Museum of American Art, Smithsonian Institution, Gift of Mrs. Genevieve Wisel in memory of Dan Wisel.

is central to the art of old New England throughout this period, informing both the Puritan and Revolutionary era imagery.

In addition to these large horizontal images of men (and sometimes women) in the New England landscape, Boughton produced numerous small vertical images of single women or couples in Puritan garb, with titles linking them to Longfellow's *Courtship of Miles Standish* or Hawthorne's *Scarlet Letter*. A few of the latter include little Pearl; others position Hester Prynne at the door of a house, as Able, the community helper, but certainly not as Hester the Adulteress.[20] Some were figures reprocessed from the original 1867 *Pilgrims Going to Church*. One such, a *Priscilla* of 1879, in which a female figure walks alone across a snow-covered field with the houses of the community behind her, became about 1890, with the addition of a rifle-toting man in tights, the inevitable steeple-crown hat, and a caption "Pilgrims Going to Church in Colonial Times," the label on a tin can of strawberries.[21] The austere image that locates American Puritan events at the level of history painting—the pinnacle of the hierarchy of genres in the canon of art—is now transformed into a marketing strategy for domestic consumption. Clearly the mediating instrument was the immensely and internationally popular poetry of Longfellow.

The Courtship of Miles Standish had been published originally in 1858. It involved for Longfellow a turning away from his original dramatic intentions regarding Puritan history (just as Bradford's history was being fully published). By 1868 he had returned to his original plan, in the "New England Tragedies" of "John Endicott" and "Giles Corey," parts of his large-scale trilogy entitled *Christus: A Mystery* (1872). It was not, however, this tragic dimension of colonial history that appealed to his loyal audiences but the lighter pastoral of *Miles Standish*. Reprinted again and again in the postwar years, the poem elicited visual interpretations, from a multitude of small engraved illustrations in the nineteenth century to a set of huge murals, which N. C. Wyeth did for the Metropolitan Life Insurance Company in the early 1940s (Fig. 36).[22] The impact of the poem in these years can be felt even in images like Thomas Eakins's *Courtship* (ca. 1878) that seem to work ironically off a shared understanding of the poem.[23] Courtship images include one of John Rogers's most popular parlor sculptures, *"Why Don't You Speak for Yourself, John?"* (Fig. 37), and a pair of interior images, of Miles Standish and John Alden, *John Alden's Letter* (Fig. 38), and of Priscilla and John (1884), by Charles Yardley Turner, exhibited in Chicago at the Columbian Exposition in 1893.[24]

Longfellow's poem and its illustrations constructed a visually attractive colonial past, with beautiful (though frequently austere) landscapes, precise costuming, and historical actors "brought to life" in ways recognizable to their nineteenth- and twentieth-century audiences. Marginalized as "savages," Native Americans are al-

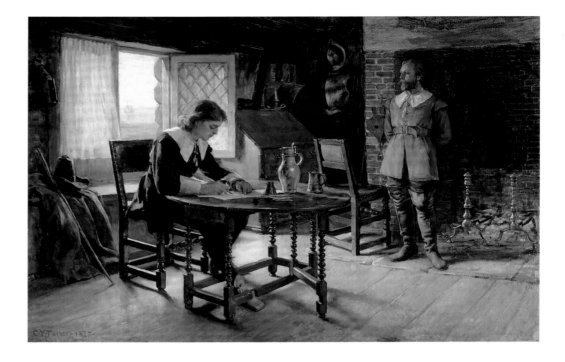

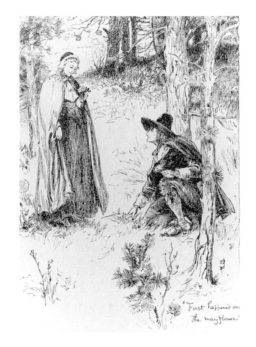

lotted one brutal scene in which Standish triumphs over them (and the head of one is returned to the Pilgrim fort, to the dismay of Priscilla). The gender drama is carefully nuanced to pit the gruff but well-born Miles, military protector of the community, against the sensitive, more modest John. In the Turner image Standish, whom one could almost mistake for a Cavalier, with his long boots and pointed beard, defends the hearth, while the scholarly Miltonic Alden sits with pen poised. Longfellow's Priscilla is at once direct and honest, domestically active at her spinning wheel, "arch" rather than sentimental, and rewarded for her patience with a wedding and a ride on the white bull, like a medieval damsel. That ride is configured finally, in the closing lines, as a journey "in the valley of Eschol. / Like a picture it seemed of the primitive, pastoral ages, / Fresh with the youth of the world, and recalling Rebecca and Isaac, / Old and yet ever new, and simple and beautiful always."

The appeal of the poem and its illustrations over time lay precisely in its capacity to dissolve conflicts of race and territorial control, of bold venturing into the new world versus returning to the old, and of contending male and female roles. The final tableau erases the problematic future in a generalized union with a mythic past, both Old Testament (the view from Pisgah and beyond that Bradford could not find) and seventeenth century. When Harriet Prescott Spofford retold the Priscilla story for Edmund Garrett's *Three Heroines of New England Romance* (Fig. 39), she acknowledged that the anachronisms of Longfellow's version were many and well known, but "every incident in their pages is absolutely true to the life of the period." It was not the "bare facts" but our capacity to identify with the past: "because we like to make these people, looming large through the mists of time . . .

real enough for our sympathies."[25] The Promised Land lay in this stable, recovered past, "old and yet ever new, and simple and beautiful always," the antithesis of late-nineteenth-century New Englanders' experience of the present.

What masks this ideological achievement—using the past, however unconsciously, to soften the critique of the present—is the precise attention to setting, which has led to the labeling of many of these works as "colonial revival." Writers of earlier nineteenth-century romances like Walter Scott and Fenimore Cooper had carefully worked up the vraisemblance of their Highland or Huron costumes or local dialects. The visual artists of these history pieces filled their images with period artifacts. Pewter tankards, turned and gate-leg tables, studed leather chairs, cradles, and spinning wheels appear again and again, often copied from or modeled on the cherished few existing seventeenth-century artifacts in collections on display at Plymouth (see Fig. 86), Salem, Boston, and, later, Deerfield.[26] The richly appointed room in Turner's *John Alden's Letter,* like the earlier Ehninger *Thanksgiving* engraving (see Fig. 33), with its hanging armor, brass andirons, and bull's-eye windows, is a model of elegance.[27]

The praying posture of the father in the Ehninger is echoed thirty years later in Henry Mosler's *Pilgrims' Grace* (Fig. 40). A German-Jewish artist brought up in Cincinnati, Mosler spent more than twenty years abroad, mostly in France, creating precise Breton peasant scenes. In 1894 he returned to the United States, to translate his old-fashioned rural themes into historical American terms. He found a house in Easthampton, Long Island, to use as the model for the humble but cluttered, paneled interior of *Pilgrims' Grace.* Careful costuming (down to the child's

40. Henry Mosler, *Pilgrims' Grace,* 1897, oil on canvas, 98.4 × 131.5 cm (38 3/4 × 51 3/4 in.). Allentown Art Museum, Gift of Mr. and Mrs. Norman Hirschl, 1977 (1977.04).

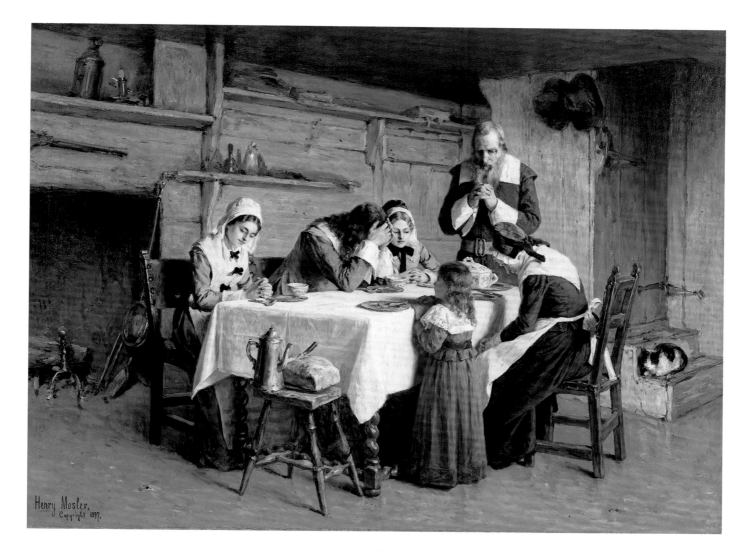

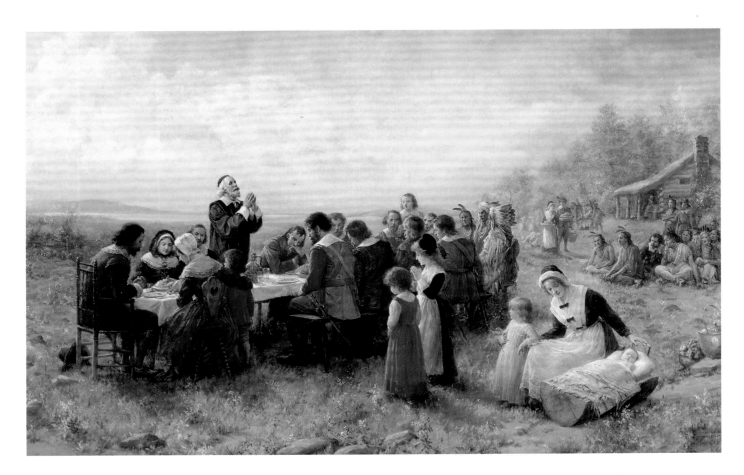

41. Jennie A. Brownscombe, *First Thanksgiving at Plymouth*, 1914, oil on canvas, 71.1 × 111.8 cm (28 × 44 in.). Pilgrim Society, Pilgrim Hall Museum, Plymouth, Massachusetts.

lace collar) is exactly contemporary with the researches and publications of Alice Morse Earle, aptly dubbed "The Mother of American Material Culture,"[28] and a few elegant ceramic pieces complement the inevitable pewter.[29] The central action in the Mosler painting is the act of prayer, the "grace" before the meal, and this spiritual marker is the organizing principle of the pictorial design. All lines and planes lead to the praying father.[30]

What is a private religious ritual in Ehninger and Mosler's images becomes a public event in another image, Jennie A. Brownscombe's *First Thanksgiving at Plymouth* (Fig. 41). As an insistently narrative, moralistic, and stylistically mimetic image, produced one year after the modernist explosion of the Armory Show in New York, the Brownscombe painting is surely an embarrassment to any "progressive" version of American art history. Like the Boughton image, it has been endlessly reproduced in graphic form, while the original finds its home, appropriately, in Plymouth, in Pilgrim Hall, the 1824 landmark that has welcomed pilgrims and tourists for more than 150 years.

The association with Mosler is not coincidental. Though Brownscombe began as an artist-illustrator in New York in the 1860s, she went on to study with Mosler in his Paris studio in 1882–83. Like many wealthy American artists, she traveled frequently between America and Europe. Her oil paintings appeared in major exhibitions, and she worked as a graphic artist for magazines and also for the lithographer Louis Prang in the production of greeting card and calendar images as did Howard Pyle, N. C. Wyeth, Maxfield Parrish, Frank Schoonover, and many others.

The *First Thanksgiving* gives the father's prayerful gesture to a recognizable portrait image of Elder Brewster. The armed figure across the table from him must surely represent Miles Standish. The elongated table suggests images of the Last Supper, but the presence of women, when coupled with the pair of praying children and prominent woman with cradle, forming a powerful diagonal, argues a different dynamic. The mother anchors the spiritual gesture in female domesticity, and the

42. Frederic Dielman, *The Marriage of Doctor Francis LeBaron and Mary Wilder*, 1894, etching, 56.4 × 74.3 cm (22 × 29 1/2 in.). Harriet Beecher Stowe Center, Hartford, Connecticut.

Indians are carefully marginalized.[31] Despite the obvious anachronisms (the Plains Indian headdresses, the log cabin), Brownscombe has carefully mapped the social and spiritual space of a peaceful New World. If it seemed badly out of date both stylistically and thematically to promoters of the 1913 Armory Show, those who supported a less well-known 1909 Armory Show argued that Edwin Austin Abbey, Edwin Howland Blashfield, and Jennie Brownscombe, among others, created paintings that served an important social function: "Many children . . . never see any good pictures outside of the schoolroom, and if a proper proportion of the school pictures are of a patriotic and historical interest their educational influence will be marked."[32]

A substantial community is gathered indoors to witness another domestic ritual in *The Marriage of Doctor Francis LeBaron and Mary Wilder,* a 1695 event in Hingham, Massachusetts, which linked a daughter of Plymouth to a French physician, who had been shipwrecked and resettled in Hingham, where he left a substantial estate at his death in 1704. The large oil version, exhibited at the National Academy of Design in 1894, was turned into a delicate etching (Fig. 42).[33] The somber clothing of the gathered assembly sets off the elegant attire of the marriage partners. Costume signalizes a key distinction, one that we saw in the Turner *John Alden's Letter* (*see* Fig. 38), and which had emerged in the graphic representations of the 1880s and 1890s in the work of Dielman, Abbey, and Pyle. It is a movement back and forth between Puritan and Cavalier, between the austere and the elegant, in substance and style—the style of late-nineteenth-century artist-illustrators working in England and America and of their seventeenth-century subject matter. The larger claim being made through these images is that both Puritan and Cavalier were the heritage of New England. The major political and religious conflicts out of which the colonies were forged—those between the church polities of separatist Pilgrim Plymouth and Puritan Massachusetts Bay and, more dramatically, between the warring Roundheads of Cromwell and the royalist Cavaliers—were being dissolved (or ignored) by a generation more concerned with solidifying its claims to "British" and increasingly Anglo-Saxon "racial" heritage in the face of challenges to their hegemony by newer immigrant groups.[34]

Historicizing the Past: The Revolutionary War

The ultimate proving ground for this attitude was, of course, the Revolutionary War. The desire to identify with a British heritage came face to face with the demands of American patriotism. Strategies developed by late-nineteenth-century artists and writers to cope with this challenge and the ways in which they historicized the eighteenth-century "colonial" heritage form a second chapter in the historical recasting of old New England.

Earlier interpretations have linked this process to the Centennial of 1876, the responses to which produced or at least reinforced what is called the colonial revival. As with most clichés, it has some truth, although the situation was more complicated temporally and ideologically. Interest in the Revolutionary era had been, like that in the earlier colonial period, continuous. The Massachusetts Historical Society was founded in 1791, in part to preserve the documentary evidence of events that the society's founders like John Adams, historian Jeremy Belknap, and

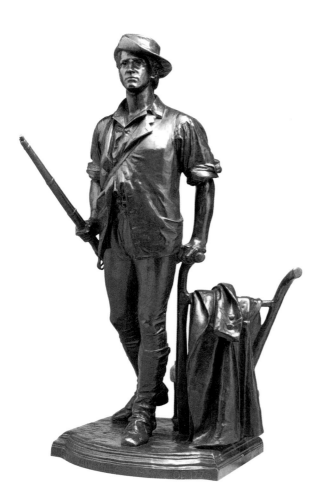

43. Daniel Chester French, *Concord Minute Man of 1775*, 1889; remodeled from 1875/cast 1917, bronze, 81.9 × 43.5 × 46.7 cm (32 1/4 × 17 1/8 × 18 3/8 in.). National Museum of American Art, Smithsonian Institution, museum purchase.

others had just lived through; so the future could fully grasp the meaning of this period. The great correspondence revived between Adams and Thomas Jefferson, after they had both retired from office, was dedicated to sorting out the significance of the years in which they had played such critical roles. Cooper's second novel was *The Spy: A Tale of the Neutral Ground* (1821)—that is, the space of ambiguous loyalties during the Revolution. One scholar calculates that more than twenty dramas on Revolutionary War themes were published in the forty years before the Civil War.[35]

The images of and monuments to George Washington in every decade from the 1770s to the 1850s—which gave us Emanuel Leutze's liberal northern *Washington Crossing the Delaware* (1851) as well as Junius Brutus Stearns's series on Washington the aristocratic Virginian and plantation owner—and beyond are the most obvious testimony to the continuous reprocessing of colonial imagery to serve the differing and often conflicting needs of later generations for a past that would both reinforce their present commitments and help alleviate their anxieties.[36]

Washington's connections with New England were limited but intense. Woodrow Wilson, in his 1896 biography of Washington and in his later "Colonies and Nation," serialized in *Harper's Monthly* in 1901, stressed his fellow-Virginian's notions of honor, authority, and pride of "breeding at the head of an army whose enemies deemed it a mere peasant mob and rowdy assemblage of rebels." Washington's taking command of the troops on Cambridge Common led to endless artifacts venerating the "Washington Elm."[37] Within this general context, New England played a special historical role, for it was the place where, as the first stanza of Emerson's "Concord Hymn" asserted: "By the rude bridge that arched the flood, / Their flag to April's breeze unfurled; / Here once the embattled farmers stood, / And fired the shot heard round the world."

The aging Emerson was appointed to the committee that commissioned a youthful Concordian named Daniel Chester French to create a monument commemorating the Battle of Concord. Approved in plaster and then cast in bronze (with the Emerson stanza carved into the granite base), French's heroic figure stands in a pose adapted in part from the Apollo Belvedere. The figure has by its side a plow recalling the farmer-soldier Cincinnatus and Jean-Antoine Houdon's life-size marble image of Washington in the Richmond, Virginia, state capitol designed by Jefferson.[38] Bronze for casting the statue at Concord came from melted Civil War cannons and adds for its 1875 audience another obvious biblical association, of beating swords into plowshares and spears into pruning hooks (Isaiah 2:4). Yet the statue also insists on its rural democratic roots, through the citizen-farmer associations, the balancing flintlock, and the meticulously defined costume (no classical toga here!). The *Concord Minute Man of 1775* (Fig. 43), as the figure became known in numerous small-scale remodeled replicas of the 1875 image, balanced the elegant pose and refined features associated with its classical, biblical, and Washingtonian heroic sources against the insistent ordinariness of the figure's dress, plow, and the temporally immediate, thrusting form of the rifle—those things that "enemies" identified with "a mere peasant mob and rowdy assemblage of rebels."[39]

That same combination of classical elegance and meticulous realism is available in an exactly contemporary Revolutionary scene created by the expatriate American painter and sometime colleague of George Boughton, Henry Bacon. *The Boston Boys and General Gage, 1775* (Fig. 44) was exhibited at the Paris Salon of 1875 and the next year in Boston and at the Centennial in Philadelphia.[40] The incident that this historical canvas dramatizes has its source in Benson Lossing's writings.[41] The scenario is the moment of direct protest by a group of Boston children to the Massachusetts military governor when their sledding, snowballing, and other activities were frustrated by the occupying British soldiers. General Gage remarks to one of his officers, "the very children here draw in a love of liberty with the air they breathe."[42]

Not a grand historical scene of a major event, this is a historical anecdote, a mixing of the traditional hierarchy of genres, treated with all the diversity and specificity of incident, costume, and setting associated with narrative realism of the period. Yet in its overall design it is a carefully constructed drama of class, race, and gender in urban Boston. The heavily insistent portico and the arched windows frame General Gage and associate him with classical order, as does his gesture restraining the lunging soldier. That gesture is echoed in the black equerry reining in the noble white steed, the pair of elegantly attired young women and their tiny dog, and the open space, which allows viewers of the scene access to a reimagined Province House with its emblem of royal authority on the entablature above.

The other side of the picture, with the cavorting soldier and servant girl, the distant soldier chasing children on the snowy Common, and the obstreperous child climbing the lamppost, is organized by the thick and complex diagonal wedge of people—old and young, black and white, clad neatly or roughly, from the sprawling boy to the three children directly confronting General Gage. Even the black equerry outside the shuttered window has his vernacular counterpart in the black man who sticks his head out the open window to the left. If the narrative incident is an enactment of love of freedom as a natural attribute of American children, the elegant

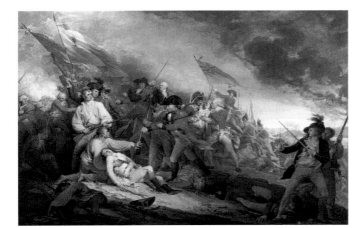

45. John Trumbull, *The Death of General Warren at the Battle of Bunker's Hill, 17 June 1775,* 1786, oil on canvas, 63.5 × 86.4 cm (25 × 34 in.). Yale University Art Gallery, Trumbull Collection.

46. Winslow Homer, *The Battle of Bunker Hill—Watching the Fight from Copp's Hill in Boston,* 1875, wood engraving, 34.6 × 23.2 cm (13 5/8 × 9 1/8 in.), from *Harper's Weekly* 19 (26 June 1875). National Museum of American Art, Smithsonian Institution, The Ray Austrian Collection (Gift of Beatrice L. Austrian, Caryl A. Austrian, and James A. Austrian).

aesthetic order of Bacon's painting is itself a signifier of restraint, controlling potential conflict.[43]

Bernard Mergen nicely argues the importance in this painting of winter and snowball symbolism in both a New England and Revolutionary War context and reminds us that the 1770 "Boston Massacre" was a snow scene.[44] This painting is, however, unlike the 1838 snowball fight on Boston Common recreated by Henry Adams in *The Education of Henry Adams,* between the North Enders and the South Enders, the forces led by "Conky Daniels" and those led by "Bully Hig" (Henry Lee Higginson, later a power in the Immigration Restriction League). That battle not only presaged participation in the Civil War, as Adams explicitly reminds us, it was also a sign of class warfare between the new Irish and the old stock, the Boston Latin School crowd.

This is precisely what Bacon's painting avoids. Abandoning Paris in 1870 during the Franco-Prussian War but surely aware of the Commune, of Émile Zola, of working-class protest, and the "mob" violence of the barricades, Bacon uses the patriotic anecdote to create a prelude to separation in which the British governor offers a model of noble restraint and reconciliation, not urban conflict and violence. *The Boston Boys and General Gage* has it both ways. Bacon's art offers another instance of the uses of the language of elegant order to reach across conflict to the English homeland. At the same time the eloquent nobility of the boys is a model of the forthright young New Englander. The usefulness of the painting was clear: William W. Corcoran purchased it and donated it to the Preparatory School of Columbian University in Washington, D.C., a social lesson to the next generation.[45]

The year 1875 marked the centennial not only of the battle at Concord and the incident with Gage but the major confrontation known as the Battle of Bunker Hill. *Harper's Weekly,* in its issue of 26 June, offered its readers a double-page version of John Trumbull's frequently engraved 1786 painting of the event "in which the raw levies of the still unorganized Continental army so gallantly withstood the onslaught of the British veterans" (Fig. 45). Although he quoted a "cynical English traveler" who thought the presence of the Bunker Hill Monument was "the only instance in which a nation raised a column to commemorate a defeat," the *Harper's* commentator insisted that it was a defeat only in name, because the colonials had run out of ammunition. The British were stunned at the American resistance, and the Americans "learned their strength and . . . the necessity of a thorough military organization." Outlining the course of the battle, referring readers to Lossing's *Pictorial Field-Book of the Revolution* and with little outline sketches above the essay for the identification of characters, the piece ended: "On page 517 we give an engraving in which MR. WINSLOW HOMER has endeavored, with an artist's imagination, to depict the scenes at Copp's Hill, where the excited citizens of Boston gathered to watch the progress of the battle and the burning of Charlestown" (Fig. 46).[46]

The juxtaposition of images is instructive. The well-known Trumbull painting surely lost something in its black-and-white translation from the original sweeping baroque interplay of forms against a sky filled with conflicting flags and the burst of fire and smoke from burning Charlestown off stage right. Nevertheless the cen-

47. Edwin Howland Blashfield, *Suspense: Boston People Watching from Housetops the Firing at Bunker Hill*, 1882, oil on canvas, 63.5 × 87.0 cm (25 × 34 1/4 in.). Gilbert and Margaret Papazian.

tral event is unmistakable: the death of Major General Joseph Warren in the fore-ground under the pine tree "American" flags and the parallel image of the death of British Major Pitcairn under the British flag. We are also given the generous act of British Major Small as he deflects the coup de grace aimed at Warren. It is not a matter of source or influence (although Bacon surely knew the famous Trumbull at least in engravings) but of the parallel stances: the emphasis not on a strident American nationalism but a balance between patriotism and recognition of British nobility. At the right edge, our surrogates, the wounded Grosvenor and the black Peter Salem (who according to tradition shot Pitcairn), stare in awe.

The smaller Winslow Homer engraving is linked in its general subject matter (the battle), and the billowing black smoke and hill at upper left correspond to the right edge of the Trumbull. Beyond that, the Trumbull is about engagement with the sublime in the grand manner; the Homer is about distanced observation. The boldly rendered group has emerged onto the roof, right at our point of entry. They stare off, the boy at the chimney above, the tiny figures gathered on other rooftops below, and the harbor, bombarding ships, burning Charlestown, and the battle hills all off in the distance. Homer is likely to have known Trumbull's description, in his 1841 autobiography, of seeing the battle from Copp's Hill, which Homer takes as his point of observation. The emphasis has shifted, however, from patriotic perfor-mance to the act of seeing itself.

One might shrug off this engraving as an art-historical oddity at the very end of Homer's career as a magazine illustrator, except that this image reverberates in the next decade and thereafter. In 1882 Edwin Howland Blashfield, newly returned from many years of study and work as an easel painter in France, exhibited at the National Academy of Design in New York his *Suspense: Boston People Watching from Housetops the Firing at Bunker Hill* (Fig. 47). Again, the act of observation is the sub-ject matter, and in this case the object of the gaze is unavailable. Rather we observe the observers. The centrally placed couple with child is an elegant norm, fashion-ably posed against the tattered roofs and scattered observers, including the waving black man. Blashfield self-consciously construes the community of "Boston people" mixed in race, class, and gender but joined in the act of looking.

Howard Pyle produced another in this sequence of rooftop observer images as a halftone illustration entitled *Viewing the Battle of Bunker Hill* for Woodrow Wilson's 1901 "Colonies and Nation" in *Harper's Monthly*.[47] The affinities among this group suggest not just that they are a solution to a formal problem or that they share a thematic similarity—focused on vision, privileging the act of looking as it comes to bear on the same historical moment—but also that this configuration was a language for asserting control. Vision becomes an exercise of power over the past.

Against this sequence of images that places conflict at a distance and identifies its late-nineteenth-century audiences as observers, we need to look at Howard Pyle's work more fully and in context. Pyle shows us how late-nineteenth-century Americans historicized the New England of the Revolutionary War era—most especially through the juxtaposition of image and text in a series of histories that appeared first in the popular middle-class magazines and then as books. Produced as pencil or pen-and-ink sketches or as oil paintings, these images were translated by the developing technology of the period into line- or photoengravings or halftone photo-offset prints and lithographs for mass circulation to a wide national and international audience.[48] This was the form through which Pyle, like Boughton, Dielman, Garrett, Brownscombe, and Pyle's Brandywine student N. C. Wyeth were best known, as Homer, Harry Fenn, and Ehninger had been in earlier decades.

Our story of the imaging of the Revolutionary past picks up in *Harper's Monthly* in 1884, where we looked at illustrators intermixing images and text of Puritans and Cavaliers. This same dynamic is visible in "The Birth of a Nation" series written by Thomas Wentworth Higginson, which rather than battles stressed politics, the development of liberty, and "the sovereignty of the people, or at least the masculine half of the people."[49] Higginson had been not only an abolitionist and the Civil War leader of a black regiment but also a supporter of women's rights. Hence it is not surprising to find him singling out the importance of the old Northwest as a territory closed to slavery. When it comes to the years of the weak Confederation and Shay's Rebellion, Higginson is evenhanded and mild, pitting Washington's action to put down the rebellion against Jefferson's opposing response. Of 1789 he says that it was "a period of much social display. Class distinctions still prevailed strongly, for the French Revolution had not yet followed the American Revolution to sweep them away."[50]

Against Higginson's liberal reading of the period, we need to set the illustrator's goals. If the illustrations of seventeenth-century scenes in these issues of *Harper's Monthly* blurred the Puritan-Cavalier distinctions, claiming a more aristocratic heritage for New England, Pyle's illustrations accompanying the Higginson history developed a gendered double language. One group of elegant line drawings articulated the world of manners; the first is a coach scene in which women are attended by the French officers at Newport (Fig. 48), and another is an interior scene, *At Mrs. Washington's Reception,* in which the fashionably dressed bow and scrape before a black-clad, stiff president. The pictorial language for male confrontation scenes, by contrast, is bold and heavily outlined. Dark-and-light patterning emphasizes the opposing parties in *Shay's Mob in Possession of a Court-House* (Fig. 49).

This method of differentiating gender and class issues through graphic technique persists in Pyle's later work and is shared by other artist-illustrators as a language of social distinction. In 1898 he and his colleagues collaborated in illustrating Henry Cabot Lodge's "The Story of the Revolution" in the pages of *Scribner's*. Lodge had been a Harvard graduate-student protégé of Henry Adams and contributor to Adams's project of extracting the roots of British and American history from its Anglo-Saxon past, before he turned directly to politics, ultimately as senator from Massachusetts. In the opening of his 1898 *Scribner's* text, Lodge introduces the characters who came to Philadelphia, and his skillful verbal portraiture, stressing visage

and costume, accompanies reproductions of eighteenth-century images of Sam and John Adams by John Singleton Copley and Benjamin Blyth; of George Washington, John Dickinson, and others by Charles Willson Peale; of Paul Revere by Févret de Saint-Mémin; and a newly recovered drawing of John Sullivan by John Trumbull. The text then emphasizes the major changes in Europe beginning with parliamentary rights and sees Britain as the seat of change and self-government, now advanced by her colonies. The Revolution is thus the fulfillment of the British tradition, George III is the villain, and George Washington the heroic figure.

Lodge has remarkably little to say about the actual Battle of Bunker Hill, although Pyle's image of the battle served as the frontispiece of the February 1898 issue of *Scribner's*. Lodge concerns himself with the "stupidity" of British policy, their failure to recognize that "the men of New England, against whom their wrath was first directed, were of almost absolutely pure English stock. They were descendants of the Puritans, and of the men who followed Cromwell." He asks rhetorically what has "happened to make their descendants in the New World degenerate? . . . Frontiersmen and pioneers whose arms were the axe and the rifle, sturdy farmers and hardy fishermen from the older settlements, of almost pure English blood, with a slight mingling of Scotch-Irish from Londonderry, were not, on the face of things likely to be timid and weak."[51] Lodge comments on the British soldiers marching "up to the redoubt as they would have paraded to check the advance of a city mob" and stresses that Americans needed to combine discipline with the accuracy of their marksmanship and "to produce a leader, recognize him when found, concentrate in him all the power and meaning it had, rise out of anarchy and chaos into order and light, and follow one man through victory and defeat to ultimate triumph."[52]

Clearly Lodge's agenda here involves the racial purity of the older Anglo-Saxon stock (on both sides of the Revolutionary conflict) and an anxiety about urban mobs, anarchy, and chaos, to be held in check by a centralizing authority. George Washington is the obvious historical referent here, but in 1898 was it McKinley? It would shortly be Theodore Roosevelt, after his march up San Juan Hill in July 1898.[53] When the book version of *The Story of the Revolution* appeared later that year, Lodge dedicated it "To the Army and Navy of the United States, Victors of Manila, Santiago and Porto Rico, Worthy Successors of the Soldiers and Sailors who under the lead of George Washington won American Independence." Lodge's text, like his politics and participation in the Immigration Restriction League, used history to strengthen the bonds with a long British tradition and constructed the continuity between that past and the imperialist policy of the Republican Party of these years.

The visual material in this volume of *Scribner's* offers an interesting counterpoint, which makes the contemporary relevance of these issues equally clear. In a series of articles by Walter Wyckoff on contemporary urban workers in the West, W. R. Leigh provides visions of their lodging, poverty, and unemployment and pictures them at police lodging houses. These are heavy images, backed by texts equally troubled by "the men themselves, how widely severed from all things human is the prevailing type." One needs to read the "Revolutionary" imagery of the eighteenth century against this anxiety about the potentiality for revolution in the late-nineteenth-century present.

48. Howard Pyle, *The French Officers at Newport*, wood engraving, from *Harper's Monthly* 68 (January 1884).

49. Howard Pyle, *Shay's Mob in Possession of a Court-House*, from Thomas Wentworth Higginson, "Birth of a Nation," originally published in *Harper's Monthly* 68 (January 1884).

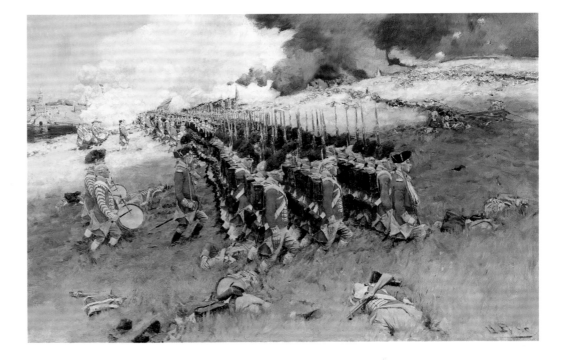

In this context, the most problematic image in the Lodge series is Pyle's *Battle of Bunker Hill* (Fig. 50), an oil painting that became in black and white the frontis-piece of the February 1898 issue of *Scribner's*. The long caption comments on the image: precisely naming the time, participants, and movement of the right and left wings and then pulling us back from these close-up identifications to name the ship in the harbor and to identify both the white smoke and the black. Shifts over time and space are the nonvisual elements stressed by the caption. The brilliance of the sunlight and contrasts of color (especially the red coats and golden field against white-and-lavender cloud forms) are lost in the graphic translation; but the essen-tial design of the image remains.[54]

But what is the effect—or more precisely, the affect—of this carefully mapped and labeled image? Our access involves stepping over the splayed bodies of the carefully dressed regimentals, whose uniforms have not protected them from death. The lines of marching men with their staccato of pointed bayonets arching into the background seem to organize the space of the image, until we realize that their compacted and repetitious forms, the impersonal machinery of an "army," divides the larger plane of the tilted landscape. The regiment is propelled by the sound of those drummers behind them, near and far. The upper-right third of the hill with its echo diagonals of stone walls is the landscape space of the rebel Americans, the "Bunker Hill" on which these British soldiers intrude, as the billowing clouds above, black and white, symbolically reenact the conflict. In a letter of 26 Decem-ber 1897 to his friend Winthrop Scudder, sometime art editor for Houghton Mifflin, Pyle writes of his proposed mural of Bunker Hill for the Massachusetts House of Representatives. Surely the image that was "very clear" in his mind at the time was based on this just-completed work: "to show the sunlight, the heat and the desperate human earnestness of the grim red-coated heroes marching up that hill to their death."[55] Was Pyle attracted to the order and discipline, the unswerving commitment of the uniformed "heroes?" In his *Nation Makers* (1903), Americans marching in the opposite direction look like a ragged rabble by comparison.[56] Pyle seems caught between his desire to find continuities to a British heritage of order, elegance, and power and to a raw energy associated with a rabble-democracy of New England rural strength but differentiated from the working-class urban immi-

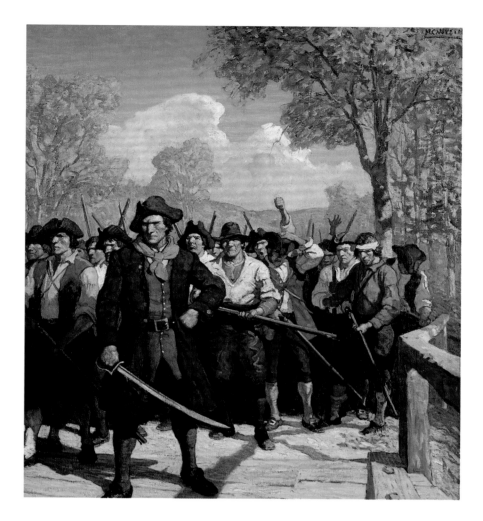

grant poor. In this, his art gave shape to a shared ambivalence of the period over the meaning of New England as place and marker for the national experience.

Pyle passed this perspective on to his students and disciples, men and women like Violet Oakley, Frank Schoonover, and, most remarkably, N. C. Wyeth. One does not immediately associate Wyeth with New England—he is part of "the Brandywine tradition"—but he was born in Needham, Massachusetts, in 1882 of New England stock on his father's side and French-Swiss heritage on his mother's.[57] Grandfather Zirngiebel was a botanical colleague of Louis Agassiz at Harvard. N. C. Wyeth trained first in Boston, before joining his fellow New Englander Clifford Ashley (later well known for his illustrated whaling books and marine paintings) in Wilmington, Delaware, at the renowned apprenticeship program for illustrators conducted by Howard Pyle. The result of a 1904 class assignment was Wyeth's *At Concord Bridge*, which ap-

51. N. C. Wyeth, *At Concord Bridge*, 1921–23, oil on canvas, 83.8 × 76.2 cm (33 × 30 in.). From the Collection of Mr. and Mrs. S. Hallock duPont, Jr.

peared as an illustration in the Butterick Company fashion magazine, *The Delineator*.[58] We have traveled a long way from the elegant bronze *Minute Man* of Daniel Chester French at "the rude bridge that arched the flood." In a letter to his mother he explained, "My point of view is from the 'Britishers' positions looking into the faces of these grim farmers who are nervously waiting for the English to fire first. Every one of them tense with anger and excitement, shuffling and grumbling, anxious to plug the redcoats in front of them!"[59] From 1921 to 1923 a mature and successful Wyeth was back in Needham, producing for Boston banks historical murals and a series of four oils that would become bank-holiday posters. One was a Thanksgiving Pilgrim scene; another was *At Concord Bridge*, a reworking of his 1904 image (Fig. 51). It is not merely that with Wyeth the point of view has shifted once more, from identification with the idealized elegant inheritor of the British tradition, to the visual observer of events, to the ambivalent glorifier of imperial power. Just when Congress was passing restrictive immigration legislation, Wyeth's American rebels are prepared to fight off all intruders, militantly blocking the pathway into their American space.

Wyeth's image transforms into an aggressive nationalism the late-nineteenth-century attempt to reclaim a British heritage, to recast the imagery of the Puritan and Revolutionary past in order to build bridges back to an "Anglo-Saxon" past in the face of a socially and economically transformed America that was increasingly marginalizing New England culture. The strident masculinity of Wyeth's imagery was a major shift from the careful inclusiveness of the earlier period, of the balancing of gender claims—albeit often traditional ones, but still actively supported by women writers, artists, and scholars.[60]

Form and Tradition in Brahmin Portraiture

During the last third of the nineteenth century many key New Englanders were the subjects of portraits, from the three abolitionist figures in the 1869 *Fugitive's Story* (*see* Fig. 1) to Frank Benson's grand 1893 image of that other aging abolitionist, Thomas Wentworth Higginson (*see* Fig. 60). Portraiture had dominated the visual language in New England from the 1670s through the colonial period, climaxing in the work of John Singleton Copley and with a continuing strength through the nineteenth century. Artist and patron collaborated to define, create, project, and memorialize the role and status of the sitter for their various audiences in private parlors and public spaces like Pilgrim Hall in Plymouth or the Redwood Library in Newport. The Wadsworth Atheneum in Hartford, Connecticut, the first major art museum in New England, opened its doors in 1844. The Boston Museum of Fine Arts was founded after the Civil War, in 1870, as was New York's Metropolitan Museum of Art, and similar institutions were established over the next thirty years in other major cities. Portrait images stayed largely in private hands until the twentieth century, since during this period museums were collecting European, classical, and in some cases Asian art. Known to historians and other scholars and exhibited on occasion (Boston had a major Gilbert Stuart exhibition in 1880), these images trickled into public collections over time,[61] and graphic versions of paintings, miniatures, early mezzotints, sculptural busts, and full-length images peppered the pages of magazines and books on colonial and Revolutionary history.[62]

Some major sculptural monuments of the period reached toward historical statement through a biographical model. The commission to French from a Boston businessman in 1883 for a large public statue of John Harvard (Fig. 52) to honor the early benefactor of the university was an ideal task, since no portrait of the minister existed. French worked up the costume with care, consulting with Charles Deane at the Massachusetts Historical Society. The large Bible resting on Harvard's leg signaled his character as "reverend, god-like, and a lover of learning." As for the portrait head, as French later wrote, "in looking about for a type of the early comers to our shores, I chose a lineal descendant of them for my model in the general structure of the face, Sherman Hoar of Concord."[63] In his use of a present New Englander's portrait as "type" of the historical past, French was grafting onto the language of biblical typology a physiognomy of racial characteristics used during these years to differentiate the "old stock" from the newer immigrant groups now contending for place and power.[64]

This same process is evident in another ideal portrait, the image known as *The Puritan* (Fig. 53). Chester W. Chapin, congressman, president of the Boston and Albany Railroad, and reputedly the wealthiest resident of Springfield, Massachusetts, commissioned Augustus Saint-Gaudens to produce the work. An earlier commission for a statue commemorating early settlers of Massachusetts had already been carried out by John Quincy Adams Ward for the New England Society of the City of New York and placed in Central Park, but it was a rather fussy piece of costuming, with high-top boots folded down, a bandolier of fuses hanging across the front, and open sleeve work.[65] Saint-Gaudens was to represent

52. Daniel Chester French, *John Harvard*, 1883, bronze, height, 180 cm (70 1/4 in.). Photograph courtesy of the Harvard University Archives.

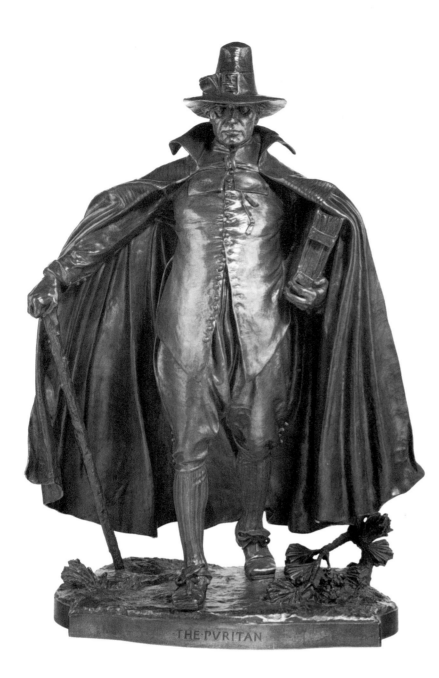

53. Augustus Saint-Gaudens, *The Puritan (Deacon Samuel Chapin)*, 1887, bronze, 77.5 × 52.1 × 30.5 cm (30 1/2 × 20 1/2 × 12 in.). Virginia Museum of Fine Arts, Richmond, Virginia. The Charles G. Thalhimer Family Fund. © 1999 Virginia Museum of Fine Arts.

his patron's ancestor, Deacon Samuel Chapin, one of the founders of Springfield. The work was presented to that city and unveiled in Stearns Square in 1887. The Chapin family helped develop the appropriate costume, including the inevitable buckled steeple-crown hat, and Chester Chapin was the model for the figure's head. After numerous sketches, Saint-Gaudens gave the image its final form—at least for the time being—muting the excessive detail of the Ward piece through the use of the enclosing yet flowing and unifying long cloak, which contains and controls the juxtaposition of the striding right side with its assertive wooden cudgel and the somewhat withdrawing left arm holding the Bible. The work captures the life of action and of thought or as Saint-Gaudens, a good Beaux-Arts student of the Italian Renaissance, would have understood it, the *vita activa* and the *vita contemplativa*.

Two subsequent events shed further light on the cultural functioning of the commission. The ambitious urban plan for Stearns Square involved a large architectural and landscape surround designed by Stanford White. It "would have been unusually effective," recalled Saint-Gaudens. "At the time we placed it there, however, the quarter of the city was poor, and in a few weeks the boys had destroyed everything in the way of vegetation."[66] The statue was removed from this neighborhood to the hill adjacent to the townhouses of the city's elite, where it was ultimately surrounded by Springfield's cultural institutions: the gleaming white classical city library, the gothic Episcopal church, and the art museum, by 1896 a brick and terra-cotta Renaissance palazzo known today after its founder as the George Walter Vincent Smith Art Museum.

The New England Society of Philadelphia subsequently approached Saint-Gaudens for a version of the statue to be placed in their City Hall Plaza, as a regional counterweight to the literally towering presence of Benjamin Franklin. Although the family resemblance was important to the Springfield commission as a "direct ancestor, . . . Mr. Chapin's face is round and Gaelic in character, so in the Philadelphia work I changed the features completely, giving them the long, New England type, beside altering the folds of the cloak in many respects, the legs, the left hand, and the Bible," turning the book around so that its spine reading "Holy Bible" was clearly visible.[67] For this commission, patron and artist used site and physiognomy to nationalize and racialize New England in a gesture of spiritual conquest. The new version was entitled *The Pilgrim*, as if the two names were interchangeable, although the shift in title would also differentiate the new commission. What the general public thought and thinks of these two public statues is an open

question, but the program of placing such Puritan/Pilgrim images outside New England bespeaks a desire, a concern, even perhaps an anxiety on the part of New England societies to insist on the visual presence of American origins.

There was, of course, an ample memory bank of images of earlier New Englanders for French, Saint-Gaudens, Cyrus Dallin, and others to draw on. Martha Babcock Amory died just before the publication of her *Domestic and Artistic Life of John Singleton Copley, R.A., with Notices of His Works, and Reminiscences of His Son, Lord Lyndhurst, by His Granddaughter* (1882). Not only did the work make available an important collection of family letters and other primary materials on Copley,[68] it also clarifies a late-nineteenth-century Bostonian strategy for strengthening the bonds between the New England elite and the British aristocratic world of the author's uncle, Baron Lyndhurst. Since, according to repeated comments by Lyndhurst, Copley had never seen a serious work of art until he went abroad, Amory creates an artist who is a self-made genius in a visually barren New England. This enables her to forge the connection back to the Old World and thus strengthen the social bonds between her own aristocratic Boston and her grandfather Copley's past, stressing his links to Loyalists and to those whose ties to Brit-

54. John Singer Sargent, *Ellen Peabody (Mrs. William Crowninshield) Endicott*, 1901, oil on canvas, 162.9 × 114.3 cm (64 1/8 × 45 in.). Gift of Louise Thoron Endicott in memory of Mr. and Mrs. William Crowninshield Endicott (1951.20.1). © 1998 Board of Trustees, National Gallery of Art, Washington.

ain were strongest.[69] This contrasts the emphasis placed by later scholars on his "Americanness,"[70] often using the *Revere* portrait as a key example.

Martha Babcock Amory and her social cohort were also clearly successful participants in the famous Lyndhurst sale of Copley's remaining works in 1864, and this suggests a second key to the importance of portraiture in creating old New England in these years.[71] The patronage and ownership of these older portraits and their display extended into the late-nineteenth-century present and reinforced the production and distribution of contemporary portraiture in Brahmin Boston.

A notable example may illuminate this process: John Singer Sargent's large 1901 portrait of Ellen Peabody (Mrs. William Crowninshield) Endicott (Fig. 54), was painted in London and exhibited at the Royal Academy in 1902 and the next year and thereafter at the Boston Museum of Fine Arts, not far from the Endicott home at 163 Marlborough Street. This was the newly fashionable Back Bay area anatomized by William Dean Howells in *The Rise of Silas Lapham* (1884). With the influx of immigrant groups into the back side of Beacon Hill, the Back Bay had also become a haven for some former denizens of Beacon Street and their institutions. When an open square was established there, with public buildings, including the 1879 Museum of Fine Arts, of which William Endicott had been a founding trustee and president, the space was named Copley Square. The Massachusetts Historical Society moved to the area in 1899.[72] Sargent was, like so many New England artists

55. Portrait of *Mrs. William C. Endicott* by John Singer Sargent, *in situ* (in the dining room of the William C. Endicott House, 163 Marlborough Street, Boston), March 14, 1913. Courtesy Massachusetts Historical Society, Boston.

56. Portrait of *John Endicott, in situ* (in the dining room of the William C. Endicott House, 163 Marlborough Street, Boston), March 14, 1913. Courtesy Massachusetts Historical Society, Boston.

and intellectuals, clearly equally at home in Boston and London, with patronage in both centers. His portrait of Mrs. Endicott, like other of his portraits, plays on its Bostonian roots in its pictorial allusions to Copley's portraits of older women.

Contemporary photographs of the Sargent portrait show how the consciously antiquarian cast of the work functioned in the dining room (Fig. 55). The image of Mrs. Endicott is large. She sits, perfectly erect, in an antique chair with a table to her right. Under the table at the lower-left edge is just a hint of a Chinese pot, which links the austere figure in black with the aesthetic decor of the dining room in which the picture hangs. The sideboard with its Chinese porcelain reminds us that both the Peabody and Crowninshield forebears of the late eighteenth century were Salem maritime families in the East Indies trade. The wallpaper and dado, in stark contrast to the sober figure, create a dynamic strongly reminiscent of Copley's strategies in his well-known portrait of Mrs. Thomas Boylston of 1766.[73] To the right of the curtained window is a smaller, thoroughly conventional portrait of the sitter's husband. Around the corner to its right, above another aesthetic sideboard with fretwork and set off by a Japanese screen, hangs a version of the popular seventeenth-century portrait of Puritan governor John Endicott, his moustache and goatee echoed in that of his descendant to his right (Fig. 56).[74] In this congeries of styles, this aesthetic mixing of periods and places, of past and present, Mrs. Endicott's solemn posture feels like a stabilizing domestic presence, a physical reenactment of older values—the somberness of the black dress suggesting perhaps even that they are lost?—amid the varied symbols of wealth, here so tastefully aestheticized.

John White Alexander's *Portrait of Sarah de St. Prix (Wyman) Whitman* (Fig. 57) offers a stunning contrast to the Endicott image. Alexander was a fashionable fin de siècle practitioner of female portraiture, specializing in idealized images of women wearing sweeping long gowns that follow art nouveau curves. His image of Sarah Whitman plays this dynamic in the loosely brushed-in background against the quiet splendor, regal pose, and contemplative glance of the figure itself. Whitman was an exhibiting Bostonian painter of landscapes, still lifes, and portraits as well as a book and stained-glass designer in the Maine coastal world of Sarah Orne Jewett. She was also on the governing board of Radcliffe College and a major benefactor of the Boston Museum of Fine Arts, among her many philanthropies. The Whitman portrait distills the complex and varied active achievements of this Brahmin leader into an image of quiet power and lavish wealth and a look hovering between hauteur and withdrawal.[75]

Some portrait images of New England worthies of this era, like Sargent's *Mrs. Endicott*, seem consciously fashioned to allude to the American "colonial" past specifically, while others appropriate the "Western" heritage of art history more broadly to anchor the represented figures in a complex of older values and, in the process, reclaim that heritage as their own. Dennis Miller Bunker's *John Lowell Gardner II* (Fig. 58) deploys what was for New Englanders a well-known Copley colonial formula of the three-quarter view, with accent on the strongly lit head and hands, the sitter swiveling to right or left in a Windsor chair close to the picture plane to confront the viewer. The tension in the portrait of the young Gardner, in its stiff propriety, is different from that in Copley's wry old *Eleazer Tyng* (Fig. 59), seated in his Windsor chair, to mention but one. Gardner's elegant hand gestures, posture, and wing collar bespeak a formality, a reserve, a withholding. Bunker may have complained to a friend, "I'll be hanged if I can see how the charming verses of Mr. Longfellow or the essays of Mr. Emerson can make up to a man for the loss of the Louvre,"[76] but this young friend of Isabella Stewart Gardner, aunt of his portrait subject, knew how to adapt the Boston portrait tradition to his Bostonian subject.

58. Dennis Miller Bunker, *John Lowell Gardner II*, 1888, oil on canvas, 127.0 × 91.4 cm (50 × 36 in.). Portland Museum of Art, Maine. Gift of The Reverend George Gardner Monks, Commander John P. Monks, and Mrs. Constantine A. Pertzoff (1944.1).

59. John Singleton Copley, *Eleazer Tyng*, 1772, oil on canvas, 126.5 × 100.2 cm (49 3/4 × 40 1/8 in.). Gift of the Avalon Foundation. © 1998 Board of Trustees, National Gallery of Art, Washington.

60. Frank W. Benson, *Thomas Wentworth Higginson (1823–1911)*, 1893, oil on canvas, 127.2 × 101.6 cm (50 × 40 in.). Courtesy of the Harvard Portrait Collection, purchased by Harvard College from the Colonial Club, 1929.

Frank Benson's version of the Copley formula in his portrait of Thomas Wentworth Higginson (Fig. 60) puts the sitter in an even more modern cane chair, the curvilinear forms of which call attention to themselves rather than recede politely to support the distinguished minister, reformer, and writer. Might they be construed as Benson's acknowledgment of the "modernity" of Higginson within the conservative older families of New England, retaining his abolitionist-feminist openness into his old age?

If one looks across the kinds of portraiture done of and for New England Brahmins during these years, one is struck by the degree to which they are historicized in one way or another, located in relation to some older pictorial tradition. The traditions vary beyond the native New England Copley version we have been examining. Some, like the female portraits or the pictures of mothers with children by George de Forest Brush, clearly draw on Italian Renaissance models by Bronzino and Botticelli.[77] Olin Warner's little head of Thomas Allen, Jr. (1889), son of the Boston painter, is indebted to Desiderio da Settignano, although an 1892 reviewer thought it had "something of that immutable grace, that abiding dignity which we find in antique art."[78]

For a classical version of the sculptural portrait *alla antica,* one could turn to Daniel Chester French's bust of Emerson (Fig. 61), carved in marble for Harvard and cast in multiple bronzes over several years.[79] Another version appeared in the head of Lowell commissioned by the Grolier Club in New York (Fig. 62). From a photograph furnished by his Harvard colleague Charles Eliot Norton, Charles Calverley produced in 1896 a bronze medallion in which Lowell, with flowing beard and double-breasted coat, is surrounded by a laurel garland. The medallion carries a Latin inscription from the Book of Ecclesiastes. It is a remarkable instance of the translation over time of the New England cultural leader. Lowell—the prewar abolitionist and creator of the vernacular voice of the *Bigelow Papers* and *The Courtin',* colleague of James T. Fields and editor of the *Atlantic Monthly,* early summer visitor and poet of the Isles of Shoals, and later American ambassador to the Court of Saint James—becomes, on his death, an image encrusted with biblical and classical associations.

We can measure the distance traveled by comparing the Lowell, based on a photograph, with a pair of photographs of his friends James T. Fields and Henry Wadsworth Longfellow taken by the British artist Julia Margaret Cameron during trips by the sitters to England in 1869 and 1868, respectively (Figs. 63, 64).[80] Longfellow was a much-portrayed figure, his fame in these years eliciting images in paint and in marble as well as in paper constructions and on film, in settings that ranged from his colonial Vassal House on Brattle Street, Cambridge (Fig. 65), to the Arch of Titus in Rome.[81] The special quality of the Cameron photograph of Longfellow is its duplication in the parallel image of his friend and publisher Fields the following year. Both are treated in profile, wrapped in velvet, giving them a distinctly Byronic cast as dark, brooding figures, although both poet and publisher were eminently outgoing public men. The images isolate the head for special study,

61. Daniel Chester French, *Ralph Waldo Emerson*, 1879, cast 1901, bronze, height 57.2 cm (22 5/8 in.). National Portrait Gallery, Smithsonian Institution. (NPG 74.13).

62. Charles Calverley, *Portrait Relief: James Russell Lowell*, 1896, bronze, diameter 17.2 cm (6 3/4 in.). Gift of the Council of the Grolier Club, Courtesy of Museum of Fine Arts, Boston.

63. Julia Margaret Cameron, *James Thomas Fields*, 1869, albumen silver print, 32.5 × 26.1 cm (12 13/16 × 10 1/4 in.). National Portrait Gallery, Smithsonian Institution (NPG.83.194).

64. Julia Margaret Cameron, *Henry Wadsworth Longfellow*, 1868, albumen silver print, 34.2 × 26.8 cm (13 1/2 × 10 1/2 in.). National Portrait Gallery, Smithsonian Institution (NPG.82.61).

the velvet absorbing light and making the figures float free of any spatial (or cultural?) context.

The Cameron images are consciously retrospective and fluid in their Anglo-New England cosmopolitanism. They recall the comment of the worldly, snobbishly amoral young American narrator in Henry James's early story, "Four Meetings" (1877), who warns a well-read but naive young schoolteacher in rural Grimwinter, New England, to go to Europe soon before the sublime and picturesque have disappeared from the Castle of Chillon and elsewhere, for "Europe was getting sadly dis-Byronized."

Of all the representations of New Englanders at the end of the nineteenth century, the greatest by far—arguably the finest American sculptures of the nineteenth century—were two memorial pieces by Augustus Saint-Gaudens. Born a Huguenot in Dublin, Ireland, raised in New York, trained as a sculptor in Paris at the Académie des Beaux-Arts, Saint-Gaudens came to New England through marriage to Augusta Homer; they bought a house and studio in Cornish, New Hampshire, in 1885. The works in question, the *Adams Memorial* (Fig. 66) and the *Shaw Memorial* (Fig. 67), crystallize issues from opposing angles. The former, commissioned by the widower Henry Adams—grandson and great-grandson of two New England presidents, scholar, novelist, critic—is a memorial to his wife, the brilliant Boston blue-blood Marian Hooper Adams, who took her own life in 1885. The abstracted, ideal representation moves away from the New England culture that shaped her and her Hooper family: from the dress of her fashionable time and place, from the photography that gave some expression to her imagination, from the gender role that defined her relationship to her husband and yet left her childless, and from the depression that defined another bond, between her and her recently dead father.[82] All these markers have been eliminated, erased, at the behest of the patron Adams and with the complicity of the artist.

The result is a powerful, moving, and finally terrifying image, couched in a generalizing classicism, of a robed, vaguely female figure who has no apparent place in

66. Augustus Saint-Gaudens, *Adams Memorial*, 1886–91, *in situ* (Rock Creek Cemetery, Washington, D.C., 1984).

67. Augustus Saint-Gaudens, *Shaw Memorial*, 1884–97, *in situ* (Boston Common, Boston, Massachusetts, 1990).

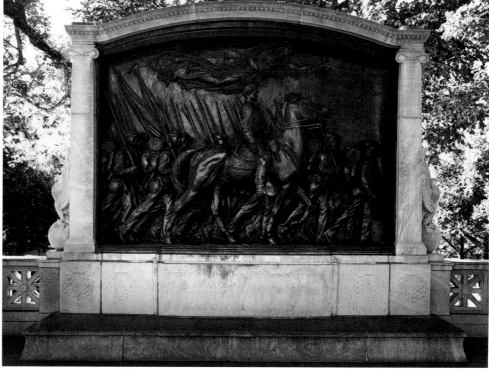

68. Dedication Ceremony, *Crispus Attucks Monument,* Boston Common, Boston, Massachusetts, November 14, 1888. Courtesy of The Bostonian Society/Old State House.

her culture. The Priscilla in John Rogers's group and other images, by contrast, has a cultural voice and gender role, as she asks her John Alden to speak for himself (*see* Fig. 37).[83] In *Checkers Up at the Farm* mother and child watch two male players (*see* Fig. 14); and even the anonymous black woman with child in *The Fugitive's Story* (*see* Fig. 1) has a voice to speak to the male abolistionist leaders. But the shrouded figure of the *Adams Memorial* has withdrawn completely inward. She may be, as some would have it, the Buddhist goddess of mercy, Kwannon, who rests in a peace that passeth understanding. Such a world of contemplation attracted Henry Adams, some of his friends, New England scholars and collectors of Asian art, and other late-nineteenth-century New England pilgrims who could find no "grace," no thanksgiving in traditional Christian forms of worship and belief.[84] The beauty and power of the memorial is finally private and isolated from its historical New England roots. It is a nameless monument, with only an egg-and-dart molding at the top and a ribbon-bound laurel wreath at the base, quiet echoes of a classical world. Finally, its site is Rock Creek Cemetery in Washington, D.C., not New England.

The *Shaw Memorial* is the opposite of the *Adams* in all respects, except in the perfect adequacy of the forms to fulfill its quite different artistic intentions. Dedicated in 1897, the *Shaw Memorial* was the result of a long series of negotiations in New England over how to give shape and form to the black presence in Massachusetts culture. In this respect it had its roots in the black community's much earlier demand for a monument on Boston Common to the Revolutionary War hero Crispus Attucks (Fig. 68). The *Shaw Memorial* is a monument to the heroism of the Massachusetts Fifty-fourth black regiment in the Civil War, and to Robert Gould Shaw, the young white colonel who led the regiment, died, and was buried in a trench

69. African-American Marchers in front of *Shaw Memorial,* Boston Common, Boston Massachusetts, 1897. Courtesy Massachusetts Historical Society, Boston.

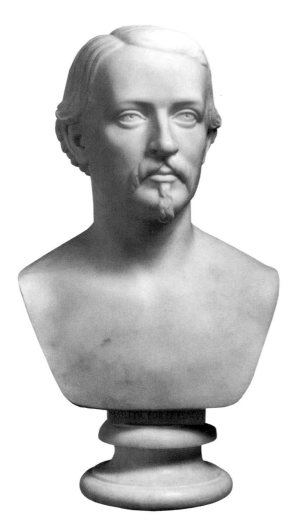

70. Edmonia Lewis, *Colonel Robert Gould Shaw*, 1867 modeled from 1864 image, marble, 59 × 33.3 × 23 cm (23 × 13 × 9 in.). The Museum of Afro American History, Boston, Massachusetts.

"with his niggers" after the unsuccessful assault and defeat at Fort Wagner, South Carolina, in 1863. (In this sense, the *Shaw Memorial* is like the Bunker Hill Monument across the harbor.) The story of these black soldiers and their leader has been frequently told, by different speakers, in different voices, and to different audiences, and the record of these re-presentations in various forms continues to grow: the carving of the names of the fallen black soldiers onto the base of the monument in 1981, the film *Glory* (1989), which focused on the interactions between the white and black New England participants, and most recently the reenactments and critical reevaluations in 1997 at the one-hundredth anniversary of the original dedication.[85]

All this sheds light on the story here of the post-Civil War reshaping of old New England. The recent events remind us that each age reshapes history to its own needs, and the new voices of 1997 bespeak the absences and silences of earlier versions of a New England history in which the role of black fugitive slaves, black citizens, and black soldiers was controlled and given voice primarily by a white leadership. When Henry Ward Beecher spoke of "the man that dared to lead the poor and oppressed out of their oppression, died with them and for them, and was buried with them,"[86] the black narrative was appropriated once again and Shaw turned into a white Christ. Others contributed to the process—Thomas Wentworth Higginson, the committee authorizing the monument, the sculptural hand and mind of Saint-Gaudens, and those who defined its meaning verbally at the dedication and afterward: philosopher William James and former governor John Albion Andrew. Booker T. Washington also spoke, as one black voice (who was known to preach moderation), and the black veterans marched (Fig. 69).

There is, of course, a difference between contemporary photographic images of the black presence at dedication ceremonies and their artistic and imaginative presence during the period. To pose that question, we must turn to the most important evidence of all, the monument itself, which offers us insight into the different and conflicting rhetorics regarding the meaning of the New England past. The figure of Robert Gould Shaw is at the center, young martyr of the old Boston aristocracy, whose death had prompted the young African- and Native-American sculptor Edmonia Lewis to fashion a small bust in 1863–4 to sell in multiple copies in the Boston area (Fig. 70). It was her ticket to Rome, her way of tapping the old abolitionist idealism to finance her escape to the classical center of the art world, although her ongoing need for patronage in Rome involved a continuing and complex relation to the writings of Longfellow—not the Puritan or Revolutionary War tales of Longfellow but his Native-American stories, especially *Evangeline*.[87]

The difference in scale between the tiny Lewis head of Shaw, fit for a parlor cabinet, and the colossal bronze public figural group by Saint-Gaudens itself suggests the differences in resources these two sculptors could marshall and the needs of their audiences. Based on photographic representations, as was the Lewis sculpture, the equestrian figure of Shaw is filtered through a grand tradition of heroic leadership: spatially to Thomas Ball's *George Washington* at the other end of the Boston

Garden (rather than his *Paul Revere* [*see* Fig. 136]) and historically to the Renaissance Colleoni monument of Verrocchio in Venice and the ancient bronze figure of Marcus Aurelius on Michelangelo's Campidoglio at the very center of Roman power.[88] The leadership role of the older Boston families is thus given historical extension, placing Shaw above, beside, and among "his men."

The facial features of the soldiers are highly individualized, based on Saint-Gaudens's numerous studies of individual African Americans. The repetition of their uniforms and vertical rhythm of their rifles bring the group together and reinforce the forward motion, the testing of male power. Their sculptural rhetoric is in the realistic mode. The ordinary soldiers march in contrast to their elegant leader. The democratic mass is juxtaposed to the elevated officer reining in and controlling the power of his steed so that it walks in rhythm with the marching men. They share one another's "animal strength," and only Shaw seems rigidly immobile. If Saint-Gaudens's earlier *Puritan* (*see* Fig. 53) combined action and thought, the hand and the spirit, the *Shaw Monument* is keyed to a stylistic rhetoric that differentiates the people from its elite leadership. It takes a direction we have seen in the work of period illustrators, until, in Wyeth's *At Concord Bridge* (*see* Fig. 51), the sword Shaw extends downward falls into the swashbuckling hand of the democratic mob. Clearly in the memorial monument, the old New England hegemony—so bitterly ironic that it comes in the form of the young dead Shaw—reasserts its power over ordinary people, still the object of abolitionist idealism. Given the heightened racism of the turn of the century, this reconstruction must strike us as ironic.

And what of the rhetoric of women? From helpmate and mother, spirit of the hearth and the spinning wheel, the woman is transformed in the Shaw monument into the floating spirit of victory, the classically garbed Republic whom the men sacrifice all to serve. In this transmutation of a Boston Ann Page,[89] of a strong woman into a symbolic form, the cultural priorities are clear in the very modeling of the figures: the fully three-dimensional reincarnated old New England leadership, the echo of the older abolitionist idealism (now a group of soldiers skillfully dissolving into the background), and the fully idealized feminine beauty evanescent in lowest relief and disappearing into the surrounding cornice. A hierarchy exists, and the *Shaw Monument* gives voice to different parts of the New England community but contains and controls their expression in the name of both the gold-domed State House across the street and the cultural community that sustains it. It would not be until 1922, after the passage of the women's suffrage amendment, that Cyrus Dallin's image of the Puritan rebel Anne Hutchinson would finally find her place there on the State House lawn.

Notes

1. Bradford, *Of Plymouth Plantation,* 61, 62.
2. The early part, with the landing at Plymouth, had been available since 1841 (see Young, *Chronicles of the Pilgrim Fathers*). The story of the manuscript, its recovery, eventual return (with much fanfare) to Massachusetts in 1897, and subsequent scholarly treatment, is told by Morison in the introduction to his 1953 edition of Bradford's *Of Plymouth Plantation.* In the midst of the Cold War, Morison argued for the "timelessness" of the Bradford history but read it as a cautionary lesson for his own generation: "More than once to this little band, as to people of free nations in our own time, came the awful question: 'Can we possibly survive?' In the discussion over building the fort (Chapter xiii) we seem to see, as through a glass, the great debate of our own time, the balance of military security against preserving a certain way of life" (xi).
3. Cooper mocked the possibility in the preface and opening chapters of *The Red Rover* (1828; Thomas and Marianne Philbrick, eds., Albany: State University of New York Press, 1991) or Longfellow's "The Skeleton in Armor" (1841); see the historical notes in the 1893 Cambridge edition of his complete poetical works, 659.
4. In fact, Hooker started out for Connecticut from Newtown [Cambridge], Massachusetts, where he was minister; but Church seemed intent on reinforcing the Plymouth origin myth. For the painting, see Kornhauser, *American Paintings,* 1:195–96.
5. For the history of the Isles of Shoals, see Susan C. Faxon, Alice Downey, and Peter Bermingham, *A Stern and Lovely Scene: A Visual History of the Isles of Shoals* (Durham: University of New Hampshire Art Galleries, 1978), 9–83.
6. See Buell, *New England Literary Culture,* esp. pt. 3, "Reinventing Puritanism," 193–280. Hawthorne's efforts stand in stark contrast to the melodramatic version of Salem witchcraft in Tompkins Matteson's painting *Trial of George Jacobs for Witchcraft* (1855), which shows the accused old man a victim of both hysterical adolescent female accusers and harsh judges.
7. Drake, *Witchcraft Delusion,* 1: iii, x. Drake's beautifully printed edition of *Witchcraft Delusion* was limited to seventy copies; his *Annals of Witchcraft in New England* was printed in an edition of 275 copies. Clearly Drake conceived his audience as bibliophile as well as filiopietistic. The visual parallel to these works is the powerful *Witch Hill or the Salem Martyr* (1869) by Thomas Satterwhite Noble. Noble's use of abolitionist imagery before the war prepares him for this subject, investing the woman with power under stress. See Birchfield, *Noble,* 74.
8. "Thanksgiving," *Harper's Weekly* 11 (30 November 1867): 753–54; the accompanying two full-page plates—Ehninger's Puritan image, *Thanksgiving Dinner among the Puritans,* and W. S. L. Jewett's contemporary scene, *A Thanksgiving Dinner among Their Descendants*—are at 760–61. For two earlier Thanksgiving visual sequences, by Winslow Homer, see Stein, "Picture and Text," 36–39. An even earlier image pitting a contemporary parlor scene against Thanksgiving in Plymouth (in a log cabin!), surrounded by emblems of Peace, Plenty, and Liberty, appeared in *Gleason's Pictorial Drawing Room Companion* (November 1854) and is illustrated in Nylander, *Our Own Snug Fireside,* 262.
9. For a marvelous rendering of the strains from one distinctly New England retrospective point of view, see "Battle of the Rams," chap. 11, in Adams, *Education.*
10. There is a large literature on this: see, for example, Sturges, ed., *Rural Vision;* Sellin, *Americans in Brittany and Normandy;* Burke, *Nourse;* Rainey and Stein, *Woodward;* and most recently, Meixner, *French Realist Painting and the Critique of American Society.*
11. See Henry James, "Our Artists in Europe," *Harper's Monthly* 79 (June 1889): 50–66, for a discussion of the group of artists whom James knew, especially as they congregated at Broadway—Frank Millet, Abbey, Alfred Parsons, George Du Maurier, Charles S. Reinhart, and Boughton: "the country that Mr. Boughton left behind him in his youth is no longer there; the 'old New York' is no longer a port to sail to, unless for phantom ships. In imagination, however, the author of 'The Return of the *Mayflower*' has several times taken his way back; he has painted with conspicuous charm and success various episodes of the early Puritan story" (61). See also Simpson, "Reconstructing the Golden Age."
12. Rainey and Stein, *Woodward,* 22; Strahan, ed., *Art Treasures of America,* 2:117–22.
13. As a graphic form, to cite almost arbitrarily from the many examples, one might instance the image in James W. Garner and Henry Cabot Lodge, *The History of the United States* (Philadelphia: Morris, 1906), 1:251; or its place in a two-page spread of Boughton images in Hart, "Pilgrims," 20–21. Distributed for school use, a kind of *Weekly Reader* of its era, this thirty-five-page pamphlet further broadcast Boughton's images. As a painting, Waugh's *Puritans* was exhibited at the Art Club of Philadelphia, *Second Special Exhibition* (1890). For a photographic version, see Glassberg, *American Historical Pageantry,* 125, which couples a 1910 pageant photograph with the second smaller 1872 replica of the Boughton painting; and for a later usage, see Stephen Eddy Snow, "The Development of a Performative Representation of the Pilgrims at Modern Plymouth Plantation," in *Performing the Pilgrims: A Study of Ethnohistorical Role-Playing at Plimoth Plantation* (Jackson: University Press of Mississippi, 1993), chap. 2, which begins with a citation of a 1627 account of a march to Fort Meeting House and the Boughton painting (21–22).
14. My own 1940s childhood memories of this image have elicited from readers of this essay similar schoolroom recollections, from very different parts of the country, suggesting that this was the formative image of who the Puritans "were."
15. Bartlett, *Pilgrim Fathers,* 236–37. Bartlett was a British travel writer and artist who had been in America first in 1836 and 1837 to work on an immensely popular collaborative project with N. P. Willis called *American Scenery* (1840–42). His *Pilgrim Fathers* was another pitch for an international market, with lovely vignettes of England, Holland, and New England.

16. The quoted passage was, in fact, a citation by Bartlett in an appendix about the dangers in the later devastation of the Puritans' war against Philip of Pokanoket, a continuously troubling and ambiguous event in American historical accounts. Washington Irving, for example, had made Philip a heroic figure in *The Sketch Book* (1820).

17. As others have pointed out, it bears some resemblance to the tonal experiments of his friend James Whistler, including that austere image of his New England mother (see Huntington and Pyne, *Quest for Unity*, 49–50).

18. Also based on the Bartlett, *Pilgrim Fathers* (see Merseyside County Council, *American Artists in Europe*, 12, pl. 26).

19. Section 5 of *The Courtship of Miles Standish* is entitled "The Sailing of the *Mayflower*." For other Boughtons on this theme, see Hart, "Pilgrims." The motif was explored also by Birge Harrison and J. L. G. Ferris. Harrison's large image of 1887 was exhibited at the Columbian Exposition of 1893; the Ferris image is dated circa 1907; for this and related images, see Barbara J. Mitnick, *Jean Leon Gerome Ferris, 1863–1930: American Painter Historian* (Laurel, Miss.: Lauren Rogers Museum of Art, 1985).

20. F. O. C. Darley's beautiful *Compositions in Outline from Hawthorne's "Scarlet Letter,"* inscribed to Henry Wadsworth Longfellow, was issued by Houghton, Osgood in Boston in 1879, again in 1884, and also loose in portfolio. One of Darley's original images in color of Hester and Pearl by the shore is today in the Delaware Art Museum. *The Elf-Child and the Minister,* pl. 4, portrays a central hall with stairs going up, armor hanging to the left, Elizabethan portraits on the landings, and tankards and studded chairs. *Hester Prynne and Pearl* also stands as the frontispiece of Edmund Garrett's *Romance & Reality of the Puritan Coast.*

21. For *Priscilla,* see Huntington and Pyne, *Quest for Unity,* 89. For "Pilgrims Going to Church in Colonial Times," see Green, "Popular Science and Political Thought Converge," 20.

22. These murals, seven of which are on Miles Standish themes, have been reinstalled from the employee lounge to the marble-walled lobby of the Metropolitan Life Building in Manhattan.

23. Eakins's works around this date, some in bas reliefs of spinning and sewing, have frequently been attributed to the colonial revival spurred by the Centennial in his hometown. I am suggesting that the DeYoung Museum image with its female in old empire dress and sprawling male in 1870s clothing plays with the colonial convention of Priscilla and her suitors tongue-in-cheek. For a related image, see Eakins's monochrome wash (Brooklyn Museum) for the engraving on the opening page of "Mr. Neelus Peeler's Conditions," *Scribner's Monthly* 18 (June 1879): 256.

24. *Revisiting the White City,* 331–32. Turner was an associate director for decorative work at the Exposition.

25. The title of the book suggests Garrett's desire to play both sides imaginatively: *Three Heroines of New England Romance: Their True Stories Herein Set Forth by Mrs. Harriet Prescott Spofford, Miss Louise Imogen Guiney, and Miss Alice Brown, with Many Little Picturings Authentic and Fanciful by Edmund H. Garrett and Published by Little, Brown and Company Boston, 1894.* Spofford herself reconfigures the final image of Priscilla riding the white bull as Europa, a further cementing of the colonial ties to lands across the sea (see 56–60).

26. Their importance had been broadcast in Bartlett's *Pilgrim Fathers,* which included illustrations of such things as "Winslow's substantial oak chair, brought over from England"(179) in the Massachusetts Historical Society, Boston; objects in Pilgrim Hall, Plymouth, like the John Carver chair, brought over in the *Mayflower,* and the Brewster chair (200, 204); and in private hands, the Fuller cradle (201), as well as tankards, leaded-glass windows, and other "Pilgrim relics" like "an old Dutch Bible with studs and clasps, and a curious spinning-wheel, no doubt also imported from the 'Old Country' by some of the first-comers" (207).

27. Longfellow was, in fact, explicit about the interior of the house constructed by the poorer John Alden: "Latticed the windows were, and the window panes were of paper, / Oiled to admit the light, while wind and rain were excluded" (canto 8).

28. Earle's *Costume of Colonial Times* (1894) was compiled as a glossary of terms, which she hoped would "prove of value and of use to artists, to portrayers of old colonial days . . . and that it will help to prevent in the future any such anachronisms as now disfigure many of our stories and accounts . . . not only through incorrect verbal description, but through equally imperfect and inaccurate illustration" (xi). She also noted that advertisements had been a chief source for her and that the records of New England predominate, because they have been best preserved after "the devastation of two wars" (xiii). Earle was already by 1894 the author of *Customs and Fashions in Old New England* and *Sabbath in Puritan New England* (1891), her first book, which had gone through eight editions by 1896. Her still valuable *Two Centuries of Costume in America, 1620–1820* (1903) was well illustrated with engravings after early images. For her life in historical context, see the perceptive dissertation by Williams, "In the Garden of New England." Although in 1894 Earle was criticized by the Reverend Daniel Rollins for not realizing the "grand work of our Puritan ancestors in laying the foundations of our great Republic here in the wilds of the new world," the title page of her *Customs and Fashions in Old New England* asserts: "Let us thank God for having given us such ancestors; and let each successive generation thank Him no less fervently, for being one step further from them in the march of ages" (quoted in Williams, "In the Garden of New England," 171).

29. Again one may turn to Earle, *China Collecting in America* (1892), which had photographs, an important resource for Earle. Her *Home Life in Colonial Days* (1899) was illustrated with photographs by Emma Coleman, Emma Sewall, the Allen sisters, and Eva Newell.

30. How Mosler as a Jew negotiated his professional career in producing genre and historical paintings is discussed perceptively in Albert Boime, "Henry Mosler's 'Jewish' Bretons and His Quest for Collective Identity," in Gilbert, *Mosler,* 91–127. His strategies in the United States and the responses of his American colleagues and audience still need sorting out, although Barbara C. Gilbert, "The

Art and Life of Henry Mosler," in Gilbert, *Mosler*, 17–57, offers significant clues. For instance, at the time he was producing *Pilgrim's Grace* and Revolutionary War scenes, he was searching for a summer residence and settled on the Catskills, not Deerfield, Massachusetts, Mystic, Connecticut, or Cornish, New Hampshire, important summer centers for artists of old Protestant backgrounds; and despite his exhibition record, he never became a National Academician (see ibid., 48–49). Both aspects of his life are probably linked to period anti-Semitism, a particular twist to the racialist side of old New England.

31. A younger mother holds at the table her male child, her chairback with a punched-out heart shape—the symbolism is insistent!

32. "City Art Exhibition," *New York Tribune*, 2 May 1909 (quoted in Ahrens, "Brownscombe," 25–29).

33. An etching of this painting is at the Harriet Beecher Stowe Center, Hartford, Connecticut, a gift from Mr. and Mrs. Joseph Hooker. Genealogical information is in *Descendants of Francis LeBaron of Plymouth, Mass.,* compiled by Mary LeBaron Stockwell (Boston: Marvin, 1904), 5–15. A small version of the Dielman etching, *A Colonial Wedding,* appears as the frontispiece. I am indebted to Elisa Cohen Tamarkin for bringing biographical information to my attention.

34. The frontispiece of the Christmas 1883 issue of *Harper's Monthly,* for example, was an engraving after Dielman's image of a young Puritan couple, *Under the Mistletoe,* and a few pages later readers were offered Howard Pyle's harsh *Puritan Governor Interrupting the Christmas Sports.* George Boughton contributed an eighteenth-century couple, *At the Kissing Bridge.* In January we return to Pyle as illustrator of Thomas Wentworth Higginson's explication of the years 1774–89, "The Birth of a Nation." April brought Edwin Abbey, as illustrator of the William Black series, "Judith Shakespeare: Her Love Affairs and Other Adventures," published in book form also in 1884 and the next month's frontispiece was another Elizabethan image, *Among the Daffodillies,* by Pyle, for "A May-Day Idyl of the Olden Time." For two perspectives on the larger question, see William R. Taylor's classic *Cavalier and Yankee: The Old South and American National Character* (New York: Braziller, 1961), and David Glassberg, "Restoring a 'Forgotton Childhood': American Play and the Progressive Era's Elizabethan Past," *American Quarterly* 32 (Fall 1980): 351–68.

35. Green, "Looking Backward to the Future," 2.

36. This material has been surveyed by Thistlethwaite, *Images of Washington;* and Wick [Reaves], *Washington.* See especially Marling, *Washington Slept Here.*

37. For Washington Elm mementoes, see Marling, *Washington Slept Here,* 29, 33, 34. Woodrow Wilson, "Colonies and Nation: A Short History of the People of the United States: The War for Independence," *Harper's Monthly* 103 (Oct. 1901): 794. For the comparable relic of Hartford, see William Hosley, "The Romance of a Relic: Sam Colt's Charter Oak Relic Furniture," *Folk Art* (Fall 1996): 49–55.

38. For the context of this, see Wills, *Cincinnatus.*

39. The history of the image's creation (including French's visits to the classical-cast collection at the Boston Athenaeum) and replication is available in Richman, *French,* 38–47. For an earlier, immediately postwar usage of the swords-plowshares configuration, see the opening page poem and image, "After the War" *Harper's Monthly* 31 (August 1865). I am indebted to Emily Dana Shapiro for calling this to my attention.

40. For this and much of the following information on this painting, I am indebted to the exhibition and catalogue *Victorian Sentiment and American History Painting;* and especially to Margaret Swallow Dwyer. Sara C. Junkin points out that Bacon and Boughton had studied with Edouard Frére in Ecouen, Brittany; that Bacon fled Paris to London in 1870 during the Franco-Prussian War; and that Bacon also did a Longfellow-inspired work, *Miles Standish at the Burial of Rose Standish* (unlocated) in 1870 (ibid., 16).

41. Lossing, *Pictorial Field-Book of the Revolution,* 488 n. 2. On Lossing's historical role, see Van Tassel, "Lossing"; and Cunningham, "Historian on the Double," 54–64ff.

42. Lossing, *Pictorial Field-Book of the Revolution,* 488 n. 2.

43. "A vision of American youth empowered with great dignity to speak out for human rights against tyranny," as Junkin insists, in *Victorian Sentiment and American History Painting,* 13.

44. Mergen in *Victorian Sentiment and American History Painting,* 21–24; for the snowball fight, see the opening of chapter 3 in Adams, *Education.*

45. *Victorian Sentiment and American History Painting,* 7–9, 25. Did Corcoran, as a Confederate sympathizer only recently returned to society, also read the painting in terms of this more recent reconciliation?

46. "The Battle of Bunker Hill," *Harper's Weekly* 19 (26 June 1875): 522; Currier and Ives had produced three versions (Gale 0419–21).

47. The 1901 *Harper's* image and the two pencil studies are reproduced in Abbot, *Pyle,* facing 122, 130, 136; the original illustration appeared in *Harper's Monthly* 103 (October 1901): facing 792; a delicate pen-and-ink vignette (without rooftops) of the carefully rendered church and town, ship *Lively* in the harbor, and the Charlestown hills beyond appears at 795.

48. We are indebted to museums like the Delaware Art Museum in Wilmington (Pyle's home territory) and nearby Brandywine River Museum at Chadds Ford, Pennsylvania, which collected and later exhibited the "original" drawings and oil paintings, many of which passed from the artist's studio directly to museum collections rather than through private patrons and purchasers.

49. Higginson's swipe is in *Harper's Monthly* 68 (January 1884): 241. We recall that Higginson was also the literary critic to whom Emily Dickinson felt comfortable appealing for poetic advice.

50. Higginson, "Our Country's Cradle," *Harper's Monthly* 68 (February 1884): 418.

51. Henry Cabot Lodge, "The Story of the Revolution," *Scribner's* 23 (February 1898): 200; the whole Bunker Hill episode is 200–202.

52. Ibid., 202.

53. The paintings Frederic Remington made of the event sometime later that year look back to the

Scribner's image that had appeared in February and which Remington in all likelihood knew. He and Pyle were colleagues and friends. Alexander Nemerov briefly notes the comparison of images in his *Frederic Remington and Turn-of-the-Century America* (New Haven: Yale University Press, 1995), 61.

54. The caption reads: "The scene represents the second attack and is taken from the right wing of the Fifty-second Regiment, with a company of grenadiers in the foreground. The left wing of the regiment, under command of the major, has halted, and is firing a volley: the right wing is just marching past to take its position for firing. The ship-of-war firing from the middle distance is the Lively; in the remoter distance is the smoke from the battery on Copp's Hill. The black smoke to the right is from the burning houses of Charlestown."

55. Quoted in Abbott, *Pyle,* 230; he had sent the Bunker Hill picture to the art editor at *Scribner's* on 18 November 1897 (ibid., 166).

56. For an image of the battle portrayed from the rebel side, see John Sloan's frontispiece illustration for Stephen Crane, *Great Battles of the World* (Philadelphia: Lippincott, 1901); the original sketch is reproduced in David Scott, *John Sloan* (New York: Watson-Guptill, 1975), 67.

57. See *N. C. Wyeth and the Brandywine Tradition* (Harrisburg, Pa.: William Penn Memorial Museum, 1965); the opening chapter, "Howard Pyle's World of Illustration," in Allen and Allen, *Wyeth;* and the new David Michaelis, *N.C. Wyeth: A Biography* (New York: Knopf, 1998).

58. In a letter of 10 February 1904, Wyeth called the assignment at the Pyle school "one of the best subjects in the world to paint. The 'Battle of Concord' at the 'Old North Bridge.'" He then enthusiastically reported to his mother his success—"I never enjoyed making a picture more in my life. I have finally identified myself with every character, entering into each man's character until I almost know how he would talk—laugh—and act. . . . laying the foundation for a *great nation.* Just think what it means!" When he took the picture to New York in March, it was a big success with art editors (Wyeth, ed., *The Letters,* 71, 72, 79).

59. Ibid., 72. Wyeth's black-and-white image in "Familiar Quotations Pictured": "Here once the embattled farmers stood / And fired the shot heard round the world"—Emerson, in *The Delineator* 62, no. 10 (October 1905): 576 (cited in Allen and Allen, *Wyeth,* 257).

60. This opens an entirely different perspective, of the contribution of women to this process. I have mentioned Brownscombe and Earle; Jewett, especially in her *Tory Lover* (1901), attempted to deal directly with the Revolution as an argument over the meaning of one's English heritage and the nature of loyalties. The role of women as preservationists is dealt with perceptively in Giffen and Murphy, eds., *"Noble and Dignified Stream."*

61. See Troyen, *Great Boston Collectors,* 31; she indicates that by 1905 the Museum of Fine Arts owned only five Copleys, four Stuarts, two Smiberts, one West, and three Trumbulls, by contrast to their outstanding collection today; however, private owners did often lend their early portraits to exhibitions.

62. Earle's work on costume history and New England customs, for example, was heavily dependent on her reading of pictorial evidence.

63. Richman, *French,* 60. As Richman points out, the letter was addressed in 1921 to the librarian of the Boston Athenaeum; the story of the commission is detailed (56–61). Sherman Hoar was youngest son of Ebenezer Rockwood Hoar, the Concord representative who had secured the congressional appropriation of cannons for French's earlier *Minute Man* casting.

64. Typology was a form of scholarly exegesis of Old Testament events—like the view from Pisgah. As a literal prefiguration of a specifically Christian drama, the "Holy Land" become the Resurrection and life after death. As a mode of understanding and of reading events in American history and literature, see Ursula Brumm, *American Thought and Religious Typology* (New Brunswick, N.J.: Rutgers University Press, 1970); Sacvan Bercovitch, ed., *Typology and Early American Literature* (Amherst: University of Massachusetts Press, 1972); and Roger B. Stein, "Thomas Smith's Self-Portrait: Image/Text as Artifact," *Art Journal* 44 (winter 1984): 316–27.

65. The base by Richard Morris Hunt was inscribed, "To Commemorate the Landing of the Pilgrim Fathers on Plymouth Rock, December 21, 1620," with the society's name below. See Sharp, *John Quincy Adams Ward,* 215–17. The work was engraved and analyzed in *Harper's Weekly* (6 June 1885), and a strongly critical article by Truman Bartlett appeared the following year: "Early Settler Memorials.—I. 'The Pilgrim,'" *American Architect and Building News* 20 (4 September 1886): 107–9.

66. Saint-Gaudens, ed., *Reminiscences of Augustus Saint-Gaudens,* 1: 353–54; see also the early sketches illustrated in volume 2.

67. Ibid., 1: 354

68. A second critical group of material was discovered in the early twentieth century in the British Public Records Office (Guernsey Jones, ed., *Letters & Papers of John Singleton Copley and Henry Pelham 1739–1776,* vol. 71 of the Massachussetts Historical Society *Collections,* 1914); and in the 1930s Barbara Neville Parker and Anne Bolling Wheeler produced for the Boston Museum of Fine Arts a catalogue of the American portraits of Copley, with a stress on the identification of his sitters, making him the best-documented American artist (rivaled only by Gilbert Stuart—a Bostonian only at the end of his career) until well after 1945. Carrie Rebora, "Copley and Art History: The Study of America's First Old Master," in Rebora and Staiti, *Copley in America,* 3–23, surveys this territory.

69. The debate over Copley's loyalties continues, from William Dunlap's 1834 attitude that he had sold his American birthright by staying abroad after 1774, to Albert Boime's flat identification of him with his Loyalist father-in-law Richard Clarke on issues of slavery ("Blacks in Shark-Infested Waters: Visual Encodings of Racism in Copley and Homer," *Smithsonian Studies in American Art 3* [winter 1989]: 20–36), on the one hand, to more moderate and nuanced views like those of Paul Staiti in Rebora and Staiti, *Copley in America,* 25–51, which sees Copley as attempting to negotiate a space for himself between extremes to maximize potential patronage. I am persuaded that this latter is closer to the truth, because it takes into account his repeated assessment that "America"

would emerge as an independent nation and that he wished to be positioned as an avatar of this new national expression.

70. This is the line especially from James Thomas Flexner to Jules Prown and Barbara Novak (in different ways) and ultimately Rebora herself, in the title of her essay, "Copley and Art History: The Study of America's First Old Master."

71. For the catalogue of the Lyndhurst sale, see Jules Prown, *John Singleton Copley* (Cambridge: Harvard University Press, 1966), 2: 400–405.

72. Whitehill, *Boston*.

73. For the decor, see Burke et al., *In Pursuit of Beauty*.

74. The anonymous seventeenth-century Endicott portrait, the "original" of which is in the Massachusetts State House collection, was, according to Richard Saunders, "repeatedly copied in the eighteenth and early nineteenth centuries—perhaps more than any other colonial leader's portrait. [John] Smibert's copy is one of as many as nineteen copies that are thought to have been done" (Saunders, *Smibert*, 211–12).

75. Scholarly study on Whitman is still fragmentary, although Giffen and Murphy, "Noble and Dignified Stream," draws upon her book design (see the note, iv) and links her to ceramic work (128); she is included in Martha J. Hoppin, "Women Artists in Boston, 1870–1900: The Pupils of William Morris Hunt," *American Art Journal* (winter 1981): 17–37; and was the subject of a small exhibition, "An Artistic Friendship: Sarah Orne Jewett and Sarah Wyman Whitman at Berwick Academy," at the Old York Historical Society in 1997. An important "Biographical Outline" of her life by Betty Smith is in the curatorial archives of the Boston Museum of Fine Arts.

76. Quoted in Hirshler, *Bunker and His Circle*, 9.

77. See, for example, Carol Troyen's entry on *Mother Reading* (1905) by George de Forest Brush in Stebbins, *Lure of Italy*, 380.

78. Quoted in Greenthal, Kozol, and Ramirez, *American Figurative Sculpture in the Museum of Fine Arts*, 204. I am indebted to George Gurney for calling this image to my attention.

79. See Richman, *French*, 51–55, and Richman, "French," 224–46. One can spot a plaster version of the French bust in a photograph of French's friend the painter Abbot Handerson Thayer standing outside his studio.

80. This was the trip in which—as another token of Anglo-American bonds—Albert Bierstadt gave a dinner for Longfellow on 9 July 1868 in London, attended by eighty English and American guests, at which Bierstadt presented Longfellow with a small oil scene from *Hiawatha* (Stein, "Portfolio," 170–72).

81. See especially Burgard, "Lewis and Longfellow." For the portrait of Longfellow and his daughter in Rome, see William H. Gerdts, "Church, Healy, McEntee: The Arch of Titus," [Newark] *Museum* 10 (winter 1958): 18–20.

82. For a brief look at her brother Edward Hooper as a collector of Winslow Homer, see Burns, *Inventing the Modern Artist*, 214–16.

83. In 1872, while in Rome, a twenty-four-year-old Saint-Gaudens gave his female sitter, Eva Rohr, two pie plates painted with images of Priscilla and John Alden (see Dryfhout, *Saint-Gaudens*, 4, 57).

84. Many have written of this; a helpful summary can be found in Lears, *No Place of Grace*, 47–58, 225–41, 261–99.

85. See "The Shaw Memorial and the Sculptor Saint-Gaudens," *Century* 54 (June 1897): 176–200, which included a history of the monument, an essay on Saint-Gaudens, and Thomas Wentworth Higginson's "Colored Troops under Fire" (194–200). See also Dryfhout, *Saint-Gaudens*, 222–29; Marcus, "Shaw Memorial."

86. Quoted in *Lay This Laurel*, photographs by Richard Benson and essay by Lincoln Kirstein (New York: Eakins, 1973).

87. Actually, it was just at this point that the center of training for sculptors was shifting from Rome to Paris. Lewis's place within the expatriate community is still an open question. For recent thinking on the issue, see Proctor, "Travelling between the Borders of Gender and Nationality"; for her relation to Longfellow, see Burgard's excellent "Lewis and Longfellow."

88. For one New Englander's contrasting sense of the loss of that ancient power, see Henry Adams's self-imaging on the steps next to the Campidoglio, in "Rome," chap. 6, in Adams, *Education*.

89. See Dryfhout, *Saint-Gaudens*, 214; and for an earlier Bunker image of Ann Page, see Michael Quick, Marvin Sadik, and William H. Gerdts, *American Portraiture in the Grand Manner, 1720–1920* (Los Angeles: Los Angeles County Museum of Art, 1981), 212–16.

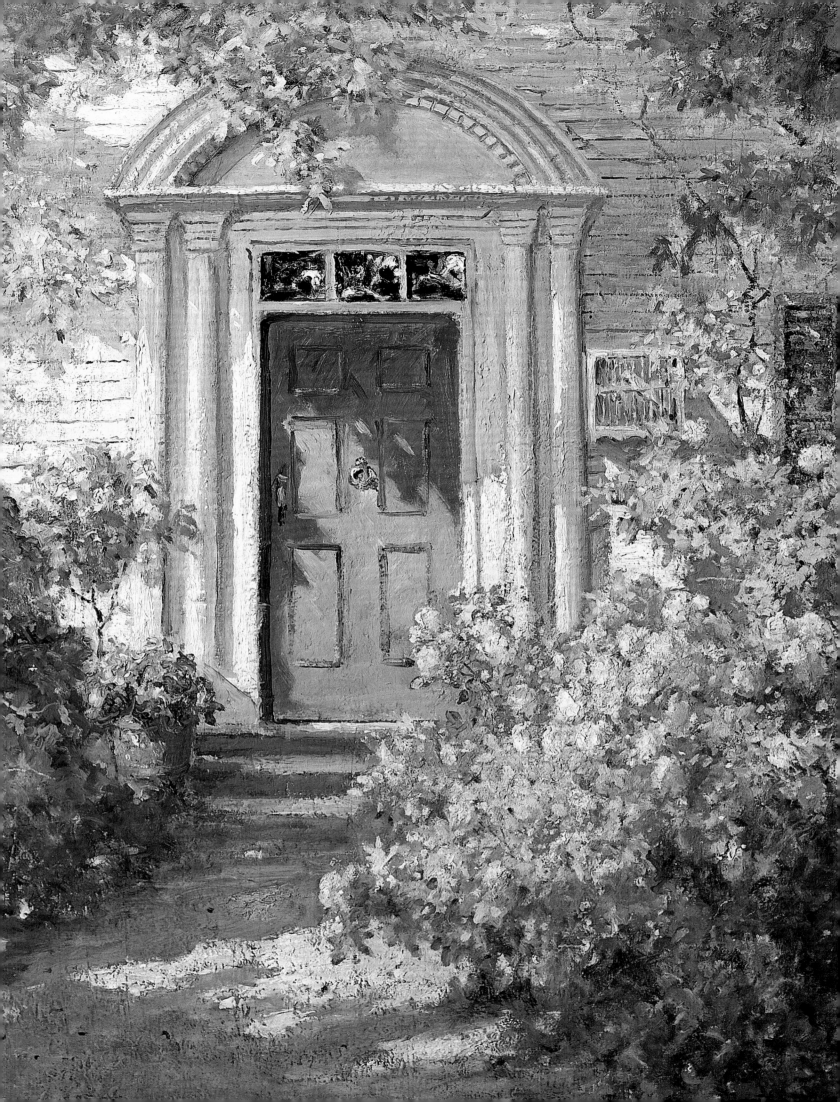

The Discreet Charm of the Colonial

WILLIAM H. TRUETTNER & THOMAS ANDREW DENENBERG

Pilgrims, Revolutionary War soldiers, and Boston Brahmins, self-consciously and often quite accurately clothed in their respective pasts, appeared in paint, stone, bronze, and graphics well into the twentieth century. But the heyday of this "historical" old New England had been earlier, in the last decades of the nineteenth century. During these same decades other old New Englands had arisen, images of which were drawn from two separate sources: the quiet old towns of southern New England (with their urban counterparts, Beacon Hill and Back Bay drawing rooms) and the forbidding, granite-lined coast of Maine. These two New Englands also had a duration of several decades. In one medium or another each lasted through the 1930s. One should not hold too firmly to these dates or locations; the dates are difficult to pin down, and artists and writers sometimes merged the two New Englands. Nevertheless, a familiar stereotype evolved from each: the old towns were seen as genteel and refined, closed worlds in which a stable social hierarchy prevailed. The coast of Maine, rugged and open to the elements, was characterized as masculine and heroic. This rugged coast and how it was represented is the subject of chapter 5, "Perils of the Sea." The story of the New England composed of sleepy, old-fashioned colonial villages begins here, with an attempt to show what attracted artists to these villages and what was considered newly important about their colonial past.

Framing this past were two distinct images: doorways of old houses (Fig. 71) and elm-lined thoroughfares (Fig. 72). The roles of these images were in many ways identical. They constructed a gracious past and extended (not quite openly) an invitation: from where the viewer stands, he or she is either encouraged to cross the threshold or proceed down the thoroughfare. If measured in space, the distance traveled may not be great. In time, however, no end is in sight. The doorway prevents a glimpse into the house interior; the thoroughfare, on the other hand, goes on and on. Passing through these doorways or along these thoroughfares was an imaginative act for turn-of-the-century viewers. They traveled alone (Fig. 73), or nearly alone, and in only one direction. Inevitably the viewer was drawn toward the past, symbolized by the colonial facade or vintage trees and homes lining the unpaved street. The point of departure, the present, was left behind. Prompting the journey was less a desire to recover a specific past than to search for what was missing in the present of 1900.[1] What was missing from such images, however, amounted to something not easily defined or pictured. The viewer's imagination was called on to fill in the scene on the other side of the door or at the end of the thoroughfare.

A Useful Past

Grandmother's Doorway (see Fig. 71), then, not only facilitates entry into the past, it also represents a set of historical concerns shared by viewers of the painting. What these are, how they are rooted in a particular historical era, and how they change

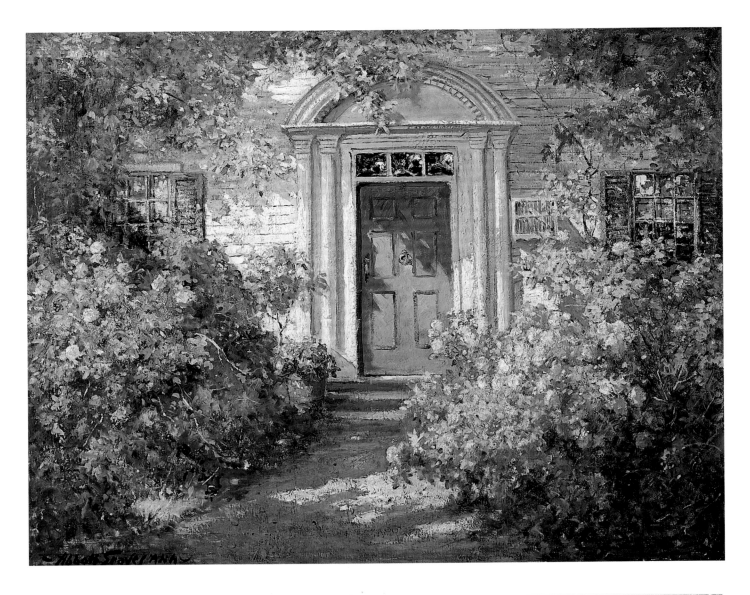

71. Abbott Fuller Graves,
Grandmother's Doorway, ca.
1900, oil on canvas, 101.9 ×
127.0 cm (40 1/8 × 50 in.).
Courtesy Strong Museum,
Rochester, New York.

72. Frances and Mary Allen,
Deerfield Street, Looking North,
ca. 1900, platinum print, 15.2 ×
20.3 cm (6 × 8 in.). Pocumtuck
Valley Memorial Association,
Memorial Hall Museum,
Deerfield, Massachusetts.

73. W. G. von Glehn, *New England*. From *International Studio* 47 (July 1912).

74. Paul Strand, *Empty House, New England*, 1945, photograph. © 1950, Aperture Foundation, Inc., Paul Strand Archive.

over time is essential to showing how perceptions of New England also change over time. *Grandmother's Doorway,* for example, painted by Abbott Fuller Graves about 1900, represents a handsome late Georgian doorway of about 1790, with full round columns supporting a beautifully proportioned segmental pediment.[2] To represent New England at the end of World War II, the photographer Paul Strand selected a very different doorway, a hard-edged Greek Revival example of about 1840, which he discovered in Maine. He called the photograph *Empty House, New England* (Fig. 74). The Graves painting alludes to hospitality, to a polite and prosperous past; beyond grandmother's doorway are a comfortably furnished interior and a kindly woman wearing an old-fashioned dress. The doorway of *Empty House* is much less inviting, not only because nothing is behind it but because it represents a difficult, harsh, even forbidding past—a past that, like the house, claims adversity as a badge of honor.

The title of the Graves painting is, of course, one obvious clue to its meanings. *Grandmother's Doorway* signifies a domestic past, a family past. To return to that past, the viewer must be familiar with the interiors of such houses. For someone who is, a *picture* of an old doorway is a sufficient reminder. Graves, therefore, has not replicated an entire house or perhaps even a particular house. Instead, he banks tall flowering shrubs on either side of the doorway and trails branches above it, using nature to frame three sides of the painting. The bottom edge, interrupting the perspective lines along the path leading to the door, flattens the pictorial space inside this "natural" frame. Patterns of light falling across the front of the house, muted (almost dusty) colors, and the picturesque tangle of flowers on either side of the path, untended but not wild, also reveal a composing hand. Such images, whether made as paintings, photographs (Fig. 75), or prints, prepare the past for consumption. They make it tangible, retrievable, available—a reassuring aide-mémoire.

But what past was being made available and whom did it reassure? Turn-of-the-century images of rural New England rarely address such questions directly. Like the design of the doorway in the Graves painting, details may recall a specific past, but the "moment" of the painting could be anywhere between that past and a vaguely defined present.[3] Nor do these images claim attention by insistently reconstructing Puritan history or Revolutionary and Civil War scenes. Instead, they obscure chronology, easing the viewer back into a comfortable but indefinite past. His-

torical specificity is traded for an image that will memorialize in broader terms. A second and equally important role for pictures like *Grandmother's Doorway* was to create a beautiful past, a world governed by aesthetic and moral codes that seemed increasingly obsolete in modern society. The *Literary Digest,* taking up the issue in 1927, points out the salient features of a similar Graves painting. It "looks like a doorway in Salem," the *Digest* writer observes, "tho it might be anywhere in the old comfortable New England towns where colonial architecture abounds, and is still cared for. It reminds us of the days of grace and leisure that have in recent years slipt away from us."[4]

At the turn of the century real or painted doorways were often surrounded by a profusion of flowers. Their apparent disarray was another way of invoking the past: they naturalized tradition and beauty, bringing it forward in the guise of an old-fashioned garden (as distinct from the formally arranged beds of late Victorian gardens).[5] In another, more spectacular example of this genre, by the impressionist painter Childe Hassam, flowers and vines envelop the front porch of poet Celia Thaxter's home on Appledore Island (Fig. 76). Standing on the porch,

75. Frances Allen and Mary Allen, *Doorways*, 1913, four platinum prints on cardboard. Pocumtuck Valley Memorial Association, Memorial Hall Museum, Deerfield, Massachusetts.

as if under a rustic halo, are Thaxter and one of her grandsons. Flowers and family designate the space as feminine and domestic, two more characteristics of the turn-of-the-century world about to be entered. After stepping through the doorway, the viewer enters the parlor (Fig. 77), where Thaxter entertained artists (including Hassam) and writers of her day—a space no less remarkable than the one in front of the house. A suggestion of the outdoors—in the form of light and flowers—fills the room, introducing colors so luxurious that they almost overwhelm the simple furnishings and architecture. Still, the room is devoted to quiet pursuits—looking, reading, thinking. These allude to Thaxter's own interests (the books and flowers on the foreground table, the paintings and prints on the walls) and to those of the young woman at lower right, deeply absorbed in her book.

If Hassam's *Room of Flowers* does not immediately spell out confinement, the boundaries of this world are nevertheless tightly drawn and concentric. "At the center," David Park Curry writes, "are individual figures in personal retreat." The parlor, in turn, broadens that space into "a habitat for contemplation." Beyond that realm is the Appledore Island of Thaxter's creation, "a place detached from the new urban life and reassuringly identified—like Thaxter . . . and her poetry—with the very bedrock of old New England and earlier America."[6]

Not surprisingly, those who enter this exclusive past also proceed singly or in pairs. Like Celia Thaxter's home and garden on Appledore Island, Deerfield, Massachusetts, was a similar retreat, reached not through the flower bedecked doorways of Graves or Hassam but along pathways drawn by James Wells Champney, artist,

76. Childe Hassam, *The Garden in its Glory (Isle of Shoals Garden)*, 1892, watercolor, 50.8 × 35.2 cm (19 15/16 × 13 7/8 in.). National Museum of American Art, Smithsonian Institution, Gift of John Gellatly.

77. Childe Hassam, *Room of Flowers*, 1894, oil on canvas, 86.4 × 86.4 cm (34 × 34 in.). Manoogian Collection, Dearborn, Michigan.

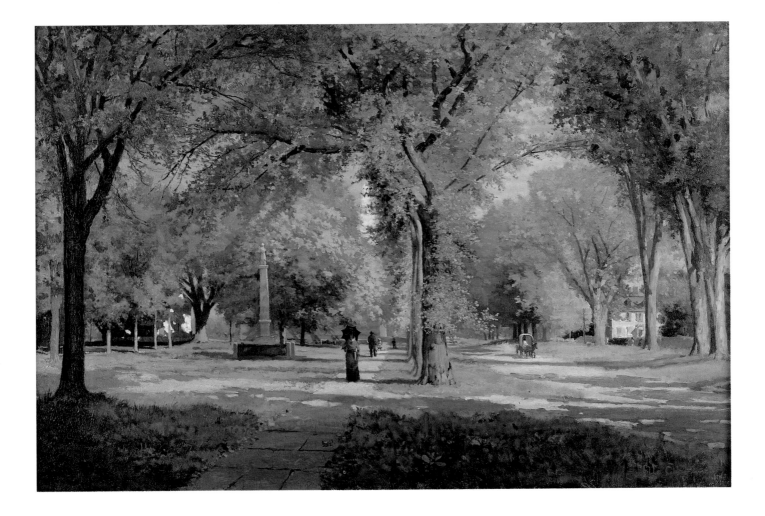

78. James Wells Champney,
Town Common, Deerfield, ca.
1877, oil on canvas, 45.7 × 66.0
cm (18 × 26 in.). Courtesy of
Historic Deerfield, Inc.,
Deerfield, Massachusetts; gift of
Miss Frances Malone.

photographer, and antiquarian, who devoted much of his career to re-creating life in old Deerfield. *Town Common, Deerfield* (Fig. 78) is one such attempt, a view that includes a Civil War monument predating the *Shaw Memorial* in Boston by some thirty years.[7] The Deerfield monument occupies the center of the village green. Arching above and lining the main street are tall elms. Down the sidewalk, partially obscured by foliage is the Red Brick (Congregational) Church, completed in 1824, and at far right stands another Deerfield landmark, the Manse, an elegant home built in 1773. The diagonals connecting these monuments, along with the axes designated by the sidewalk and street, map town history in a cursory fashion. The great elm corridor, however, ultimately connects past and present. The picture is painted in a modified Barbizon style, with strong patches of autumn color highlighting the foliage. The rhythm of the trees and the shadows they cast form a processional, leading slowly back to an earlier Deerfield, resonant with age and authority. Gently resisting time are a few strollers on the sidewalk and a horse and wagon coming up the street. Old and new Deerfield, according to Champney's picture, enjoy a rare harmony.

Champney was not alone in his endeavor to link past and present. But other local artists and photographers—George Fuller, Augustus Vincent Tack, the Allen sisters, Emma Coleman—pursued their goals less openly. Champney divided his time between a Fifth Avenue studio, where he maintained a successful portrait practice, and his wife's ancestral home on the main street of Deerfield, where he painted old-fashioned rural genre scenes (Fig. 79).[8] The relative ease with which he made the transition suggests that the urban nature of his career did not conflict, indeed somehow complemented, the rural; he was comfortable with one foot in the present and the other in the past. In this he anticipated the position of many of his con-

79. James Wells Champney, *Landscape of the Deerfield Valley*, ca. 1877, oil on canvas, 65.4 × 45.1 cm (25 3/4 × 17 3/4 in.). Courtesy of Historic Deerfield, Inc., Deerfield, Massachusetts.

temporaries. The path of their careers was more or less progressive, but their hearts told them to beware of the modern age.

The Champney painting and the decade in which it was done also mark Deerfield's new awareness of itself as vintage New England. This was as much a case of historical happenstance as strategic planning.[9] Through the nineteenth century small farms surrounding the town had been consolidated into larger holdings, causing local ownership of the land to decline, and industry had settled in nearby Greenfield, on the banks of the Connecticut River. Left behind in Deerfield was an impressive range of colonial homes, many in disrepair, a few commercial buildings, an academy desperately in need of students, glorious old trees, an aging population, and a unique history as a seventeenth-century frontier outpost, attacked and several times destroyed by Indian tribes from the north. These ingredients were thoughtfully packaged in the 1880s and 1890s by a number of enterprising women—some local, others from Boston, New York, and Chicago—who were comfortably well off, well educated, and eager to step into civic roles that for an earlier generation would have been "unnatural."[10] When they came together in Deerfield, they formed a remarkable sisterhood, based on mutual interests and strong personal ties. As a group, the women were dedicated to reviving the cultural landscape of Deerfield. This they accomplished by repairing and refurbishing old houses, sometimes with hammer and paintbrush in hand, and by developing an exceptional range of programs to highlight and explain the local past.

"I hate monuments," said Alice Baker, perhaps the most influential member of this group, when eying the numerous marble and granite historical markers on the streets of Deerfield.[11] Baker and her friends advocated instead "common parlors," that is, the formation of public gathering spaces around town, each containing images and objects invested with, in the words of two recent scholars, "the moral power of a mythological colonial past."[12] These parlors ultimately transformed the whole of Deerfield—community, town, and a growing number of historic properties—into one large "commemorative space," at first devoted to consciousness-raising at a local level but soon attracting a considerable number of tourists—six thousand in the summer of 1908—many from beyond New England.

By the last decade of the nineteenth century Deerfielders had devised another way to profit from their past, this time launching the town as a craft center. Plans to develop craft production, which grew out of common-parlor discussions, proceeded on the assumption that Deerfield's chief commodity, its past—and reproductions of that past—could be sold to improve the town's present economic circumstances. Those who would gain resided at both ends of the social spectrum. Craft training was offered to the families of local farmers, whose prospects had dimmed over the years, and to leading citizens, who were convinced of the therapeutic value of working with their hands.

Each of the three leading craft organizations—The Society of Blue and White Needlework, the Pocumtuck Basket Makers, and the Deerfield Society of Arts and Crafts (later known as Deerfield Village Industries)—produced distinctive work for

80. Deerfield Society of Blue and White, *Doily*, 1900–1910, diameter, 23.0 cm (9 in.). Pocumtuck Valley Memorial Association, Memorial Hall Museum, Deerfield, Massachusetts.

81. Deerfield Society of Blue and White, *Acanthus Leaf Pocket*, 20.5 × 12.8 cm (8 × 5 in.). Pocumtuck Valley Memorial Association, Memorial Hall Museum, Deerfield, Massachusetts.

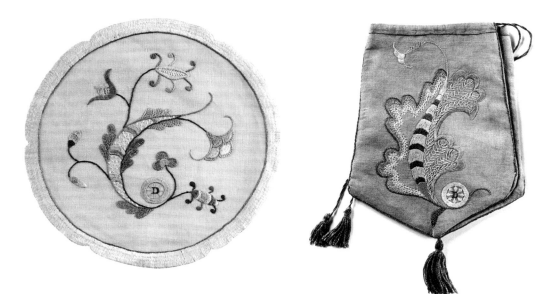

82. Frances and Mary Allen, *Sewing Group*, ca. 1900, platinum print. Pocumtuck Valley Memorial Association, Memorial Hall Museum, Deerfield, Massachusetts.

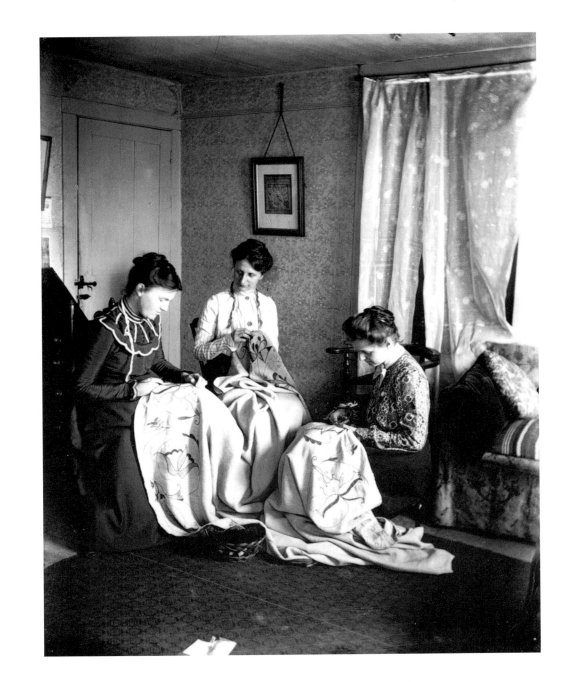

83. Pocumtuck Basket Makers, *"Old Indian House" Basket*, ca. 1900, raffia, 24.3 × 29.5 cm (9 1/2 in. ht. × 11 1/2 in. diam.). Courtesy of Historic Deerfield, Inc., Deerfield, Massachusetts.

84. Edward Thorn, Caleb Allen, and Cornelius Kelley, *"Hadley Chest,"* ca. 1901, oak and pine, 91.4 × 119.4 × 50.8 cm (36 × 47 × 20 in.). Courtesy of Historic Deerfield, Inc., Deerfield, Massachusetts; gift of Dr. Preston Bassett.

a gradually expanding audience.[13] Local women trained to do fine needlework were the mainstay of the Society of Blue and White. Their designs, flowers and foliage arranged in graceful arabesques (Figs. 80, 81), were initially drawn from colonial textiles in nearby collections. Their reputation, perhaps enhanced by the beautifully staged photographs of the Allen sisters (Fig. 82), quickly spread beyond Deerfield. Blue and White products were featured at national arts and crafts shows and purchased for use in the White House by Mrs. Theodore Roosevelt, Mrs. Calvin Coolidge, and Eleanor Roosevelt.

Handsome raffia baskets made by the Pocumtuck group also borrowed imagery from the Deerfield past. Woven into the example illustrated (Fig. 83) is a picture of the Old Indian House, a seventeenth-century building noteworthy for having survived an Indian raid on the town in 1704. Hadley chests and other small Connecticut Valley pieces were replicated by men associated with the Society of Arts and Crafts. Some pieces were collaborative efforts, such as the Thorn and Allen chest (Fig. 84). The beautifully carved front panels were made by a local doctor, Edward Thorn. The other two key parts of the chest, the solid carcass (or frame) and the skillfully forged strap hinges that attach the top to the carcass, were made, respectively, by Caleb Allen, a Deerfield old-timer, and Cornelius Kelley, a local blacksmith and Irish immigrant. Such a project expresses a determined effort by three men to create a common past.[14]

What happened in Deerfield from about 1870 to 1930—the remake of an agricultural community into a center for dispensing the aims and ideals of colonial America—raises the question of whether it was a revival or a program with a modern social agenda, borrowing at will from the past.[15] The preservation activities that went on in Deerfield are a case in point. Splendid old houses were not only repaired and refurbished but sometimes moved to new locations, so that the town could assume a grace and dignity suited to the taste of those in charge of local preservation activities.[16] Thus the Deerfield of circa 1930 was as much the creation of George Sheldon (self-appointed town historian), Alice Baker, and later preservationists as the result of an ongoing scrutiny of town records. Discouraging such scrutiny was the need to make Deerfield *look* authentic, a task not necessarily guided by historical or archaeological research. The moralizing lessons of history, Baker believed, were better taught by a past that was attractive and well kept than by one that showed lack of grace and a bit of dirt and decay around the edges.[17]

Historians also argue that interest in the colonial never really ceased, that its symbolic and historic value locked into place almost as soon as value-laden arti-

facts and environments (Plymouth Rock, the John Hancock house, colonial kitchens, old-fashioned villages, spinning wheels, the Washington Elm, rural life, blacksmith shops) had either disappeared or were in danger of being forgotten.[18] Waves of nostalgia about the colonial, then, reoccurred through the nineteenth century, each accompanied by the production of popular historical artifacts. Chairs made from old spinning-wheel parts were one such item (Fig. 85). They began to appear in middle-class parlors soon after the Civil War—as expansion in the New England textile industry increasingly removed textile production from the home.[19]

By the 1890s, however, the colonial was taken up by a more select group of patrons and connoisseurs, no less nostalgic than their predecessors but with deeper concerns about the future. They saw themselves as guardians of culture, of an aristocratic New England past. While they differed about how to perform their roles, as Dona Brown and Stephen Nissenbaum point out in the historical overview, they shared a common dislike of what the United States was becoming—an industrial democracy with a broadly diverse working-class population. From their point of view (or more specifically from their growing concern about where the na-

85. *Spinning Wheel Chair*, ca. 1890, painted maple and pine, 130.8 × 64.1 × 70.5 cm (51 × 25 × 27 1/2 in.). Courtesy Strong Museum, Rochester, New York.

tion was headed) arose a new version of the colonial, one that gathered momentum after the Centennial Exposition in Philadelphia and that sounded distinctly New England as the century drew to a close.

Antiquarian to Arts and Crafts

At another level, the argument of the "guardian class" was about the loss of historical memory, what Henry James called in 1907 a "suppression" of "an old conscious commemorated life."[20] He and Baker would have agreed that therein lay the reserve the nation needed to confront modernism, but they differed considerably about what should be done. James was more inclined to wring his hands in dense, self-absorbed prose, lamenting the absence of values and standards that had guided previous generations. Baker's approach was anything but passive. Her training as an educator predisposed her to make of Deerfield an enduring history lesson. She was as willing to fight the day-to-day battle to preserve old New England as James was to assume that the past he knew and cared about was on the verge of extinction.

Baker's activities merged two somewhat different approaches to preserving the past, both with a common ancestor in the antiquarian movement. The poet Henry Wadsworth Longfellow and others, who in the decades preceding the Civil War gave the movement a certain respectability, can best be described as "relic" gatherers. Their passion was history, not connoisseurship. The trophies of the era—the cradle of Peregrine White (Fig. 86), the sword of Miles Standish, and the chairs of

Elder Brewster's Chair. - Cradle of Peregrine White, Pilgrim Hall.

86. A. S. Burbank, Postcard of *Elder Brewster's Chair and Cradle of Peregrine White*, 3 1/2 × 5 1/2 in. Pilgrim Hall, Plymouth, Massachusetts, Private collection.

87. Frontispiece from Mary D. Brine, *Grandma's Attic Treasures: A Story of Old Time Memories* (New York: E. P. Dutton and Co., 1882). Courtesy of Helena Wright.

Salem witches, displayed at institutions such as Pilgrim Hall in Plymouth and the Essex Institute in Salem—served to substantiate regional myths for which Longfellow, Hawthorne, and Whittier were providing national audiences.

After the war, antiquarianism was more evident at all levels of society. The dark side of the Union victory—the loss of loved ones and a more conspicuous industrial landscape—caused introspection rather than celebration. The result was a renewed search for an ideal New England past. Sporadic efforts were made to restore historic buildings and antique collecting slowly became a mainstream pastime. Clarence Cook, a journalist and discerning art critic, was one of many who encouraged collecting. "Everybody can't have a grandfather, nor things that came over on the Mayflower," he wrote in 1881, "and those of us who have not drawn the prizes in life's lottery must do the best we can under the circumstances."[21] Those lacking a prominent ancestor, in other words, could acquire one by touring the countryside and purchasing the items he or she might have owned.

Another way of collecting the past was through books like *The Homes of Our Forefathers* (1879) by Edwin Whitefield and *Grandma's Attic Treasures* (1882) by Mary D. Brine (Fig. 87). The former was an early attempt to illustrate and describe major historic houses in New England; the latter, a poignant tale of an old farmer's wife selling off "obsolete" furniture, only to have it reclaimed by a favorite granddaughter, who found it by chance in a city antique shop. The granddaughter, anxious to improve her city home with fine old pieces, brings one up to the era of novelist Edith Wharton. Early in her career, Wharton and architect Ogden Codman had co-authored *The Decoration of Houses* (1897), part connoisseur's manual and part home-furnishing guide, meant to enlighten those recently moved to the city (and presumably up in the world) as well as to sharpen the eye of those already in prosperous circumstances. The assumption behind Wharton and Codman's tasteful advice was that a well-furnished room embodied integrity and character, a place where one could simultaneously engage the present and learn valuable lessons from the past.

Public programs to put other groups in touch with the past were also underway. Many were sponsored by second- and third-generation New England families, whose antiquarian interests could not be confined to drawing rooms. In 1910 William Sumner Appleton, grandson of a pioneer textile manufacturer, founded the Society for the Preservation of New England Antiquities (SPNEA), the most successful preservation organization of its time.[22] Alice Baker, whose family resources were not those of Appleton's, carried on a more modest program in Deerfield, restoring Frary House and assisting with the craft revival. In Salem and other coastal towns similar programs were instituted, concentrating even more on the reproduction of local historical artifacts. The Salem program was located in the House of the Seven Gables (Fig. 88), newly refurbished by the architect Joseph Everett Chandler and patron Caroline Emmerton, an early board member of SPNEA. The process taught there was basically a form of manual training, of learning by doing.[23] It operated on the assumption that the skillful reproduction of historical artifacts led to a better understanding of the cultures that had originally produced them. What was sold from

SLOYD CLASS AT WORK

88. *Sloyd Class—at the Settlement Association*, 1920s. Photograph courtesy of the House of the Seven Gables Settlement Association, Salem, Massachusetts.

these craft workshops also helped program a larger audience to see old New England in terms of a common set of symbols, including Windsor chairs, Hadley chests, Blue and White needlework, silver tea services, candlestands, and locally designed baskets and pottery.

Similar institutions in Boston encouraged craft production. The foremost was the Society of Arts and Crafts, Boston (SACB), founded in 1897 by a group of Brahmins. Like the English organizations that served as its model, the society provided marketing and retail opportunities to its artisan-members. By 1901, with publication of the journal *Handicraft* and the opening of the Handicraft Shop in Boston, the society claimed a national voice and increased local retailing prospects for its members. SACB members, however, were of two minds about tradition. Despite their debt to the English movement, they looked to local forms and styles when creating the finely wrought silver vessels (Fig. 89), jewelry, book covers, and furniture that were the hallmarks of the craft revival in New England. One prominent member, silversmith George Christian Gebelein, explicitly declared his allegiance to local craft traditions when he advertised himself as the successor to Paul Revere.[24] The revival of traditional craft production at the turn of the century, in both urban and rural environments, cast a special aura over the New England past. Not only did it provide a unique, hands-on educational opportunity for many people in the region, but it further established the past as an ideal aesthetic haven. Fine craftsmanship, the revival taught, revealed the past in its most essential and, therefore, most beautiful form.

Some combination of these two strains—the connoisseur's approach advocated by Wharton and the more pronounced aestheticism that governed craft production—is also evident in image making at the turn of the century. How the two strains cooperated can perhaps best be understood by following the hypothetical transfer of a colonial piece from actual to painted space. A slender, functional, attractively designed gate-leg table, for example, placed in a well-appointed turn-of-the-century drawing room surely adds integrity and character (Wharton's words) to

89. George Christian Gebelein, *Coffee and Tea Service*, 1929, silver and ebony (tea kettle: 31.4 × 23.0 cm [12 1/4 × 9 in.], coffeepot: 22.4 × 24.3 cm [8 3/4 × 9 1/2 in.], teapot: 22.4 × 24.3 cm [8 3/4 × 9 1/2 in.], creamer: 16.0 × 12.3 cm [6 1/4 × 4 5/8 in.], covered sugar bowl: 21.8 × 9.6 cm [8 1/2 × 3 3/4 in.]). Courtesy of Museum of Fine Arts, Boston; anonymous gift, 1986 (778-782).

its setting, helping to complete a historical ensemble. The same table, appearing in
New England Interior (Fig. 90), by the Boston painter Edmund C. Tarbell, assumes a
similar role. It becomes part of another composition, including fashionably dressed
women, tasteful furnishings, and an intimate architectural environment. Absent a
"real" environment, however—the mellow appearance of an old house or a room
crafted to look old—Tarbell's brush takes over, toning and aging—aestheticizing—
the past into which the table has been placed. The painted past takes over from the
real past, but the role of the table remains more or less constant. Comfortably situ-
ated in either past, it recalls an ideal colonial world.

Images and Artists

Gate-leg tables, genteel interiors, colonial doorways, and elm-arched thoroughfares
suggest other issues. They are reproduced with surprising frequency in turn-of-the-
century images. Indeed, the four are near or at the top of the preferred iconography
of the period—a list that is noticeably short and that raises the question of what
subjects appear less frequently. Among those are mill towns, unless set in a land-
scape that pastoralizes (or obscures) the manufacturing process (Fig. 91), large ur-
ban centers, crowds, traffic, commerce, industrial sites, and working class or ethnic

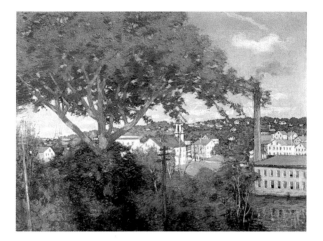

91. J. Alden Weir, *The Factory Village*, 1897, oil on canvas, 73.7 × 96.5 cm (29 × 38 in.). Jointly owned by the Metropolitan Museum of Art and Cora Weir Burlington (1979.487).

groups, especially those from eastern Europe. Theodore Robinson provides one of several exceptions to this sampling, perhaps because he was trained in France, among realists and impressionists whose images represented urban life, whether on cobblestone streets or grand boulevards, as a mix of classes. In his 1884 *Beacon Street, Boston* (Fig. 92) a well-dressed woman strolls beside Boston Common. Several steps away (and down the social ladder) a laborer and several draft horses are presumably engaged in street repair.

Photographers generally focused on work done under less attractive circumstances; through their lenses additional New Englands come to light. One of those is composed of skilled factory workers who had reached a respectable, if not quite middle-class, status (Fig. 93). Below them was working-class New England—a less skilled group engaged in civic improvements (constructing subways, elevated railways, bridges, water mains, power stations, etc.) in Boston and other large New England cities (Fig. 94). Perhaps unintentionally these pictures often show the circumstances of poor blacks and recent immigrants (Fig. 95). More difficult to locate are photographs of middle-class blacks, a small group found mostly in Boston. Examples recently published depict a close-knit community, whose pride and decorum measure its sense of belonging to a larger society (Fig. 96).[25] The Irish, on the other hand, were more often represented by luminaries—politicians (Fig. 97), churchmen, and sports figures—than by a striving middle class. In addition, they were mocked by cartoons that savagely condemned immigration and imagined ethnic characteristics.[26]

Another level of society altogether is found in Beacon Hill and Back Bay drawing rooms and in the genteel, usually rural, communities on which the artists focused. The attractions of these old towns were real enough: an ample supply of vintage houses for rent or sale, picturesque rural surroundings, and good hunting for an-

92. Theodore Robinson, *Beacon Street, Boston*, 1884, oil on canvas, 43.2 × 53.3 cm (17 × 21 in.). Wadsworth Atheneum, Hartford. The Ella Gallup Sumner and Mary Catlin Sumner Collection Fund.

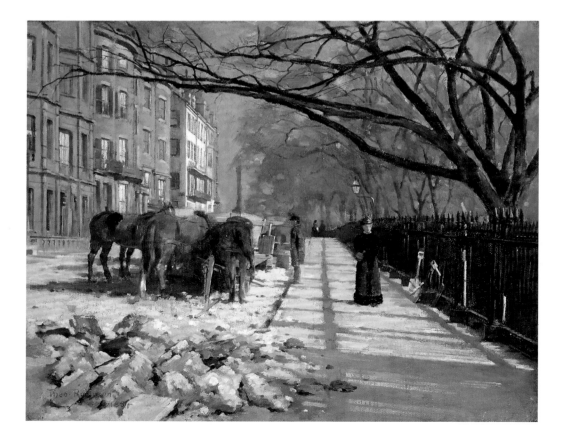

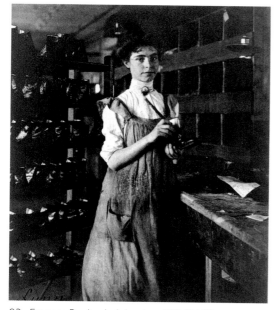

93. Frances Benjamin Johnston, *Mill Girl* (Shoe Factory, Lynn, Massachusetts), 1895, photograph. Library of Congress, Prints and Photographs Division.

94. *At Work in the Culvert under Commonwealth Avenue, Boston, Massachusetts*, ca. 1890, photograph. Boston and Albany Railroad Collection, Society for the Preservation of New England Antiquities.

95. Paul Rowell, *8 Lindall Place*, 1911, photograph. Boston Elevated Railway Company Collection, Society for the Preservation of New England Antiquities.

96. Hamilton Sutton Smith, *Masonic Centennial, Prince Hall Grand Lodge, Copp's Hill, Boston*, 1908. From the Hamilton Sutton Smith Collection of the Museum of Afro American History, Inc., Boston, Massachusetts.

97. *John F. Fitzgerald, Mayor of Boston, 1910–1914*, 1912, photograph. Brown Brothers.

94.

95.

97.

96.

tique collectors.[27] What appealed to potential patrons also seems to have appealed to the artists. In fact, the artists sometimes arrived at the old towns first, and it was their presence that subsequently attracted an upscale crowd. Old Lyme, Connecticut, and Cornish, New Hampshire, for example, were revived when the artists first discovered them, and they continued to develop when summer people and tourists followed. These newcomers remodeled homes or built new ones, often in a colonial revival style.

The artists who painted this genteel, time-worn New England managed to live quite comfortably. At the same time, they disdained the material concerns of the contemporary industrial elite.[28] Those who purchased New England scenes also preferred a less formal domestic style—one guided by the ideals of simplicity and refinement. Artists and patrons ("choice spirits") who gathered at Cornish every summer wished above all to distance themselves from modern urban life.[29] They replaced it with nature and the past, with an everyday choreography that merged the two in the same way their paintings merged life and art. What artists and patrons shared, Kathleen Pyne has written, was a concern for a "higher life."[30] Art was to be the medium leading to a new realm of human progress—one more dependent on aesthetic and moral concerns than on the machinations of commerce and industry.

With a few notable exceptions, turn-of-the-century artists led lives almost as respectable as those of old-family New-Englanders.[31] Not surprisingly, many were from old families: Hassam, Abbott Thayer, Frank Benson, Maria Oakey and Thomas Dewing, Tarbell, Willard Metcalf, Arthur Dow, Ellen Day and Philip Leslie Hale, Abbott Fuller Graves, and Lilla Cabot Perry, to name only a few, could point to seventeenth-century New-England ancestors. Although most had exchanged old-family for middle-class circumstances, their views and aspirations were a good deal higher. Their art, in that sense, was a step toward regaining their former status.[32] Turn-of-the-century collectors such as Charles Lang Freer and John Gellatly, who could not claim an illustrious lineage, had chosen a similar route to "improve" themselves. Indeed, both set themselves apart from the mainstream collectors of the day, those like Catherine Lorillard Wolfe and William K. Vanderbilt, who bought French academic and Barbizon paintings, and the Morgan, Frick, and Havermeyer group, whose interest was primarily in European old masters.[33] Gellatly and Freer not only preferred to collect contemporary American art, but their personal habits and fastidiously arranged private galleries aligned them more closely with a New England sensibility than with the taste of prominent New York industrialists.

Most painters of New England scenes were either New Englanders or artists from elsewhere who had settled in New York and whose paintings were intended for a New York market. They had adopted New England as a summer retreat (some stayed longer, into the fall), but many of them painted New England subjects all year long. Most belonged to one or both of two major groups, the Ten American Painters and the Old Lyme school. The former, as the name indicates, had a limited membership (which included Tarbell, Benson, and DeCamp), a perceptible Boston accent, and a devoted Boston clientele. It also had a more formal agenda. Every one of "The Ten" had previously belonged to the Society of American Artists (one of two major professional organizations in New York; the other was the National Academy of Design) but had become impatient with the society's annual exhibitions. Through the 1890s the society's selection committees had turned more conservative and were in some cases openly hostile to impressionism.[34] In response, "The Ten" began to exhibit together in 1898 and continued to do so until 1917. The members were not, however, committed to redirecting the course of American art. By the standards of European modernism, or even those of the Ashcan painters, they were a cautious group, appealing to patrons also comfortable with the status quo.[35] Still, "The Ten" wanted their own voice, for critical and commercial pur-

poses, and with it they succeeded.

The Old Lyme school, whose summer headquarters was Florence Griswold's spacious home in Old Lyme, did not take itself as seriously as "The Ten." A certain old-boy camaraderie prevailed at their gatherings, and they had no limit on membership or fixed exhibition schedule. The "school," at least in its early days (1900–1910), consisted of almost anyone who appeared on the Griswold doorstep (some word-of-mouth screening was involved) and could afford the modest room and board. "Miss Florence," as the artists called her, was the engaging, well-informed descendant of a prominent local shipping family and owner of an elegant but run-down mansion, in which, she said, "everything savors of the past."[36] Opportunities for painting in the neighborhood and Griswold's hospitality turned out to be a winning combination.[37] Henry Ward Ranger and his Barbizon-inspired followers were first on the scene, but by 1903 the landscape was supplemented by other subjects—old houses, interiors, gardens, leisure activities—as Hassam,

98. Willard Leroy Metcalf, *May Night*, 1906, oil on canvas, 101.2 × 93.3 cm (39 1/2 × 36 3/8 in.). In the Collection of The Corcoran Gallery of Art, Washington, D.C., Museum Purchase, Gallery Fund (07.7).

Metcalf, Twachtman, Weir, and other impressionists replaced the Ranger-style artists. Metcalf's often reproduced moonlight view of the mansion (Fig. 98), with the ghostly figure of a young Florence Griswold on the front lawn, ties this phase of the Old Lyme school to "The Ten," especially to the softly lit landscapes inhabited by women in elegant gowns painted by Dewing in Cornish (Fig. 99). Metcalf used the darkly luminous facade of the old mansion to symbolize the New England past. Dewing did the same with nature—with the lush summer meadows and groves of birch and pine surrounding Cornish.[38] Both were backgrounds for an imaginary old America.

99. Thomas Wilmer Dewing, *Summer*, ca. 1890, oil on canvas, 107.0 × 137.8 cm (42 1/8 × 54 1/4 in.). National Museum of American Art, Smithsonian Institution, Gift of William T. Evans.

100. Frank W. Benson, *Summer*, 1909, oil on canvas, 92.3 × 112.8 cm (36 × 44 in.). Museum of Art, Rhode Island School of Design, Providence; Bequest of Isaac C. Bates (13.912).

Painting the Past

The artist Frank Benson came from an old Salem shipping family. His grandfather, Samuel Benson, had been in the China trade and had brought back from East Asia not only precious cargoes of spices and tea but scrolls, screens, beautifully patterned silks, ginger jars, and blue-and-white Canton china.[39] These rare items, along with fine early furniture, decorated his house in Salem, which was eventually passed down to his son. Frank was born and raised in the same house, presumably still furnished with China trade treasures, although by that time the Benson family had reinvested its shipping profits in the cotton business. Such families continued to prosper, with old wealth underwriting a newer, industrial New England, and producing a comfortable, if restless, third generation. Like William Sumner Appleton at SPNEA, they were more committed to saving old New England than to encouraging the growth of new New England, although it seems clear they could not accomplish the former without coming to terms with the latter.[40]

With his mother's encouragement, Benson entered the School of the Museum of Fine Arts in Boston and matriculated with a banner class, which included Tarbell. Success as an artist and five children came along at about the same rate, so that by 1901 he needed a summer studio with a large house nearby. At the suggestion of a friend, he rented an old farmhouse on North Haven Island in Penobscot Bay. So perfectly did it fulfill artistic and family needs that the Bensons returned every summer for many years thereafter. And one after another, dazzling plein-air paintings of the artist's daughters emerged from his North Haven studio.

The island at that point must have looked like a set piece from a short story by Sarah Orne Jewett. A few summer people had come; otherwise the residents managed sheep farms or depended on mackerel seining for their livelihood. Across the open terrain of the island Benson's children ranged freely, touched, it would seem, only by the warm sun and fresh breezes. *Summer* (Fig. 100) brings together his four daughters, auburn-haired beauties who give North Haven the air of a Puritan Cap d'Antibes. One girl gazes out to sea, her pose reminiscent of ship figureheads (Fig.

101) and of Winslow Homer's sturdy fisherwomen (*see* Fig. 170)—deliberate references to the New England past. Equally obvious is the protective mission of the paternal brush, maintaining strict control over the daughters, immaculately encamped on a hillside of flowers and all but one clad in virginal white. The moment cannot last. A hint of the Persephone myth infuses the scene, reinforced by formal strategies that signal impending change—the angle of light, fragile blue and purple shadows, and shimmering pigment surfaces. The gaze seaward of the standing daughter also heralds change (or intrusion). And yet closure and restraint are features of the composition—the curving shoreline surrounding the four figures, who form a triangle so carefully arranged that even the blue shawl on the ground beside the daughter on the left is a strategic element, and the forward momentum of the daughter on the hill is canceled by her sister furthest down, who faces not the horizon but the opposite direction.

Thus, for all the girls' freshness and high spirits, nothing has upset their decorum. With a minimum of adjusting and a change of clothes, three of Benson's four daughters could substitute for the three women reading in an interior of almost the same date by Tarbell (Fig. 102). Moreover, both Benson's shoreline and Tarbell's drawing room are characteristically New England settings of the period, made more so by the grace and breeding of the women who appear in each. *Summer* especially equates class with racial purity, with Anglo-Saxon bloodlines in danger of being thinned by waves of immigration.[41] Benson's daughters also have popular national counterparts in the Gibson Girls (Fig. 103) and in Howard Chandler Christy's racier females.

High summer, with long, leisurely afternoons deepening into shadow, was a favorite motif of the New England impressionists. So was fall, a time marking seasonal change. Often that change was measured against the enduring architecture of New England—old houses, churches, villages—and against fixtures of the landscape—old trees, winding streams, rock outcroppings, characteristic hill formations. The next group of pictures essentially combines historic architecture and landscape in the same way Benson's four

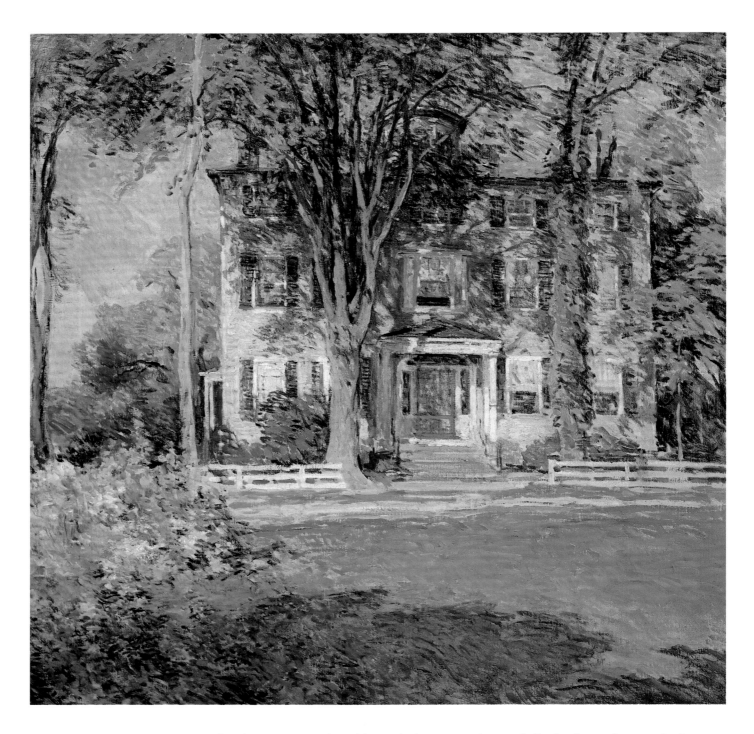

104. Willard Leroy Metcalf, *Captain Lord House, Kennebunkport, Maine*, ca. 1920, oil on canvas, 91.4 x 91.4 cm (36 x 36 in.). Gift of Mrs. Henrietta Metcalf, Courtesy of the Florence Griswold Museum, Old Lyme, Connecticut.

daughters are comfortably settled on a windswept hillside above the sea. Architecture and figures are naturalized, made to seem at home in their respective landscapes. The architecture, however, refers more directly to the past. Metcalf's *Captain Lord House, Kennebunkport, Maine* (Fig. 104) and Hassam's *Church at Old Lyme, Connecticut* (Fig. 105), for example, are pictures whose present is mostly constructed to look backward.

In a letter of 1908 to J. Alden Weir, his friend and fellow impressionist, Hassam described Old Lyme, stressing several times the "old" that in his mind connected the town to the landscape. "We are up here in another old corner of Connecticut," Hassam wrote, "and it is very much like your country. There are . . . large oaks and chestnuts and many fine hedges. Lyme . . . at the mouth of the Connecticut River . . . is a pretty fine old town."[42] Tall elms, analogous to the oaks and chestnuts Hassam mentions in his letter, embrace the Lord mansion and Old Lyme church, sanctioning each facade as both New England and American. The elms also guaran-

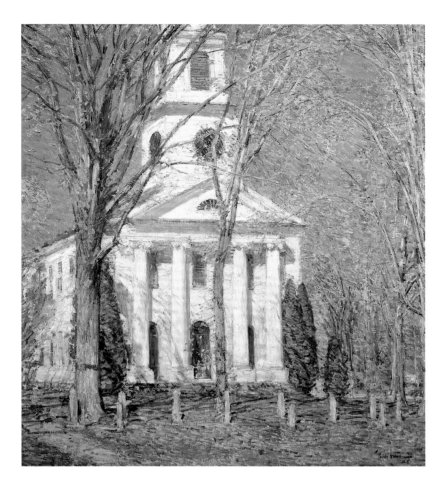

105. Childe Hassam, *Church at Old Lyme, Connecticut*, 1905, oil on canvas, 92.8 × 82.5 cm (36 1/4 × 32 1/4 in.). Albright-Knox Art Gallery, Buffalo, New York; Albert H. Tracy Fund, 1909.

tee the age and preservation of the two buildings, assuring the viewer that the natural and constructed are equally authentic and venerable.

Other historical roles played by the two buildings are more complex. The Lord mansion, built shortly after the War of 1812, was considerably changed at the turn of the century.[43] Metcalf's facade screens these changes from view. In addition, he has removed several small houses in front of the mansion and introduced a generous green space (or stage) in the foreground of the painting. The space permits the viewer to see the house in "decongested" surroundings, to see it, presumably, as it would have looked in the past. The history of the church at Old Lyme turns around the Lord mansion narrative. In 1907, two years after Hassam had painted the church, it was destroyed by fire.[44] By 1910 it had been rebuilt, carefully following the lines of the old church. The haste to rebuild, one suspects, was to some extent driven by the need to restore the image of the town created by the Old Lyme painters.

Formal differences between the two pictures are also important. Metcalf uses nature to frame the Lord mansion, drawing the viewer toward it through a series of planes parallel to the plane of the picture. And he tones the facade of the mansion with deep, softly brushed shadows to give it warmth, the patina of age. Nature enfolds and frames the mansion, drawing the viewer toward it through a series of planes parallel to the picture. The Old Lyme church is a bit more austere, its white facade sharply lit and more clearly defined against the autumn sky.[45] On closer inspection, however, shadows lace across the columns of the church, their delicate patterns a subtle reminder of age, and sky-blue tints wash the side of the building, tints that soften the architecture, merging it with the landscape. The vertical accent of the facades is also handled differently. The framing elms and broken horizontal roofline heighten the Lord mansion; the truncated spire somewhat diminishes the Old Lyme church. Regardless of these distinctions, however, the two pasts represented in these paintings—a domestic past that was comfortable and attractive and a spiritual (Congregational) past that was stern and self-denying—work toward a common meaning. They (the two pasts) argue for the primacy of a traditional way of life, elevating it to the form of a religion. In this religion, however, the spiritual seems slowly to give way to the aesthetic. A subtle change in composition here, a soft touch of color there, and eventually the hard edges (and issues) of the present dissolve, leaving the viewer in an ideal past.

According to Metcalf and Hassam and the views of Deerfield by Champney (*see* Fig. 78) and Gloucester by Alice Schille (*see* Fig. 107), few are admitted to this old New England faith. Not a soul disturbs the tranquility of the Metcalf and Hassam pictures, and only a few strollers cross Champney's Deerfield green or wander down the Gloucester Street painted by Schille. Moreover, the latter two paintings measure this quiet detachment over nearly a forty-year period. The Champney painting

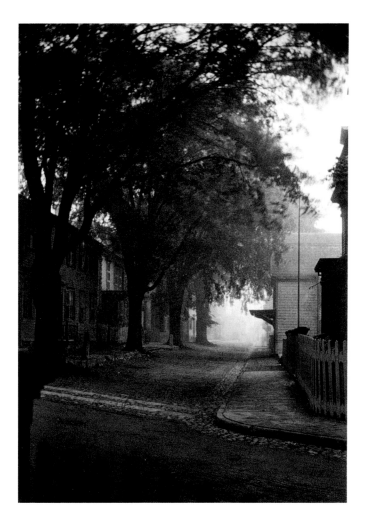

106. Clarence White, *New England Street*, 1907, platinum print, 24.1 × 15.8 cm (9 1/2 × 6 1/4 in.). The Museum of Modern Art, New York. Gift of Mr. and Mrs. Clarence H. White, Jr. Copy Print © 1998 The Museum of Modern Art, New York.

is laden with postcentennial nostalgia; the shade of the past is everywhere. A similar formula carries through Clarence White's *New England Street* (Fig. 106) to Schille's Gloucester street scene, although both are more frankly tourist pictures, encouraging viewers to visit old New England. That is especially true of the Schille watercolor, with its plein-air palette and sloping street, leading away and down from the foreground (Fig. 107). Also evident is what is not in the picture—the commercial fishing port and "new" Gloucester, already the subject of paintings by John Sloan (Fig. 108) and Stuart Davis (*see* Fig. 206), who seem to relish imposing the new on the old.[46]

Charles Lang Freer, whose collection included turn-of-the-century views of New England by Thayer, Dewing, Metcalf, and Dwight Tryon, once described the color of a prized Chinese bowl as "a delicate gray-ish sea-green, suggesting in consistency the sea in its churning shallows, lightened by minute air bubbles."[47] Freer's discerning eye is perhaps an unfair guide to use when judging the perceptions of the young woman in *The Blue Cup* (Fig. 109). Part of the problem is that artist Joseph DeCamp, no stranger to Boston drawing rooms, nevertheless leaves open the question of class. The woman seems a bit elegant for a maid or housekeeper and yet too simply dressed to qualify as a matron.[48] But that may be the point. She is apparently on a learning curve, set in motion by the beauty of the blue cup. The touch of her fingers, as well as her color and expression, inform the viewer of a sudden epiphany. Moreover, the light illuminating the cup casts fine shadows on her features, imparting to them a similar translucency. A softer light crosses the tabletop beside her, where it first calls attention to the mate of the cup she holds in her hands. Behind that cup, glow the colors of other exotic objects yet to be examined.

Art-historical quotations from the past are abundant. One may refer back to Copley's paintings—those in which objects above or on tabletops are reflected in them. Another goes back further, to Vermeer and to seventeenth-century paintings of female saints in ecstasy. The objects in the painting—the China trade items and neoclassical tea table—are, of course, direct borrowings from genteel old New England. This past is also invoked by closure and containment, by excluding a present beyond the limited interior space of the painting. Within that space, conceived as if it were a hothouse, containing not flowers but exquisite heirlooms, the woman is obliged to recognize both the value of a beautiful past (in the form of the china cup) and the need to preserve and care for it. Outside the rarified atmosphere of *The Blue Cup,* outside the feminized interiors that are a hallmark of the Boston school, such lessons are more difficult to learn.[49] In the masculine workday world, art and the past have diminished authority. They are reserved for evenings, weekends, trips to the country. Only the drawing room and quiet old-fashioned villages like Deerfield offer a continuum, a place where art and the past can flourish.

Tarbell's *New England Interior* (*see* Fig. 90) and a studio picture by Boston artist Ignaz Gaugengigl (Fig. 110) are also characteristic New England interiors of the period.[50] Each is quietly toned, informally arranged, and beautifully appointed. *The Artist's Studio,* in particular, displays a rich variety of objects: rugs, tapestries, antlers

107. Alice Schille, *White Houses*, ca. 1916, watercolor, 44.5 × 52.1 cm (17 1/2 × 20 1/2 in.). Courtesy of The Canton Museum of Art, James C. and Barbara J. Koppe Collection.

108. John Sloan, *Hill, Main Street, Gloucester*, ca. 1916, oil on canvas, 65.4 × 100.9 cm (25 3/4 × 39 7/8 in.). The Parrish Art Museum, Southampton, New York, Littlejohn Collection.

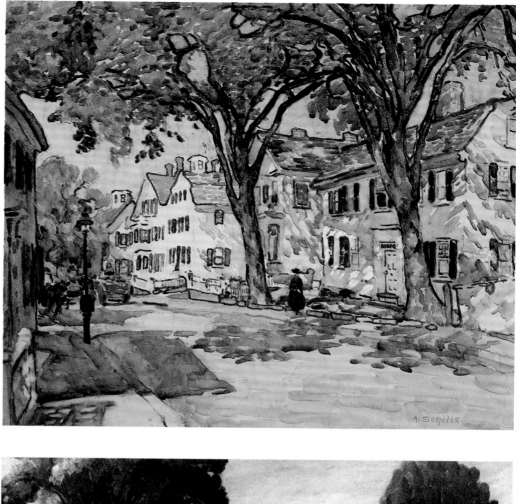

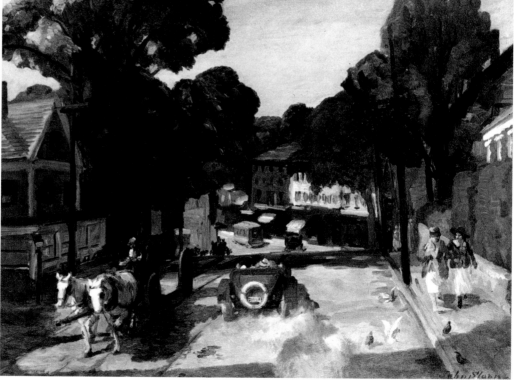

109. Joseph DeCamp, *The Blue Cup*, 1909, oil on canvas, 126.7 × 104.5 cm (49 7/8 × 41 1/8 in.). Gift of Edwin S. Webster, Lawrence J. Webster, and Mrs. Mary S. Sampson, in memory of their father, Frank G. Webster. Courtesy of Museum of Fine Arts, Boston.

110. Ignaz Gaugengigl, *The Artist's Studio*, ca. 1910, oil on canvas, 57.2 × 76.2 cm (22 1/2 × 30 in.). Adelson Galleries, Inc., New York.

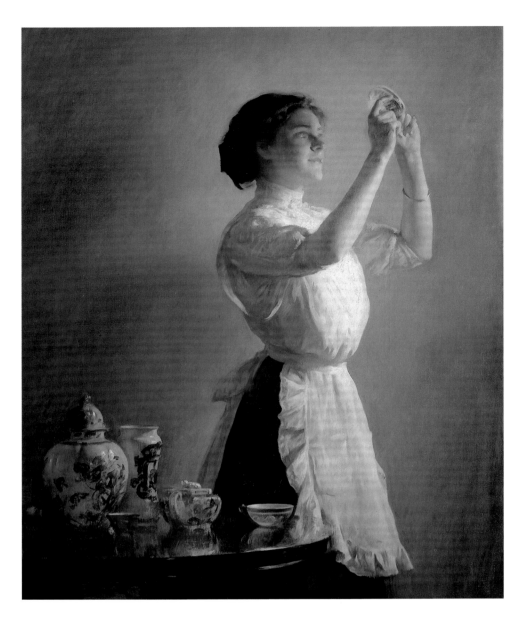

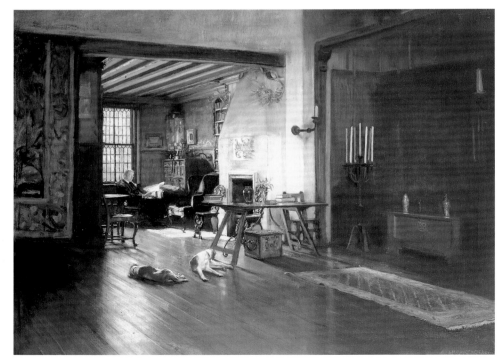

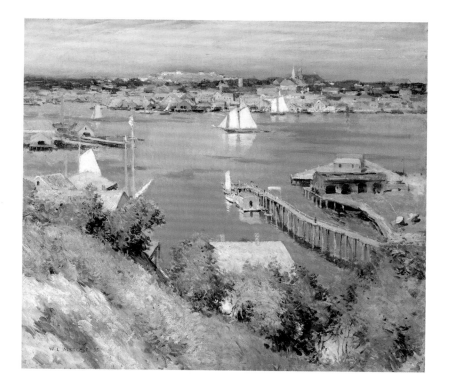

111. Willard Leroy Metcalf, *Gloucester Harbor*, 1895, oil on canvas, 66.0 × 73.0 cm (26 × 28 3/4 in.). Mead Art Museum, Amherst College, Gift of George D. Pratt, class of 1893.

(on the chimney piece, barely discernible), orientalia, pictures, and furniture (including Queen Anne and Chippendale chairs). The past is pervasive, but again no specific past comes to mind. Both the decor and the light, diminished by passage through windows, seem to put time on hold, as if it no longer measures a finite series of events. Tarbell and Gaugengigl, however, are lively composers of interior space; their figures often have less prominent compositional roles than those in DeCamp's paintings. Thus the importance of the past is made apparent not through a single transfiguring experience but through a less obvious internalizing process—the conversations of the two women in *New England Interior* and the imaginings of the artist, seated in the inner sanctum of his studio. That process has an analogue in the spatial arrangements of both interiors, each expanded and divided by windows, doorways, and alcoves. Fine gradations of color and light contribute to this effect. They further nuance the interior spaces as well as the private thoughts and feelings of the figures within them.

Taking the Colonial Public

The remote and exclusive New England appearing in the work of "The Ten" and the Old Lyme painters is only one version of the regional past in circulation at the time. Other versions of that past reached out to broader audiences. Village industries, such as those underway at Deerfield and the immigrant training program at the House of the Seven Gables brought a more tangible colonial past into the lives of middle- and working-class people. The preservation movement—ranging from organizations like SPNEA, with its self-imposed mandate to rescue, restore, and exhibit old buildings, to numerous illustrated books and periodicals issued as an aid to recollect and savor the past—also broadened the appeal of the colonial past. Antique collecting, from its historical to its more aesthetically informed phase, and the impetus it gave to the reproduction market attracted a middle class that needed an old-fashioned antidote to urban life. Photographers sometimes trained their cameras on newer subjects, like the black population in Boston, and yet their work too can be read as descending from pre-Civil War abolitionist images, as a before-and-after sequence that tells its own New England story.

Images promoting tourism also delve into the past. They began several decades before the Civil War and proliferated afterward. At the turn of the century these images continued to focus on places, especially along the New England shore, with long-standing historical associations. Deerfield and Old Lyme as well as Gloucester, Rockport, and Provincetown, the Isles of Shoals, and Ogunquit were pictured in numerous paintings, prints, and photographs. The subjects selected at these various locations were often similar, although the medium in which they were reproduced tended to determine how time specific they were. Metcalf's *Gloucester Harbor* (Fig. 111), for example, sets the viewer on a sunny headland, with a blue expanse of water separating him or her from the warehouses and canneries across the harbor, the commercial base of what was then the largest fishing port in the world. Old wharves in the foreground and a graceful schooner coasting through the center of the picture

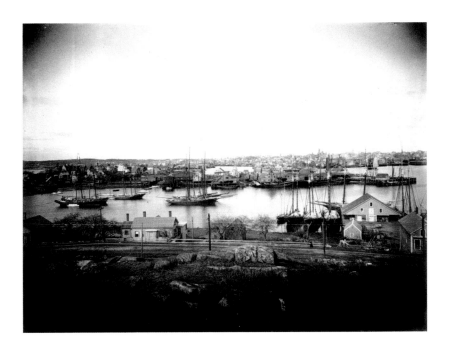

112. Herman W. Spooner, *View from Banner Hill, East Gloucester*, ca. 1900, photograph, 20.5 × 25.6 cm (8 × 10 in.). Cape Ann Historical Association, Gloucester, Massachusetts.

more openly admit Gloucester's role as a fishing port. But the current state of the fishing industry and where the viewer stands in relation to the present or past, the painting refuses to make clear.

A photograph of Gloucester harbor (Fig. 112), taken shortly before 1900 and aimed in the same direction as the Metcalf painting (that is, east to west, with Rocky Neck interceding between the two shores), gives more specific information about time. The trolley line in the foreground, the variety and age of the fishing boats in the inner harbor, the configuration of the houses on Rocky Neck, and the large freighter between Rocky Neck and the western shore of the harbor are chronological markers not present in Metcalf's painting. The photograph, however, aestheticizes the harbor in its own way, with picturesque fishing boats at anchor in the foreground, an even tonality, and a calm and purposeful spatial recession, based on horizontal bands that carry one's eye across the harbor to the opposite shore. Moreover, the photograph, like the painting, keeps its distance from the commercial operation of the harbor. What hindsight does reveal is another kind of commerce, that of making and selling the past. Both painting and photograph have subtly transformed (the painting more discreetly) the colorful old harbor into an image that would, over the next few decades, help establish it as a prime tourist attraction and the visual resource for the largest art colony in New England.

Brochures (Fig. 113) and posters (Fig. 114) followed paintings and photographs as train (and subsequently automobile) travel became a more convenient way of touring New England. The images carried in commercial media were standard views of New England, with the mountains and the seashore still the prime subjects. Despite the generalized features of the landscape in both the Berkshire Hills brochure and New York Central poster, time is calculated more closely than in the earlier painting and photograph. The poster distinguishes between present and past by assigning the viewer to the foreground and then carefully dividing that space from the past, which exists below and at a distance from the present. The brochure in turn marks that present with sightseers in period dress, accompanied by their automobile, and with landscape forms done in a suave arts and crafts style. The poster landscape, like the brochure landscape, draws from many different sources to create a regional stereotype. Unlike the brochure, however, the poster does not employ actual figures to mark the present, but their presence is nevertheless implied. The trees in the foreground, strikingly off-center additions to an otherwise conventional landscape composition, lead one to that assumption. They bring to mind the familiar landscape objects a passenger might note when looking through a train window (the top edge of the poster cuts off the top of the large tree). Thus both images (the brochure and the poster) and the graphics accompanying them place viewers firmly in the present, looking beyond (or out) at a neatly framed, attractively composed past.

Neither railroads, preservation societies, nor village industries were the most active proselytizers for colonial New England, however. That distinction belonged to a retired Congregational minister, Wallace Nutting, who went on to found a colonial revival commercial empire in the first decade of the twentieth century. Nutting conceived of the past not as something imaginary or elusive but as tangible—a past

he could sell to a middle-class audience firmly situated in a modern, industrial present. But while selling, Nutting was also preaching. Underlying his sense of what to restore, reproduce, and offer the public was, according to Karal Ann Marling, a "private, interior iconography"—featuring old fireplaces and doorways—shared "with others of his tribe similarly devoted to the regeneration of American virtue through the restoration of the American home."[51] Spreading the gospel, therefore, was as important to Nutting as turning a profit. Indeed, one was dependent on the other. At the height of his career, for example, he owned five beautifully furnished historic-house museums, each strategically located along a motor-touring route through New England. He tapped an even larger market with a line of popular, hand-colored photographs (Figs. 115, 116), books, and reproduction furniture (Fig. 117). Virtue, in these forms, could be used to decorate middle-class parlors. For those on a limited budget, Nutting staged subjects like *The Blue Cup* with "authentic" colonial backgrounds. For more affluent customers, he provided "Nutting originals" (gate-leg tables, chests, Windsor chairs) made at his factories in Saugus and Framingham, Massachusetts.

Nutting was also happy to advise those seeking the "real thing." By the 1920s, however, that role had been effectively taken over by antique dealers, by the stunning examples that appeared in the newly opened American wing at the Metropolitan Museum of Art in New York, and by publications such as *Antiques* magazine, designed to appeal to a postwar middle class newly interested in Americana and in artifacts that revealed a more down-to-earth past. The "super-modern world" in which they lived, *Antiques* emphasized

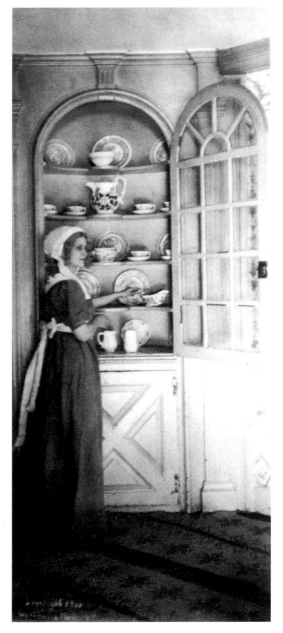

115. Wallace Nutting, *Apple Pie* (interior of the Cooper-Frost-Austin House, Cambridge, Massachusetts), ca. 1915, hand-colored platinotype, 19.2 × 23.7cm (7 1/2 × 9 1/4 in.). Society for the Preservation of New England Antiquities.

116. Wallace Nutting, *The Corner Cupboard*, ca. 1915, hand-colored platinotype. The Michael Ivankovich Antiques & Auction Co., Inc., Doylestown, Pennsylvania.

117. "Beauty, Construction, Style," advertisement for Wallace Nutting furniture, *Antiques* 9 (January 1926).

BEAUTY CONSTRUCTION STYLE

WALLACE NUTTING

in its first issue (1922), was "purposefully disdainful of tradition," a condition the magazine set out to remedy by appealing to connoisseurs, amateurs seeking a "humane acquaintance with the past," and collectors preoccupied with the chase, "forever stalking" the perfect Windsor chair.[52] Those responding to the *Antiques* menu surely had wide-ranging collecting interests, but many, one assumes, were new to the market and from a class that had not followed such pursuits before.

Succeeding examples of the colonial reaching a broader audience mostly repeat the approach of Nutting, who aggressively marketed a newly fabricated version of the past, or that of *Antiques,* which counseled its readers to collect the "real" past. Both approaches had the virtue of bringing the colonial within reach of the everyday consumer, but as time went on Nutting's probably had greater impact. Two examples that follow his lead are the depression-era marketing strategies of the Chase Brass and Copper Company of Waterbury, Connecticut, and, more far reaching, the development of colonial suburbs in the 1930s. Chase Brass and Copper, one of the premier suppliers of pipes and plumbing accessories to the building trade, lost many of its customers in the years following the stock-market crash of 1929.[53] To keep from going under, the company called in a group of talented designers—Russel

118. Walter Von Nessen, *Diplomat Coffee Service* (Chase Manufacturing Co.), ca. 1935, chrome plated brass, 29.9 cm diam. × 21.0 cm height (11 3/4 × 8 1/4 in.). The Connecticut Historical Society, Hartford, Connecticut.

119. Miles Standish Richmond, *A Group of Fifty New England Colonial Homes*, title page. Metropolitan Federal Savings and Loan Association, Boston, Massachusetts, 1939, Collection of Richard M. Candee.

120. *New Ideas for Building Your Home*, (Better Homes and Gardens, 1942). Collection of Richard M. Candee.

Wright, Lurelle Guild, and Walter Von Nessen—to create a product line for the average household. What emerged were streamlined serving dishes and cocktail shakers as well as many other items, such as Von Nessen's Diplomat Coffee Service (Fig. 118). Each of the three vessels in the set was made from a single piece of chrome-plated extruded copper, a technology Chase had previously used to manufacture industrial hardware. But the design of the vessels looks to the past. The tall, fluted coffee pot, in particular, is a stunning hybrid, indebted to both the designs of Paul Revere and the streamlined aesthetic of the 1930s.

Soon after the end of World War I a middle-class exodus from cities to suburbs was underway. This trend had begun, on a grander scale, during the last decades of the nineteenth century, when large tracts of rural land still surrounded major urban areas. But even the smaller tracts available to these later suburbanites offered more space, more privacy, and more peace of mind than could be found in the city.[54] Urban conditions during the 1930s continued the trend, although on a more modest scale. Most houses built in the new suburban areas, both in the East and the Midwest, followed traditional designs—colonial, Tudor, or some sort of historical mixture. Around Boston, predictably, the colonial style predominated. Subdivisions of small Cape Cods and individual colonial models, such as those designed by Miles Standish Richmond, architect to customers of the Metropolitan Federal Savings and Loan Association in Boston (Fig. 119), reintroduced the colonial home as "efficient, comfortable, and reasonable," the ideal solution for housing middle-class Americans.[55] Not surprisingly, the style offered the same note of reassurance provided by the Diplomat Coffee Service. Bankers and buyers of modest homes were convinced that the new colonials (Fig. 120) represented a solid investment during troubled times. This was especially true of first-time buyers who had only recently worked their way out of crowded cities. Signs of an enduring past—those manifest in the familiar lines of the colonial style—directed them toward these newly developed suburbs. Colonial doorways in other areas of the city might still admit only a select few, but those offered by firms like Metropolitan Federal were available to all who could afford a small down payment and who believed in the rhetoric, if not the politics, of the New Deal.

Notes

1. A similar aim is expressed by Albert G. Robinson: "the pleasure of hunting for old doorways in New England lies almost as much in the search as in the discovery" (Robinson, *Old New England Doorways*, 21).

2. The frequency with which colonial doorways appear in paintings, prints, photographs, and popular media at the turn of the century is also explained by Wallace Nutting. These doorway images, he wrote in 1912, "preserve the historical charm of the life of our fathers." At the center of this life, he continues, are the hearths, "hospitable and beautiful front doors," winding stairs, and old settles of our ancestors (quoted in Marling, *Washington Slept Here*, 173).

3. A house with a similar doorway, located in Newbury, Massachusetts, was constructed about 1790 (see Robinson, *Old New England Doorways*, pl. 12). Numerous books featuring colonial doorways bracket the date of the Graves painting. Earlier examples include Whitefield, *Homes of Our Forefathers*, and Wharton, *Through Colonial Doorways*. Two that followed are Robinson, *Old New England Doorways*, and Wright, ed., *House & Garden's Book of Houses*.

4. Quoted in Peters and Lukehart, eds., *Visions of Home*, 84.

5. See Emmet, *So Fine a Prospect*, 130–43, 177–90.

6. Weinberg, Burke, and Curry, *American Impressionism and Realism*, 92. Ironically, Thaxter's presence on Appledore Island probably helped it become more attached to urban life.

7. Another Civil War monument appears in *Martyr Hill* by Louis Guglielmi (*see* Fig. 210).

8. For the Deerfield–New York axis of Champney's life, see Monkhouse et al., *Champney*, 13–17.

9. See two recent books on the subject: Stillinger, *Historic Deerfield*; and McGowan and Miller, *Family and Landscape*.

10. Smith-Rosenberg, *Disorderly Conduct*, 245.

11. Quoted in Miller and Lanning, "'Common Parlors,'" 439.

12. Ibid.

13. The Society of Blue and White Needlework was founded in 1896 by Ellen Miller and Margaret Whiting. Its activities, along with those of the Pocumtuck Basket Makers, are described in Flynt, McGowan, and Miller, *Gathered and Preserved*, 50–53. Another helpful source is Zusy, "Against Overwork and Sweating."

14. For more information on the chest, see Denenberg, "Consumed by the Past"; and Ellen M. Synder-Grenier, "Cornelius Kelley of Deerfield, Massachusetts: The Impact of Change on a Rural Blacksmith," in Bert Denker, ed., *The Substance of Style: Perspectives on the American Arts and Crafts Movement* (Winterthur, Del.: Henry Francis du Pont Winterthur Museum, 1996), 263–79.

15. Two books of essays are especially important for expanding and redefining the aims of colonial revivals: Axelrod, ed., *The Colonial Revival in America*, see especially Kenneth Ames's Introduction, 1–14; and Giffen and Murphy, eds., *"Noble and Dignified Stream."*

16. In 1913, when submitting a plan to redesign the green in Litchfield, Connecticut, Frederick Law Olmsted, Jr., argued that the "controlling idea of all improvements should be . . . refined simplicity," the same motive of design that characterized the "old Colonial style of architecture." "All people of good taste," he added, would associate this motive with what was "desirable in a country town." See letter of 16 April 1913, from Olmsted to Seymour Cunningham, president of the Village Improvement Society. The letter, in the collection of the Litchfield Historical Society, was kindly brought to the author's attention by Judy Maxwell.

17. Naus, "Their Own Labor, Their Thought, and Good Taste," 3, 12–15.

18. Green, "Popular Science and Political Thought Converge."

19. Monkhouse, "Spinning Wheel," 155–72.

20. James, *American Scene*, 53.

21. Cook, *House Beautiful*, 62.

22. Appleton's career is treated at length in Lindgren, *Preserving Historic New England*.

23. The boys' program at the House of the Seven Gables was based on Sloyd exercises, developed by the Swedish educational theorist Otto Salomon and promoted in this country by the Sloyd Training School in Boston which, by 1898, was publishing the *Sloyd Bulletin*. The exercises were designed "to facilitate the economic and social integration of the immigrant into the community" (see Denenberg, "Chandler"). At another level such programs were driven by the fear that new immigrants, not properly assimilated, would create social and political unrest. As one Salem journalist observed, the proliferation of "foreigners" in the local community should be dealt with by trying to "Americanize" the best of them. "They are here, they already hold the balance of power in city politics, and if they are not given the hand of fellowship and assimilated and inspired with respect for American ideals and American institutions, they will get absorbed and go to swell the columns of socialism, militant laborism, and other worse isms" (quoted in Kammen, *Mystic Chords of Memory*).

24. See Meyer, ed., *Inspiring Reform*.

25. Sichel, *Black Boston*.

26. L. Perry Curtis, Jr., *Apes and Angels: The Irishman in Victorian Caricature* (Washington, D.C.: Smithsonian Institution Press, 1971).

27. See Brown, "Purchasing the Past," 7–11.

28. A principal advocate for old New England, Harvard professor Charles Eliot Norton addressed the mansion-building habits of these industrialists: "I have heard a worthy . . . old friend observe of the sumptuous palaces of modern gentry, that 'money could do much with stone and mortar, but, thank heaven, there was no such thing as suddenly building up an avenue of Oaks'" (Charles Eliot Norton, "The Lack of Old Homes in America," *Scribner's* 5 [June 1889]: 636).

29. For more on Cornish, see Pyne, *Art and the Higher Life*, 139–48; Hobbs, *Dewing*, 19–21; and *A Circle of Friends: Art Colonies of Cornish and Dublin* (Durham: Thorne-Sagendorph Art Gallery, Keene State College, and the University Art Galleries, University of New Hampshire, 1985), 33–72.

30. Pyne, *Art and the Higher Life*, 6–7.
31. See Hobbs, *Dewing*, 9–10; and Lessard, *Architect of Desire*.
32. Pyne, *Art and the Higher Life*, 254. While spending the summer of 1920 in Old Lyme, the artist Peggy Bacon (a modernist impatient with older styles of painting) wrote to a friend: "We are pining away for congenial society . . . the Lyme artists [are] a sickening crew of stuffy, snobbish, wealthy ante-impressionists with a few super-moderns such as the impressionists Everett Warner and Guy Wiggins" (quoted in *Peggy Bacon*, 17).
33. Typecasting this group is, however, a bit dangerous. Catherine Lorillard Wolfe also owned Winslow Homer's *Life Line* (*see* Fig. 165).
34. Gerdts, "The Ten," 11–12. Among critics there was growing enthusiasm for impressionism.
35. Gerdts ("The Ten," 15, 22, and 29) notes, however, that New York critics, when reviewing the annual shows of "The Ten," favored New York members, whom they thought more adventuresome. When the shows traveled to Boston, local critics praised instead Tarbell, Benson, and DeCamp. Some indication of what stylistic traits were thought to distinguish one versus the other of the two artistic camps is given in a review of the 1911 New York exhibition of "The Ten." The Boston contingent was called "a body of refined, middle-aged men . . . no longer seduced by the siren of the moderns; they have filled their pictorial sensations to the vanishing point and are content with simple phrases, jeweled cadences" (quoted in Bedford, *Benson*, 129). "The Ten" showed in New York at commercial galleries—Durand-Ruel, Montross, and Knoedler. When the exhibitions went to Boston, where galleries were smaller, they were shown at the exclusive St. Botolph Club.
36. Anderson, "A Season in Lyme," 27. Florence Griswold also maintained an old-fashioned garden. Despite the informal atmosphere that prevailed in her home, the painters must have sensed that when in Old Lyme, they were in touch with old New England. As the author of a 1926 guidebook noted, "Lyme is a most American town. . . . Descendants of the early settlers are still living in the ancestral homes, even to the seventh generation. . . . The slightest claim to kinship makes you welcome—but you have to 'be born' to 'belong'" (Whiteside, *Touring New England*, 119).
37. Also attracting artists to Old Lyme was the Lyme Summer School of Art, sponsored by the Art Students League and presided over by Frank Vincent DuMond. The same year the school opened (1902) the first of many "summer annuals" was held, featuring an art show in the town library (see *Connecticut and American Impressionism*, 121–22, 129–30). Accompanying the first show was a display of "prized" antiques and curios, lent by local residents. Like the craft shows in Deerfield, the summer annuals put Old Lyme on the tourism map and helped revive its economy.
38. Pyne, *Art and the Higher Life*, 273.
39. Bedford, *Benson*, 16.
40. Bedford says that Benson had a "strong" financial portfolio, built by carefully investing the proceeds from his painting sales (ibid., 126).
41. See Van Hook, *Angels of Art*, 205–7. Bedford notes that in other pictures of Benson's daughters, the artist sought to represent the "truthful appearance of young American womanhood" (Bedford, *Benson*, 143).
42. Quoted in Hiesinger, *Hassam*, 124.
43. For a detailed account of the changes, see Peters and Lukehart, eds., *Visions of Home*, 96.
44. Hiesinger, *Hassam*, 137 n. 37.
45. Hassam greatly admired New England churches, saying that they had "the same kind of beauty as Greek temples" (quoted in Hiesinger, *Hassam*, 125). After the Old Lyme church burned, he addressed the issue more pointedly: "I always had a real and pagan delight in the many and beautiful aspects of that old church" (*Connecticut and American Impressionism*, 133). By the 1920s the church represented not only New England but a style considered "purely American." See Rhoads, "Colonial Revival and the Americanization of Immigrants," 352–53. Jack Becker, curator of the Florence Griswold Museum, kindly brought this reference to my attention.
46. Many of Schille's subjects were also of new Gloucester (see Wells, *Schille*, no. 17).
47. Quoted in Curry, *Whistler at the Freer*, 19.
48. Three sources on this painting are particularly helpful: Gerdts, *Masterworks of American Impressionism*, 122, 159; O'Leary, *At Beck and Call*, 250–53; and Buckley, *DeCamp*, 113–14. Whether this is a servant, coached by an offstage employer, or a woman of higher station, engaged in self-culture, the broader message the painting sends is that the pursuit of beauty is transferable, down the social hierarchy. Among Boston school painters, DeCamp seems most responsive to the educational philosophies of those sponsoring craft societies in Deerfield, Salem, and Boston.
49. Trevor Fairbrother defines what he regards as the key stylistic traits of Boston school interiors: "an application [of paint] that is careful, gentle, and knowledgeable; restraint from the effects of color or execution that destroy the harmony of the whole; an overall finish that wants to be as much a part of a long artistic tradition as an expression of the individuality of the artist" (Fairbrother, *Bostonians*, 77).
50. For more information on *New England Interior* and *The Artist's Studio*, see, respectively, Docherty, "Model Families," 61; and *American Impressionism*.
51. Marling, *Washington Slept Here*, 174. In addition to Marling's discussion of Nutting (171–76) and numerous books written by him, two recent articles are helpful in understanding his career. These are Barendson, "Nutting"; and Woods, "Viewing Colonial America through the Lens of Wallace Nutting."
52. "*Antiques* Speaks for Itself," *Antiques* 1 (January 1922): 7.
53. For a fuller explanation of Chase's marketing strategies, see Denenberg, "Chase Chrome."
54. Stilgoe, *Borderland*, 296–300.
55. *A Group of Fifty New England Colonial Homes*. Richard M. Candee, professor of American and New England studies at Boston University, kindly supplied this information from his personal files.

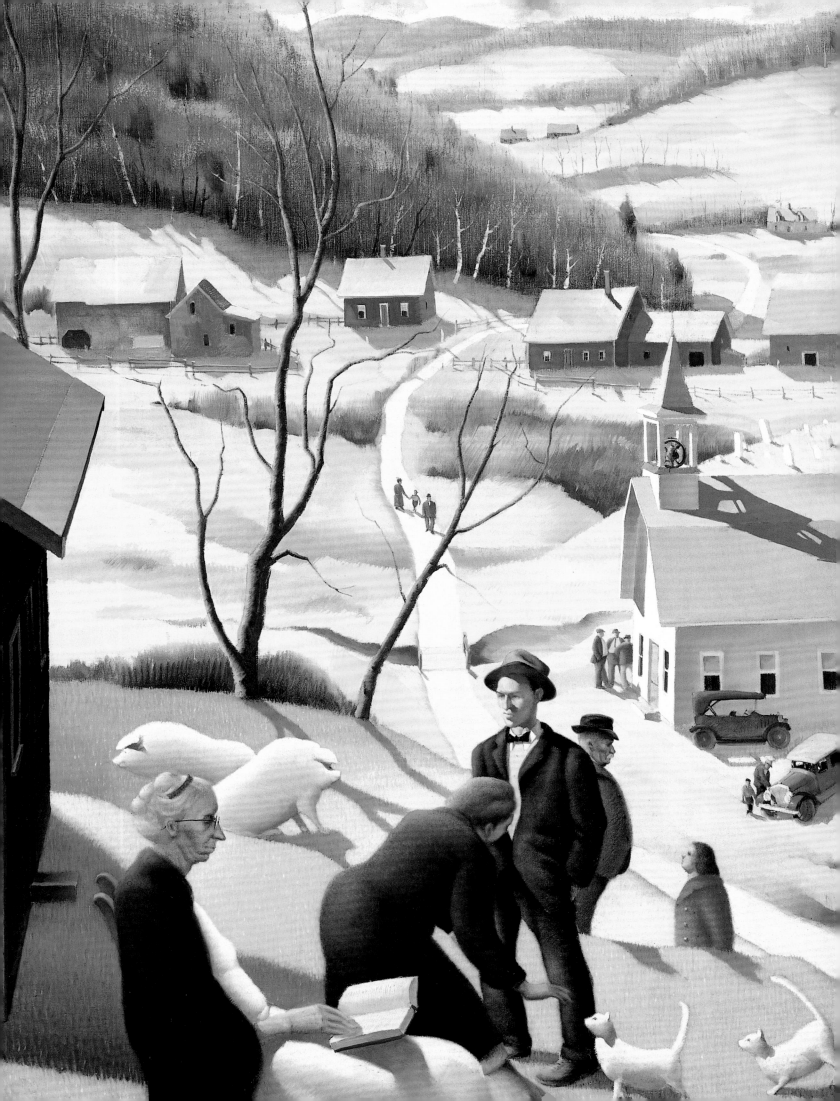

Small-Town America

WILLIAM H. TRUETTNER

Images of New England in the 1930s were no more governed by a single set of beliefs or artistic concerns than they had been in 1900. "Yankee" modernists, for example, abandoned their New York studios every summer for a stay at one or more favorite haunts along the New England coast. There they tested new formal strategies on subjects previously canonized by generations of representational artists. Another group, responding more directly to social issues raised by the Great Depression, sought a modest, old-fashioned New England in the rural uplands of Vermont, New Hampshire, and Maine. These artists were more traditional picture makers than the modernists, although some stylistic overlap existed between the two groups and neither focused exclusively on one location. The different artistic temperaments of the two groups are also difficult to separate on the basis of social and political beliefs. In both these seem to have varied widely, yet the artists who painted and photographed the rural north had in common an aim not necessarily shared by the modernists. They wished to address widespread concerns about the national economy and urban life.

Preceding those who went to the rural north in the 1930s were many distinguished artists, beginning with landscape painters such as Thomas Cole, John F. Kensett, Albert Bierstadt, and George Inness, all of whom had gone to the White Mountains in the nineteenth century to paint what would become, or already were, major tourist attractions. Others followed in the early twentieth century, Abbott Thayer and Willard Metcalf, to name well-known figures, and, by the 1920s, several modernists, John Marin, Marsden Hartley, and Marguerite and William Zorach, who customarily spent their time on the coast. But their objectives were not those of the artists and writers who in the 1930s worked to fix a regionalist image on this part of New England, to make it into a major source for images of small-town America. How these artists managed to have it both ways, to represent New England as a familiar rural stereotype and as cozy, down-to-earth America is perhaps key to how skillfully their images were made and marketed.

Our Town

Thornton Wilder's play *Our Town* opened on Broadway on 4 February 1938. The playbill for subsequent performances, at least those dating from 7 March, featured a cover illustration of Grover's Corners, New Hampshire (Fig. 121), the fictional town in which Wilder had set the play.[1] The illustration by Adolph Dehn, a regionalist painter working out of New York in the 1930s, pictures a town that has seen better days. Old false-front buildings and a church line one side of the street; a park or common, lacking any picturesque details, lies on the other side. The street is nearly empty, except for a horse and carriage and a few figures who loiter along the sidewalk. Only the train crossing the end of the street and smoke pouring from a

Paul Starrett Sample, *Beaver Meadow* (detail), 1939, oil on canvas, 101.6 × 123.2 cm (40 × 48 1/4 in.). Hood Museum of Art, Dartmouth College, Hanover, New Hampshire; Gift of the Artist, Paul Sample, class of 1920, in memory of his brother, Donald M. Sample, class of 1921.

JED HARRIS
presents

OUR TOWN

A PLAY BY
THORNTON WILDER

with

FRANK CRAVEN

MOROSCO THEATRE

121. Adolf Dehn, *Our Town*, Morosco Theatre Playbill, 1938. The Harvard Theater Collection, The Houghton Library.

factory chimney in the background interrupt the feeling of sleepiness and decay.

In the months that followed, *Our Town* became a critical and financial success and brought Wilder a second Pulitzer Prize.[2] Dehn was apparently called on again to illustrate Grover's Corners, this time for a large poster (Fig. 122) that would prominently acknowledge the prize as well as inform audiences that the play could be seen in the "air cooled Morosco Theatre." The second time around, Dehn came up with a considerably different Grover's Corners. The depression-era feeling seems to have lifted. The town looks vital, neat, and clean, with more attractive local architecture (the store on the left, made over from an old saltbox), more activity (two additional horse-and-buggy rigs and no loiterers), more religion (four churches, one at the end of main street, where the train previously ran), and an absence of industry. Moreover, two principals in the play, Emily Webb and George Gibbs, are seen courting under a tree in the left foreground.

The success of the play must in some way account for the brighter look of Dehn's poster. But one also notes that the clock has been turned back: the appearance of Grover's Corners is more consistent with the idealized, horse-and-buggy era (1901–13) in which Wilder set the play. Dehn's second image markets Grover's Corners as much more old New England than the playbill image, a strategy that would undoubtedly have broadened the public appeal for *Our Town*. More difficult to know is whether Dehn or Wilder (or both) had such a strategy in mind. One can argue, nevertheless, that they were following the lead of other artists and writers, who, when addressing New England subjects during the 1930s, were similarly inclined to register the present in terms of an old-fashioned rural past.

A telling example of that turning back occurs in the third and final act of *Our Town*, when the Stage Manager describes a windy hilltop where the town cemetery is located. "Yes, beautiful spot up here," the narrator remarks. "Mountain laurel and li-lacks. I often wonder why people like to be buried in Woodlawn and Brooklyn when they might pass the same time up here." Pointing across the stage to make-believe seventeenth-century gravestones, he continues: "Strong-minded people that come a long way to be independent." Another group of graves, marked by iron flags, are those of Civil War veterans. They, the narrator explains, "had a notion that the Union ought to be kept together . . . and they went out and died about it."[3] Through the narrator Wilder uses the hilltop scene not only to look out, beyond Grover's Corners, but also to make that view a way of looking back. The view in this case reaches all the way to Brooklyn and is, on one level, popular anti-urban rhetoric of the period, comparing repose on a lilac-covered hilltop in New Hampshire to a plot in a crowded city cemetery. But the rhetoric also implies a return: coming home to be buried *is* going back to the past.

123. Paul Strand, *Burying Ground, Vermont*, 1946, gelatin silver print, 23.8 × 18.7 cm (9 3/8 × 7 3/8 in.). Philadelphia Museum of Art, The Paul Strand Retrospective Collection: 1915–1975, gift of the Estate of Paul Strand. © 1950, Aperture Foundation, Inc., Paul Strand Archive.

In the next passage the narrator engages the past more directly, tracing the New England character back to the first wave of settlers who came to Grover's Corners. He then proceeds to nationalize that character, with his allusion to Civil War veterans—boys, he claims, who had never seen more than fifty miles of New England but believed that it represented a microcosm of the United States. One suspects Wilder of plotting an evolutionary nationalist geography, in which Grover's Corners grows into New England, New England into the Union, and the Union into the United States. When one proceeds in the opposite direction, back to Grover's Corners, the devolution makes even clearer how much the scheme features the New England past as the national past.

That past, Wilder implies, continues to unfold in the present. Thus the town has a presence in the past; it has roots that go deep, into a soil enriched by history and tradition. Moreover, the town is not located in one of the temperate, pastoral, and urbanized areas of New England. Its roots are sunk, like the grave markers photographed a few years later by Paul Strand (Fig. 123), in a remote, rugged, northern clime. From the hill where the cemetery lies, the narrator reminds us, one can see with "a glass" all the way to the White Mountains, emblems of northern New England from the early nineteenth century to the present day.

Wilder's version of Grover's Corners could have been drawn from many sources. One, perhaps too obvious, was the town of Peterborough, New Hampshire, which he came to know as a resident of the MacDowell Colony. From 1924 on he spent numerous summers at the colony, including the summer of 1937, just before he began work on *Our Town*.[4] Additional, and more likely, inspiration must have come from an ongoing literary investigation of the New England past. During the 1920s and 1930s Wilder was an academic (he taught first at The Lawrenceville School in Princeton, New Jersey, then at the University of Chicago) as well as an author, and he was surely familiar with books such as Lewis Mumford's *Golden Day* (1926), in which the author pays tribute to New Englanders rising "to the challenge of the 'American scene.'" Emerson, Thoreau, Whitman, Melville, and Hawthorne created in their work an imaginative New World, Mumford claimed, one that "arose out of free institutions planted in unpreempted soil, molded by fresh contact with forest and sea."[5] From Mumford's sturdy New Englanders, determined to leave their imprint on "unpreempted soil," to strong-minded, independent early Americans, buried in graveyards like the one above Grover's Corners, does not seem a great distance. Both writers constructed the New England past as a special kind of American experience—a challenging encounter with a rugged, untested new land.

Works that followed Mumford's continued to plot a New England tradition within American arts and letters. Among the most important are *Studies in Classic American Literature* (1923) by D. H. Lawrence, *Main Currents in American Thought* (1927–30) by Vernon Louis Parrington, *The Re-Discovery of America* (1929) by Waldo Frank, the writings of William Carlos Williams, and pathfinding studies of vernacular arts and culture by Constance Rourke.[6] During the same period Robert Frost had become the legendary farmer-poet of New England (Fig. 124).

Other issues are raised by Van Wyck Brooks's *Flowering of New England,* published in 1936, a narrative account of New England letters from the early nineteenth cen-

tury to the death of Thoreau in 1862. Endorsed by most critics, the book achieved best-seller status almost overnight and won a Pulitzer before the year was out. But scholars, F. O. Matthiessen in particular, were uneasy about the New England constructed by Brooks; they thought it too comfortable and homogeneous.[7] Grover's Corners, one could argue, has some of the same characteristics. Across the tracks from where the Gibbs and Webb families live are "Canuck" and Polish families, briefly mentioned in the first act and never heard from again. "Our" town, then, acknowledges diversity but draws a line between Yankees and so-called immigrants; nor does Wilder attempt to engage other social and economic problems of the period. Modern life has hardly made a dent in the daily routine of Grover's Corners. The proximity of World War I, which the reader learns about only through the musings of the narrator, and the appearance of a horseless carriage on Main Street are two of the few topical events in the play that locate action in a chronological rather than an abstract time frame.

On the other hand, the cultural distance between Grover's Corners and Brooks's account of Concord is substantial. Life in the former is relentlessly middle class; eccentric behavior and long-winded literary discussion are luxuries no one has time for.[8] Wilder's narrator says so, both directly and in his manner of speech, which is terse, laconic, and salted with provincial phrases. It is designed to convey profound ideas about life cycles and their meanings with a marked absence of style. Stage action is also simple and direct, reduced to the bare needs of the plot, and characters are so convincingly cast as ordinary that one marvels at how the play maintains dramatic force. These formal traits suggest, of course, that Wilder wants the play to reach a wide-ranging urban audience, to touch those who may have come to the city from a Grover's Corners. In addition, he is tuned to a 1930s aesthetic that appears frequently in the work of contemporary painters and photographers representing New England. Author and image maker are bound by their wish to make art out of the lives of strong-willed, tight-lipped, middle-class Yankees and the locale in which they flourished.

Grover's Corners is also located north of Boston, in the heart of the rugged New England that Robert Frost had been writing about for two decades. Wilder probably meant it to represent a generic New England, but scholars today are more inclined to see it as a community image that replaced the one represented by the turn-of-the-century New England whose home base was in genteel colonial towns like Deerfield, Massachusetts, Old Lyme, Connecticut, and Portsmouth, New Hampshire. Why in the 1920s the regional image began turning north, to rural Vermont and New Hampshire (and to the Maine coast), and why artists such as Dehn and Gregorio Prestopino (*see* Fig. 209) chose to represent it in more common, everyday terms, are questions not easily answered. No single issue seems to have prompted the new emphasis given to northern New England during those years nor was there a dedicated group of local regionalists, as in the Midwest, advocating such a program. Indeed, whatever cultural transformation went on is probably better described as a search, in this case for a more unassuming and egalitarian (within Wilder's guidelines) New England. The difference between

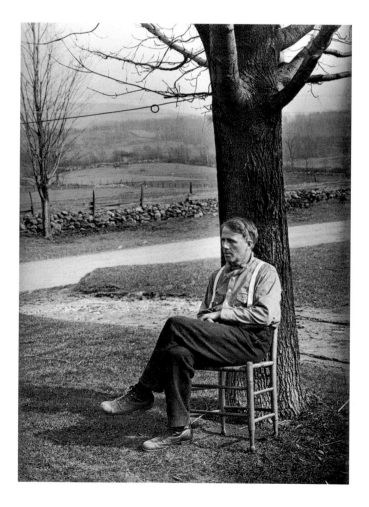

124. Paul Waitt, *The Farmer-Poet at the Stone Cottage*, 1921, Blackington Collection, Courtesy of Yankee Publishing Inc., Dublin, New Hampshire.

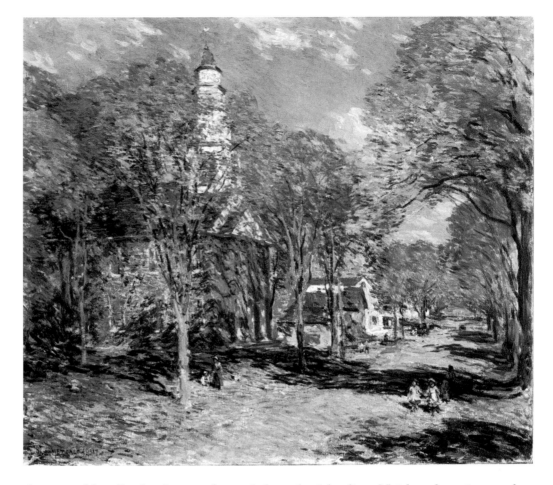

these two New Englands was often subtle and misleading. Neither those invested in the genteel New England of the turn of the century or in the later version of the 1930s wanted urban and industrial intrusion. And yet, the earlier generation could hardly avoid it. Their life-styles were deeply indebted to an urban economy, a debt acknowledged by the number of Childe Hassam paintings devoted to Boston and New York subjects. Those who in the 1930s turned to the rural North, on the other hand, were leery of cities and urban social problems. They wished to be less associated with modern bureaucratic life, less attached to a failing economic and social system (although not so unattached as to be beyond occasional government support).[9] In a more positive sense, they sought what people all across the country were seeking: down-to-earth neighbors, supportive communities, and roots, not necessarily those that made a more illustrious family tree but those that would reach down, fixing one to a place with an enduring past.

More insight into the difference between these two New Englands is provided by impressionist Willard Metcalf's 1917 view of the main street of Old Deerfield (Fig. 125) and a photograph of Brattleboro, Vermont, taken by Marion Post Wolcott in 1940 (Fig. 126). Metcalf's picture of Deerfield all but excludes the present—only a few pedestrians, mostly children, break the spell of the past. Otherwise, all signs of contemporary life—traffic and commerce, for example—have been erased. Deerfield consists of one long elm-lined street, a corridor that invites only a few to stroll down it, deeper into the past. Restrictions are set up by the Congregational church with its prominent tower and the old houses that face the street, imposing symbols of an established religious and social order. Nothing is asserted, however. Soft touches of autumn foliage obscure the buildings, distancing them from the present, and raking light creates heavy, still shadows along the street. Time seems to have stopped long before 1917, in some halcyon age that will continue as autumn changes to winter, winter to spring, and so on.

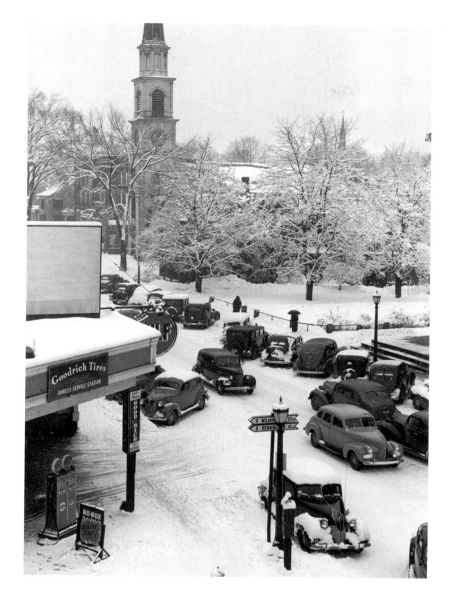

Wolcott was one of the talented photographers employed by Roy Stryker at the Farm Security Administration (FSA) during the 1930s.[10] Her photograph of Brattleboro, a large industrial town in southern Vermont, openly admits both the present and middle-class life. At the same time she acknowledges the past, setting the modern town center, all angles and corners, against a gentle background of snow-covered trees. Above the trees rises a church steeple, and beyond them is a row of old houses ("old" Brattleboro). To get to this past, one must first negotiate the present—a gas station, with four signs somewhat ominously advertising national-brand products. The viewer's gaze then takes in the automobile traffic on Main Street. Beyond that are a few brave pedestrians, stark silhouettes against the snow blanketing the ground. The mood of the scene is routine and businesslike and could be duplicated in any number of small towns. But two special messages emerge: life goes on in Yankee Brattleboro despite the elements and, although commerce has come to town, it is held in check, at least temporarily, by the presence of the past.

Guidebooks also indicate how much the idea of New England changes during these decades. *Old Paths and Legends of New England,* for example, the title of a book first published in 1903, suggests that old New England is elusive and mysterious. Only with the help of the well-educated, well-bred author, drawing together historical and literary references from the past, can one hope to understand it.[11] By the 1930s, however, elusiveness and mystery were out. New titles, like *Here's New England!,* used for a 1937 Federal Writers' Project (FWP) guide, implied that genteel mediators were unnecessary.[12] New England was accessible, the new titles claimed, to anyone (middle-class tourists especially) who could follow a map.

Between publication of the two books, the touring geography of New England also expanded northward. The earlier *Old Paths and Legends* concentrates on historic sites in Massachusetts and Rhode Island, never once mentioning Vermont and Maine, and singling out Portsmouth as the only place in New Hampshire worth a visit. The authors of *Here's New England!* devote more than half the text to describing Vermont, New Hampshire, and Maine, emphasizing the scenic attractions of the three states as well as their historic towns and villages. Equally revealing are the different ways colonial towns like Newburyport are given historical presence in the two books. In *Old Paths and Legends,* for example, contemporary Newburyport seems to be cast from the same mold as Metcalf's Deerfield, with an "elm-arched thoroughfare of charming homes," presided over by an impressive Episcopal church. When the author turns back to eighteenth-century Newburyport, she describes it as a place of "pomp and splendor," filled with ambitious young sea captains and

126. Marion Post Wolcott, *Corner of Main Street, Center of Town, after Blizzard, Brattleboro, Vermont,* 1940, gelatin silver print. Library of Congress, Prints and Photographs Division.

merchants, whose pride, wealth, and culture were the foundation of colonial society. The most obvious signs of their accomplishment were the great mansions built along High Street, the same street that by 1903 had become a "charming thoroughfare." The transition of High Street from a seat of power to a tourist attraction seems to mark a similar decline in Newburyport's economy, from what the author describes as the "good old mercantile times" of the eighteenth century to the early twentieth century, when making "silver goods in colonial designs" was one of many "successful industries."[13] Commensurate with that decline—the transition from high commerce to industries that reproduced the past—was a deepening nostalgia for colonial times and for an established economic and social order.

Much less sentiment clouds the pages devoted to Newburyport in *Here's New England!* The town is briefly introduced as a former shipping port, no mention is made of elm-lined thoroughfares, and the "High Street houses" are called "a staunch monument to the shipwrights who built them for the captains and merchant-owners."[14] During the thirty-four years separating the two entries, Newburyport had probably not changed a great deal, but the class of those consuming old New England had indeed. Prosperous sea captains and merchants, the focus of the 1903 book, had lost favor among FWP authors. Instead they credited shipwrights, the artisan class of the eighteenth century, with building the imposing mansions lining High Street.

Town Meetings and Rural Ways

When the concept of a genteel and prosperous old New England did fade, at least as a subject to inspire artists and writers, it was replaced by a more austere, democratic, middle-class New England, bred of many strains but dominated by the belief that rural communities, as well as those who lived in them, were uniquely self-sustaining.[15] Few towns ever approached such a condition, either before or during the 1930s, but the belief persisted.[16] Supporting it, for somewhat different reasons, were artists, writers, the New England tourist industry, L. L. Bean, *Yankee* magazine, and New Dealers in Washington.[17]

The idea of a self-sufficient New England, although it had little historical support, was nevertheless encouraged by 1930s regionalists, not only for New England but for other parts of the country—anywhere, in fact, that the idea of self-sufficiency could be grafted on to local tradition.[18] In most cases these arguments can be understood as a way of dealing with the depression, of making the best out of prolonged and unrelieved economic hard times. Industrial capitalism, many Americans had concluded, was deeply flawed, a system both stifling and inhumane and, most disturbing of all, virtually impossible to control. At a moment's notice it might wreak havoc across a broad spectrum of the population. One way of addressing the problem was to invent industrial environments that were progressive, that re-personalized the manufacturing process. Post office muralists in highly industrialized areas of the country—the mid-Atlantic and the upper Midwest—sometimes took this approach, painting factory scenes in which the power of machines is matched by the strength and ingenuity of the workers who operate them.[19] Another recourse was to go outside the system, perhaps not literally but to an imagined place, like the past, where the effects of the present were more or less neutralized.

Few worked harder in the 1930s to return New England to an ideal preindustrial state than novelist and longtime Vermont resident Dorothy Canfield Fisher. Writing in the WPA guide to Vermont (1937), she explains why "many Americans," as well as Vermonters, had become refugees from modern times. The shock of the depression, she maintains, made them "turn, disillusioned, away from the future that wasn't so near as they thought and perhaps was going to be very different from what they hoped, back toward the past still jogging with slow steadiness on its

horse-and-buggy back-road way."[20] Vermonters, in particular, were better equipped to sustain economic hard times, Fisher argues, because they had never quite embraced industrial capitalism and its social consequences. "We still live in small units where personal relations . . . are the rule of daily life. . . . On our streets it is the sight of a totally unknown face or figure which arrests attention, rather than, as in big cities, the strangeness of occasionally seeing somebody you know."[21] Communities in which this homespun mix of liberal and conservative views prevailed were sure to be somewhat exempt from national economic ills.

Fisher's version of small-town New England had its counterpart in Midwestern regionalism and in other local community-building scenarios.[22] The New England she describes, however, gained a degree of uniqueness when coupled with town-meeting imagery. These meetings, long considered model forums for debating local issues, took on during the 1930s the added responsibility of representing democracy in its purest form. After war broke out in Europe, New England also became known as the birthplace of democracy.[23] Town Meeting of the Air, a program based on the format of a New England town meeting but broadcast alternately from Town Hall in New York and other cities across the country,

127. Marion Post Wolcott, *Townspeople at a Town Meeting to Ballot . . . on . . . Intoxicating Liquors,* 1940, gelatin silver print. Library of Congress, Prints and Photographs Division.

128. Marion Post Wolcott, *Men in Town Meeting,* 1940, gelatin silver print. Library of Congress, Prints and Photographs Division.

beginning in 1935, was one way the "birthplace" theory was publicized.[24] Another way was through John Gould's small but influential book *New England Town Meeting: Safeguard of Democracy* (1940). "Absolute independence characterizes the Town Meeting," Gould wrote. "No one tells a Yankee how to vote, no one dictates. . . . [They] value their inheritance. . . . They, of all Americans, are closest to democracy."[25]

Among FSA photographers, Marion Post Wolcott seems to have been the New England specialist on Stryker's staff, and Stryker's prompting perhaps directed her toward town-meeting imagery. Invariably selecting older men of different classes at these meetings, she arranged them in hierarchical fashion (Fig. 127) or before a window that framed a traditional New England facade (Fig. 128), to emphasize their commitment to this time-honored form of local government. Wolcott also prepared the way for Norman Rockwell's *Freedom of Speech,* although by 1943, when the painting was made, the patriotic content of such scenes was strengthened and, when appropriate, used for posters to aid the war effort (Fig. 129).[26] Rockwell's central figure, dressed in dark khaki work clothes, has a vaguely military look as he

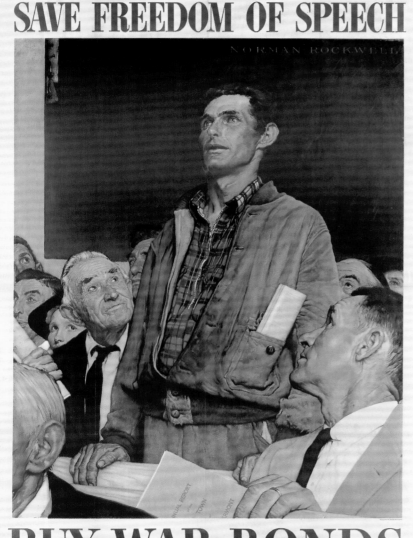

SAVE FREEDOM OF SPEECH

NORMAN ROCKWELL

BUY WAR BONDS

stands to deliver his opinion, and the various townspeople who surround him are surely meant to represent all Americans, fighting in one way or another for their freedom.

The dark rectangular area behind the head and shoulders of the speaker also works to universalize his image; he brings light to the darkness surrounding him. Rockwell is careful to make the viewer understand that such a tradition begins at home, with circumstances peculiar to town meetings. He cast the group from his Arlington, Vermont, neighbors (young and old, working and middle class, with one woman and a swarthy face peering around the speaker's right shoulder). Prominently displayed in the speaker's pocket and in the hand of the man seated at lower right is the annual report of the town of Arlington. The artist places the hand holding the report, adorned with a wedding ring (symbol of constancy?), on the same level as the speaker's right hand, darker, heavier, and more gnarled, which tells its own story of honest hard work.

The quest for an individual voice—for recognition of that voice in an urban and industrial society—at the core of town-meeting images gave rise to a distinctive New England genre of

129. Norman Rockwell, *Freedom of Speech*, 1943, lithograph, 71.1 × 50.8 cm (28 × 20 in.). Photo courtesy of The Norman Rockwell Museum at Stockbridge, Massachusetts. Norman Rockwell Art Collection Trust. © The Curtis Publishing Company. Printed by permission of the Norman Rockwell Family Trust, Copyright © 1943 the Norman Rockwell Family Trust.

the 1930s and early 1940s. That genre was built on a particular strength, the region's age and history. But it nevertheless expressed the same concerns—independence, self-help, family and community ties, a better future—addressed by regionalists around the country. Moreover, the genre was packaged for national as well as regional consumption, and it circulated, through paintings, prints, and photographs, to different audiences. FSA photographs, for example, appeared in newspapers and magazines across the country.[27]

Pictures of small towns are the staple of this genre. They are shown neatly folded into a range of hills or surrounded by open land (Fig. 130). At the other extreme, stressing independence and isolation, are lone houses, often set on bleak country roads (Fig. 131), and churches standing on rural hilltops (Fig. 132). Image makers also concentrated on single-proprietor businesses—general stores, blacksmith shops, boatbuilders, even peddlers—to show that small-scale economic activity could be both sustaining and rewarding. Louise Rosskam's picture of the smiling apron-clad manager of a general store in Lincoln, Vermont (Fig. 133), makes the point that the proprietor regarded performing all operations of the business, from accounting to stock tending, a satisfying experience. Not surprisingly, those higher up the economic ladder or affiliated with nonlocal businesses were rarely sought out by FSA photographers.

130. Louise Rosskam, *Air View of Cemetery and Town. Lincoln, Vermont,* 1940, gelatin silver print. Library of Congress, Prints and Photographs Division.

132. Paul Strand, *Church on a Hill, Northern Vermont,* 1945, gelatin silver print, 24.1 × 19.2 cm (9 3/8 × 7 1/2 in.). Philadelphia Museum of Art: The Paul Strand Retrospective Collection: 1915–1975, Gift of the estate of Paul Strand. © 1950, Aperture Foundation, Inc., Paul Strand Archive.

131. Paul Strand, *Corea, Maine,* 1945, gelatin silver print, 11 × 14 cm (4 5/16 × 5 1/2 in.). Philadelphia Museum of Art, The Paul Strand Retrospective Collection: 1915–1975, Gift of the Estate of Paul Strand. © 1950, Aperture Foundation, Inc., Paul Strand Archive.

133. Louise Rosskam, *Proprietor of General Store, Lincoln, Vermont,* ca. 1940, gelatin silver print. Library of Congress, Prints and Photographs Division.

Farmers are almost an independent category within this genre of rural life. Like proprietors of other small businesses, they pursue their work alone (Fig. 134), but the land they plant and harvest has its own special New England features. The hilly terrain and rock-strewn soil convey the idea that unlike other parts of the country, the land does not make the job any easier. Indeed, these conditions, as well as the harsh climate, seem to compel New Englanders to survive. The ideology was also imposed by FSA photographers on other regional afflictions—rural poverty in the South, dust-bowl conditions in the lower Midwest, migrant-labor abuse in California. Each image, finally and sometimes perversely, turns near catastrophe into resolve, into a willingness on the part of the disadvantaged to confront adversity.[28] New England images are by no means unequivocal in stating this belief; nor do they all march in the same direction. But many reveal a strong tendency during this period to represent the region (especially Vermont, New Hampshire, and Maine) as a hopeful alternative to urban modernism and industrial calamity. That said, the argument becomes much more complicated. Village scenes, for example, the defining image of the period, appear to share a fairly consistent iconography: each incorporates a vintage cluster of houses and commercial buildings, interspersed with church steeples and tall elms or oaks. This particular arrangement is either presented as a street scene or set in a spacious, rolling landscape. Villages are fairly modest, not only in size but also in relative prosperity. Activity within them is unhurried; people go about their business in a deliberate way, with communication kept to a minimum. Most if not all appear to be Yankees. Others who settled in these towns—a succession of immigrants, including Irish, eastern Europeans, French Canadians, and blacks—are rarely seen.

However similar the iconography of these village scenes, their meanings—beyond a common concern with age and tradition—vary considerably. Even those done as oil paintings seem to pursue many different ideas about old New England. Grandma Moses's *In the Green Mountains* (*see* Fig. 141) is literally a picture of innocence, determined to bring alive the "good old days." Grant Wood's *Midnight Ride of Paul Revere* (Fig. 135) uses a naive style for quite different purposes. Arguably the

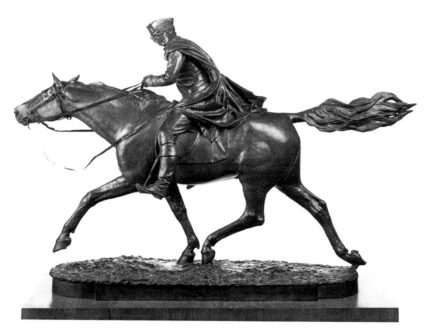

most complex and difficult to understand of these village scenes, Wood's painting raises several important questions. The most obvious is why Wood, a Midwestern regionalist, reached out of his own territory to appropriate a New England subject? One answer may be that, despite the waning reputations of both patriot and poet (Henry Wadsworth Longfellow) during the 1930s,[29] the midnight ride of Paul Revere was a historical event still firmly entrenched in the popular imagination of the East, where Wood, like other Midwestern regionalists, sought wider recognition.[30] At the same time the artist dismisses the "real" or previous conventions for representing a New England community. The viewer looks down on the scene as if it were a miniature stage set and puzzles over scale relationships and a setting rendered with comic perversity. The church steeple towers excessively (and a bit ominously) over the surrounding village. The landscape, as Wanda Corn has noted, is more reminiscent of Iowa than Massachusetts; and the houses have a bleak, separate look.[31] They are spread out over the prairie instead of being clustered together, New England style, to form a community.

Wood seems to be of two minds about the picture. He wants to claim for the Midwest its share of colonial heritage, a past and tradition that the midwestern landscape, no matter how rich and abundant he made it look, seemed to lack.[32] And yet history has consciously and humorously been turned into a myth. The

135. Grant Wood, *Midnight Ride of Paul Revere*, 1931, oil on masonite, 76.9 × 102.5 cm (30 × 40 in.). The Metropolitan Museum of Art, Arthur H. Hearn Fund, 1950 (50.117). All rights reserved, The Metropolitan Museum of Art. © Estate of Grant Wood; licensed by VAGA, New York.

136. Thomas Ball, *Paul Revere*, 1883, bronze, 84.1 × 31.1 × 80.7 cm (33 1/8 × 12 1/4 × 31 3/4 in.). Cincinnati Art Museum, The Edwin and Virginia Irwin Memorial (1909.385).

determined courier of freedom made by Thomas Ball in 1883 (Fig. 136) reappears as a small scared figure, momentarily in the historical spotlight but about to vanish into a shadowy, surreal past. If Revere's own reputation cannot save him, however, Wood's composition does. A playful arrangement of angles and curving lines, it takes most of the sting out of Revere's fate but leaves the viewer wondering what Wood was up to. Was he, for example, poking fun at the "insider's" view of New England—the comfortably old-fashioned village scenes painted a generation earlier by the impressionists?

In 1939, when Paul Sample painted *Beaver Meadow* (Fig. 137), he was a resident of Hanover, New Hampshire, only a short distance from the real Beaver Meadow, Vermont. The painted Beaver Meadow is also indebted to Wood's Paul Revere painting. The focus on the village church or meeting house, the way the road organizes the composition into a meaningful narrative, and the crisp, linear definition of figures, buildings, and trees are clearly borrowed from Wood's earlier work. But the mood of Sample's picture is strikingly different. His view of New England is

137. Paul Starrett Sample, *Beaver Meadow*, 1939, oil on canvas, 101.6 × 123.2 cm (40 × 48 1/4 in.). Hood Museum of Art, Dartmouth College, Hanover, New Hampshire; Gift of the Artist, Paul Sample, class of 1920, in memory of his brother, Donald M. Sample, class of 1921.

138. Luigi Lucioni, *Village of Stowe, Vermont*, 1931, oil on canvas, 60.0 × 85.1 cm (23 5/8 × 33 1/2 in.). The Minneapolis Institute of Arts, Gift of the Estate of Mrs. George P. Douglas.

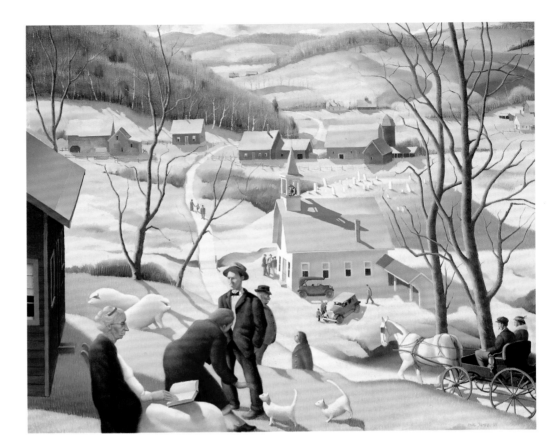

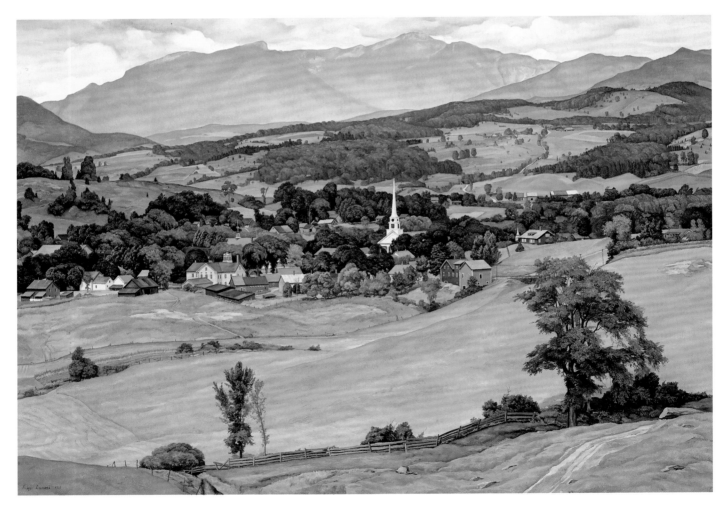

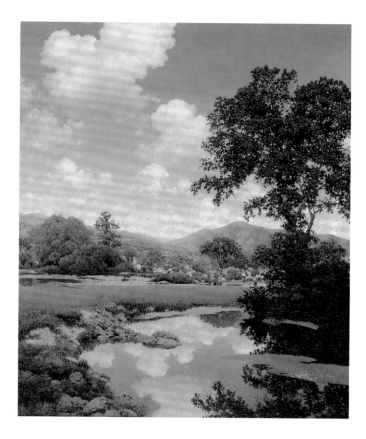

139. Maxfield Parrish, *June Skies (A Perfect Day)*, 1940, oil on panel, 58.4 × 47.0 cm (23 × 18 1/2 in.). Private Collection, courtesy the American Illustrators Gallery, New York.

140. John F. Kensett, *Mount Washington from the Valley of Conway*, 1851, oil on canvas, 104.1 × 159.9 cm (41 × 63 3/8 in.). Davis Museum and Cultural Center, Wellesley College, Wellesley, Massachusetts, Gift of Mrs. James B. Munn (Ruth C. Hanford, Class of 1909) in the name of the Class of 1909.

that of a critical "insider"; he sees it not as a historical fable but as an Eden fallen on modern times.

Soft, enticing spring colors carpet the landscape, houses and barns sit comfortably beside a winding road, and a series of rolling hills guarantees an ever-present supply of nature and abundance. In the middle ground, however, are the cemetery and town meeting house, two obvious symbols of community and the past. With gravestones askew, the cemetery looks untended, and the two automobiles parked beside the meeting house disturb its old-fashioned aura (to say nothing of what they would do launched on the narrow road running through the village).[33] Past and present are at odds; they resist the bonding operation, however imperfect, performed by Marion Post Wolcott on Brattleboro. The figures in the foreground, starkly isolated from one another in position, activity, and attitude, add a further discordant note to the atmosphere of Beaver Meadow. What the painting seems to offer is the form but not the substance of Dorothy Canfield Fisher's neighborly view of Vermont.

Other major village scenes of the period, Luigi Lucioni's *Village of Stowe, Vermont* (Fig. 138) and Maxfield Parrish's *June Skies* (Fig. 139), go off in a different direction. Both appear to ratify 1930s views about New England, to the point that a respectable pastoralism evolves into escapism, but they do so for very different markets. Lucioni, who identified the mountains above Stowe with those of his north Italian birthplace, seems to have settled on the area around Stowe as his quintessential America. Encouraging him in this view was Mrs. J. Watson Webb, co-founder of the Shelburne Museum, who had met Lucioni in New York and invited him to Vermont to paint landscapes.[34] Before he arrived he had apparently looked at Hudson River school views of the White Mountains (Fig. 140), and when he began his picture of Stowe he framed it in a similar way. In the process, however, the older Claudian formula gave way to a new emphasis on order and privacy. Not a single figure works in the ripe summer fields in the foreground of the picture. And the village is screened from close observation by its distance from the viewer and by the picturesque arrangement of trees and houses. The effect is suspiciously alpine, not a rock or tree or house is out of place. But this everything-in-its-place look, if rigid, is also reassuring. It determines the central position of the church steeple, a sacred beacon, and above it, of Mount Mansfield, a corresponding natural beacon.

Unlike Beaver Meadow, change has never come to Stowe. It is, in Lucioni's eyes (and perhaps some of Mrs. Webb's vision intrudes too), a carefully preserved property.[35] To encourage that view, the atmosphere has been pumped out of the picture, and signs of age and tradition appear everywhere, from the split-rail fence in the foreground to the static peaks embracing the town. Hindsight, however, raises questions about assertions of permanence. By 1940 the largest, highest ski lift in the country was built on Mount Mansfield, and Stowe grew to accommodate the thousands of visitors who came to use it.

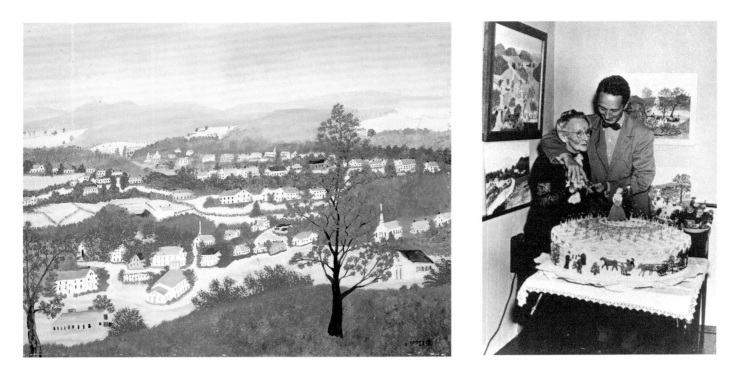

141. Grandma Moses, *In the Green Mountains*, 1946, oil on pressed wood, 43.2 × 53.3 cm (17 1/2 × 21 1/2 in.). © 1992, Grandma Moses Properties Co., New York. Courtesy Galerie St. Etienne, New York.

142. Grandma Moses's colleague, Norman Rockwell, attending her nintieth birthday party in Arlington, Vermont, hosted by Dorothy Canfield Fisher.

Maxfield Parrish and Grandma Moses provided in their New England views more popular forms of escape. What they escaped to—or preserved—were places that never were, except in their own vivid imaginations. That of Parrish remained more in the present, Grandma Moses retreated to the past in fits and starts—historical continuity was never her strong suit—but even when in the past, her work has recognizable 1930s traits. Parrish's picture-making formula, developed at the ever-expanding New England "cottage" he maintained near Cornish, New Hampshire, was to banish, as much as possible, the modern and the unpleasant. Automobiles, roads, tourists, agricultural activity, commerce, and inclement weather rarely, if ever, appear in his work. What the viewer sees instead are vivid blue skies, iridescent green pastures, and gently flowing brooks. The last invariably reflect the peace and serenity of the surrounding countryside. The main consumer of Parrish's landscape paintings was Brown and Bigelow, a national calendar and greeting-card company with headquarters in Minneapolis.[36] Brown and Bigelow reproduced the landscapes as calendar prints, every year from 1936 to 1963, with certain popular pictures repeated more than once. Parrish's skilled hand and fanciful palette were both his virtue and his vice. Too often, it seems today, he encouraged his audience to see art as a cheerful alternative to everyday life. In that sense, his New England landscapes operate very differently from Lucioni's view of Stowe. Parrish's work taps a popular strain of fantasy and make-believe; rural New England is staged as a pastoral Camelot. Lucioni's view of Stowe, on the other hand, aims at a more elite audience, seeking to fix, as if under a bell jar, a real and unchanging rural New England.

Although stylistically quite different, Grandma Moses's *In the Green Mountains* (Fig. 141) mines the same popular view of New England as Parrish's landscapes, but with several major exceptions. Grandma Moses's naive style was perceived in the 1930s as having a powerful truth-telling capacity. Her great gift, it was argued, was that she had never been trained as an artist or subjected to a culture that valued art as exceptional.[37] Her memory, occasionally jogged by images she came across in books or magazines, was constructed as the wellspring of her art. Today what Grandma Moses remembered is thought to be less important to her art than her will to keep busy, after a life of hardship, and her talent for seeing as an Edenic countryside the none-too-promising environs of Eagle Bridge, New York.[38] Especially when it takes the form of cozy villages, her work follows a 1930s agenda for

representing New England. Grandma Moses's pictures, like those of Parrish, trav-
eled a commercial route almost as soon as they left her easel, appearing in books,
national magazines, and Christmas cards.[39] Her personal celebrity followed a simi-
lar course, helped along by a visit to Washington, D.C., in 1949, where she received
an achievement award from President Harry S. Truman, and a ninetieth birthday
party in Arlington, Vermont, hosted by Dorothy Canfield Fisher and attended by
her younger and more famous colleague, Norman Rockwell (Fig. 142).

Rockwell not only provided a core New England image with his *Freedom of Speech*
painting (and poster; *see* Fig. 129), but the same "Four Freedoms" series included
Freedom from Want (Fig. 143). The painting gave form to the kind of highly ritual-
ized family gathering that was supposed to be going on inside the houses in the vil-
lage scenes previously noted. The painting was also made to remind a wartime na-
tion of the values for which it was fighting. According to the artist, the cast was his
own family, including the housekeeper, who delivers to the table a large, plump per-
fectly roasted turkey, which (again according to the artist) was consumed soon after
it was painted.[40]

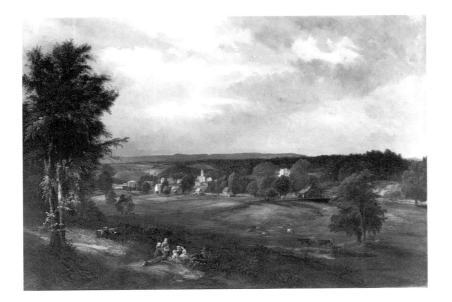

144. James M. Hart, *Village Scene near Albany, New York*, 1850, oil on canvas, 76.5 × 107.4 cm (30 1/8 × 42 1/8 in.). National Museum of American Art, Smithsonian Institution, museum purchase.

On one level, the painting depicts the good fortune of the Rockwell family, extended to represent the typical American family. Warmth and good cheer are matched by the generous supply of food (too generous for the times, Rockwell later thought). The old gentleman who presides does so in a patriarchal fashion, dispensing with grace but otherwise continuing the role that heads of families and church elders had assumed in earlier Thanksgiving paintings by Henry Mosler and Jennie A. Brownscombe (*see* Figs. 40, 41). From the window behind him a cleansing white light falls across the table, transforming the food and the serving pieces into ceremonial items. The white-on-white patterns of the tabletop also provide a relatively austere surface across which the family carries on a lively exchange. That exchange ripples down both sides of the table, and finally out to the viewer, who is engaged by the glance of the middle-aged man at lower right.

Sharing is the more subtle message of the picture. The bowl of fruit in the center foreground is an invitation to join the family gathering, to experience the blessings of middle-class life. At the same time, to move from the viewer's end of the table to the opposite end involves working through the family hierarchy—the serious side of the sharing message. One must earn the prestige associated with patriarchal authority. Thus the painting begins to explain the social dynamics of the nuclear family—how it defines values and maintains order and stability in an America still recovering from the depression. This, in turn, explains why *Freedom from Want* is tied to the previous village scenes. The social process defining the family as both an individual and a collective unit is the same process sustaining communities and, by extension, the nation. No matter at what level one is playing, the standards of performance are the same.

As in the village scenes, signs of difference in *Freedom from Want* are also kept to a minimum. White, middle-class American values—those anchored in the past by the Thanksgiving Day celebration and in the 1940s by a certain level of material comfort—prevail. Whatever the balance, *Freedom from Want* proved to be a remarkably successful image. When it appeared in the *Saturday Evening Post* (6 March 1943), the magazine was besieged with requests for reprints.[41] Soon after, it was published as a poster and then used in countless ways to aid the war effort. To this day, it remains one of the best-known paintings in America.

New England at Work

New England scenes painted at the turn of the century generally emphasize sedate landscapes, fine old buildings, and small social gatherings. The presiding mood is restful, unhurried. In 1930s paintings of New England, work is a more conspicuous theme, whether or not it is shown directly. Generous plots of farmland, in some stage of cultivation, surround the village scenes just described (those by Sample, Lucioni, and Grandma Moses). These pictures measure the working relationship between landscape and community, how one contributes to the other, how production is naturalized and personalized by the pastoral setting. Sample's knowledge of Wood's paintings suggests that all three New England artists may have been looking over their shoulders at Benton, Curry, and Wood, wondering what to borrow

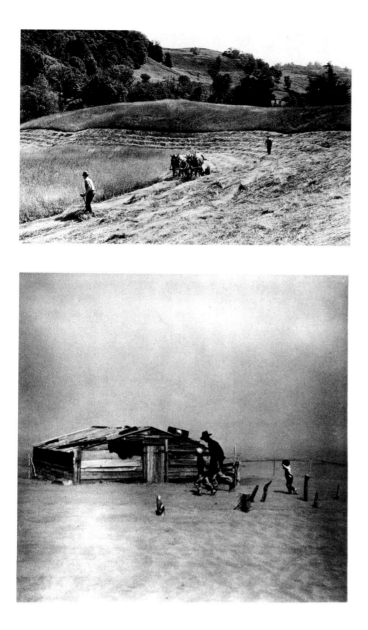

(or reject) from their more famous colleagues. What the New Englanders rejected, of course, was the Midwestern artists' assertion of unparalleled abundance, suggested not only by crops in the field but by the horizon-to-horizon sweep of their landscapes. That degree of abundance, clearly at odds with New England farm production in the 1930s and with the region's rocky upland pastures, could not be entertained as a credible depression-era strategy.

The signs of community the Midwesterners tucked into their rolling landscapes were a different matter. That lesson was absorbed, certainly by Sample and perhaps by Lucioni and Grandma Moses. The small farm or community buildings depicted by Curry and Wood in their landscape paintings may have encouraged the New Englanders to look back at their own tradition (James M. Hart's *Village Scene near Albany, New York* [Fig. 144]) is a good example), in which town and landscape share the same relationship as farm and landscape in Midwestern regionalism. Another lesson that perhaps traveled from the Midwest to the East was how to make the land itself reveal the kind of work required to bring forth new crops. Curry, Benton, and Wood show an occasional figure behind a plow but more often agricultural production is signaled by fences, hay rows, cornstalk bundles, neatly plowed fields, or simply by the patterns and colors of the swelling landscape. These motifs and formal strategies, used more sparingly by artists representing New England, are also evidence of an imaginary return to the rural, to an environment presumably regulated by natural (and dependable) production cycles.

One of Arthur Rothstein's most striking photographs, *Cutting Hay, Vermont* (Fig. 145), gives this

145. Arthur Rothstein, *Cutting Hay, Vermont*, 1937, gelatin silver print. Library of Congress, Prints and Photographs Division.

146. Arthur Rothstein, *Dust Storm, Oklahoma*, 1936, gelatin silver print. Library of Congress, Prints and Photographs Division.

1930s agricultural ethic a special New England meaning. The photograph builds on the Barbizon tradition. Patterns of light and dark, the two figures wielding their scythes, and the team of horses pulling a vintage mowing machine cast a bucolic spell over the landscape. But a more modern aesthetic prevails. Gracefully sweeping curves—the wide swath of mown hay in the foreground, the soft shoulder of grass above, which follows the same contour, and the steeply wooded hillside beyond—assert that the land and those tending it are joined in a familiar, long-standing ritual. Moreover, the mowing process follows the contours of the land; it is aligned with nature, with stewardship of the land, to guarantee that it will remain productive for future generations. The previous year, in Oklahoma, Rothstein had taken one of the best-known photos of the depression era. Called *Dust Storm, Oklahoma* (Fig. 146), it shows a father and two sons trying to reach home through a high wind laden with stinging dust particles. The father, gaunt and worn, the crude dugout he and his family occupy, and the parched, flat land are moving evidence of hardship and defeat. All of Oklahoma, all of the Southwest, the photograph implies, lies waste; the land has literally been blown away. New England, on the other hand, appears to be a gentler, stable, more productive land, where one can depend on a decent crop year after year. There is, of course, no denying the physical difference between the two regions, but Rothstein in addition may have been influenced

147. William Zorach, Study for
The Shoemakers of Stoneham
(relief sculpture in Stoneham,
Massachusetts, Post Office), ca.
1942, charcoal, colored pencil,
and wash on paper, 91.4 ×
182.9 cm (36 × 72 in.).
National Museum of American
Art, Smithsonian Institution, gift
of Tessim Zorach and Dahlov
Ipcar.

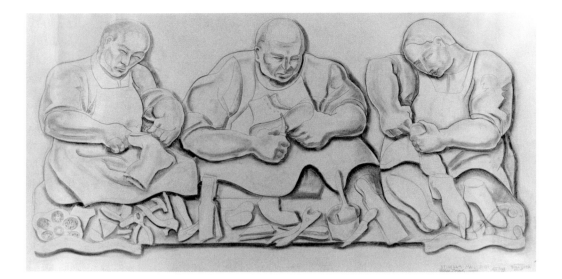

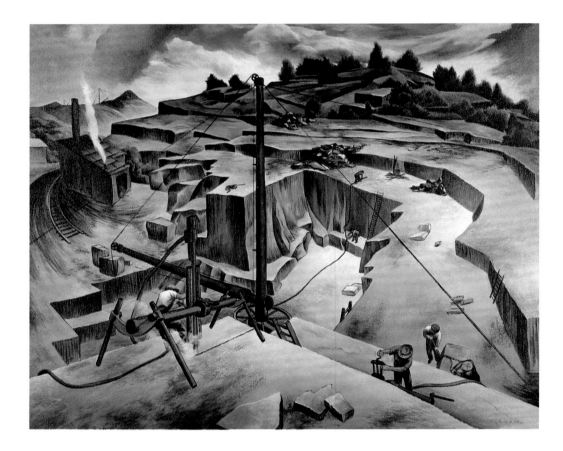

148. Francis Colburn, *Granite
Quarry*, 1942, oil on canvas,
59.1 × 86.4 cm (28 1/4 × 34
in.). Collection of Robert Hull
Fleming Museum, University of
Vermont, gift of the artist.

by a depression-era agenda for representing each. Oklahoma, when compared to New England, had a shorter (Anglo-European) past. Early white settlers drove their plows through the thick prairie grass, giving little thought to what would happen when it disappeared. By the 1930s the process had in some areas devastated the land, a condition highlighted by a popular government film called "The Plow that Broke the Plains," released in 1936.[42] Rothstein's New England farmers are made out to be a different breed. A sense of tradition guides their approach to the land. They tend it carefully, to pass it on to the next generation in the same condition they received it.

Images of New England at work in the 1930s also include major local industries, especially those with a long history of supplying the nation with a particular product. Two impressive examples are sculptor William Zorach's *Shoemakers of Stoneham* (Fig. 147), a large terra-cotta mural in the Stoneham, Massachusetts, post office,[43] and *Granite Quarry* (Fig. 148), by Francis Colburn, a talented Vermont regionalist. The mural by Zorach pays tribute to the local shoemaking industry, personified by three heroically proportioned workers, an older male, flanked by two younger colleagues. (Women made shoes, too, but males with bulging muscles better fulfilled the ideological role of labor in the 1930s.) The workers are strong, dedicated, and skillful. Hands and forearms as well as the predella of tools beneath the figures inform viewers that shoemaking is a serious craft, involving years of training and a keen understanding of how to select and shape raw materials. The parallel to carving a sculpture is implicit in every gesture the figures make.[44]

By the late 1930s shoemaking was more of an automated process than shown here (soles, for example, were stamped by machine), and Stoneham, which had once been a center of the shoemaking industry, had been gradually transformed into a residential suburb of Boston. Vermont quarries, which generated another New England industry, opened shortly after the War of 1812. During the 1930s they were still furnishing considerable amounts of high-grade granite to construction sites around the country.[45] Colburn's picture transfers to the Vermont landscape the heroic role played by the shoemakers in Zorach's mural. Lessons from Thomas Hart Benton, who would have been leaving the Art Students League in New York about the time Colburn arrived (1935), are evident in the thick-textured clouds and dark evergreens that cap the hill above the quarry. Below them is the sterner stuff of which the landscape is made. Round forms give way to angular cliffs, and blues and greens to neutral shades of brown and gray as the viewer's attention is drawn to the quarry pit. The cliffs dwarf the workers but not their ingenuity; this part of the landscape they, not nature, have made. The pneumatic drill suspended from the channel bar in the foreground of the picture and the crane, around whose tower the man-made landscape is arranged, stand as secular totems to the workers' success. Both also require considerable (again, masculine) strength to operate.

The Vermont WPA guide describes the local stonecutters, well paid for their hazardous work, as "free-spending" and "pleasure-seeking," the blue-collar playboys of New England.[46] The image tactfully acknowledges the success of an immigrant labor force (mainly Scots, Italians, and Scandinavians), which had fought early and hard for union representation.[47] Colburn's painting appears to embody that history as well as a formula for the continued successful operation of New England quarries. Realistic details of men and machinery, set strategically within the rugged abstract design of the landscape, suggest a productive match between the two.

Not all New England images of the period avoided hard-core economic issues. The region had been devastated by the depression, and some artists (mostly photographers) directly confronted rural and urban poverty. In *Old Abandoned Farmhouse* (Fig. 149), for example, FSA photographer Carl Mydans draws a neat

149. Carl Mydans, *Old Abandoned Farmhouse*, 1936, gelatin silver print. Library of Congress, Prints and Photographs Division.

150. *Strawberry Picker, Falmouth, Massachusetts*, ca. 1930, photograph. Alton H. Blackington Collection in the Yankee Publishing Collection, Society for the Preservation of New England Antiquities.

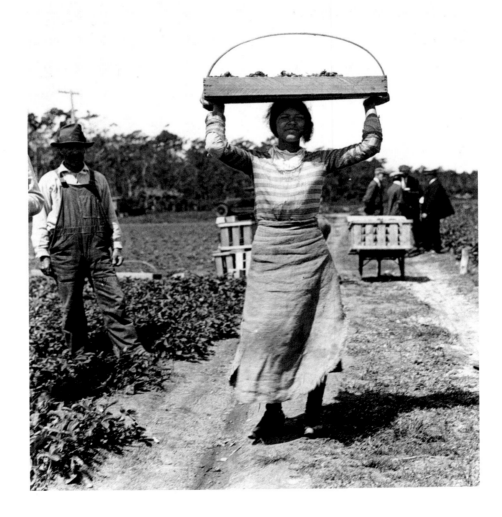

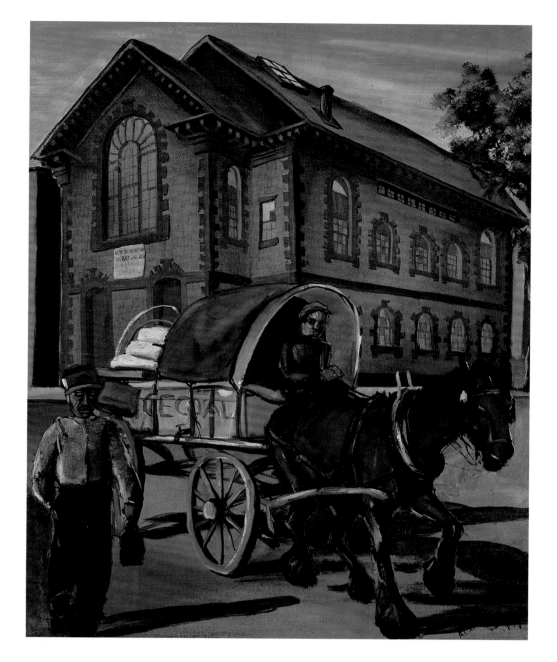

distinction between foreground and background to highlight conditions in the former. Thus, the abandoned car and rundown buildings in the foreground constitute a harsh introduction to the otherwise pastoral (and stereotypical) Vermont landscape, which commences in the middle distance and extends to the horizon. Roughly dressed workers appear in other photographs. In the example illustrated (Fig. 150), the woman holding a basket of strawberries on her head and the fieldworkers beside her are probably Cape Verdeans from New Bedford, Massachusetts, an industrial town near Falmouth. Unable to find employment in their hometown, they had turned the sandy soil of lower Cape Cod into flourishing strawberry farms.[48] The woman and her basket, with its gracefully arched handle, appear to connect the two sides of the picture, the one occupied by the black fieldworkers, the other by more prosperous whites in the background, the probable consumers of the strawberries and the photograph as well.

Fewer oil paintings of this period address hard times,[49] and those that do more often emphasize urban (usually Boston) rather than rural poverty. One of the most unusual is *Boston Street Scene* (Fig. 151), by Allan Rohan Crite, a black Bostonian, who must have seen urban poverty firsthand and who was painting pictures for

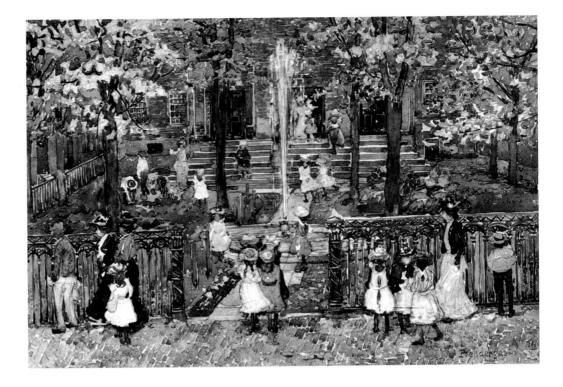

152. Maurice Brazil Prendergast, *West Church, Boston*, ca. 1901, transparent and opaque watercolor over graphite on paper, 27.6 x 39.2 cm (10 15/16 x 15 3/8 in.). The Hayden Collection, Charles Henry Hayden Fund, Courtesy of Museum of Fine Arts, Boston.

those no great distance from it.[50] *Boston Street Scene* again juxtaposes past and present, with perhaps some debt to Maurice Prendergast's several views of the old West Church in Boston (Fig. 152), painted about 1901. Prendergast, however, used the church facade as a backdrop for an active local community (the church had by then become a library). No such intention informs Crite's picture. The handsome Georgian-style church looming up in the background has a sign on its facade announcing it has been sold and will soon be taken over by a Catholic congregation. In the meantime, in front of the church, an old black man begins his daily rounds, selling ice and coal from his horse-drawn wagon. The proud colonial heritage of Boston has done little to improve his circumstances. Nor, one assumes, will it help the Irish, who have inherited a neighborhood that has seen better days.

Promoting Tourism

By 1935 worsening economic conditions prompted the six New England governors to launch a "Selling New England" tourist campaign. Over the next several years the New England Council blanketed the East and Midwest with radio spots, newspaper and magazine advertisements, and brochures touting New England on every level, from recreation to "discovering the past." Promotional material issued by the council inevitably reminded potential tourists that healthy outdoor activities could be supplemented by an enlightening history lesson. One council poster concludes: "Explore charming colonial villages. Stand where the Pilgrims stood. Ride the route of Paul Revere. Visit the scenes of America's historic and literary greatness. Vacation in old New England." An image frequently accompanying such texts was that of a small, old-fashioned village, set in a landscape reminiscent of Vermont or New Hampshire.[51]

Popular tourist attractions—historic places, seasonal attractions (fall colors), local characters, and recreational sites (from mountains to seashore)—again appeared as popular and alluring images. Thus the work of painters such as Aldro Thompson Hibbard, a younger contemporary of Frank Benson and Edmund C. Tarbell, as well as similar subjects reproduced in other media, have all but taken over as the real New England. Hibbard's landscapes mostly feature seasonal activity, such as maple-sugar gathering or logging (as well as summer on the coast), subjects also popular in

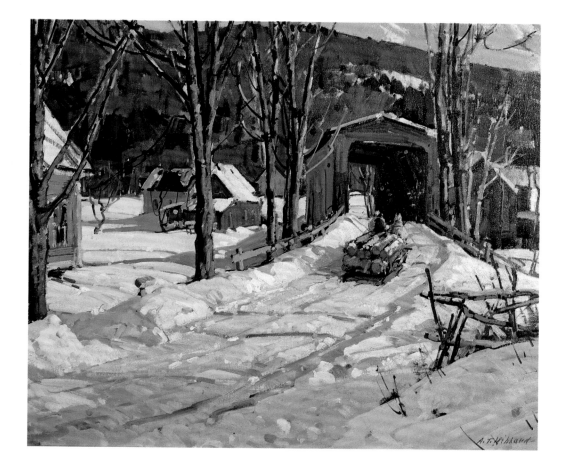

post Civil-War genre scenes. In pictures like *Covered Bridge in Vermont* (Fig. 153), however, these traditional subjects are given a distinctly new painterly attraction. Late afternoon shadows, richly infused with blue and yellow, lie across the snow, a tribute perhaps to Abbott Thayer's winter scenes of Mount Monadnock.[52] Heading home through the shadows is a logger driving a sleigh loaded with sections of trees probably felled the previous summer. The road leads through a covered bridge (a passage through time) to old houses and farms across the river. The brilliant red of the barn on the viewer's side of the river gives life and warmth to this past. Russet-colored leaves on trees standing on the hillside above the bridge accomplish a similar purpose. For Boston school patrons, Hibbard's appeal lay in his ability to construct an artful counterpart of the rugged outdoors, suitable for display in a well-appointed New England study. His snow scenes sold well from the 1920s up to World War II and perhaps longer.

Posters and photographs of skiers were a less discrete way of selling winter in old New England. They encouraged the growth of a new sport that would soon flourish in Vermont, New Hampshire, and Maine. The most important of several large areas developed during the 1930s was at Stowe, site of the Lucioni painting (*see* Fig. 138). To promote recreational skiing, a mostly upper-middle-class sport, image makers abandoned the FSA look. Glamour, the kind urban dwellers bring to the country, replaced it. Posters were designed in a chic contemporary style (Fig. 154) or to show attractive people in the latest ski apparel. New York fashion photographer Louise Dahl-Wolfe was at Stowe shortly after it opened, shooting pictures, which later appeared in *Harper's Bazaar*, of Mrs. J. Negley Cooke, an accomplished skier and Cleveland socialite (Fig. 155). Marion Post Wolcott also helped promote skiing, this time with a sharp eye for how city folks came to the country. One way was in elegant touring cars. When parked in towns like Woodstock, Vermont, with ski racks attached to their trunks, they add a singularly modern touch to old New

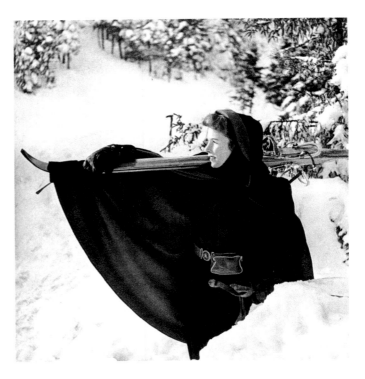

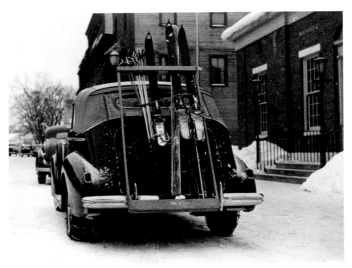

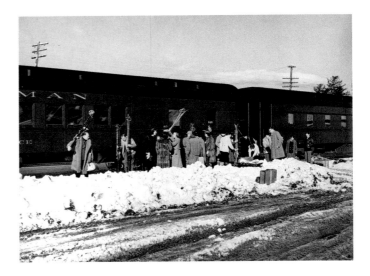

154. *New Hampshire* (poster), ca. 1940, lithograph. Poster Collection, Boston Athenaeum.

155. Louise Dahl-Wolfe, *Mrs. J. Negley Cooke in a Hooded Cape, Mt. Mansfield*, photograph, *Harper's Bazaar* 75 (1 March 1941).

156. Marion Post Wolcott, *The Town Has Nine Ski Tows . . . Woodstock, Vt.*, 1940, gelatin silver print, 15.4 × 18.6 cm (6 1/16 × 7 5/16 in.). Library of Congress, Prints and Photographs Division.

157. Marion Post Wolcott, *(Ski Train) Skiers Arriving Early in the Morning with the Weekend Ski-meister*, 1940, photograph, 17.8 × 20.3 cm (7 × 8 in.). Library of Congress, Prints and Photographs Division.

158. Jack Delano, *Picknickers along Highway 12A Hanover, New Hampshire*, 1941, gelatin silver print. Library of Congress, Prints and Photographs Division.

159. *Biggest Package Ever* (Oldsmobile advertisement), *Life* 6 (22 May 1939).

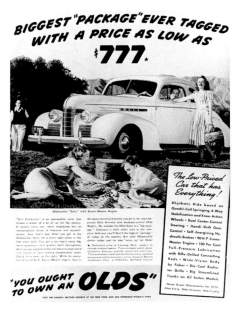

England (Fig. 156). Another way was in fast trains with Pullman accommodations, which left the city on Friday evening and discharged their well-dressed passengers the next morning at destinations such as North Conway, New Hampshire (Fig. 157). Since the 1850s North Conway had been a stage and then railway terminus for tourists visiting the White Mountains.

The final works in this chapter, one done before and one after World War II, show the different ways New England images could be marketed for nationalist (or patriotic) content. At first glance, however, what both works appear to have in common is New England tourism. *Picnickers along Highway 12A Hanover, New Hampshire* (Fig. 158) by FSA photographer Jack Delano represents motoring through New England with the down-to-earth appeal of an automobile advertisement (Fig. 159). Gently curving hills and a well-maintained highway wrap around a shady picnic area in which three people have stopped. Parked nearby is their late-model sedan, providing the comforts of home while on the road. *Connecticut* (Fig. 160), by Charlotte Sternberg, a local artist, makes a more subtle pitch. Prominently displayed in the foreground are a mother and child crossing a rustic bridge, and a sign for Route 7, a historic highway leading north through western Connecticut, the Berkshires, and up into Vermont. The picture expands the iconography of 1930s village scenes with a factory issuing smoke from both chimneys and a small domed building, above which flies an American flag. Otherwise, a certain whimsy prevails. The picture is composed to read as both modern and traditional, as a pattern of shapes and colors and as a "real" old-fashioned place.

In both images, however, tourism seems to be only part of the story. Before Delano set out for New England, Roy Stryker had counseled him to make pictures that emphasized traditional regional subjects—"autumn, pumpkins, raking leaves, roadside stands"—and to infuse the series with a sense of abundance. "You know," Stryker continued, "pour maple syrup on it . . . mix well with white clouds and put on a sky-blue platter. I know your . . . photographer's soul writhes, but . . . do you think I gave a damn . . . with Hitler at our doorstep?"[53] Even in *Highway 12A,* probably taken at the beginning of Delano's New England tour, the photographer seems to keep in mind Stryker's advice. Stopping for a picnic, in this particular setting, conveys a sense of leisure, of well-being. Such pictures, Stryker believed, had national currency. They were capable of raising the level of patriotism across the country, of convincing Americans that their abundant land and the freedom to enjoy it must be defended at all costs.

Sternberg's *Connecticut* is a postwar picture (1946), one of many commissioned by the Container Corporation of America to construct a state-by-state image of America. The works had both a local and national significance; each represented a place where the Container Corporation did business. When published in national magazines as part of a Container Corporation advertising campaign, they created a national corporate image.[54] Like Sternberg's *Connecticut,* many of the works turn back to local history and legend to demonstrate what was unique about the state they represent. Most of these also call attention to recent local events and accomplishments. *Connecticut,* except for the woman and child in the foreground, is less equivocal. The traditional iconography claims that the past is the present, for local or national consumption. Which raises one final point. Delano's photo of Highway 12A, a prewar image, brings a degree of modernity to New England, while Sternberg's picture turns back the clock. The latter is evasive about change, at the same time it assumes a role in a modern industrial advertising campaign.

160. Charlotte J. Sternberg, *Connecticut,* from the "United States" series, 1946, gouache on paperboard, sheet: 45.8 × 38.0 cm (18 1/16 × 15 in.). National Museum of American Art, Smithsonian Institution, gift of the Container Corporation of America.

By the 1950s a traditional New England was once again being used for national purposes, this time to fight the Cold War. One advocate of this New England was Henry N. Flynt, a wealthy Greenwich, Connecticut, lawyer, and, along with his wife Helen, an exceedingly generous contributor (of both money and time) to restoration projects in Deerfield. He was also coauthor of *Frontier of Freedom* (1952), an illustrated history of Deerfield, whose trim and well-ordered postwar appearance Flynt had been working to achieve since the early 1930s. In his book Flynt claims that "visual truth speaks louder than words in contradicting [Communist] propaganda." What is needed to "demonstrate . . . the strength of America today," he continues (singling out a photograph of the Deerfield main street taken about 1900 by the Allen sisters [*see* Fig. 72]), is a "graphic picture of . . . a New England village." Such a picture tells a story of "daring and courage . . . of fiery patriotism and love of life."[55] Alice Baker, mistress of a genteel and feminine Deerfield at the turn of the century and a close friend of the Allen sisters, would surely have been surprised to see it transformed into the male outpost of the free world imagined by Flynt. But the real story of old New England is that it does its cultural work—locally or nationally—for whomever claims it and whenever the need arises.

Notes

1. The playbill illustrated, from the Harvard University Theater Collection, is inscribed with the date 7 March 1938.
2. The prize was awarded 2 May 1938; see Simon, *Wilder*, 144. Wilder's first Pulitzer (1928) was for *The Bridge of San Luis Rey*. In 1938 John Marquand's novel *The Late George Apley* also won a Pulitzer. Despite its satirical turn, *Apley* offers strong proof that interest in proper old-fashioned Boston coexisted with the new focus on rural New England during the 1930s. The superb collection of eighteenth-century American decorative arts assembled by Maxim Karolik and his wife Martha Codman Karolik during the late 1930s does too (see Carol Troyen, "The Incomparable Max: Maxim Karolik and the Taste for American Art," *American Art* 7 [summer 1993]: 67–74).
3. Wilder, *Our Town*, 80.
4. Simon, *Wilder*, 38, 132.
5. Mumford, *Golden Day*, 43–44.
6. William Carlos Williams's best-known work in this vein is called *In the American Grain* (1925), although it seems more a parody than a record of American achievement. Constance Rourke's major works are *American Humor* (1931), *Davy Crockett* (1934), and the posthumously published *The Roots of American Culture* (1942).
7. Matthiessen, *American Renaissance*, xvii.
8. Wilder, *Our Town*, 25.
9. Movie director Frank Capra was deeply concerned over the same issues. From the late 1930s on, he maintains, his films addressed the "cry of the individual against being trampled . . . by massiveness—mass production, mass thought, mass education, mass politics, mass wealth, mass conformity" (quoted in Levine, "Hollywood's Washington," 189).
10. Roy Stryker, who had a rare understanding of the power of images, was head of the historical section of the Farm Security Administration from 1935 to 1943. Under his direction a dozen or more photographers—including such stars as Walker Evans, Dorothea Lange, Ben Shahn, Gordon Parks, Russell Lee, Arthur Rothstein, Carl Mydans, and Marion Post Wolcott herself—roamed the country, at first "aggressively" documenting rural poverty, then backing off somewhat to present a more positive view of small towns and rural life. The results were expertly placed by Stryker. FSA photographs appeared in every leading newspaper and magazine in the country during the late 1930s and early 1940s. One could argue that Stryker had a soft spot in his heart for New England. The hard-core poverty shots that so often define the South and the Southwest during the mid-1930s were taken less frequently in New England. Instead, the region more often appears as an ideal Yankee hometown. It was also a training ground for FSA photographers, many of whom went there on their first mission, presumably with one of Stryker's shooting scripts in hand. Wolcott, who seems to have been on the New England circuit more often than others, enjoyed telling Stryker hardship tales. During a cold February in 1940, when making her Brattleboro series, she described herself to him as "fingerless, toeless, noseless, earless." Despite such handicaps, Wolcott's series includes several stunning winter scenes. See Hendrickson, *Looking for the Light*, 159; and Hurley, *Portrait of a Decade*, 95–146.
11. Abbott, *Old Paths and Legends of New England*. The preface (iv) is signed "Katherine M. Abbott, Belvidere, Lowell [Massachusetts]." At least one Abbott was associated with the Lowell textile mills and may have subsequently purchased the house called Belvidere in nearby Chelmsford. See Eno, *Cotton Was King*, 65, 253.
12. The full citation is *Here's New England! A Guide to Vacationland*, written and compiled by Members of the Federal Writers' Project of the Works Progress Administration in the New England States (Boston: Houghton Mifflin, 1937). The guide was sponsored by the New England Council, whose efforts on behalf of regional tourism are covered further on in this chapter.
13. Abbott, *Old Paths and Legends of New England*, 228.
14. Federal Writers' Project, *Here's New England!*, 47.
15. Although published in 1953, Dorothy Canfield Fisher's *Vermont Tradition* is based on observations that appear in her novels of the 1930s, such as *Bonfire* (1933). Part 4 (341–92) of *Vermont Tradition* describes how locals, "emotionally and materially broken by the Civil War," coped with their problems. The best-known community study of the period, *Middletown* (1929), by Robert S. Lynd and Helen Merrell Lynd, was less sanguine about the sustaining power of tradition, but Robert Lynd, in turn, had his own ax to grind. See Fox, "Epitaph for Middletown."
16. The belief seems to have gained more credibility in New England than elsewhere, perhaps because during the previous century towns with thriving cottage industries appeared to be self-sustaining. Even so, before the end of the century a marked rural decline had set in, with industry moving to larger towns and farms operating at subsistence level. See Graffagnino, "Arcadia in New England," 54–59; and Edward T. Hartman, "A Yankee Renascence," *The Survey* 54 (1 July 1925): 385–88. By 1930 most New England towns were part of a larger market system and were being serviced by regional financial institutions.
17. Bernard DeVoto, for example, argued in 1932 that New England "had had hard times . . . in one way or another for three hundred years," but that "Yankee nature" had found a way to endure, to establish "something fixed and permanent . . . to tighten one's belt and hang on." A bankrupt nation, DeVoto concluded, "might learn something from New England" (Bernard DeVoto, "New England, There She Stands," *Harper's Monthly Magazine* 164 [March 1932]: 407, 415). L. L. Bean fashioned from his own experience and from similar north country rhetoric a line of camp accessories and outdoor clothing that, by the 1930s, he was marketing to "sports" living in East Coast suburbs (see Montgomery, *In Search of L. L. Bean*, 51–71). *Yankee* magazine offered its own special blend of regional pride and boosterism. "Even when the depression was at its worst," wrote a guest editor in 1937, "the average New Englander managed somehow to keep his chin up, his feet on

the ground and his emotions under control" (*Yankee* 3 [January 1937]: 1). The next year, an unsigned article, entitled "Trade-Marked Lobsters," claimed that "Canny Maine looks out for her own . . . now the Pine Tree state has come out with an advertising wrinkle as ingenious as anything Yankee land has seen. Every Maine lobster that finds its way to market is trade-marked with an aluminum tag. . . . On the tag [appears] the legend, 'State of Maine Lobster, Firmer Meat, Finer Flavor'" (*Yankee* 3 [July 1938]: 11). The quintessential *Yankee* statement, however, came in the August 1938 issue (p. 5). After asking readers about their choice for president in the upcoming national elections, *Yankee* encouraged them to look beyond "the elephant" and "the donkey" for a party that has "as an emblem . . . the American eagle . . . a fearless, straightforward king of birds with an eye that sees public issues squarely for what they are." New Dealers used the idea of a fiercely independent New England in more subtle ways. They promoted it as a strategy for combating hard times, but followed with state and local assistance programs when conditions required.

18. Steiner, "Regionalism in the Great Depression," 432–34.
19. Park and Markowitz, *Democratic Vistas*, 73–85, 93–96.
20. Federal Writers' Project, *Vermont*, 4–5.
21. Ibid., 5–6. Self-esteem and material opportunity, Fisher continues, are bought with "perseverance, hard work, reliable character, and moderate efficiency in some useful occupation."
22. Wood, *Revolt against the City*, for example, advocates rural life and farming as a way around the depression. Despite the appearance of Wood's name on the title page, Wanda Corn makes a good case for the book being ghostwritten by Frank Luther Mott, a close friend of Wood's and an equally ardent midwestern regionalist (see Corn, *Wood*, 153 n. 85).
23. Hooper, *Life along the Connecticut River*, 11.
24. Describing the program in 1942, moderator George V. Denny wrote: "The early New England town meeting helped the founders of this nation to reason together and hammer out on the anvil of honest discussion an American philosophy in 1776. Why cannot the Town Meeting of today be used to help us find a political philosophy which America may give to the world in the twentieth century?" (Denny, "'Town Meeting Tonight,'" 69). Jere R. Daniell, professor of history at Dartmouth College, kindly brought to my attention this reference and the one that follows.
25. Gould, *New England Town Meeting*, 10, 59.
26. President Franklin Delano Roosevelt delivered his Four Freedoms speech to Congress in January 1941. The paintings came forth, in a burst of inspiration, two years later. "I suddenly remembered," Rockwell later wrote, "how Jim Edgerton had stood up in a town meeting and said something that everybody else disagreed with. But they had let him have his say. No one had shouted him down. My gosh, I thought, that's it. . . . I'll illustrate the Four Freedoms using my Vermont neighbors as models. I'll express the ideas in simple, everyday scenes. . . . Take them out of the noble language of the proclamation and put them in terms everybody can understand" (Rockwell, *My Adventures as an Illustrator*, 338–39). The *Saturday Evening Post* of 20 February 1943 carried the first reproduction of the painting. The poster was made soon after (Ibid., 343–44).
27. They are the 1930s counterpart of the illustrated material that appears here in chapter 1, "After the War: Constructing a Rural Past." Stange, "The Record Itself," 1.
28. Or, as Stryker expressed it, "You could look at people and see fear and sadness and desperation. But you saw something else too. A determination that not even the Depression could kill" (quoted in Fleischhauer and Brannan, eds., *Documenting America*, 33).
29. Gabriel, ed., *Pageant of America*. See vol. 6, Williams, *American Spirit in Letters*, 121; and vol. 11, Wood and Gabriel, *Winning of Freedom*, 164. See also novelist Esther Forbes's *Paul Revere and the World He Lived In*, an everyday account of Revere's life and times. Forbes casts Revere not so much as a hero but as a craftsman and patriot, whose symbolic deed made him into "something greater than himself" (247).
30. If Wood's plan was to attract an Eastern patron, it eventually worked. Since 1950 the *Midnight Ride of Paul Revere* has belonged to The Metropolitan Museum of Art in New York. The painting's first owner, Mrs. Cecil M. Gooch of Memphis, Tennessee, purchased it in 1931 from the Forty-fourth Annual American Painting and Sculpture exhibition at the Art Institute of Chicago. According to Metropolitan Museum records, the painting was exhibited frequently between 1931 and 1942.
31. Corn, *Wood*, 86.
32. The desire to compensate for the absence of the colonial in the Midwest may also explain Wood's *Overmantel Decoration* (1930), painted a year before *Paul Revere* (see Corn, *Wood*, 75–77).
33. See Robert L. McGrath's helpful analysis of this painting in McGrath and Glick, *Sample*, 40.
34. Saunders, Westbrook, and Graff, *Celebrating Vermont*, 190.
35. The painting was given to the Minneapolis Institute of Arts by George P. Douglas, a lawyer and trustee of the institute. Douglas was a native of Stowe.
36. See Ludwig, *Parrish*, 145, 174–88.
37. Kallir, *Art and Life of Grandma Moses*, 14.
38. Eagle Bridge is on the New York–Vermont border. According to Jane Kallir, it was a depressed rural community in the 1930s when Grandma Moses began her painting career (interview with Jane Kallir at Galerie St. Étienne, New York, November 1997).
39. Kallir, *Grandma Moses*, 19.
40. Rockwell, *My Adventures as an Illustrator*, 342–43.
41. Ibid., 343–44.
42. The film, sponsored by the WPA's Dance Theater, was made by Pare Lorentz. See Leuchtenburg, *Roosevelt and the New Deal*, 329; Lorentz, *FDR's Moviemaker*, 39–43, 45–50; and Synder, *Lorentz*, 20–25.
43. *The Shoemakers of Stoneham* was one of several WPA commissions undertaken by William Zorach in the 1930s (see Park and Markowitz, *Democratic Vistas*, 214, 228, 235).

44. "I never realized what a rich and important industry shoemaking is," Zorach remarked, to call attention to the craft skills shared by sculptor and shoemaker (Ibid., 51–52).
45. Federal Writers' Project, *Vermont*, 361.
46. Ibid., 78.
47. The work itself was backbreaking and harmful. Silicosis, caused by prolonged breathing of the dust from particular kinds of stone produced by pneumatic drills and cutting and finishing machines was often lethal (see Hathaway, "Men against Stone," 18–21).
48. Cape Verdean sailors and their families settled in New Bedford in the nineteenth century, where the men shipped out on whalers. More Cape Verdeans followed in the early twentieth century, working in the cranberry bogs and strawberry farms surrounding Falmouth (see Halter, *Between Race and Ethnicity*, 112–13).
49. Two notable exceptions are *Martyr Hill* (*see* Fig. 210) by Louis Guglielmi and *Main Street, Peterborough* (*see* Fig. 209) by Gregorio Prestopino.
50. Allan Crite's first major exhibition was held in 1934 at Grace Horne Galleries on Newberry Street in Boston. Other local exhibitions followed, but sales were mostly limited to drawings and watercolors. For additional information on Crite, see *Allan Crite's Boston* or contact Jackie Cox-Crite, president, Allan Rohan Crite Research Institute and Museum, Boston.
51. *Selling New England*, 11 (see the quotation), 4 (note the image of old-fashioned village).
52. Fairbrother, *Bostonians*, 213.
53. Quoted in Hurley, *Portrait of a Decade*, 148. Donna Cassidy, professor of art history at the University of Southern Maine, kindly provided Stryker's shooting script for this and other trips to New England by FSA photographers.
54. Harris and Norelli, *Art, Design, and the Modern Corporation*, 58, 60.
55. Flynt and Chamberlain, *Frontier of Freedom*, 1.

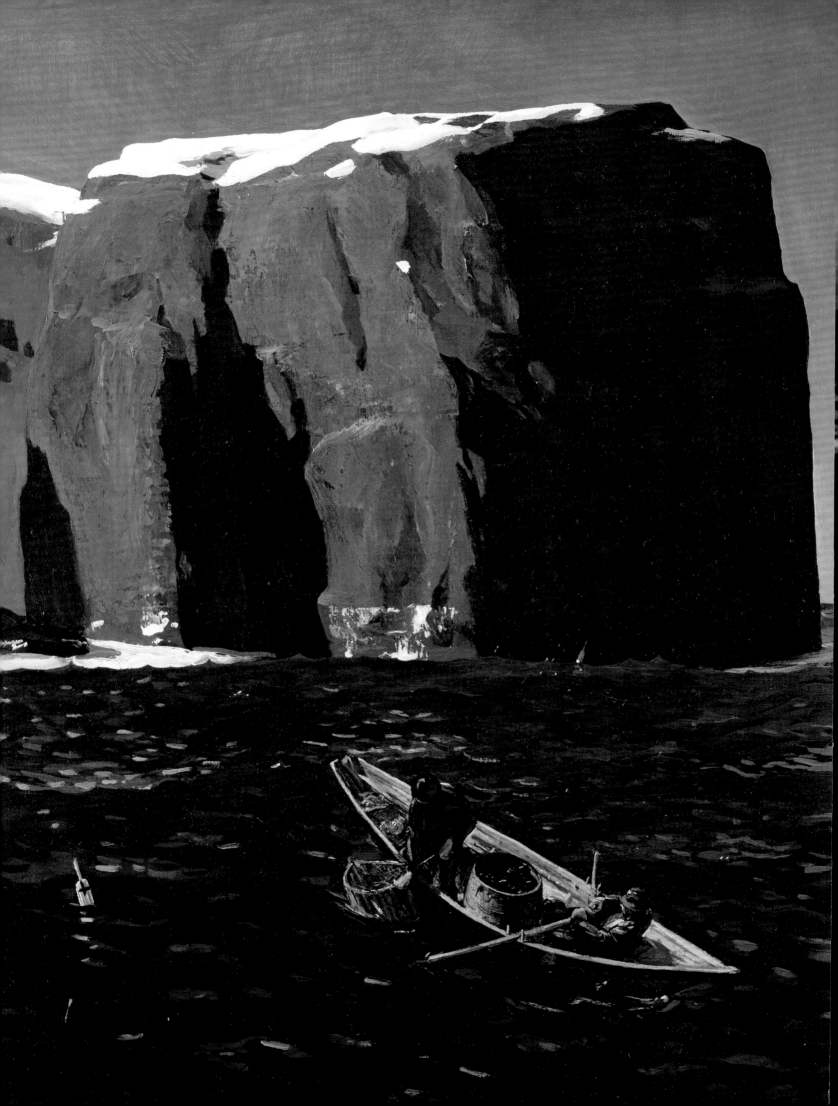

Perils of the Sea

BRUCE ROBERTSON

Out on the coast of New England, particularly in Maine, something especially characteristic of the region seems to take place, every day, every hour, indeed every minute. There the ocean meets the land, as the waves reach and pull back and reach again to ravage or caress the shore. There New England begins, or ends, depending on your temperament and mood. While many regions have coastlines, New England's seems especially rich in associations. Varied as the coast is, by the end of the nineteenth century its meaning and image had coalesced around one dominant core. The vision of the coast recorded by summer residents like Childe Hassam at Appledore is bright and soft. The New England coast that resides in memory, once the visitors have gone, however, stands firm against the endless energy of the ocean, a granite that resists force or persuasion. The metaphor the image presents was read in any number of ways, but primarily it stood as a sign of New England's moral rectitude, the tie to its Puritan past and the subsequent (and perhaps contradictory) quests for freedom embodied in the Revolution and abolitionism. This set of values could also be read more personally, in the language of sexual transference that saturated so much of public culture at the end of the nineteenth century. As Freud reminded his audiences at this time, the sea was an image of femininity, the rocks, a sign of manhood resisting the water's destructive forces. The metaphors embodied in the rocky coast and the voracious wave were reflected in the figures of the sailor or fisherman, outlined against the sea and standing in his boat or on the shore, looking out at the waves. These men were sentinels, guardians, the first immigrants to the New World and the last chance against change. They were as stalwart as the rocks they lived on.

What gave these images their special strength at the end of the nineteenth century, and their special location in New England, was the particular collision between history and modernity enacted there and then. New England, by the end of the century, claimed more convincingly than any other region to be the place where the acts and ideas that had engendered the United States had come into being and where living remnants of that authentic history still survived. As the notion of what constituted the heart of New England receded from its southern tier of states, Boston and points north promoted their claim to stand apart from the ongoing movements of American history and rebuke its excesses and probable future. Against the endless and ambiguous future, New England was presumed to represent the constancy of timeless values, a strong rock amid a sea of change. History might have its domestic, genteel, and variable side, but it could also embody virile political ideals—Revolutionary values of independence, action, strength. This version of history found its living expression most popularly in images of seaboard communities. The New England coast was granite of a particularly principled kind.

Rockwell Kent, *Toilers of the Sea* (detail), 1907, oil on canvas, 96.5 × 111.8 cm (38 × 44 in.). New Britain Museum of American Art, Connecticut; Charles F. Smith Fund (1944.1).

143

The Frontier Ocean

The meaning of New England that lay in its landscape or at least the sign of that claim for moral authority was nowhere more self-evident than on its shores. The farms and forests of the inland areas, from northern New England down to Connecticut, ranged from still prosperous to played-out hillsides. For most of the nineteenth century more fertile fields had opened up to the west. On land, at least, claims for New England's continuing leadership could be countered, but the sea was constantly renewed. Should fishermen and whalers destroy the stocks close to home waters, the sea itself always gave plentifully somewhere in the globe that New England fishermen quartered. Even as the Far West was settled and the frontier declared closed, with California rapidly becoming a sunny paradise, the Atlantic Ocean could be construed as a perennial last frontier: "As the frontier pushed westward, there were still many who remained behind. . . . The pull of the sea held many others at the water's edge. In reality America had two frontiers, one working steadily across the continent and the other pushing out finally to the farthest ends of the oceans. The men and women of each knew the same hand to hand struggle with nature." So wrote the author, Ralph Henry Gabriel, of *Toilers of Land and Sea* (1926), a volume in *Pageant of America* (1925–29). He added, however, that while the land was subdued, "the sea remains the same forever and he who entrusts his life to the ocean must always remain, in spirit, a frontiersman."[1]

The actual picture was more complex, more contested, in every way. As the mythic image of New England was consumed, it fed on itself, erasing the perception of facts that might contradict that myth, which grew simultaneously less real as it grew more prevalent. Whatever the aura of timelessness and infinite plenitude with which the ocean was endowed, the actuality was different. For all his confident certainty, Gabriel inadvertently acknowledged "the inroads made by the vast fishing operations that characterize the twentieth century. How little the colonial fisherman of New England would have thought that the fish which he found so abundant off his coasts could ever need artificial replenishment."[2] Moreover, Portuguese, blacks, and other races and nationalities had populated the fisherfolk stock just as much as Canucks and other immigrants had filled the ranks of laborers on land. The "pure" Yankee fishermen was a mythical creature.[3]

Winslow Homer and His Influence

Nonetheless, the requisite elements of the imagery associated with the mythic New England coast were few, and easily satisfied in the seaside resorts so popular from the mid-nineteenth century onward. The artist who articulated this heroic idea most fully was Winslow Homer, a native New Englander who moved to Prout's Neck, Maine, in 1883 and lived there the rest of his life (avoiding the worst of the winters by escaping to the Caribbean).[4] Homer's vision, in fact, largely determined the content and style of this subject for his contemporaries and several following generations. Unlike other artists who were responding to an earlier prevailing style (the colonial revival) or modeling their paintings on those of a powerful predecessor like Copley, Homer, in his sea paintings, reframed the idea of the heroic coast of New England (as opposed to the summer shores typified in the work of Hassam) so that his images became inescapable for other artists, critics, and audiences.

In 1880, in the northern fishing village of Cullercoats, England, Homer began to build a pictorial repertory of hardy fisherfolk and sailors, often caught in dramatic moments as the sea threatened to overwhelm them. With his move to Maine in 1883, these scenes became the subject of major oil paintings. Then in 1890 he began to produce oils of the rocky shore that lay outside his studio at Prout's Neck. In these paintings, pitting the ocean against the land, Homer exaggerated both the isolation and the peril to a very satisfying degree. His paintings of fishermen and

the Maine coast were an immediate success with the critics, even if they seldom sold as quickly as Homer wished. While his fishing paintings connected in an abstract way to the lives of their viewers, the reality of his landscapes could easily be ascertained at Prout's Neck, a short train ride from Boston. Visitors could and did come, staying in one of the hotels that lay just yards away from the Homer family houses and studio. Homer and his brothers, in turn, were crucial in developing Prout's Neck as an exclusive resort. Homer was a definite feature drawing tourists to the place, a situation that he consciously created even as he deplored it. In the end, he and his art became synonymous with the subjects: "Some taciturn trapper or skipper reckoning with natural appearances might paint like this."[5]

The great break in Homer's career had come in 1880, when he had left the United States and retreated to Cullercoats. Before he left, he had been known as a chronicler of country life, who painted children, young women, and rural Southern blacks. While his work was admired, it was not seen as radically different from that of any other genre painter of the day. After his return from England, and during the 1880s as he painted contemporary history paintings of heroic figures challenging the elements, that reputation began to fade. His landscapes of the 1890s—cold marines and bleak coastal views—permanently relocated his reputation as the artist of the North, not the North of the political Union, but the north of the soul, the terrain of tough choices, inimicable nature, harsh conditions. His pictures of hunters and fisherman consolidated this reputation.[6] Master of the land that lay north of easy cultivation, Winslow Homer was, by the time of his death, the most admired artist in America.

Since his market and the critics who trumpeted his reputation all lay further south, what was the attraction of this subject matter? In a sense, the paintings offered a line of demarcation between what the northern part of the nation offered and what the rest of the world might hold. It is not just the South that the paintings opposed but also the West, the East, Europe, and the rest of geography. They offered to the nation a sense that the old values remained viable and available and served to rebuke or inspire other artists and cultural performers. Most importantly, they constructed these values not as genteel or sophisticated but as rustic and hardy. As one critic said of his painting: "It is a male art and often a raw art."[7] The same could be said of the New England landscapes he depicted, as Charles Woodbury, another painter of the Maine coast, proclaimed: "One of the characteristics of American landscape is that it has a virility we do not find in Europe. The American people are full of life and their natural expression is force."[8] Made masculine, art could withstand all the charges of immorality and marginality brought against it by those concerned with the health of the nation.[9] In the complex cultural war waged between the sexes at the end of the century, in which sexualized imagery was deployed through a process of transference, some comfort was gained by positioning art solidly on those unmovable rocks, where it could withstand the worst charges of irrelevance or degeneracy. Many critics read into Homer's paintings the imagery of battle, common language in a period of growing imperial ambition (and closely allied to the imagery of "Nature, red in tooth and claw," promoted by Darwinism), identifying them even more closely with national issues (and Revolutionary origins). Homer painted "a world of ceaseless strife and motion," as the critic Frank Jewett Mather, Jr., said soon after the artist's death.[10]

Rock-Bound Coasts

The heart of what Homer had to offer lay in his landscapes, and the most influential were reduced to the absolute basics of land, sea, and sky. Such a motif was not entirely new in American painting. While earlier views were identifiably placed in the context of seaside resorts, Homer's (which in actuality were painted in the same

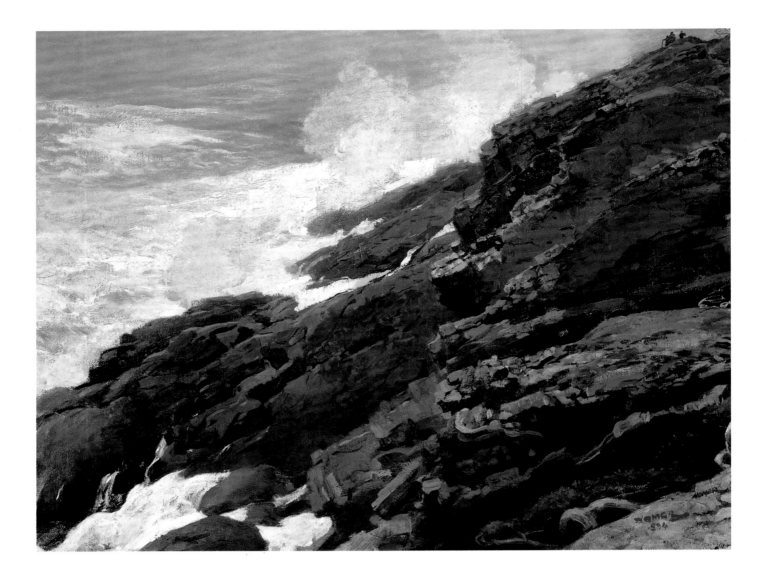

161. Winslow Homer, *High Cliffs, Coast of Maine*, 1894, oil on canvas, 76.8 × 97.2 cm (30 1/4 × 38 1/4 in.). National Museum of American Art, Smithsonian Institution, Gift of William T. Evans.

sort of place) gave the impression of far greater remove from civilization. *High Cliffs, Coast of Maine* (Fig. 161) exemplifies this group of works. At first glance, nothing could be simpler. A patch of solid, brownish rocks descends to the froth and swell of a stormy sea. A closer look reveals people on the rocks, and the rocks themselves are somewhat cracked and broken. It is difficult in places to figure out where the seaweed leaves off and the rock begins. Nothing happens here except the eternal struggle waged by water and rock against each other. The formula used by Homer—the diagonal swatch of dark, solid matter holding down the lighter, vital waves and white sea spray, a composition compressed into an almost square format—was immensely influential, imitated or echoed by countless artists.[11] For them and their critics the subject became inevitable: "Few, if any, external influences have made themselves more potently felt in American art than the geographical one exerted by the coast of Maine. There is something characteristically American typified by these rugged, rocky shores, and the endless, tumultuous surge of the ocean waves upon them, which has been the inspiration of some of our greatest and most truly national paintings."[12] For artists wishing to render the immediate power of the ocean, rather than its abstract infinity, Homer's motif virtually replaced the longer, horizontal scenes of rolling waves and shoreline favored by the previous generation.[13]

Aside from the illustrators of the ocean—those artists such as Woodbury, Paul Dougherty, and especially Frederick J. Waugh (who made a respectable living off depicting waves; he won the popularity prize of the Carnegie International five times from 1934 to 1939)[14]—the group most affected by Homer's example were the

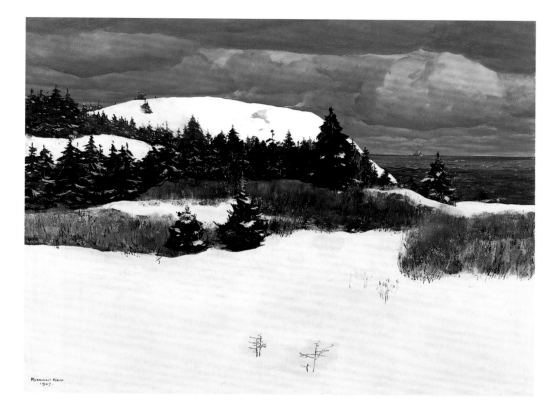

162. Rockwell Kent, *Maine Coast*, 1907, oil on canvas, 86.7 × 112 cm (34 1/8 × 44 1/8 in.). © The Cleveland Museum of Art, 1998, Hinman B. Hurlbut Collection (1132.1922).

realist artists surrounding Robert Henri. Because Homer was such a powerful realist painter (only Eakins challenged him, in the eyes of younger artists after 1910), this was perhaps inevitable. Nonetheless, Homer's paintings still needed to be creatively misread in order to make them useful. Eager to engage with so famous a model, Henri's followers read social truths out of Homer's apparently almost abstract landscapes. Henri observed: "[Winslow Homer] had such a sense of proportion that his work would hold a business man straight. He gives the integrity of the oncoming wave. The big strong thing can only be the result of big strong seeing."[15] In referring specifically to the Prout's Neck paintings, Henri averred that the subject was not limited to a question of local environment; instead out of these works one could read the central concerns of the American artist: "It is personal greatness and personal freedom which any nation demands for a final right art expression."[16] For Henri, it was a straight line from Homer's waves to a consideration of the nature of American liberty, free of the ravages of the capitalist. Where for older critics Homer's paintings might uphold conservative readings of American freedom, Henri could view them as supporting the progressive ideas animating his circle. Whatever the audience, Homer's views of the Maine coast were always constructed to embody critical ideas about America.

After Henri visited Maine in 1903, he advised his students to go there. The first to follow him was Rockwell Kent, in 1905, who arrived on Monhegan Island and stayed, on and off, for six years. *Maine Coast* (Fig. 162) shows a Maine that no summer visitor but only a resident could know, that is, only someone like Homer. Following his first exhibition of these views in 1907, critics and fellow artists were not slow to make the comparison: "One young man, Rockwell Kent, is already doing shorescapes and marines that are being favorably compared with the paintings of Winslow Homer." The similarities lay not simply in their picturing this coastline off-season but that both made "big, simple statements" about nature. Kent was "a worthy successor to the master of Prout's Neck, whose rugged rock-ribbed coast he has depicted with forthright simplicity and directness that has something of the stark actuality and bitter tang of the sea itself." Henri's colleagues agreed: John Sloan wanted to buy a few, and George Bellows was envious.[17]

Each time an artist successfully claimed Homer's coast as his own, however, the going got tougher for those following. These paintings of the coast were always produced within the realm of picture making, even as they were painted plein air, directly in front of the subject. Bellows, strongly influenced by Kent, put off going to Monhegan until 1911, after Kent had left. Inevitably his first paintings of the Maine coast were modeled closely on Kent. By the time of his second visit, in 1913, the forms, in paintings such as *Hill and Valley* (Fig. 163), were simplified and muscular and more landscape elements were assimilated. Bellows had begun to see Monhegan through Homer's eyes as well as his own, unmediated by Kent's example.

At the same time these realists were selective in what they saw in Homer. Out of Homer's rather barren landscapes, Henri and his colleagues would, under the impact of the Armory Show and the discovery of van Gogh and the Fauves, discover a rainbow of possibilities. Bellows's 1913 landscapes of Monhegan already disclosed the impact of the Armory Show, but Sloan's paintings of Gloucester, Massachusetts, were perhaps more interesting, melding the past and the future. *Fassett's Cove* (Fig. 164) matched Homer's motifs to expressionist color and anticipated the uses to which an artist like Milton Avery might still be putting these motifs in the 1950s. At the same time, color had not been entirely absent from Homer. Looking more closely at *High Cliffs,* one can see mottling the rocks the same pure colors used by Sloan. Sloan was never so self-conscious an artist that he was likely aware of this correlation, but, at the same time, it reminds us that Homer, for all his overt allegiance to realism, could also be as "aesthetic" as any of his contemporaries and not as committed to his own myth as his critics were.

Fisherfolk

While it was necessary to place these virile stories of New England in a specific landscape, it was also critical that they be exemplified in a society; and so the fisherfolk who inhabited this landscape were indispensable. At the same time, however, people were much more problematic than rocks and water, both of which could be taken as immutable, while the fishing industry and the people who were part of it were all too evidently under attack in a changing world of industry and immigration. With a certain amount of wishful thinking, one could still see them as they may have been. Fishing, despite being a business, could be claimed as resolutely unmodern and uncapitalistic: "As in agriculture, the corporation has made little progress in the fisheries of the Banks. Like the farmer, the fisherman who owns his schooner and his nets or trawls is independent and an individual."[18] Fishermen, too, existed outside time: "Poor but independent, living from hand to mouth, rugged and weatherbeaten, the type changes little in a swiftly moving age."[19] In the end, of course, such reactions were not about the fishermen, but the artist and viewer responding to what he or she saw. Rockwell Kent revealed this most clearly, remembering his first encounter with Monhegan and the local men: "Standing upon a headland I'd look down at lobstermen at work, their dories almost in the back-wash of the surf. God, how I envied them their power to row! To pull their heavy traps! I'd see my own thin wrists, my artist's hands. As though for the first time I saw my work in true perspective and felt its triviality."[20]

In reality, Kent and other artists were looking as much at Homer's paintings as they were at the fishermen: "[Homer] has interpreted, as none other, the primitive life of our New England coast, the life of those who 'go down to the sea in ships' and cast their nets off its rocky shores."[21] Perhaps most influential were the paintings of men at sea, the ones furthest away from the dubious land: "In [these pictures] it is no longer the rocklike cliffs against the sea but rocklike men against the sea—and essentially the painting formula is the same."[22] From the very first, Homer was interested in the power of the sea to overcome the individual. His first big figu-

163. George Bellows, *Hill and Valley*, 1913, oil on panel, 45.7 × 55.9 cm (18 × 22 in.). Colby College Museum of Art, Waterville, Maine.

164. John Sloan, *Fassett's Cove*, 1915, oil on canvas, 66.0 × 81.3 cm (26 × 32 in.). Kraushaar Galleries, New York.

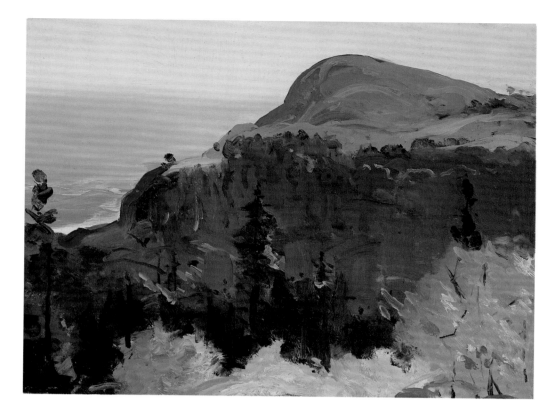

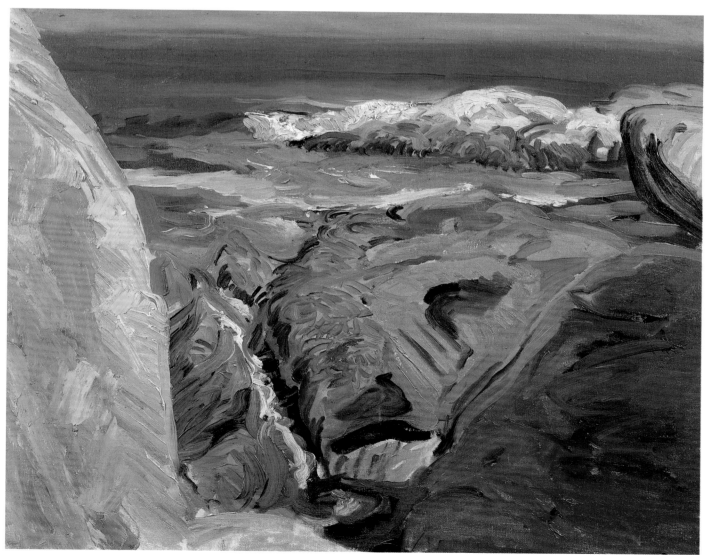

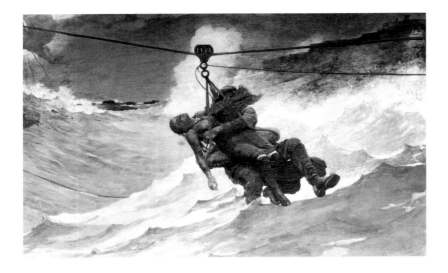

rative sea picture was *The Life Line* (Fig. 165), based on observations he had made in New Jersey and set close to shore. In his fishing paintings he explored a range of situations from the quotidian of work to the drama of weather and currents—fog, high seas, great waves. These canvases pictured the Grand Banks off Newfoundland, the destination of most New England fishing fleets and regarded as an extension of their fishing communities. At the center of his fishing paintings is the trilogy from about 1885, completed after his final move to Prout's Neck: *Herring Net, The Fog Warning,* and *Lost on the Grand*

165. Winslow Homer, *The Life Line*, 1884, oil on canvas, 73.0 × 113.4 cm (28 3/4 × 44 5/8 in.). Philadelphia Museum of Art; The George W. Elkins Collection.

166. Winslow Homer, *Lost on the Grand Banks*, 1885–86, oil on canvas, 80.0 × 125.4 cm (31 1/2 × 49 3/8 in.). Private collection.

Banks (Fig. 166). An ascending drama of peril, the trilogy concluded with one of the great hazards on the Grand Banks—a fog bank coming in, cutting off the men in their dories from the main boat. For all their universality, these are regional paintings, celebrating "the very concentration of strength" embodied in these hardy New Englanders.[23]

Rockwell Kent, among Henri's students, was most consistently interested in contests emphasizing hardihood, a struggle he located in style as well as subject matter. Deploring tonalist softness ("What in the world has happened to mankind that *soft*—soft lines, soft colors, soft effects—means excellence?"), Kent preferred hard contrasts of color and line.[24] *Toilers of the Sea* (Fig. 167), obviously inspired by Homer's *Fog Warning* and other fishing paintings, is sharper in its contours and colors but less dramatic in its situation. Committed as a realist to painting what he saw, more or less, Kent experienced cold and long hours fishing off Monhegan Island but very little danger.[25] The real boldness of the painting, as commented on by critics, was in the paint. In what might seem to us an exaggerated response to the

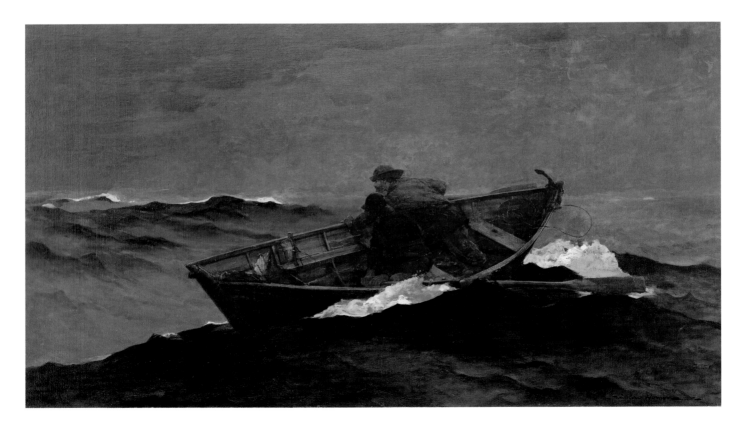

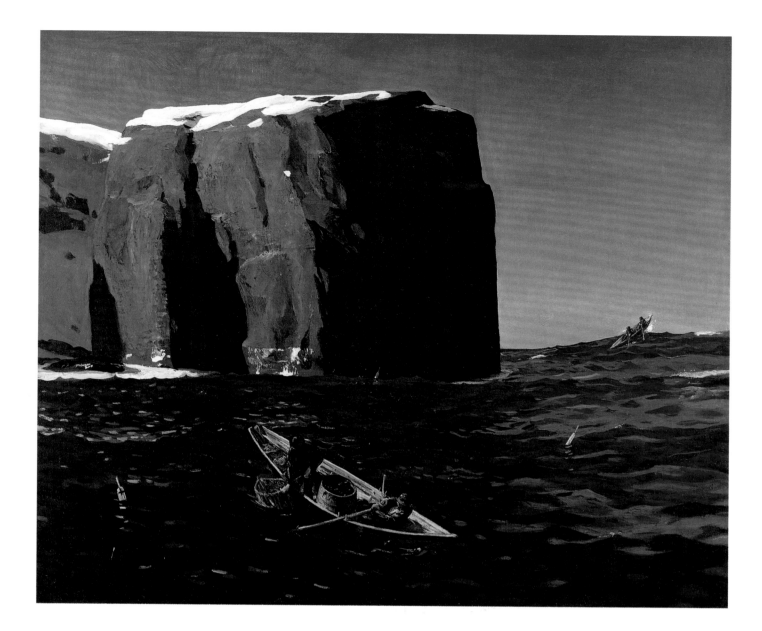

167. Rockwell Kent, *Toilers of the Sea*, 1907, oil on canvas, 96.5 × 111.8 cm (38 × 44 in.). New Britain Museum of American Art, Connecticut; Charles F. Smith Fund (1944.1).

rather smooth surfaces of Kent's paintings, one critic admiringly saw "rough paint, crude paint, very rough paint."[26] The terms pay obvious homage to Homer, whose painting style was considered, in the same years, "virile, vigorous, rugged, powerful, and remorselessly truthful as a record of what he saw."[27] These are Yankee, New England virtues, translated into the materiality of the paint, one that all Homer's imitators and followers tried to claim for themselves—or the critics claimed for them.

Realistic Stories

The narrative aspect, not the dramatic effects, of Homer's paintings presented a problem to realist artists like Kent. Homer's stories, as opposed to his motifs, appealed to a different sort of painter, from the world of illustrators in which Homer had first earned his livelihood. Among these was N. C. Wyeth (exactly the same age as Bellows and Kent), who in the early 1920s followed his heart to the north and settled in Port Clyde, Maine, where the ferry leaves for Monhegan (as a prospective year-round resident he made the wise choice). His impulse had much to do with finding his roots—roots that were WASP and New England (he had just spent a year or two trying to rehabilitate the family house in Dedham, Massachusetts). Moving further north, he gave in to the cultural longings embodied by Homer's paintings. He even named his house Eight Bells, after the painting of the same name by

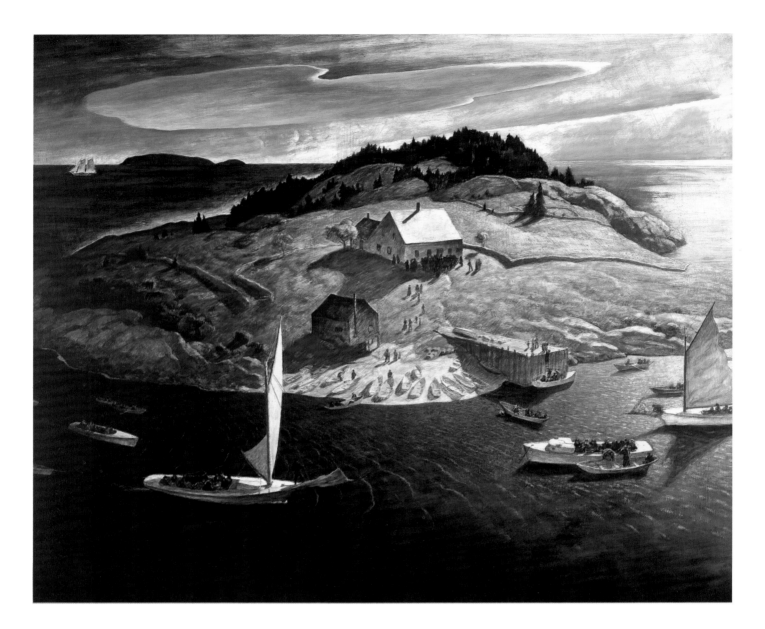

168. N. C. Wyeth, *Island Funeral*,
1939, tempera on panel, 111.8
× 132.1 cm (44 × 52 in.). Art
Collection of the Hotel duPont,
Wilmington, Delaware.
Photograph courtesy of the
Brandywine River Museum,
Chadd's Ford, Pennsylvania.

169. Rockwell Kent, *Burial of a
Young Man*, ca. 1908–11, oil on
canvas, 71.4 × 132.7 cm (28 1/8
× 52 1/4 in.). The Phillips
Collection, Washington, D.C.

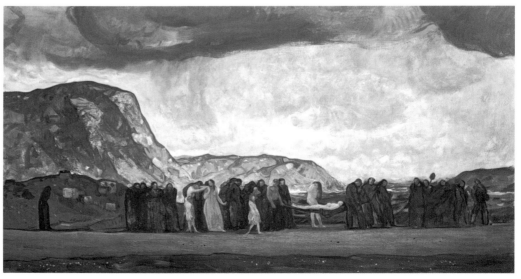

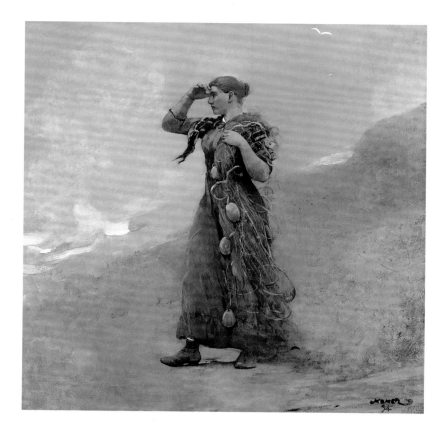

170. Winslow Homer, *The Fisher Girl*, 1894, oil on canvas, 70.5 × 70.5 cm (27 3/4 × 27 3/4 in.). Mead Art Museum, Amherst College, Amherst, Massachusetts, gift of George D. Pratt, Class of 1893.

Homer. This painting of two sailors taking the measure of the sun was, as he said, one of "the productions of men who are dead in earnest, who hate all bunting and shams, and who have taken off their coats in the service of truth and are not ashamed to be found in their shirt sleeves"—just as Wyeth wanted to be viewed.[28] While most of his career was occupied with illustration assignments, during the last decade of his life his paintings focused on local fishermen. *Island Funeral* (Fig. 168), one of the last and largest, depicts a community assembling to say farewell to one its own—perhaps a drowned fisherman. In arguing why his town never became rich, James Connolly, a popular storyteller of Gloucester fishing yarns, suggested that with the loss each year of eighty or so young men the heart blood of the community was always leaking away.[29] Despite such misfortune, Connolly maintained, the town held fast. Wyeth makes the same point, as the small figures gather together under one roof in the center of the canvas. He asserts the timeless tradition of this fishing life, stately and unchanging, rock solid, with the possibility of transcendence suggested by the moving clouds. Even as the funeral takes place on an island, the image of community echoes John Donne's line, "No man is an island." Kent depicted a similar subject, in *Burial of a Young Man* (Fig. 169), prompting Mather to remark: "If one could imagine a Winslow Homer cut free from his realistic moorings, one would have a rough picture of the genius of Rockwell Kent."[30] In other words, this theme of death, which Homer never makes explicit in his New England sea paintings, was nonetheless uncovered by audiences and other artists.

Fisherfolk on Shore: Real Work

As Wyeth's painting suggests, however, the lonely fisherman in paintings by Kent and Homer also belongs to a community. In fact, Homer's first appreciation of the heroic world of fishing folk developed on land. His watercolors of Cullercoats concerned primarily women mending nets and waiting for the men to return. Not until he had the opportunity in 1884, now as a year-round resident of a fishing community, to be rowed out among the herring fleet, did he begin to paint the men at work on the ocean. Before then he had been, essentially, an onlooker, a tourist. Nonetheless, Homer often returned to those onshore subjects, where the solitary fisherman finds a home. At the same time, ideas of domesticity threatened the image of supreme individuality and masculinity, the chief appeal of these paintings. How to resolve the paradox? The answer: remove all signs of gentility and femininity. Homer's vision is a male-centered community, radically at odds with those of his contemporaries like Hassam. The women in Homer's paintings, like *The Fisher Girl* (Fig. 170), are not sweet but are as heroic, large, and strong as their menfolk.

Unfortunately the very avenue by which these proud communities could be viewed also led to the destruction of their virtues—the arrival of summer visitors. Moreover, technology was rapidly undermining traditional fishing techniques. These communities of indigenous heroes were vanishing even as they were wit-

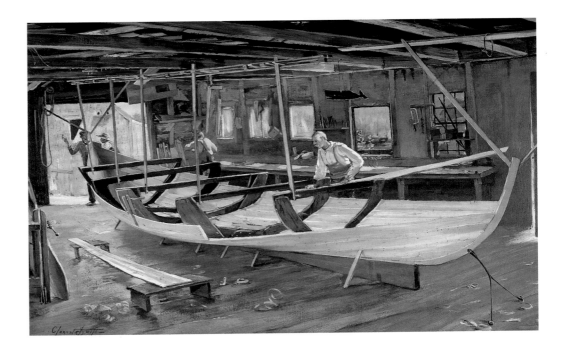

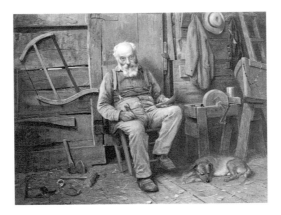

nessed by artists. Clement Nye Swift represents this dilemma acutely, from a native's point of view. Born in Acushnet, Massachusetts, he spent most of his life there. Swift's interests were rural and realist, which meant that he valued the specific associations of a place. While studying in France he explored Brittany, writing short stories from the material he had gathered and painting the distinctive regional costumes and customs. His return to Acushnet in 1882 was a return to a local community with its specific flavors of timelessness and peculiarity—one that he knew well as an insider. Living just outside New Bedford, a major center of the whaling industry, Swift focused on the rapidly receding past in his poems and paintings. He was also an early trustee of the New Bedford Whaling Museum at the Old Dartmouth Historical Society.

Swift's *Leonard's Boat Shop* (Fig. 171) depicts a dory being built in a small boatbuilder's shop. While dories were used for many kinds of fishing, in New Bedford they were part of the whaling industry. By 1900 square-rigger whaling ships were no longer built, and whales were harpooned with explosive charges, shot from a ship's deck. Dories were less and less in demand by whalers. Nonetheless, no signs of modern technology show here; everything is done by hand. The painting is a paean to a passing age, one that refuses to acknowledge change. J. G. Brown's *Boat Builder* (Fig. 172) is a more explicit rendering of what Swift is trying to say, universalized and moving beyond the specific example of New England. The painting is actually a self-portrait, depicting the artist in old age.[31] As the painting is autobiographical—not that Brown was ever a boatbuilder—it makes a statement about the nature of Brown's style and his art: both are deeply naturalistic, both look like what they are, both are honest and take no shortcuts. They are not modern. In the largest sense, these paintings of New England fishing culture, by making an identification with the hardness of the life and the hardness of the painting, as did so many critics and audiences, make a case for naturalistic, even realist art being fundamentally American in just the way New England is. While many areas of

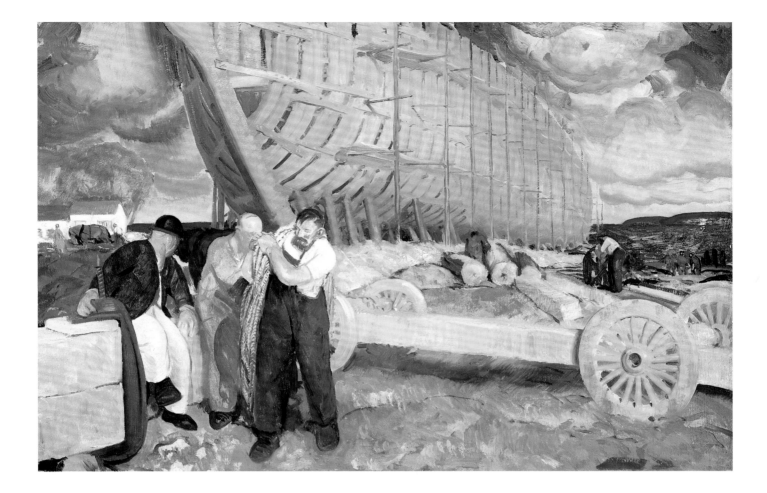

173. George Bellows, *The Rope* or *Builders of Ships*, 1916, oil on canvas, 76.2 × 111.8 cm (30 × 44 in.). Yale University Art Gallery, given in memory of Chauncey K. Hubbard, B.A. 1929.

the country might claim a close connection to "realistic" art (such as the Southwest, with its endless and popular images of cowboys), the link is overdetermined in New England. Norman Rockwell is unsurprisingly a New Englander.[32] It is in this sense that Andrew Wyeth, whose work lies outside the chronological purview of this discussion, is identified as a quintessential American image maker, even as he divides his time between rural Pennsylvania and Maine as did his father, N. C. Wyeth.

Other artists continued to make these connections. Bellows, a realist artist of the next generation, is a case in point. At one level, he, like his teacher Henri, was interested in authentic "types." Part of the pleasure of travel for many artists was to locate interesting people who seemed to personify their surroundings, living avatars of that region's soil. This chase led many of the Ashcan artists to the ghetto, and Henri to the Southwest, to Ireland, and to Spain. As Bellows explored New England, he too felt the attraction of finding occupational "types."[33] Shipbuilders occupied a special place in this pantheon of workers and ethnicities.

Bellows painted fishermen for the first time in 1913 on Monhegan, in part because he had a studio above the beach where fishermen cleaned their catches. The following summer he painted many portraits of them.[34] In 1916, with the threat of war, he spent the summer on the mainland in Camden, Maine, near the shipyards. Describing the paintings of boats, he wrote to Henri, "The result while in continual danger of becoming either illustration or melodrama has nevertheless in several cases evolved into rare pictures."[35] *The Rope* (Fig. 173) is one of them. The unfinished boat looms over the men like a leviathan. They in turn calmly ignore it and the threatening clouds, as they go about their work. Unlike many of Bellows's earlier scenes of industrial activity, this juxtaposition heroicizes the men. However large the thing they are creating, it does not diminish them. In contrast, in his paintings of the construction of Pennsylvania Station in New York in 1904, the ex-

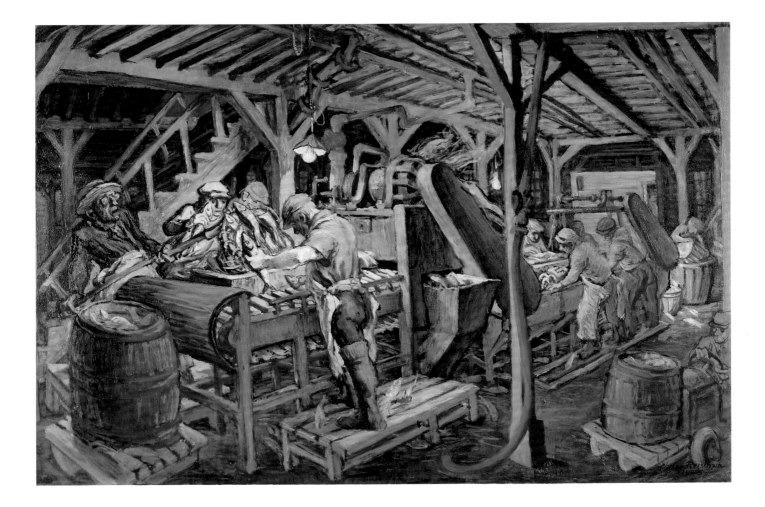

174. Philip Reisman, *Mackerel Machine*, 1944, oil on panel, 63.5 × 91.4 cm (25 × 36 in.). Cape Ann Historical Association, Gloucester, Massachusetts.

cavation becomes a monstrous landscape that dwarfs the human figures. This disparity of scale is a common feature of his urban scenes, where human figures struggle to be seen. But as he wrote the following year: "When I paint the beginning of a ship at Camden, I feel the reverence the ship builder has for his handiwork. He is creating something splendid, to master wind and wave, something as fine and powerful as Nature's own forces. . . . When I paint the colossal frame of the skeleton of his ship I want to put his wonder and his power into my canvas, and I love to do it."[36] Despite their different artistic allegiances, Brown's identification with boatbuilding as a metaphor for art making was felt by Bellows too.

The boat Bellows was engrossed in was actually about to go to war. It was being built for the government to protect the coast under the threat of German ships. Although still eager to stay out of the war at this point, Bellows could not ignore it. He had been deflected from his vacation in Monhegan by his wife Emma's concern over enemy gunboats along the coast. Faced with the prospect of American engagement in the war, he must have been reassured by the mastery of these overdetermined American activities and types. Bellows celebrates the congruence of labor and material, man and his creation, posed together against the threat of force. Homer's coded references to battle become less subtle in the work of later realists, in another instance of their simplification of his work.

One world war later and yet another generation of realists removed, Philip Reisman had a slightly different take. A Polish émigré Jew raised in New York and a member of the John Reed Club, Reisman, as a socialist, was devoted to painting things "as they are." "I do not see any romance or poetic sentiment in this very harsh economic system," he said at the time. His work in the late 1930s was appraised by critics as a "proletarian art achieved without straining in the simplest

175. Carroll Thayer Berry, *Bath Iron Works, World War II*, 1941, oil on canvas, 82.6 × 92.6 cm (32 1/4 × 36 1/8 in.). Collection of the Farnsworth Art Museum, Rockland, Maine, museum purchase, 1972.

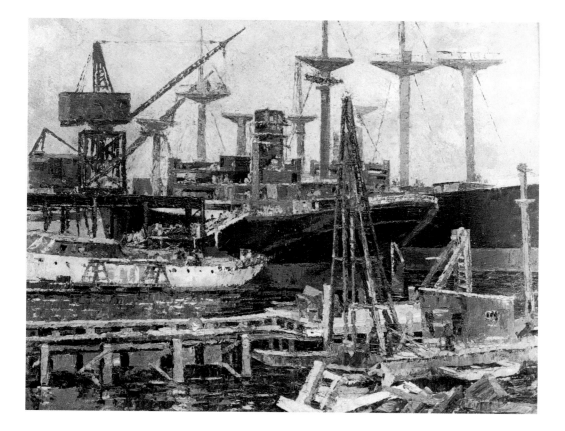

and most direct fashion."[37] Much later the artist would reflect that he "took the humanist approach of Honoré Daumier and Pieter Brueghel," thus negotiating an artistic trajectory for himself that went from overtly urban and Marxist in its aims to something more bucolic.[38] The nonurban aspect of his art—the Brueghelian, as it were—first found expression toward the end of World War II. In 1944 he had the opportunity to spend the summer in Rockport, on Cape Ann, so favored by landscape artists and painters of the summer scene. Reisman, however, turned his attention to the canneries in Gloucester, the still-working elements of the port's historic fishing industry. He eventually did almost one hundred canvases depicting the lives of fishing-industry workers. *Mackerel Machine* (Fig. 174) pictures a factory in Gloucester where mackerel was canned for the army.[39] The style reflects van Gogh's early paintings of peasants (but with a more colorful palette). The subject marries modern machine and peasant, technology and nature, and both are subject to capitalist oppression. The war has only made things worse, subjecting the vestiges of independent self-confidence to degrading regimentation. Despite this, the painter admired the strength and skill of the workers: again, the romance of the New England yeoman lingers on. While utterly different in style, Carroll Thayer Berry's *Bath Iron Works, World War II* (Fig. 175) is a similar mix of contradictory impulses. On the one hand, Berry displays a documentary pride in a reserved New England shipping industry, over-topping the wooden boat with a big iron-plated warship; on the other, this industrial scene is swathed in a gently broken impressionist brushstroke, reminiscent more of Hassam than of Bellows or Homer.

Documentary photographs of the fishing industry, while focusing on much the same subject matter—like *Man with Sturgeon* (Fig. 176) and *Fishermen Playing Cards* (Fig. 177)—are not nearly so histrionic. Paul Strand's photographs—*Corea, Maine* (Fig. 178)—are even cooler, keeping a modernist distance from the emotional heat of their subjects. "Realism," translated into other media, tended to abjure the overt rhetoric derived from Homer's narratives.

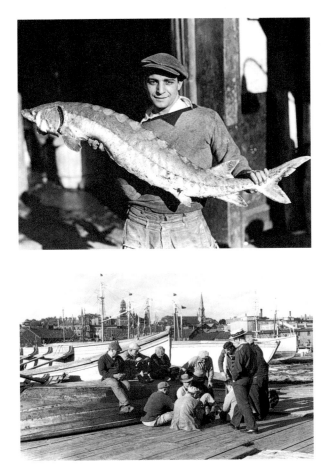

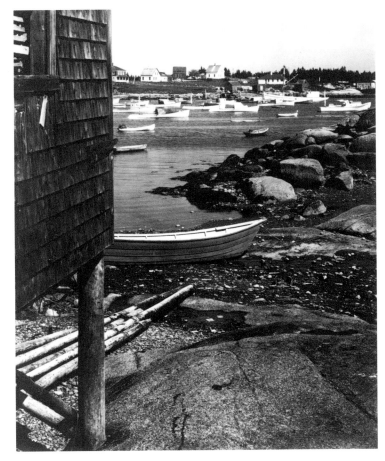

176. *Man with Sturgeon, Boston, Massachusetts*, 1931, photograph. Alton H. Blackington Collection in the Yankee Publishing Collection, Society for the Preservation of New England Antiquities.

177. Arthur Rothstein, *Fishermen Playing Cards, Gloucester, Mass.*, September 1937, gelatin silver print. Library of Congress, Prints and Photographs Division.

178. Paul Strand, *Harbor, Corea, Maine*, 1945, gelatin silver print, 24 × 18.8 cm (9 7/16 × 7 3/8 in.). Philadelphia Museum of Art: The Paul Strand Retrospective Collection: 1915–1975, Gift of the Estate of Paul Strand. Photograph by Lynn Rosenthal, 1998. © 1971, Aperture Foundation, Inc., Paul Strand Archive.

Pure Fishing Stock

Homer had imagined a community of fisherfolk united by work and the cohesion produced by isolation and the fearful and constant toll of the sea. Reinvigorated in another "northern" place—Cullercoats in the north of England—he was also inspired by the ethnic unity of the community. In the United States he turned not to the heterogeneous summer communities and fishing villages of Massachusetts, near his native Boston, but went further north as he had done after arriving in Liverpool and London, to some place more isolated and, not incidently, more backward and hence, "purer."[40]

In part the myth of New England resides in this notion of purity, one which is largely, and always has been, spurious. Only one artist consistently chose subjects that reflected a mixed community, and that was Charles Hawthorne. Hawthorne arrived in Provincetown in 1899 and immediately settled there, establishing a highly successful summer school. A realist trained in the Munich tradition, he concentrated on the figure, often cast into shadow á la Rembrandt. Instead of turning his back on the European realities of Provincetown—its large Portuguese community—he focused on it.

The Portuguese fishing communities of New England had long been of special interest to tourists, as representing the picturesque and exotic. At the same time, Portuguese fishermen played a crucial role in the local economy. This ambiguity—the opaque object of the tourist's gaze, the active subject of a working-class community—is the veiled position endured by most natives living in a tourist zone. We are accustomed to this issue when we travel abroad, when all locals are exotic. In New England the problem was slightly different in that some natives (at least those who were of "Yankee stock") could make claims to authenticity and self-determination superior to that of most visitors. This different issue—which resolves itself

179. Attributed to Angelo Lualdi, *Our Lady of Good Voyage*, ca. 1915, painted wood, 53.8 × 20.5 × 16.6 cm (21 × 8 × 6 1/2 in.). Cape Ann Historical Association, Gloucester, Massachusetts.

along urban/rural or rich/humble dichotomies rather than racial lines—occupies much of the local-color fiction of writers like Sarah Orne Jewett. But the Portuguese were not Yankees.

The model for *Our Lady of Good Voyage* (Fig. 179) by Angelo Lualdi exhibits this uncomfortable fact vividly. Made for the facade of Our Lady of Good Voyage Church, it has the appearance of folk art, as something arising from its community. The circumstances of its making are not so simple, however. The original church had burnt down in 1914, and in the rebuilding effort much of the community of Gloucester assisted, including such rich Anglo residents and visitors as A. Piatt Andrew, Henry Dana Sleeper, and Mrs. Isabella Stewart Gardner (all of Boston). The rebuilt church was modeled consciously on churches in the Azores, to make it more authentic.[41] The statue is similarly more "authentic" than what had been there before, self-consciously expressive of Catholic imagery in a state that felt its traditions to be severely Protestant, even though it was made in Boston and paid for by rich Anglo Bostonians.[42] Our wish, then, to separate these communities into locals and visitors, into Anglo and Portuguese, one and the other, must fail. The two are deeply intertwined and use each other constantly. Nonetheless, some distances are maintained. The Portuguese community speaks and Lualdi's statue suggests it is heard, but it is an open question whether those who paid for it heard quite clearly what they were being told. But having described the circumstances of the statue's creation in 1915, it is without question that within a generation, the statue, like the church, had become the community's, however we define that group.

Hawthorne's work exhibits just this dilemma of interpreting the relationship between the Portuguese community and those who viewed it. In a large series of oil paintings, he painted studies of fishermen, either singly or in groups. The European precedence for the paintings—images of saints or holy families, as in *The Family* (Fig. 180)—was in part a way of getting closer to his artistic roots, a way to claim part of a tradition that went back to Rembrandt and Hals. These were Hawthorne's own pictures of outsiders, like Rembrandt's portraits of Jews. At the same time he engaged with this community, he rendered it picturesque. The reality of their lives is not a case he presses; rather he pushes them back into the past by making them timeless. Meanwhile, he allows them to stare directly at us. The viewer has the curious sensation of the figures existing in two spaces simultaneously: the world of "art" and the here and now. This must have been close to the reaction of most summer visitors as they tried to fit the reality of ethnic and racial difference in New England into their settled and stereotypical notion of the place.

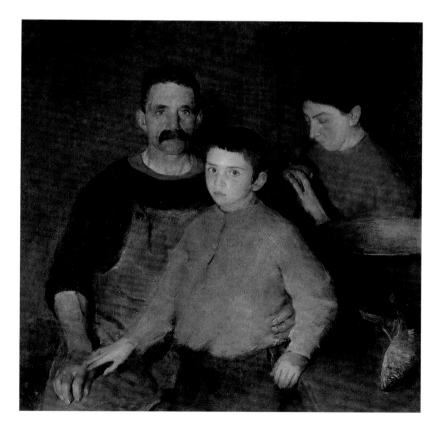

180. Charles Hawthorne, *The Family*, 1911, oil on mahogany panel, 101.6 × 101.6 cm (40 × 40 in.). Albright-Knox Art Gallery, Buffalo, New York, Friends of the Albright-Gallery Fund, 1912.

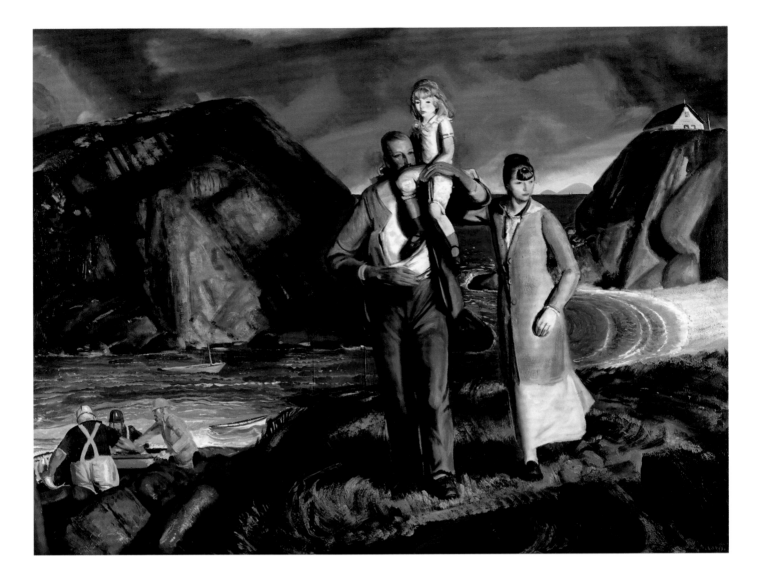

181. George Bellows, *Fisherman's Family*, 1923, oil on canvas, 97.8 × 123.8 cm (38 1/2 × 48 3/4 in.). Private collection.

Bellows's strategy, in *Fisherman's Family* (Fig. 181), expressed more vividly the equivocal nature of the position of most artists in identifying themselves with their fishermen subjects.[43] The title group is no fisherman's family but a portrait of the artist's family, standing above the beach where the fishermen worked on Monhegan, just where his studio had been. The group of fishermen in the background on the left reappear in other paintings. Bellows wants to invest himself with the attitudes and characters that Hawthorne paints from the outside, but he can only do it halfway. The invented community he posits here really belongs firmly on shore: this fisherman is not going to go out and haul in fish all day. Bellows's position is the same as Kent's and the impulse is the same—to have the artist's forearms pumped up with the honest virile strength of the worker. While Kent actually went out and lived that life—at least for awhile—Bellows was too sensible to do so.

At the same time the painting is in dialogue with other paintings, by Bellows and by his predecessors and contemporaries, by Eakins and the modernists. A hybrid work, it awkwardly integrates the past and the future, staking a claim to tradition and modernity. This middle ground posits Bellows's strength as well as his weakness and is typical of American realist artists in the early 1920s. It is also characteristic of the awkward nature of the nonabstract elements of Homer's work, as absorbed by this generation ten years after his death—the stories (however ambiguous) Homer's paintings told and, to a degree, their active creation of a New England myth. Its future is the future of these New England myths, eventually to be abandoned by forward-looking "serious" artists, those who wanted to maintain a

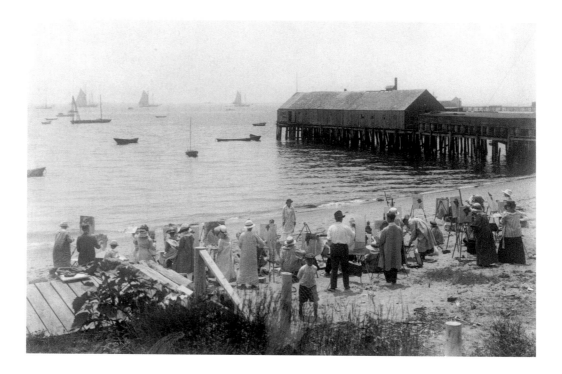

dialogue with modernity. For all his posture of strength and certainty, Bellows actually stands tentatively, pulled both ways.

The essential difference between Bellows's position and Kent's is that Bellows visited the island while Kent lived there. More accurately, Bellows belonged to the community of artists who made Monhegan an active summer colony while Kent passed through that colony to become part of the native community, at least for a few years. Hawthorne's position participates in the same dilemma, for all his focus on local Portuguese fishermen. Most of Hawthorne's students did not follow his example and, instead, painted each other, posing like the woman in the Chansonetta Stanley Emmons's 1927 photograph of an artist's class in Rockport (Fig. 182). The position from which all these painters worked, try as hard as they might, even as hard as Reisman, was artistic, and hence, one where "fishing" was staged.

Summerfolk

Homer, again, provided a model for that artistic staging ground. Prout's Neck was a resort, created in part by the Homers. While they never owned the large hotels, they were able to develop the rest of the neck into a summer colony for Bostonian professionals and others. The most dramatic, rugged, and timeless images of New England were created amid the most quintessential of modern New England industries, real-estate speculation. Homer could look out from his studio and ignore what lay behind him, but it took an act of will to do so.

In like fashion, Emmons's photograph of an artist's class presents a classic confrontation between the artistic observer and her subject. Facing out to sea, they have before them the working pier of the town on their right and the harbor scattered with fishing boats and dories, some under sail in the distance. What they are actually painting, however, is the woman standing just in front of them. In other words, for them, the port—the "real thing" of New England—serves as backdrop, as they capture the qualities of light at midday, the figure of the woman, dazzled under the light and the reflections from the sand and water.

William Henry Lippincott in *The Marginal Way* (Fig. 183) depicts a similar situation. Two elegant young ladies in rather old-fashioned dress walk down a pathway above the sea. They have just passed a man and woman who are proceeding back

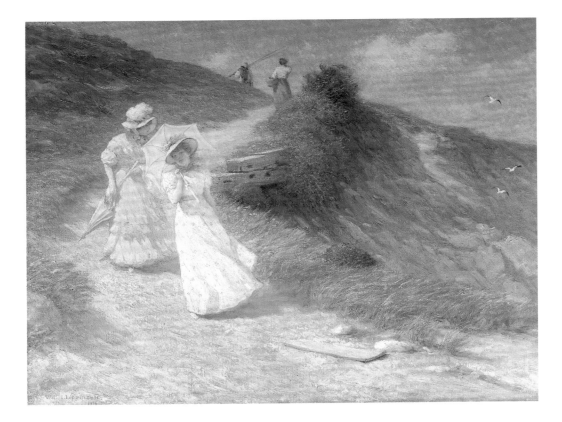

up the path. The pair in the foreground are summer visitors; the pair they have passed, a local woman and a fisherman. The first pair are moving into the day at a leisurely pace, the pair in the background have been working since dawn. The painting dramatizes, in a sentimental fashion, the conflict between hard-working locals and leisured summer visitors.

In contrast, J. O. J. Frost's painting *Fishing Schooner* Josephine *on the Grand Banks* (Fig. 184) represents, it would seem, the naive point of view of the locals, one which glorifies the fisherman's calling. The reality is more complex. First, like the tourist perspective, Frost's too is nostalgic. The schooner *Josephine* was the boat on which Frost had first shipped out as a sixteen-year old, in 1868. He was only a fisherman on the Grand Banks for two years, and he claimed he had turned to land occupations at the request of his intended bride. Afterward he remembered those two years as the most adventurous, the most intense of his life—and the least domesticated. In the 1920s he began to record those memories, in essays and paintings. The impetus for these retellings was specific: he began to preserve the past in response to visitors who wanted to be told "anything about the old town and about the way the fishing business was carried out . . . that started me to try."[44] In other words, tourists prompted the paintings; they were the audience, and without them there would have been no painting. Frost wanted to preserve local history, but his audience was not local. The reaction of his community was less than positive; they felt embarrassed by the paintings and by Frost's attempts to exhibit them to tourists.[45]

Morris Kantor's *Captain's House* (Fig. 185) might almost be a portrait of Frost. In this painting we see again the locals from the visitor's point of view. While kindly acknowledging the stylistic apparatus of the naive artist—hard outlines, repetitious pattern, tilted perspectives—Kantor gives the scene a superior, modernist twist by dissolving the walls at strategic intervals. This is no portrait of an old-time New England sea captain but a reduction of him to a type, an emblem of New England, little different from the old-fashioned schooner over the mantlepiece or the charmingly busy wallpaper in the parlor. Beyond the walls of the figure's cottage are revealed all the other emblems of coastal New England: winding village street, Fed-

184. John O. J. Frost, *Fishing Schooner* Josephine *on the Grand Banks*, ca. 1925, oil on masonite, 33.0 × 45.7 cm (13 × 18 in.). Courtesy, Peabody Essex Museum, Salem, Massachusetts.

185. Morris Kantor, *Captain's House*, 1929, oil on canvas, 66.2 × 76.2 cm (26 × 30 in.). National Museum of American Art, Smithsonian Institution, gift of Mrs. Morris Kantor.

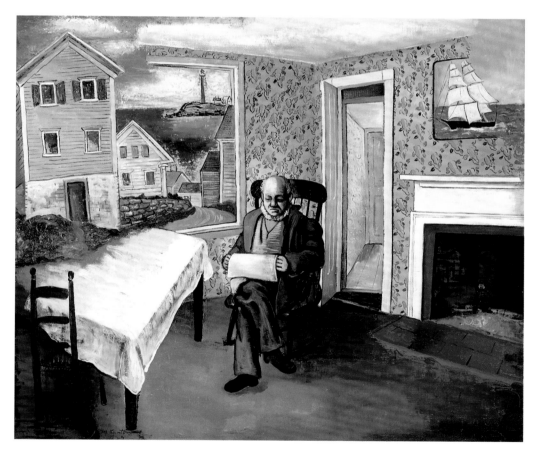

A SURPRISE.

ARCTIC EXPLORER—"Oh, yes; we lived on 'canned food' for two years whne in the arctic."
GIRL—"Why, I didn't know there were country boarding-houses in the arctic."

eral-style homes, seaside fish houses, even a lighthouse. In its piling up of such New England signs, it is little different, in the end, from the image advertising Connecticut devised by Charlotte Sternberg (*see* Fig. 160). While they rest at opposite ends of the artistic spectrum in every way—the painting destined for a gallery and a private collector and the other designed for mass distribution—they cannot help but participate in the community created by tourism.

Art Colonies

Again, Emmons's photograph gets to the heart of the matter. Like most tourists, artists seldom strayed from each other. They migrated to colonies, and a few were dominant, formed around interesting scenery (such as Appledore) or magnetic teachers. Gloucester had long been a tourist and artistic destination and needed no new teacher to help create its legend. Around most other art colonies, an artist's summer school served as the catalyst. Charles Hawthorne in Provincetown, picking up where William Merritt Chase had left off at Shinnecock, New York, opened his school in 1899. Charles Woodbury led one in Ogunquit. A few centers grew up on scenery alone, like Monhegan or Appledore. By the mid-twentieth century artists could be found spread out along the Maine coast. Henri had originally discovered Monhegan because his Philadelphia friend, the landscape painter Edward Redfield, had been exploring the possibilities of Boothbay Harbor, feeling that Gloucester was played out as a novel subject.[46] Even on this first trip to Monhegan, well before art circles in New York had heard of it, Redfield discovered one to two dozen artists on Monhegan. Henri memorialized that summer with his editorializing on a cartoon from *Judge* magazine (Fig. 186), in which he identified the scene at Boothbay Harbor and the figures as Redfield's family and friends. The cartoon comments on the lack of difference between "true" hardship and the trials of summer boarding houses for visitors to New England coastal towns, indicating that all these experiences collapse into something like farce.

Two fishing towns in particular became objects of devoted attention—Gloucester and Provincetown. Even as visitors loved their quaintness, they destroyed them. Sloan was moved to complain about the ubiquity of artists during his summers in

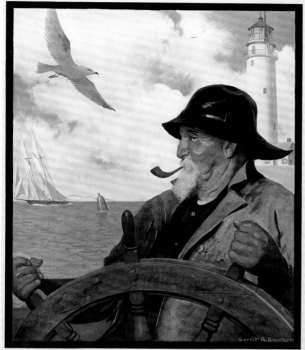

187. Gerrit R. Beneker,
The Pageant of Cape Cod,
1914, lithograph, 56.5 × 35.2 cm
(22 1/4 × 13 7/8 in.). The William
Chauncy Langdon Papers, Brown
University Library.

188. Henry J. Peck, *The Day's
Catch,* cover of *Success Magazine*
10 (July 1907). Courtesy,
Peabody Essex Museum, Salem,
Massachusetts.

189. After Leonard Craske,
*Down to The Sea in Ships
Bookends,* cast metal, 12.7 × 12.7
× 20.3 cm (5 × 5 × 8 in.).
Collection of Robert Chase.

Gloucester: "There was an artist's shadow beside every cow in Gloucester, and the cows themselves are dying from eating paint rags."[47] Summer colonies, however, preferred to think that they were imbibing something authentic along with their fresh air (and alcohol—the memoirs of journalist Hutchins Hapgood lead one to believe that the principal stimulant to the holiday atmosphere was drinking). They wanted to be a part of the traditions they consumed. One avenue for this was the community pageants established by the American Pageant Association in the 1910s, such as the Cape Cod Pageant organized in Sandwich, Massachusetts, by William Chauncy Langdon in August 1914.[48] Gerrit R. Beneker's poster for the pageant (Fig. 187) reduces fishing to its basic elements: an old salt behind the wheel, a large sailboat to the left of him, and a lighthouse to the right. The image has become trivialized, marketable, consumed. According to the ethics of the American Pageant Association, pageants were to be locally organized, arising from local sentiment and recording local history. Langdon was from New York; the occasion for the pageant was the opening of the Cape Cod Canal (hardly an act of open-sea fishing), intended to promote markets for agriculture. In creating so powerful a myth of New England, it had become hard for residents and visitors alike to

tell myth from reality. Both participated at one end or the other of the consumer chain, both profited by it. In the face of changes going on outside New England and well beyond local control, often it was all they had. The profit and consumption of the imagery so carefully built by Winslow Homer was national and ubiquitous: Henry J. Peck's painting *The Day's Catch* was used for the cover of *Success Magazine* (Fig. 188) and Leonard Craske's heroic sculpture of a fisherman on the waterfront in Gloucester becomes a pair of bookends (Fig. 189). The high art of Winslow Homer had become part of an American visual culture, one marketing a New England commodity.

The Great Whale

Perhaps the greatest story of the New England seas is one that really does not take place there, Herman Melville's *Moby-Dick* (1851),[49] which had a power derived not only from Melville's technique but also its subject: "the greatest of the fishermen were the old-time whalers."[50] Provincetown and Gloucester were mainly fishing towns, and New Bedford was the center of the whaling industry. Because the town did not attract summer tourists and artists the way the other towns did and because

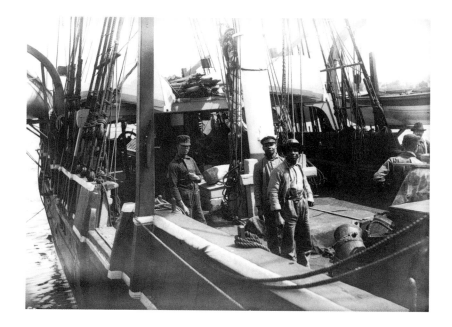

191. William H. Tripp, *Crew of the New Bedford Whaling Barque* Kathleen, *Outward Bound in the 1890s*, photograph. The Kendall Whaling Museum, Sharon, Massachusetts.

whaling was already a semi-mechanized industry by 1900, whaling never became a ubiquitous subject. Nonetheless, it entered the visual culture just as profoundly.

The end of the line for whaling, in fact, provides a perfect illustration of the mechanisms that produced and distributed the images discussed in this chapter. Clifford Ashley, an illustrator devoted to whaling, published his images in several books (like *The Yankee Whaler* [1926]). His paintings imagine the subject of the mighty battle between man and ocean in terms taken from Homer and other illustrators. These heroicized images, however, sing a quiet note. In *Stripping the* Wanderer (Fig. 190) Ashley depicted the last square-rigged whaler under American registry being cleaned after the end of voyage. The *Wanderer* had been built in 1878 in Mattapoisett, Massachusetts, and had made eleven trips out of New Bedford (and twelve out of San Francisco). In its old age, it starred in the first movie about whaling, *Down to the Sea in Ships* (1922). Subsidized by the Whalemen's Association of New Bedford, this fictionalized documentary was intended to preserve a memory of the great period of whaling now quickly vanishing. Elmer Clifton, who had worked with D. W. Griffith, directed it, under the advice of local sea captains and others. The effort was much like the historical pageants so popular before the war. It also shares with Frost's contemporaneous depictions of whaling the same blurring between local memory and tourist nostalgia—only in a new technology that could reach a much wider audience (the movie was distributed throughout the country and in Europe). Ashley's painting, then, to a degree, capitalizes on the fame that came to the boat through the movies. A year later the *Wanderer* was wrecked as it left the waters of Massachusetts. Its companion in the movie, the *Charles W. Morgan,* was rescued from a sandbank in New Bedford in 1941 and towed to Mystic, Connecticut, where it became the only surviving square-rigged whaler, safely preserved in the Mystic Seaport Museum. Ashley's painting, then, rests at an intersection of three paths—one out to the movies, one to a museum, and one to his books. As an image, the *Wanderer,* existing as an artifact only in memory, still manages to reach every kind of mass-market audience, from the most elite to the broadest and most popular.

One element it fails to include is the one actually documented in photographs of the *Wanderer* and its sister ships (Fig. 191). This was the decidedly multiracial crew. The voices of the Africans, African Americans, and Native Americans, like those of the Portuguese fishermen in Hawthorne's paintings and the fugitive's voice at the beginning of this book, are drowned out in the drive to produce an image of New England that fulfilled the imperative set by audiences and artists in Homer's day, an image that was American in its hardness, its certainty, its virtue, and its violence, but not in its diversity.

Notes

1. Gabriel, *Toilers of Land and Sea,* 297.
2. Ibid., 313.
3. Even as artists and other cultural figures might be aware of this fact, they discounted it as background material to the essential story of New England's Yankee heritage. William Chauncy Langdon, organizer of a series of New England pageants in the 1910s, included in his pageant for Saint Johnsbury, Vermont, a scene of French, German, Italian, Scotch, Irish, and Scandinavian children dancing in ethnic costume to represent the immigration into the area. Adult immigrants, however, tended to be ignored. See Glassberg, *American Historical Pageantry,* 98.
4. Homer spent time in Gloucester during the late 1870s, but his images of fishing and ships produced there focus on children.
5. Frank Jewett Mather, Jr., "The Art of Winslow Homer," *The Nation* 92, no. 2383 (2 March 1911): 225.
6. The hunting took place, for the most part, in the Adirondacks and not in New England; however, "the backwoods, the wilderness and the frontier, also a stern ocean, have never been far from man's consciousness in this easterly province" (Herrick, "Maine," 123). For an extensive discussion of Homer's market, see Burns, *Inventing the Modern Artist,* chap. 5.
7. Mather, *American Spirit in Art,* 75.
8. Quoted in Tragard and Hart, *A Century of Color,* 13. These associations held well into the twentieth century. "There was always, in my memory, something strong, wholesome, rugged, untamed, and romantic, about the Maine of those days, and more than most parts of the modern world. Maine has kept its native quality, moral and physical. . . . It is the last stronghold of the Puritan" (Herrick, "Maine," 119).
9. See, among many others, Robertson, *Reckoning with Winslow Homer;* and Burns, *Inventing the Modern Artist.*
10. *The Nation* 92, no. 2383 (2 March 1911): 225. Or, "A pounding sea gnawing at the foot of the cliffs" (Mather, *American Spirit in Art,* 83).
11. See Robertson, *Reckoning with Winslow Homer.*
12. Ralph W. Carey, "Some Paintings by Gifford Beal," *The International Studio* 44 (August 1911): xxix. Carey talks about not only Beal but also Paul Dougherty and Frederick J. Waugh.
13. This earlier format (exemplified in the work of William Haseltine and Alfred Bricher), which featured in the foreground a long beach suitable for strolling on, was based on the experience of resort goers.
14. While these illustrators of the ocean have largely fallen out of favor today, in their own time they were the subject of many favorable critical reviews, avidly collected by museums (which have often since deaccessioned the works), and widely reproduced. Their influence can still be seen in the formulas that dominate popular sofa paintings.
15. Henri, *Art Spirit,* 269; see also 99.
16. Ibid., 136.
17. Quoted in Robertson, *Reckoning with Winslow Homer,* 103, 182 n. 5.
18. Gabriel, *Toilers of Land and Sea,* 308.
19. Ibid. As an indication of how deeply embedded this image is, even critics saw heroic fishermen in Homer's Gloucester images of children: "The fearless fishers of Gloucester, those splendid Vikings of seine and trawl became his subjects" (Henry Reuterdahl, "Winslow Homer, American Painter: An Appreciation from a Sea-going Viewpoint," *The Craftsman* 20, no. 1 [April 1911]: 17). Elsewhere, Homer's interest in fishermen is attributed to his ancestry: "The blood of his sailor ancestors was coming to the fore at last" (Van Dyke, *American Painting and Its Tradition,* 98).
20. Kent, *It's Me, O Lord,* 122.
21. Ann Seaton-Schmidt, "Some American Marine Painters," *Art and Progress* 11, no. 1 (November 1910): 7. Others also felt these paintings were truly American: "his rugged canvases of fishermen and the sea . . . have been acknowledged to be more purely native in spirit than anything that had been done up to his time" (John Cournos, "Three Painters of the New York School," *The International Studio* 56, no. 224 [October 1915]: 239).
22. McBride, *Flow of Art,* 413.
23. Kelly, "Process," 22, quoting the *Boston Daily Evening Transcript* review in 1886 of *Herring Net.*
24. Kent, *It's Me, O Lord,* 191.
25. Monhegan fishermen were noted for their superior skill (see Quinn, *Beautiful America,* 140).
26. Quoted in Robertson, *Reckoning with Winslow Homer,* 103, in contrast to Homer's much more broken, layered touch.
27. William H. Goodyear, "The Watercolors of Winslow Homer, 1836–1910," *Brooklyn Museum Quarterly* 2, nos. 3–4 (October 1915): 367.
28. Kelly, "Process," 238. Adding to its availability as an image and its popularity, *Eight Bells* (1886) was also reproduced as an etching.
29. Connolly, *Book of the Gloucester Fishermen.*
30. Mather, *American Spirit in Art,* 162.
31. Kathleen Placidi, "Beyond Bootblacks: *The Boat Builder* and the Art of John George Brown," *Bulletin of the Cleveland Museum of Art* 77, no. 10 (December 1990): 366–79. The metaphor of boatbuilding and art making or of boats and human life is an old one in American art, made most obviously in Thomas Cole's series "The Voyage of Life" (1842).
32. Sarah Burns makes the point, in the last chapter of *Inventing the Modern Artist,* that the values of easily readable, storytelling images that modernist artists tried to expunge from their art remain in the foreground in Rockwell's. Just as New England projects an image of being left behind as the

rest of the country has moved on, so too is Rockwell's visual style something seemingly left behind, unchanged by fashion.

33. Bellows had tried to lure Henri to Rockport by saying it was "a lime quarry town full of limemen and types" (quoted in Nicoll, *Allure of the Maine Coast,* 30).

34. Ibid., 24.

35. Nicoll finds these "epic paintings of American subjects . . . the true culmination of Bellows's years in Maine" (ibid., 29).

36. Quoted in Morgan, *Bellows,* 200.

37. Isidore Schneider, "Philip Reisman's Paintings," *New Masses* 19, no. 4 (21 April 1936): 28 (quoted in Hemingway, *Philip Reisman's Etchings,* n.p., n. 30).

38. Quoted in Bush, *Reisman,* 33.

39. Ibid., 71.

40. "Of Maine's three-quarters of a million inhabitants today, five-sevenths are of native-born white stock, less than one-seventh of foreign parentage (mainly French Canadians), with only a thousand Negroes and less than a thousand Indians. Where else in the United States can be found an equal homogeneity of Anglo-Saxon blood?" (Herrick, "Maine," 120).

41. See "Our Lady of Good Voyage Church," pamphlet, n.d. (ca. 1975?), a copy of which is in the Cape Ann Historical Society, Gloucester, Massachusetts.

42. See curatorial files, Cape Ann Historical Society, Gloucester, Massachusetts.

43. *Fisherman's Family* (1923) repeats a picture he had first painted in 1914 and destroyed in 1919.

44. "Marbleheaders Saved *Constitution,*" *Marblehead Messenger,* 11 September 1925 (quoted in Katz, "J. O. J. Frost," 24).

45. Ibid., 28–29.

46. Nicoll, *Allure of the Maine Coast,* 8. Redfield goes to Boothbay Harbor in 1903, because of the scenery and its possibilities "in the selling line" without the competition of places like Gloucester.

47. Quoted in Holcomb, *Sloan,* 9.

48. Prevots, *American Pageantry,* chap. 3, and 185.

49. McBride (*Flow of Art,* 333) compares Homer to Melville; as does Mather, *American Spirit in Art,* 128.

50. Gabriel adds: "Brave without recklessness, resolute and resourceful, self-reliant and self-possessed, guarding the lives of his men and the safety of his ship, the captain of a whaler was one of the finest types America has produced" (Gabriel, *Toilers of Land and Sea,* 314, 319).

Yankee Modernism

BRUCE ROBERTSON

As the historical overview by Dona Brown and Stephen Nissenbaum announces, the period covered by this book is one in which the United States becomes "modern" but New England remains pictured as "a place of steadfast tradition." If New England appeared to reject the modern, the modern nonetheless intruded at every point. So far we have been concerned largely with tracing the work of more conservative artists as they built and developed the rich repertory of New England imagery. But radical, modernist artists also felt the pull of New England. Like their less radical colleagues, they had access to the same lode of visual material. They saw the same advertisements, were subject to the same marketing efforts, and were no more immune than anyone else from the wash of popular culture that extolled old New England.

But how might they use it? As the title of this chapter suggests, the situation seems oxymoronic, something stereotypically old-fashioned combined with its antithesis. Modernism is concerned with the new, and nowhere was the new felt more strongly and modernist artists more heavily concentrated than in New York. Indeed, by most signs, modernism seems almost entirely a Manhattan project. What could American modernists hope to gain by leaving the city? Whatever the answer, the fusion of these terms reveals something interesting about New England and the nature of modernist art in America in the first half of the twentieth century, something about the enduring nature of these visual traditions, so carefully crafted in the preceding half-century, and their uses in a modern age. While much of the response was as summery as the climate most of these visitors experienced, the encounter could be jarring, especially when artists dug hard below surface appearance. There they sometimes encountered disturbing subjects. Even more rarely, the strangeness and power of New England that mythmaking had done so much to embalm could sometimes come alive.

Contradictions

By and large, tourism framed the encounters of modernist artists with New England. Like countless other summer vacationers, they left the heat of Manhattan as soon as they could and went where they could afford to go. Perhaps their only distinction was that because they did not have to return to a regular job at the end of their holiday, they could stay after Labor Day if they wanted to. Their experience was of beaches in Massachusetts and Maine, with the labor of fishermen an interesting bit of local color in the foreground, or of farms and mountains in New Hampshire and Vermont, with charming white clapboard buildings in the background. While they might pay lip service to an attempt to understand the "realities" of New England—which by and large constituted depicting the work habits of the natives—in truth they seldom got much closer than any other visitor shopping

206. Stuart Davis, *Landscape with Garage Lights* (detail), 1932, oil on canvas, 81.3 × 106.4 cm (32 × 41 7/8 in.). Memorial Art Gallery of the University of Rochester, Marion Stratton Gould Fund.

for souvenirs.[1] Indeed, many artists clustered in self-contained summer colonies, all predating the modernists.

At the same time, the motifs generated during their summer vacations are often found for significant periods in these artists' work. Instead of being in New England for a holiday from their vocation, some of their most productive painting time was spent there. Nonetheless, the field of play for their New England paintings was not New England but New York, where the paintings were marketed.[2] If New England is antimodern terrain—which any survey of the art schools, collectors, and art museums (with very few exceptions) would confirm—then we must attempt to explain how antimodernist subjects were acceptable for modernist artists and audiences in avant-garde New York.[3] The case of John Marin is the most obvious example. Here was an artist whose watercolors of islands, fir trees, and schooners (Fig. 192) could have graced the walls of any weary Wall Street banker's office, next to the Winslow Homers. Does the modernist character of Marin's style simply envelope a traditional valentine to American scenery? One of the points of this discussion will be to suggest that this "modernism/antimodernism" dichotomy so often used to describe the state of cultural affairs after the turn of the century is seldom useful and perhaps does not exist.

Still, the modernist view of New England certainly seems antihistorical or appears to reject the overt history of New England—the Pilgrim Fathers, the *Mayflower*, the Salem witch trials, or even Henry David Thoreau and William Lloyd Garrison—the mythic stories that gave New England its cultural preeminence in popular culture during this period. But it is not a wholesale rejection of the values embedded in the Yankee past. Their view of the region appears to be rather genteel, favoring landscapes and beach scenes or, at its most rigorous, gently realist, with a few scenes of bucolic farms and hardy fisherfolk.[4] On the whole, then, the subject matter of modernist depictions of New England picks up where the work of Winslow Homer and Childe Hassam and their followers left off but stripped of its overt nostalgia. It does not constitute a radical departure—with few exceptions—

from the work of the very generation modernist artists were seeking to displace. These points would suggest that New England for these artists was a purely decorative subject, one in which redoing confirmed subjects in a new style, an act emphasizing their formal means, was the main point. But was this really the case? Was the New England these artists were seeing really the same as the New England of the generation before them?

Modernists and Antimodernists

But then, was there ever a single, simple view of New England? Those who tried to comprehend the particularities of the place before them, who sought some essential truth about the nature of existence beyond appearance (a central point of modernism) or engaged with the history and meaning of the place, sometimes turned up something darker than the burnished veneer of New England might lead one to expect. Consider these three vignettes of New England, written in the years between World War I and World War II:

> The true epicure in the terrible, to whom a new thrill of unutterable ghastliness is the chief end and justification of existence, esteems most of all the ancient, lonely farmhouses of backwoods New England; for there the dark elements of strength, solitude, grotesqueness and ignorance combine to form the perfection of the hideous.[5]

> I'll lead you to a spot. I'll show you a something, done, created, made by some ones, not I myself but seen for myself by myself. . . . This spot, this place of mine a village, where clustered about you can see if you *look* dream houses of a purity of whiteness, of a loveliness of proportion, of a sparingness of sensitive detail, rising up out of the greenest of grass sward.[6]

> The opulent rigidity of this north country . . . produces a simple, unaffected conduct and with it a kind of stark poetry exudes from their behaviors, that hardiness of gaze and frank earnestness of approach which is typical of all northerners. . . . Maine is likewise a strong, simple, stately and perhaps brutal country, you get directness of demeanor, and you know where you stand, for lying is a detestation, as it is not in the cities.[7]

At first glance these views could not be more different, and it would be tempting to sort them out into the usual modernist/antimodernist dichotomy. But where would the division be made? Between the first text and the others? Separating the middle text from the first and last? Identifying the authors—H. P. Lovecraft, an author of gothic horror stories (and, thus, the latter-day descendant of Hawthorne and Poe); John Marin and Marsden Hartley, modernist artists—tells us how we are supposed to cut and paste. I would argue, however, that the three artists have as much in common as they differ and that the commonalities resolve around two points. It is exactly what binds together these incongruously diverse artists that renders the modernist view of New England distinctive and, perhaps, decidedly un-"modern."

First, there is a fundamental belief that the story of New England is one of moral culture and tradition. Whether that morality is viewed as fallen into gothic ruin (Lovecraft) or lovingly preserved (Marin) or thriving (Hartley), the axis of response remains on this line—not honor, not beauty, not pleasure but moral truths, rectitudes, certainties, plainness. The hardness of New England derives from its virtue as much as from its stony fields and rocky coasts.

What should this morality have to do with modernist art? What attracted artists of the modern to such a place and such a question? Here, too, we must answer that there are several modernisms. While modernist art, for the most part, is identified with the city, new technology, and new mores, a strand in modernism locates its utopian longings in the universal, the abstract, the ideal, which, since the failure of most other social institutions for liberal elites, has been found in nature and the

nonurban, with the primitive.[8] It might be easy to assert that modernists of this antiurban brand all painted in New England, but the division is not so easy, complicated as it is by divided loyalties on the part of the artists and accidents of geography and fate, as well as the pattern of summer vacations.[9] Technological and Neoplatonic modernisms are no more easy to divide from each other than New York is from New England.

The second commonality is that in the practice of all three artists, the trope of New England resolves itself around an iconic image composed of several parts: a landscape, a structure, and the figure that populates them. The process of selection results in a scene of great density—a few things, intensely felt. Lost is the field of sensation beloved of impressionist artists like Hassam or the narrative ideas of Homer. A certain stillness replaces them. Experiencing New England was more than dressing it up in modern costume; it involved vibrating in harmony with the objects embodied by it. As the much admired French philosopher Henri Bergson wrote, the artist must move "back within the object by a kind of sympathy in breaking down, by an effort of intuition, the barrier that space puts between him and his model."[10] But this was not achieved easily.

The Familiar in New Forms

Central to the practice of most modernist artists was the claim that by rejecting realist representation they were seeking something more essential than surface semblance. Often their practice centered on rendering the iconic object, the thing that in its essence contained the truth of the subject it referred to, not a symbol but a re-creation. Much of modernist art was concerned with clearing the painting surface and starting afresh, a *tabula rasa* mentality that sought to eliminate conventional concerns of holding a brighter mirror to the world. The artist's experience connected without mediation to the material world, and nothing else, was their aim. Hartley's *Lobster on Black Background* (Fig. 193) or Paul Strand's *Toadstool and Grasses, Maine* (Fig. 194) are not still lifes but are what Alfred Stieglitz would have called an "equivalent."[11] William Zorach's sculpture *Granite Cat* (Fig. 195) under-

scores the connection at several levels. Carved out of a boulder of Maine granite, the shape of the rock is barely changed, and what is released from the interior of the native stone through the sculptor's direct carving is the humblest, simplest household animal—a house cat. Hartley's comment on Marin's watercolors is apt here: "Marin's wave is a wave, his house is a house, his sail is a sail, his tree is a tree, his rock a rock."[12]

The primary difference between these objects and earlier studies of still-life objects is the degree to which the modernist works appear to eschew narrative and history, social context and environment. When an environment is provided, it does not function as representation. In Hartley's *Sea View, New England* (Fig. 196), although abounding with the elements of a traditional still life, the conjunction of the landscape in the background with the fish in the foreground emphasizes the artificiality of the painted construct. Such a way of creating a representation of an environment that is simultaneously anti-environmental was a popular strategy and can be found in Yasuo Kuniyoshi's *Fish and Seaweed* (Fig. 197) and Stuart Davis's *Anchors* (Fig. 198). In Davis's work the anchor functions metonymically, as a visual and verbal sign of the activity on the dock behind it. These still lifes are portraits, as Hartley insisted. They animate aspects of New England life as persons, making them speak directly to the view as presences rather than things that the painter has represented.[13]

Landscape and Architecture

Modernist depictions of landscape differ from earlier work in much the same way. Hartley's *Evening Storm, Schoodic, Maine, No. 2* (Fig. 199) is a prime example, where the wave is the wave, the rock the rock. Working on the same principle, Hartley and Marin,

194. Paul Strand, *Toadstool and Grasses, Maine*, 1928, photograph. © 1950, Aperture Foundation, Inc., Paul Strand Archive.

195. William Zorach, *Granite Cat*, 1935, Maine granite, 25.4 × 40.6 × 30.5 cm (10 × 16 × 12 in.). Mr. and Mrs. John Whitney Payson.

196. Marsden Hartley, *Sea View, New England*, 1934, oil on cardboard on wood panel, 30.4 × 40.6 cm (12 × 16 in.). Acquired 1939, The Phillips Collection, Washington, D.C.

like many others, reduced the region to two landscapes: coast and mountain. (None of the indeterminate, domesticated zone between yard and cow pasture, favored by American impressionists, for these artists.) Hartley painted *Mount Katahdin, Maine* (Fig. 200) as the spiritual heart of the state. He declared after finally reaching it: "I have achieved the 'sacred' pilgrimage to Ktaadn Mt . . . I feel as if I had seen God for the first time."[14]

The structures that further identify the landscapes as New England are treated in the same way. One might contrast Hassam's views of the Congregational church in Old Lyme (*see* Fig. 105) with Hopper's church in South Truro (Fig. 201).[15] Both may function as symbols, but Hopper's church is the iconic thing itself. Hopper's painting also suggests that these modernist paintings cannot avoid the fact that they depict New England. Audiences could not look at the church without thinking of the popular myths of stern Puritans and so on.[16] In Hopper's painting *Two Puritans*, a pair of plain cot-

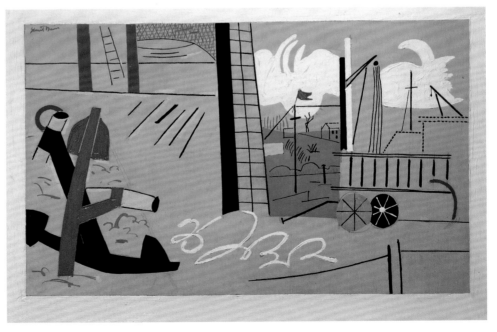

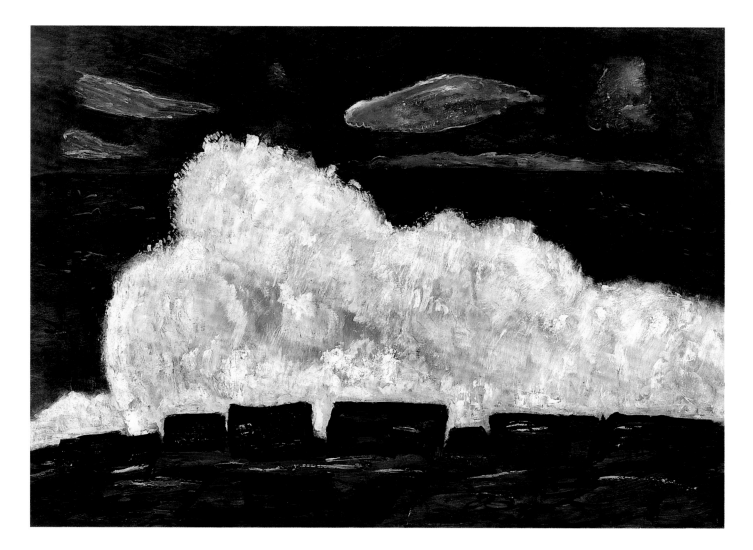

199. Marsden Hartley, *Evening Storm, Schoodic, Maine, No. 2*, 1942, oil on canvas, 76.2 × 101.6 cm (30 × 40 in.). Brooklyn Museum of Art, Bequest of Edith and Milton Lowenthal (1992.11.18).

200. Marsden Hartley, *Mount Katahdin, Maine*, 1942, oil on hardboard, 76.2 × 101.9 cm (30 × 40 1/8 in.). © 1998 Board of Trustees, National Gallery of Art, Washington (1970.27), Gift of Mrs. Mellon Byers.

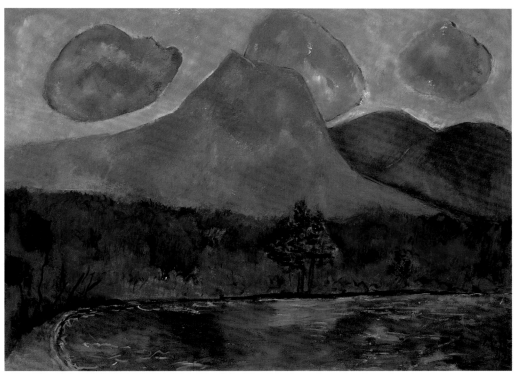

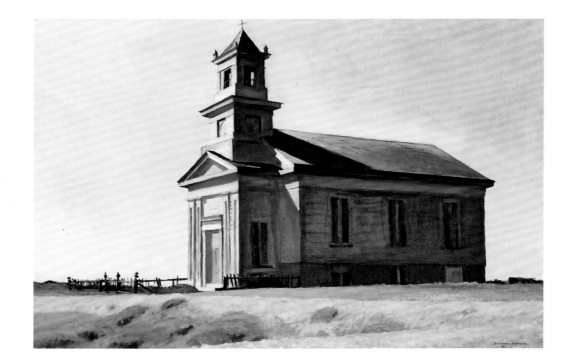

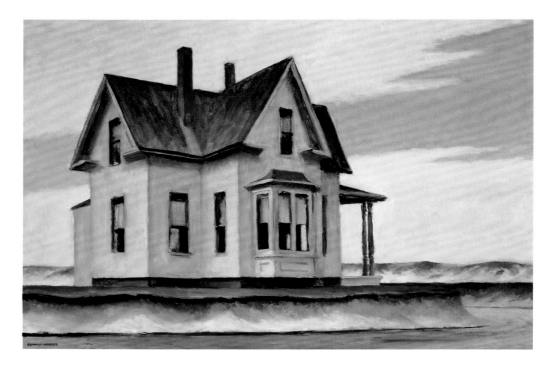

tages underscores the connection even as they satirize it.[17] The landscape is connected to the people who live there. The intimacy of the landscape and the building that represents its tenants are made even more evident in *House by an Inlet* (Fig. 202), in which a rather solid and unadorned, turn-of-the-century house is now slowly undermined by the ocean. A simple, middle-class survivor of an earlier age, the house stands as a bleak reminder of older values, against which time and nature take their toll. The Cape Cod houses that appear in many Hopper paintings in the 1930s and early 1940s all share a plain dignity in their isolation, silently standing athwart changing tides. Again, Hartley on Marin: "The earth has body, the sea has body, the sail has strength, the island remains fixed in the sea, and the houses are set on their islands where generations of islanders have lived, moved and had their peculiar beings."

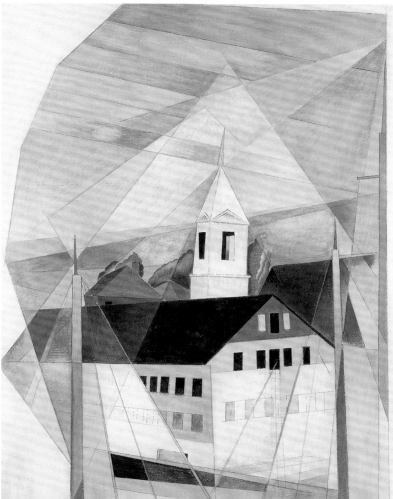

203. Charles Demuth, *Box of Tricks*, 1919, gouache and graphite on composition board, 48.5 × 38.7 cm (19 1/2 × 15 1/4 in.). Courtesy of the Museum of American Art of the Pennsylvania Academy of Fine Arts, Philadelphia. Acquired from the Philadelphia Museum of Art in partial exchange for the John S. Phillips Collection of European drawings (1984.8).

As the portrait still lifes suggest, the empathetic line connecting viewer to object worked both ways. Inevitably the landscape led back to its inhabitants. Hartley's *Evening Storm* (*see* Fig. 199), on the surface an abstract image of wave and rock, is also a personification of death in the act of taking the lives of sailors, "stiff tone of death / in every wave."[18] The quintessential New England structures—white-spired churches; strong, clean lighthouses; solid barns; lonely houses—become actors in the landscape, representative "types," much like the "types" of people to be found there—farmer, Puritan, fisherman, old maid, all figures in the popular imagination.[19] Most artists attempted portraits of these actorlike buildings at some point in their careers. Hartley, of course, tried them all. Perhaps the two most complex and ambivalent motifs were the figures of the house (especially in Hopper's art) and the church, signposts of the domestic and overtly moral side of New England's history, which artists like Homer had successfully ignored.[20] Charles Demuth's *Box of Tricks* (Fig. 203), painted in Gloucester, Massachusetts, combines the schooner and the harbor in the foreground with a dematerialized spire shaping the connections between them. The critic Henry McBride, looking at this and other works, many of which focus more obviously on the steeple, observed that "not even Hawthorne has been so painstaking with gables. . . [Demuth] draws the sharp clean line of our souvenirs of Sir Christopher Wren with an intensity that suggests an inward rage."[21] McBride detects lurking under the cool precisionist exterior both Hawthorne's dark allegories and a distorting anger.

Modern New Englanders

The buildings, like the landscapes, point to people, the most famous of which were the historical heroes and stereotypical Yankees. A Jewish New York artist of modernist tendencies, Theresa Bernstein Meyerowitz recorded her instructions to her first pupil, a Mary Pomeroy Robinson, as they sat on Bass Rocks at Gloucester (rocks that had been the subject of countless paintings since Fitz Hugh Lane and William S. Haseltine had depicted them in the 1860s): "I explained to her the nature of these rocks, that they were really the stern and barren coast, and how they had guarded the continent until the time the Pilgrims came here. I tried to give her the feeling of their permanence."[22] Neither the subject nor the sentiment was new—what could be modern about this beyond the style?[23]

Part of the answer must lie in who is speaking, in the remarkable intersection of a New York Jew teaching a WASP about the Pilgrims. The consciousness of racial and ethnic difference in this period is slippery, coming in and out of focus at no discernible prompting.[24] Nonetheless, issues of racial purity and American racialism define much of the period's cultural dialogue. Every artist and critic resorted to the lan-

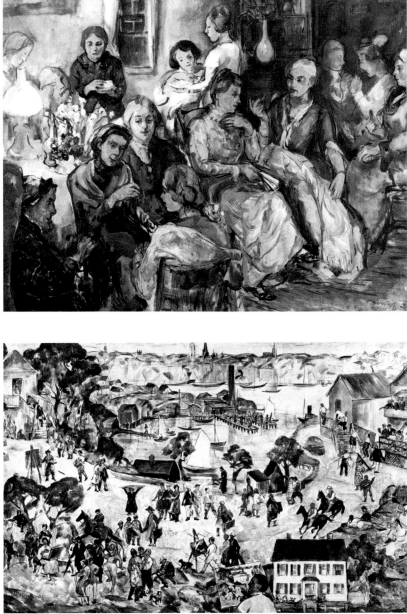

guage of race at one point or another, no matter on what side of the political divide they might find themselves.[25] The Meyerowitzes called their cottage "Gaviotta," (Portuguese for "sea gull").[26] Theresa recalled, "we could look out from Gaviotta and see the little Finnish girls dancing in a circle on the hill."[27] This quote describes the view from a cottage where descendants of Nathan Hale visited the Meyerowitzes frequently. Gloucester is a miniature melting pot, and the Meyerowitzes's cottage is self-consciously seen as one too. Bernstein's painting of her artist friends, *New England Ladies* (Fig. 204), pictures both New England blue bloods like Lillian Westcott Hale and the Meyerowitzes.[28] The painting is a companion to William Meyerowitz's *Gloucester Humoresque* (Fig. 205).[29] Here he dramatizes the diverse subjects among the townspeople and competing allegiances among the painters. At either side of the harbor, artists troop to the two exhibiting societies, academic and radical, with the view of Gloucester Harbor sandwiched in between. Meyerowitz plants himself squarely in the middle, trying to see it all.

The self-conscious art colony did, in fact, touch on walls outside it. The goal of extreme selection could not fully disguise the complexity of the landscape it digested. At all times, experience was founded on a seemingly common denominator, the "Puritan landscape," that was the backdrop to New England. A modernist (in Gloucester and in New England), then, might be defined as one who negotiated ethnic and historical differences, neither retreating fully into the past nor ignoring it completely. They might use their outsider status to achieve a more comprehensive view and yet remain distanced by their "objectivity." As a result, despite Theresa's exhortations, few modernist artists were so deeply rooted in New England or so passionately engaged with its past that they were able to bring vividly alive the "Pilgrim" or "Puritan."

204. Theresa Bernstein, *New England Ladies*, 1925, oil on canvas, 102.6 × 126.9 cm (40 × 49 1/2 in.). Cape Ann Historical Association, Gloucester, Massachusetts.

205. William Meyerowitz, *Gloucester Humoresque*, 1923, oil on canvas, 92.3 × 133.3 cm (36 × 52 in.). Cape Ann Historical Association, Gloucester, Massachusetts: Collection gift of James F. O'Gorman and Jean Baer O'Gorman.

Art Worlds

Meyerowitz's painting alludes to the increase, beginning with the onset of World War I, in modernists visiting the vacation spots of New England. The production of art in New England, at least by visiting New Yorkers, was mostly confined to a few art colonies: Provincetown on Cape Cod; Gloucester, north of Boston on the mainland; and Ogunquit on the coast of Maine. Other places had some reputation, and artists might visit them for a season or two: Monhegan and Mount Desert in Maine and many smaller places along the shore. Most unusual was John Marin's annual return to Stonington in Maine, a town without other artists to hobnob with, a fact

Marin appreciated. No place, however, was that far from friends and colleagues, as his letters confirm, any of whom might come visiting at any moment. Few artists went inland very far—Woodstock, New York, seemed to mop up most of those who wanted greenery instead of waves.

The experience of New England offered by these colonies could be an unhappy mix of inspiring scenery and grating sociability. Maurice Sterne, writing to Mabel Dodge, records the continuing fascination of the Maine coast for modernist artists and the attendant problems. He had gone to Maine, to stay at Hamilton Easter Field's summer school for free while he decided whether or not Maine would help his rheumatism (it did). "You have no idea, darling, how wonderful in expression some of the rocks are: huge masses protruding into the sea, the expression on the land side grave and longing, on the side facing the sea full of horror and passion, as if the rocks were shrieking to the waves to give them rest. And what wonderfully rhythmic spirals and curves in the reflections of the rocks in the water, so sensitive." But then he encounters the other artists: "From between the cliffs suddenly peeped out a girl's hat, or the top of an easel, or the squinting eye of a male painter. I really felt that I couldn't stand it."[30]

Nearly all these colonies predated modernist artists by some decades. The mix between old and new was not always easy: Meyerowitz's painting dramatizes the conflict revolving around exhibition spaces and societies. Nonetheless, the American scene, at least before the economic imperilment of the 1930s sharpened everyone's claws, was seldom as divided and competitive as in Europe. There tended to be connections among most artists, and the divisions between radical and traditionalist were generally blurred.

Emblematic of the nearly seamless bond between "realists" and "modernists" is the career of Stuart Davis in Gloucester, a romantic setting of "hardworking fishermen and tree lined streets."[31] "I went to Gloucester," Davis remembered, "on the enthusiastic recommendation of John Sloan," a social radical but a fairly conventional realist. Davis returned nearly every year until 1934: "That was the place I had been looking for. It had the brilliant light of Provincetown, but with the important additions of topographical severity and the architectural beauties of the Gloucester schooner. The schooner is a very necessary element in coherent thinking about art." The reason schooners were so important? "They function as a color-space coordinate between earth and sky."[32]

Yet for all Davis's purely formalist response, more than what schooners emblematized was lurking beneath the surface. One critic, Elizabeth Lockett, explained that the art-world politics of Provincetown paled "in comparison to the comings and goings of the fishing schooners on the bay . . . awakening an age-old consciousness of peril on the sea."[33] But it was not just schooners; everything reminded them that they were in New England—a place apart. Hamilton Easter Field, founder of the more progressive art colony in Ogunquit, advertised his summer school by urging students to "open your eyes wide, get the local tang. There's as much of it right here in Maine as there is in Monet's Normandy."[34] In her essay on Provincetown, Lockett wrote: "The busy populous town itself . . . is strangely remote and set apart from the distant mainland. As Thoreau remarked: 'A man may stand here and put all America behind him.'" She added that, as a result, one is also that much more aware of Europe, especially England (and Portugal), and concluded: "What a backdrop for the jazz blatancy and clangour of this Human Comedy are the elm-shaded, lilac-flanked houses, white Colonial churches and madly bright dahlia-filled gardens, which cherish as decoration and as souvenir monstrous vertebrae of the slaughtered Leviathan!"[35] The colonial and tourist past—the "elm-shaded, lilac-flanked houses" painted so often by Hassam and others—is set against, the "jazz blatancy" of the modern age and the "monstrous vertebrae of the slaughtered Levia-

than." But what connection could there be between blatancy and monstrosity, between jazz and Leviathan?

Modern and Grotesque

Here we have arrived back at the disturbing sense that beneath the lovely surface of New England rests something unlovely or worse.[36] Melville, who enjoyed such a revival of interest in this period and was closely identified with New England's special nature, particularly among modernists, has Captain Ahab declare of Moby-Dick: "All visible objects, man, are but as pasteboard masks. . . . If man will strike, strike through the mask! How can the prisoner reach outside except by thrusting through the wall? To me, the white whale is that wall. . . . I see in him outrageous strength, with an inscrutable malice sinewing it."[37] In its whiteness and size, the whale becomes something strange and terrifying. What it might have been—something strong and beautiful—it no longer is to Ahab and beneath the even swell of the ocean now lurks some hidden and perverse danger. In like fashion, the beautiful house becomes, in Lovecraft's words, "grotesque" and "hideous" in its age and solitude. The key word in Lovecraft's text is "grotesque."

This is a term with a long and interesting history, derived first from the Renaissance revival of Roman decorative design, the capricious dismembering and jamming together of human and animal parts to provide elements in room decoration—a sign of the capricious world of nature. Strictly defined, it is the result of "combining heterogenous and incongruous details or employing distortion for artistic effect."[38] For more modern scholars, with eyes sharpened by Freud's insights into the ferment of dreams and chance, it has become useful as a term to designate that which has been repressed, by society or the individual, and, by extension, that which has been marginalized. The grotesque is order's "Other." Peter Stallybrass and Allon White have written suggestively of the connection between the grotesque and the carnivalesque in modernism.[39] They propose that one aspect of modern art's desire to overturn bourgeois sensibilities, to replace the capitalist norm with something purer and more utopian, is deeply related to what the theorist and historian Mikhail Bakhtin has, in his study of Rabelais, identified as the carnivalesque. The interests of modernist artists in marginal culture and sites—the circus, the slum, rubbish, and the trivial—is an irruption of a deep-seated tendency in Western culture to turn the world topsy-turvy, to explore those spaces and times when the usual social order is reversed. Stallybrass and White further connect the grotesque with the carnivalesque in the arena of the body. The grotesque as a term may have two senses then, both related. The first is steeped in a Freudian-inspired understanding of the force of repression. The grotesque is what survives the act of repression, the distorted traces of the id surfacing into the light as coprophilia, fetishism, self-mutilation, and so on. The grotesque may also be a Rabelaisian celebration of those forces—carnivals, bohemianism, even leisure and artistry, sloth and painting—that disrupt our increasingly regimented and preprocessed lives. The one is defined in terms of experience of the self as it is physically embodied; the other in terms of society as it is experienced. One might define them simply as bodily or environmental. In either case, New England provides a rich ground for the grotesque. Here was a region harrowed (in the popular imagination) with puritanical repression and, simultaneously, strewn with bohemian art colonies and beach resorts. The very act of establishing an orderly, moral history for New England and a tourist-driven landscape of sedate, time-honored farms, villages, and customs, the act of clearing the space for this enactment of tradition and virtue, created its reverse, pushed to the edges where it becomes strangely attractive.

While the idea of the grotesque in relation to New England has a long literary history (which may be traced back at least as far as Hawthorne), visual artists for

the most part ignored the suggestion that New England might have a darker side.[40] They downplayed the idea that New England's past might not be monolithic, or they harmonized its history of difference. An explanation for the modernist interest in the "other" has been primitivism—that search for a purer, more authentic, simpler experience located in peoples less urbane than the artists pursuing them.[41] I would argue that the grotesque is a more satisfying term to explore than primitivism, because while the latter addresses surface motivations, the grotesque reveals the inner compulsions prompting them. Primitivism explores the conscious motivations of the bourgeois; the grotesque examines their unconscious urges, the forces beyond their control. The grotesque enlarges our vision, gathering together a range of phenomena not ordinarily clustered together. Circuses and beach resorts are leisure phenomena but so are many other things—soothing drives in the countryside, playing golf, horse racing. Hartley and others were not interested in redoing Bellows's paintings of tennis games at Newport, one example of a typical (albeit elite) sport to be found in New England, and not because they were motivated purely by a political interest in the working class (Bellows was a socialist and Hartley was apolitical). What makes circuses and beach resorts common leisure phenomena, in contrast to many other activities, is their appeal to a potentially libidinous disorder. The "grotesque," as a term, hones in on those aspects of New England that lie outside the commercially produced myths of the region.

Marin referred to this idea of something that puts a wrench in the works of efficiency and order as "cussedness," which he associates with the sense of particular place: "Every place has its cussedness. And you have to get its special cussedness all over. All coast waters have their sunken ledges. Most of the near sunken ledges about here I know. I don't know their whereabouts in other places. As for the people, they're about the same the world over."[42] In this view, what produces the world of modern rationalized activity is the world outside New England, the world beyond the local, introverted, small place—a world that does not know New England's hidden rocks and shoals. A local might know his own neck of the woods, to mix metaphors, but no further. By inference, Marin argues that mastery over more than the personal and idiosyncratic is impossible. Whether we term this disruption of the ideal dream of high modernism, the things that thwart utopian (everyplace is no-place) generalities (general is not real), as "formless" or "grotesque" or "cussedness," the effect is much the same.[43] The real task of modernists in New England was to look for and celebrate those aspects of the place that destroyed the created stereotype, returning New England to the untidy, disorderly, marginalized present—but a present decidedly not New York's. At the same time nearly all these artists were reluctant to entirely extricate themselves from the nostalgic view of New England that swamped any visitor.[44]

The Urban Grotesque

For many of these artists the critical encounter that made the difference between what was being marketed and what was actually experienced could be found in the towns. Here the impulse to connect to an iconic landscape was most difficult. People could be rendered into "types," as so many of the Ashcan school artists had done, but in aggregate, people going about their daily business in the modern world were not so different wherever they might be found—as Marin had declared when he said that places, not people, had that special quality of "cussedness." In the places most of these artists were likely to reach, modern, technological change had already arrived and could hardly be ignored (except by tourists). It is in communities and people, then, that the sharpest sense of the modern grotesque emerges—the combination of distorted, heterogenous details of experience. A survey of several artists suggests the range of response.

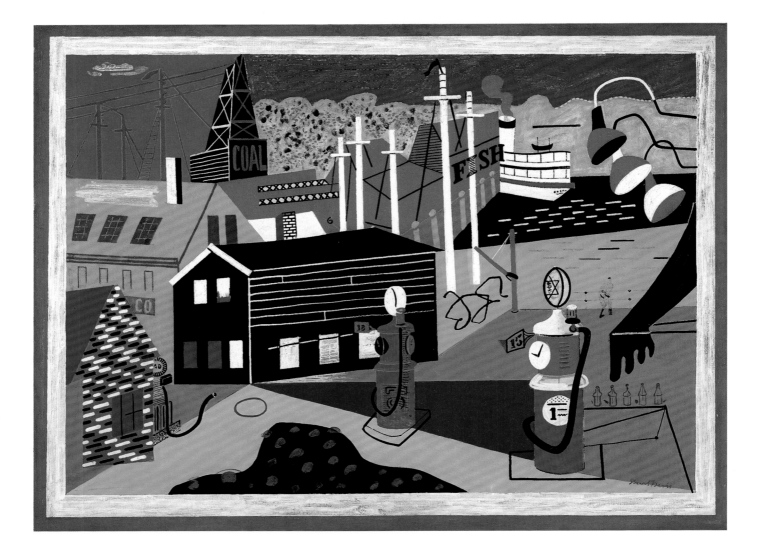

206. Stuart Davis, *Landscape with Garage Lights*, 1932, oil on canvas, 81.3 × 106.4 cm (32 × 41 7/8 in.). Memorial Art Gallery of the University of Rochester, Marion Stratton Gould Fund.

For all the abstract elements of his style, Davis's *Landscape with Garage Lights* (Fig. 206), betrays a rather mixed reaction to the commingling of old and new elements he saw in Gloucester.[45] In his memoirs he mentions that he liked Gloucester in part because it had an old-fashioned, decidedly unmodern Main Street, not "prefabricated." And he adds, "automobiles were very few" as were their "numerous attendant evils." He goes on to say that he had "for several years introduced filling station gas pumps into my landscapes," but "this compulsion was abruptly terminated when their designers went sur-realist." In Davis's painting several gas tanks are featured prominently in the foreground. Arrayed along the back of the scene, from left to right, are the masts of a schooner, signs announcing "coal" and "fish," the posts of the fish pier, a coal-powered boat, and some electric lamps. The mix of technologies and histories is complete. Dominating this New England landscape, however, are not schooners and spires but the "jazz" of gas pumps and electric lights. Not surprisingly for an artist who wished to see the landscape first in terms of its abstract (modern) qualities, Davis relegates old New England to the background.

Away from the coast, the bigger towns in the interior of New England had become dependent on large industries that had passed their peak, and, in the 1930s, were decaying. Both Stefan Hirsch (a protégé of Field) and Charles Sheeler (an early Provincetown visitor and a member of the modernist group associated with the Arensbergs in New York) depicted these factory towns in several paintings. Hirsch, in *Factories, Portsmouth, New Hampshire* (Fig. 207), builds from the blank foreground up and back into space a series of more and more intimidating and empty building forms. In the foreground rests a little shed dwarfed by the blank

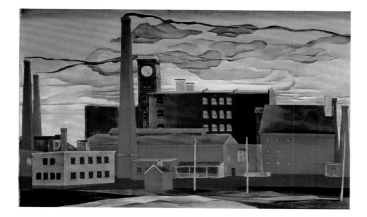

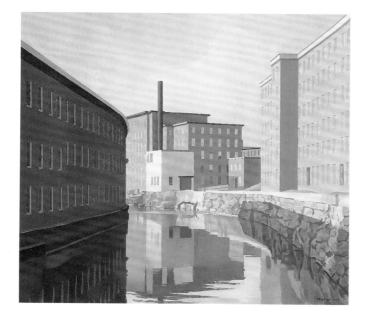

207. Stefan Hirsch, *Factories, Portsmouth, New Hampshire*, 1930, oil on canvas, 43.8 × 68.6 cm (17 1/4 × 27 in.).Courtesy of SBC Communications, Inc., Houston, Texas.

208. Charles Sheeler, *Amoskeag Canal*, 1948, oil on canvas, 56.2 × 61.3 cm (22 1/8 × 24 1/8 in.). The Currier Gallery of Art, Manchester, New Hamphshire, Currier Funds (1948.4).

facades towering over it. In the far background is a clock tower, a sign of civic identity, but this structure (once so imposing in the town center) is shrunk by the assertive smokestack crowding it to the top of the frame and belching smoke insolently over it. Hirsch clearly depicts a New England in which modernity is a failed creation, as the country and small town has been transformed into city.[46] Sheeler shares the same point of view in *Amoskeag Canal* (Fig. 208), but it is also, as Carol Troyen has noted, "oddly ahistorical," indeed, affectless and airless. Neither glorifying the technological future nor critiquing the past, it seems to embalm the scene. Here New England is fatally caught between past and future.[47]

This sense of a past that distorts the future or drags on the present can be seen in a different guise in paintings by Gregorio Prestopino and O. Louis Guglielmi.[48] Both Prestopino and Guglielmi were residents of the MacDowell Colony in the mid-1930s, a far cry in its rural New Hampshire setting from the Italian neighborhoods in New York that they were used to. Not surprisingly, they fastened on the difference between their sense of modern urban existence and of rural New England (which had its own large Italian immigrant communities, to be sure). Prestopino, in *Main Street, Peterborough* (Fig. 209), contrasts the spire of a typical New England church—seen so pristinely in Demuth's painting—against the casual and possibly unemployed loungers on the street below. One might compare this view of Peterborough with Wilder's, as seen in *Our Town*, written only a few years later. Unlike Wilder (and Adolph Dehn; *see* Figs. 121, 122), Prestopino never rises above the town to view it from the hills. He chooses to remain below on the slightly grim streets.

This bleakness is even more evident in Guglielmi's New England villages, where the signs of New England's blessed past remain as so much litter in the landscape. In *Martyr Hill* (Fig. 210) the Civil War monument honoring New England's principled and passionate leadership in the war against slavery surveys a sadly changed setting, emptied of life.[49] The foreground itself, a bridge and canal, undermines both the solidity of the hill and any access to it.[50] As the New England states advertised themselves in these years, they were settings for sports activities and historic buildings; the only element of modernity being trains and planes.[51] Guglielmi, in contrast, detects a falling off from this perfect present in both directions—an impotent past and a foreclosed future.

New England Bodies

The central sign of the grotesque, however, can be found not in the arena in which it is performed but in the bodies who act it out. One common motif pursued by both conservative and avant-garde artists was the woman in the landscape, a rendering of the Western tradition of the femininity of nature. The teaching method of more academic artists like Hawthorne often consisted of posing a woman clothed in summer dress against the light on or near the beach (*see* Fig. 182). Modern artists went several steps further. Hamilton Easter Field reputedly scandalized Charles Woodbury's students at Ogunquit by posing the model nude, but even Hassam

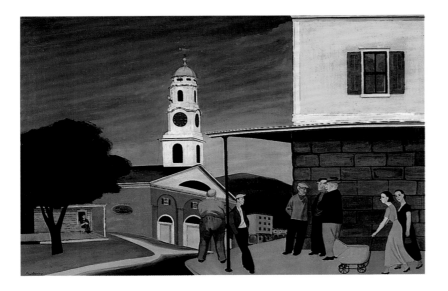

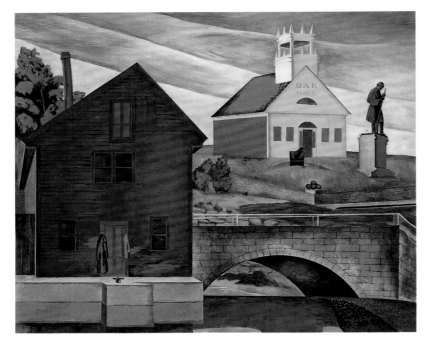

209. Gregorio Prestopino,
Main Street, Peterborough,
1935, egg tempera on masonite,
50.8 x 76.2 cm (20 x 30 in.).
Elizabeth D. Prestopino.

210. O. Louis Guglielmi, *Martyr
Hill*, ca. 1933–34, oil on canvas,
55.9 x 81.4 cm (22 x 32 1/8 in.).
National Museum of American
Art, Smithsonian Institution,
Transfer from the U.S. Depart-
ment of Labor.

produced seaside nudes by the end of his career. This easy equation of woman and nature remained a useful motif in modernist hands, but one in which the sensuality of the figure is emphasized and not its transcendent relationship to nature. William Zorach's slightly saucy *Floating Figure* (Fig. 211) is at one end of the spectrum;[52] Robert Laurent's more ponderous *Wave* (Fig. 212) is at the other.[53] The Zorachs's *Maine Islands* (Fig. 213) sums up these ideas, as it places two nude couples on rocks at either side of the composition, framing a pine-clad island and a sailboat. Slightly allegorical, slightly hopeful (who wouldn't want to imagine Maine so free, especially so mosquito-free, that one could strip down in nature), the tone is idealistic and fanciful even as it renders a Maine radically at odds with reality.

Yasuo Kuniyoshi, whose outsider status as a Japanese was even more extreme than that of most visitors, held an unapologetic gaze that uprooted conventional subjects easily. Even more than many of his colleagues in Ogunquit, Kuniyoshi sees the coast of Maine as a place for lickerish freedom, of women cavorting as mermaids—as in *The Swimmer* (Fig. 214)—or looking at the viewer with come-hither eyes and a cigarette in *Bather with a Cigarette*.[54] This is no innocent country maiden but as sharp as any city girl (which, in fact, she probably is, being another art student). In *Waitresses from the Sparhawk* (Fig. 215) Kuniyoshi is aware of the forced intrusion of the city on the country with the incongruous image of these waitresses, in their frenchified outfits, on a break outside a restaurant serving summer visitors. Placed in a breezy seaside landscape, as women had been for so many visiting art students for the last thirty years, these women could have been dropped in from Manhattan. They have nothing to do with their setting, except for the fact that they work there: they are the real inhabitants.

In all these pictures, the smooth surface of the durable past is disrupted, and the bits of experience—Civil War monuments, waitresses, factories, sexy bathing beauties—jostle together like flotsam and jetsam. The disorderliness works particularly clearly also at the level of style, a style often labeled "expressive" without ever really facing the challenge of its deformations. It is a modern grotesque.

American artists confirmed this grotesque style, while clearly European in origin, in American folk art, which was avidly rediscovered, collected, discussed, and exhibited by them, beginning with Field in Ogunquit. When we think of the "deforming" expressive style of so many of these artists not merely as a primitivist urge, in which folk art is used as a sign of the folk character of the setting or a type or a source for motifs, but as an expression of the grotesque, we look twice. What folk art revealed

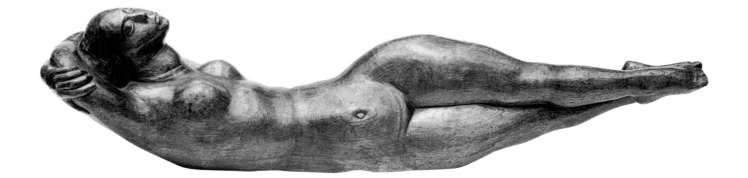

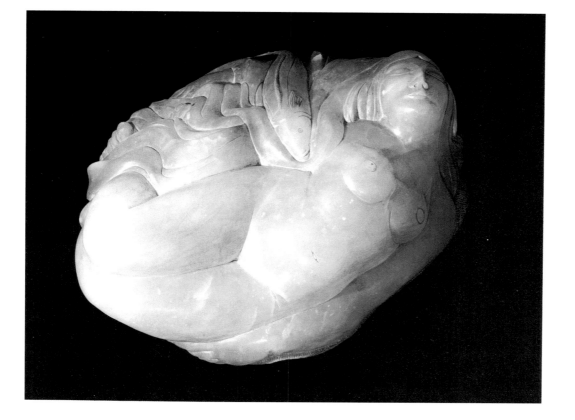

211. William Zorach, *Floating Figure*, 1922, Borneo mahogany, 23.0 × 85.1 × 17.9 cm (9 × 33 1/4 × 7 in.). Albright-Knox Art Gallery, Buffalo, New York, Room of Contemporary Art Fund 1946.

212. Robert Laurent, *Wave*, 1926, alabaster, 31 × 58 × 51 cm (12 1/8 × 22 1/3 × 20 in.). Brooklyn Museum of Art, Polhemus Fund (28.275).

213. Marguerite Zorach, with William Zorach, *Maine Islands*, 1919, needlepoint and pencil on canvas, 45.2 × 126.4 cm (17 3/4 × 49 3/4 in.). National Museum of American Art, Smithsonian Institution, gift of Tessim Zorach and Dahlov Ipcar.

214. Yasuo Kuniyoshi, *The Swimmer*, ca. 1924, oil on canvas, 52.1 × 77.5 cm (20 1/2 × 30 1/2 in.). Columbus Museum of Art, Ohio, Gift of Ferdinand Howald.

215. Yasuo Kuniyoshi, *Waitresses from the Sparhawk*, 1924–25, oil on canvas, 75.4 × 106.4 cm (29 3/8 × 41 1/2 in.). Jack S. Blanton Museum of Art, The University of Texas at Austin, Gift of Mari and James A. Michener, 1991.

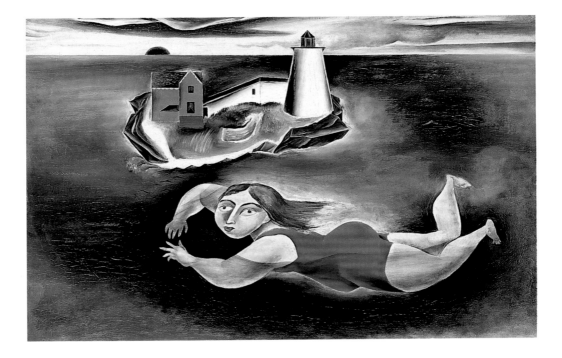

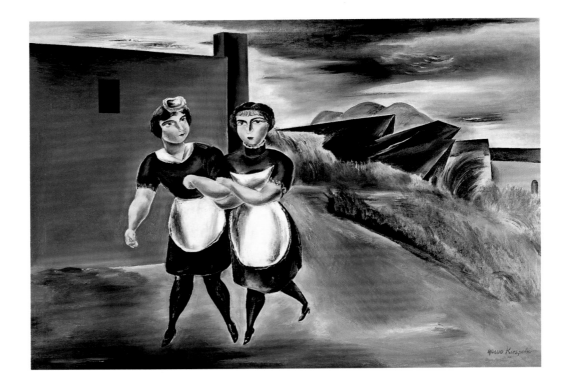

for Kuniyoshi or Laurent or Strand (Fig. 216) was not something smooth, virtuous, and indomitable in the character of these "primitives" but something cranky, quirky, unexpected, subverting the connection made in the previous generation— Homer's generation—between the landscape and the people.[55] The antecedents for this expressive deformation of the figure and an interest in folk art may be found in the European avant garde, most clearly in the German expressionists, especially members of Der Blaue Reiter, who were known to modernist circles in America principally through their almanac. The specific connection is twofold. First, Kandinsky and others touted various forms of folk art as a source of inspiration for contemporary artists, as a way of cutting through the layers of academic training and painting that had excluded and repressed this heritage. This discovery of a

216. Paul Strand, *Decoy, New England*, 1946, gelatin silver print. © 1950, Aperture Foundation, Inc., Paul Strand Archive.

natural art was then allied to a specific style, one which might be called grotesque, one which relied on extreme distortions of the figure.

Nonetheless, while modernists proclaimed their closeness to folk art and popular culture, most stood superior to the connection they had appropriated. Unlike earlier artistic work discussed in this book, modernist images did not enter mass circulation. They remained part of an elite visual culture inhabiting museums and a few private collections. Style elements of their work entered into the public domain and certainly many of these artists worked in advertising, but their reformed content did not. This inability to enter the mainstream as fully as their predecessors says much about the place of modern art in public culture in the twentieth century and the mythic place of New England, subjected to the criticism of figures like Van Wyck Brooks or distanced by academic analysis.

Marsden Hartley: Return of the Native

What Lovecraft discovered, then, as an antimodernist, was the grotesque in the traditional character of New England. What modernist artists rendered was equally distorted. To be sure this was not limited to New England; no special style was reserved for their New England paintings that was not found in their New York works. New England just came freighted with meanings that reflected on the moral history of America and its current condition—in which the spiritual guidance of the past was consumed and not replaced by the insatiable longings of an urban, technological present.

Hartley's comments and practice again are useful. Forced to return to Maine in the late 1930s in a desperate attempt to market himself distinctively as "the painter from Maine," Hartley declared in an essay entitled "On the Subject of Nativeness—A Tribute to Maine," in 1937, his sense of the character of New England, a set of values expressed in its people and its landscape, where one becomes the sign of the other. Quoted earlier in this essay, the short passage makes some significant points. The hallmarks of the North—in both landscape and people—are rigidity and plainness, directness and hardihood: "Maine is likewise a strong, simple, stately and perhaps brutal country, you get directness of demeanor, and you know where you stand, for lying is a detestation, as it is not in the cities."

Here Hartley joins the truth-telling nature of his style, a truth beyond mere representation, to the nature of his subject—both are direct in their appearance and cannot tell a lie. The implicit contrast with his New York audience is that his paintings offer a spare hardiness and frankness—time-honored qualities that confirm the value of his art, something his New York audience might well be in need of. This primitivist urge—a sense that civilization could use a corrective dose of the simpler values associated (rightly or wrongly) with less cultivated people—is fundamental to much modernist art, as noted earlier. It is allied to the idealism inherent in the iconic objects here discussed—impulses seeking to strip contemporary culture and society of bourgeois excrescences.

The idea of the rock-bound coasts of Maine and the sturdiness of its inhabitants that Hartley pays tribute to is one that had been fruitfully mined by artists since

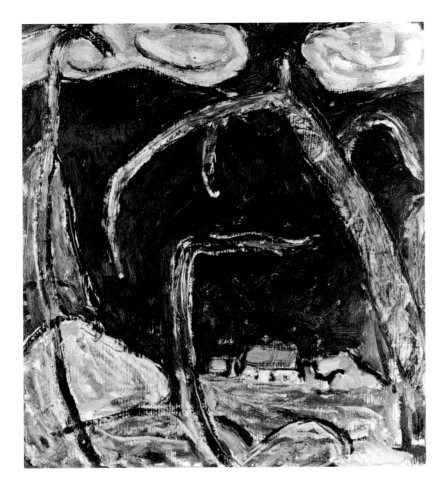

217. Marsden Hartley, *The Dark Mountain No. 1*, 1909, oil on composition board, 35.9 × 30.8 cm (14 × 12 in.). The Metropolitan Museum of Art, New York, The Alfred Stieglitz Collection, 1949 (49.70.47).

the days of Winslow Homer fifty years before and had become a standard feature of popular culture. One might ponder the ironies of a cosmopolitan modernist painter repackaging himself as a New England product to hit the high end of the market defined at its lower end by maple syrup. To read Hartley as a victim of consumer culture is too simple, however. Instead it is worth exploring the contradictions in Hartley, the ways his vision of New England is, for example, surprisingly close to Lovecraft's.[56]

First and most obviously there is a connection of subject matter. Lovecraft's horror-struck farmhouse appears in Hartley's art as well and just as obsessively.[57] At the end of Hartley's first year as a professional artist, he returned to Maine for the winter, renting a small, remote, unheated farmhouse at the foot of a mountain range. Almost completely isolated, uncertain of his future (or even of food for the next week), he worked intently during the winter, producing the paintings that would convince Stieglitz a few months later to give him his first exhibition. This period, during which he gained a measure of artistic success, would nonetheless be remembered with great fear and prompt his desire to escape from Maine, never to return. Periodically, during bouts of turmoil, he would return to the subject, as paintings from 1909, 1923, 1930, and 1933 suggest. The first of these, the so-called Dark Landscapes (Fig. 217), according to Stieglitz, were produced by Hartley during a suicidal depression. After spending the autumn in New Hampshire in 1930—his first attempt to return to Maine in twenty years and as close as he could get—he wrote to Rebecca Strand: "There's no escape day and night from facing nature constantly. But I've learnt one thing—never, never, never to turn north again as long as I live." As he wrote to Stieglitz: "New England is the country that taught me how to endure pain."[58] This lonely farmhouse appears not only in Hartley's art, of course, but in Hopper's or even in Hirsch's *Factories* (*see* Fig. 207), where the little New England structure is crowded by the factories. And the horrors of the lonely farmhouse are not limited to New England by any means.

As Hartley makes clear in his essay "On the Subject of Nativeness," the real interest lies in the connections among landscape, character, and style—which he wishes were straightforward and direct, but in the end are not. At the end of his life Hartley turned to painting the figures populating the landscape, the last element of this equation. He portrayed lumberjacks, hunters, guides, fishermen, and other laboring types. Most of his work was centered on the coast at Old Orchard Beach, south of Portland, Maine, because nowhere else was there, as he said, "so lovely a spectacle as that five mile beach covered with handsome humanity."

Canuck Yankee Lumberjack at Old Orchard Beach, Maine (Fig. 218) is, on the surface, an homage to Cézanne's *Bather* (Fig. 219), firmly placing the painting within the modernist canon. It is also more than this. Old Orchard Beach was a working-class resort; the subject is not of the same class as the painter or his audience. In-

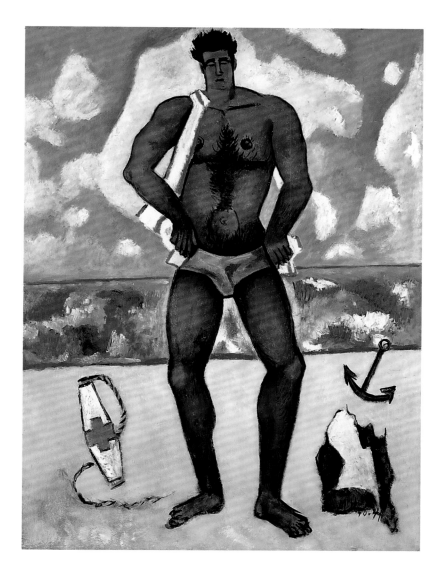

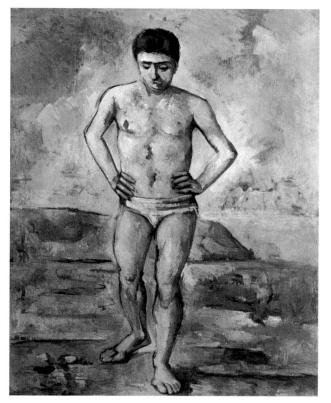

218. Marsden Hartley, *Canuck Yankee Lumberjack at Old Orchard Beach, Maine*, 1940–41, oil on fiberboard, 101.9 × 76.2 cm (40 1/8 × 30 in.). Hirshhorn Museum and Sculpture Garden, Smithsonian Institution, gift of Joseph H. Hirshhorn, 1966.

219. Paul Cezanne, *The Bather*, ca. 1885, oil on canvas, 127.0 × 96.8 cm (50 × 38 1/8 in.). The Museum of Modern Art, New York, Lillie P. Bliss Collection, photograph © 1998 The Museum of Modern Art, New York.

deed, he is the exotic Other, a Catholic French Canadian, dark and foreign—and very sexual.[59] Here we get to the root of the matter: Hartley's painting is motivated at its source by his homoerotic attraction to the man, an attraction spiced by all these things that New England was conventionally not. This Canuck lumberjack represents the things that the myth of New England had seemingly replaced and repressed. Old Orchard Beach is a zone, where, embraced in the heart of New England, Hartley could imagine himself in the wildest quarters of any gay ghetto in the world, a zone available, in fact, to any artist indulging any fantasy of disorder in any place in New England. This zone, indeed, is very different from the tourist destinations that had constructed so much of New England's visual culture, the named, historic places. This is instead a leisure zone, a liminal space outside structures of history, geography, and culture.

Hartley's homage to the artistic tradition and high calling represented by Cézanne is subverted by his desires, released in this modern New England space, one that has been discussed here by Roger Stein in very different terms in chapter 1, "After the War: Constructing a Rural Past." In *The Bather* Cézanne is consumed for other, deforming ends. The grotesque was available and useful as easily on Lovecraft's tidy Providence streets as it

was on Hartley's comfortably libidinous, bright, sunshiny strand, because in a region so overtly and sentimentally mythologized as historic, monumental, and exemplary, disorder was likely to erupt and return forcefully at any weak point, breaking into situations and categories where it should have no place.

By the end of that summer, however, Hartley was anxious to leave Maine and return to New York. As he said, he was "learning by degrees that in Maine though excitingly beautiful and profound in its solemnity, the human life seems sort of desiccated, washed out of its former stylism, and so one feels little related to anything these people think or do . . . life is not experienced here." In the end New England's grotesquerie was nothing compared to New York's.

Paul Strand: Icons

Just at the time Hartley returned to New York, Paul Strand, his compatriot from Stieglitz's 291 Gallery, was thinking of going back to New England, to formalize his full-time return to still photography after a decade spent making documentaries. To reestablish himself he started in the place where one always seems to begin in thinking about the United States, New England. He proposed to the Guggenheim Foundation that it fund his photography campaign there in 1943. While this was turned down, Strand found himself in Vermont in 1944 and in Maine in 1946. In the meantime, Nancy Newhall, who was acting as curator of the Museum of Modern Art's photography department while her husband was at war, organized in 1945 a retrospective of Strand's photographs. In her introduction, she admired this recent work: "Strand reached into the essence of New England. The shuttered white church stands on patches of snow like the terrifying grip of an ideal. In the worn doorlatch, the tar-paper patch, the crazy window among rotting clapboards, appear the ancient precision and mordant decay of New England."[60] Here we have again the trinity of values found in Lovecraft and Hartley: morality, simplicity, and decay, all bound up around images of rural community and domesticity.

Working on the exhibition, Newhall became interested in Strand's aborted Guggenheim project and proposed that they do a book together, she supplying a text based on historical documents and Strand making the photographs. For all Newhall's praise, *Time in New England*, published finally in 1950, betrays the degree to which Strand is imprisoned by the stereotypes of New England.[61] Newhall's text (produced by an author in her late thirties) traverses a fully liberal range of New England memories and associations: she quotes from fugitive slaves, bluestockings, fishermen, as well as the Puritans, farmers, and academics one might expect in a New England setting. Strand reduces this diversity to a few white faces and white churches. *Empty House* (*see* Fig. 74) is a good example of the coldness of much of this imagery. Cast in the mode of time recalled, Strand's exploration of the foundation of things in America does not break out of the stereotypes of mythic memory. The modernist vision he calls on, perfected soon after the turn of the century in New York, can only repeat its formulas some thirty years later. Its disruptive techniques have lost their edge, their deformity, under the smothering embrace of tradition. Strand confessed that he had always been under the influence of Edward Arlington Robinson's poems and was trying to create the same characters that had populated Robinson's modernized elegies. To see how much a part of the cultural landscape such a view had become, one need only note that, in the pages of *Scribner's* in 1931, Lewis Mumford declared Winslow Homer "the very prototype of those half-vulgar, half-aristocratic characters depicted by Robinson in 'Tillbury Town.'"[62] If Homer could be compared to Robinson, then for Strand to enunciate the same desired connection was no advance.

Robinson addresses the nature of New England directly, in a poem entitled "New England," published in *Dionysus in Doubt* (1925). His New England is half-frozen,

"where the wind is always north-north-east," and envious of those regions where love, passion, and joy reign freely. In his New England, "Conscience always has the rocking chair, / Cheerful as when she tortured into fits / The first cat that was ever killed by Care." Here, the vaunted New England morality, expressed most fully in abolitionism, is diminished and parodied, domesticated into an image of a New England spinster. Domesticity itself, celebrated so much in New England (as we have seen in several earlier chapters), for many other New Englanders, is deeply suspicious. *Empty House* and Strand's other photographs of desolate structures share this view. They might stand as a visual counterpart to Robinson's "Haunted House," also published in *Dionysus in Doubt*. In the poem visitors come to an abandoned house to escape the rain and leave as soon as they can, struck dumb by an unexplained sense of horror (the resonance with Lovecraft's houses or Hartley's or Hopper's is due to their common roots in a New England history of houses emptied by owners who moved to cities or new frontiers). Robinson explains the mystery heavy-handedly, hinting at the murder of a housewife by her husband. Robert Frost explores some of the same territory in his poems but much more subtly. One poem, however, brings the strain of grotesquerie inherent in modern life to the surface. In "'Out, Out—'" a buzz saw "snarled and rattled" in a Vermont farmyard (Frost is careful to name the landscape) and, even as his sister calls "Supper," "as if to prove saws knew what supper meant, leaped out at the boy's hand" and cuts it off. The boy dies, victimized deep in the heart of this bucolic setting, killed by a piece of modern technology, by the awful conjunctions of modern life. Strand's photographs, even more subtly, address the same sense of the death of rural domesticity in the modern world, celebrated once so powerfully by Whittier's *Snow-Bound*. In that poem, coldness comforts and sustains, it does not kill. The home sustains instead of denying life to its tenants.

The Vital Past

A modern view of New England that took it on its own terms, building on the terrain of the grotesque rather than being merely attracted to the region's decayed past, was still possible—so long as the artist did not belong to the groups that were so deeply invested in the myth, artists like Jacob Lawrence, Guglielmi, and Prestopino. Strand's vision was, by the 1940s, relatively bland and conventional, reducing the industrial landscape of New England to formalist shapes. In contrast, Guglielmi and Prestopino, both Italian immigrants, using a similarly abstractive formal language, show us a bleak landscape occupied by contemporary people. Both are conscious of the mix of past and present, of the signs of New England placed in the background while life goes on in the foreground. Guglielmi's vision, though, is considerably darker than Prestopino's, his streets emptier, his juxtapositions of people and objects more jarring. *Martyr Hill* (*see* Fig. 210), in particular, takes us back to the ground we had begun on, the landscape of New England after the Civil War. It reminds us of that conflagration in which New England had played such a leading role but anxiously disengages it from the future implied by the event. Crowning the hill is a veteran's meeting hall, shaped like a church but marked "G.A.R." (Grand Army of the Republic). Outside this site of memory and community stands a monument, a lone figure of a soldier, head bowed, dark and faceless. At the foot of the hill, a canal, an industrial structure, and a bridge are placed together, efficient signs of New England industry but unoccupied and hindering our access to the steepled hall on the hill. The *Shaw Memorial*, placed in the heart of Boston, had proposed a continuation of New England's moral role, in which abolitionists shepherd a community resolutely forward. Here, two generations later, only the husks of that effort remain, in a landscape depleted of life. As an Italian American, Guglielmi created work that reflects class relations, inflected by the decades-

long history of unionism and immigration. He, like Strand, is oblivious to racial diversity, although he is alert to the issues of freedom embodied in the myths of New England.

For Jacob Lawrence, as an African American, the issues of the Civil War were very much alive. In his Frederick Douglass series, he returned squarely to the defining situation of New England's moral preeminence, its support and leadership in the abolitionist cause, the situation dramatized in *The Fugitive's Story* (*see* Fig. 1).[63] For his purposes New England's mythic heroes—its Garrisons, Adams, Shaws—are peripheral. The black experience—specifically Frederick Douglass's life—is his concern, a matter in which New England seems largely to have had an abstract interest.

Shortly after Douglass fled enslavement and arrived in New York, he moved further north to New Bedford, Massachusetts, to work in the shipyards. Because of racial prejudice, he was unable to find employment in his trade as a caulker, and became a menial laborer. After subscribing to Garrison's newspaper, *The Liberator*, Douglass was inspired by Garrison's speeches to become an abolitionist lecturer himself at a rally in Nantucket organized by Garrison in 1841. In panel 18, in the sequence entitled *The Fugitive* (Fig. 220), Douglass stands on a platform gesticulating broadly to a white audience. In contrast to the previous panel, which shows Garrison seated and speaking in a church, confined within the geometry of the space, this scene breaks free of any enclosure and tight gesture. Douglass commands the crowd (all except for the little boy to the right). Inspired by Garrison, Douglass makes the dream of liberation his own and gains a greater power. Here at last we see the stereotypically homogenous New England society riven and shaken by Douglass's black presence.

Like Douglass, Lawrence had been given some of the tools needed to free his vision of America by forward-looking white radicals, by modernist art in an urban, socialist environment. Lawrence painted his series while working in Harlem for the Works Progress Administration. But the result, as Douglass reshaped the mission of Garrison and his white abolitionists, wrests the vision of its subject—a scene from the moral heyday of New England—into something strange and different and more potent. Lawrence stakes a claim for this historical New England subject that is much larger than New England, one that may now declare the same universal qualities that had animated the fight for equality in the first place. Where his other modernist contemporaries had a deeply mediated and somewhat distanced relationship to New England's political past, Lawrence succeeds in connecting modernist expressive distortions to something urgently authentic, reviving the politics of liberty anew.

Nonetheless, it would be too easy to praise Lawrence for escaping from the mass of derivative imagery created by the very success of New England's marketing of its history and landscape. This imagery remained potent in the nation at large, however modernist artists might avoid it. Norman Rockwell's *Freedom of Speech* (*see* Fig. 129), painted only a few years later in 1943, makes a useful counterpoint to Lawrence's image. In both pictures, individuals have risen from their communities to speak of personal freedom and human rights. An unbroken link in both images connects back to the founding myths of the nation, as promulgated by New England mythmakers throughout the nineteenth century. Visually utterly different and speaking to very different audiences, both works are concerned with similar issues. While one seeks to unify, to ease differences (visually stressed by the closeness of the crowd surrounding the speaker), the other seeks to break apart comfortable assumptions of community. This difference in style, audience, and intent marks a sea change in the tradition of New England as a subject for high art, even as it continued to thrive (and gain in power) in other cultural realms.

220. Jacob Lawrence, *Frederick Douglass, Series II. The Fugitive, No. 18*, 1938–39, casein tempera on gessoed hardboard, 30.5 × 45.4 cm (12 × 17 7/8 in.). Hampton University Museum, Hampton, Virginia.

We have examined in this book the successful marketing of images of New England as cultural commodities even as New England began to lose its industrial power. We have traced the production of this imagery into its immediate diffusion, via reproductions in every conceivable medium, out across the country. Beginning in the arena of elite culture, with works produced by the nation's leading artists, approved by critics and public alike, we have witnessed in this last chapter, the division of this alliance. The imagery of New England, however, lives on, continually subject to the pressures of tourism and marketing; nor has the most powerful engine of American imagery forgotten New England. From *Carousel* to *Jaws* to *Glory*, Hollywood has successfully repackaged nearly all the imagery here discussed, but at this point, one leaves the realms of exhibition galleries and the confines of any single book. Even as the region thrives anew, so too have entrepreneurs and artists found new ways to make the *Mayflower* return again, to make old New England fresh once more.

Notes

1. In a survey of the advertising used by the New England Council in 1935–36 one finds all the motifs that appear in modernist paintings of New England (see *Selling New England*).
2. Of course, New England itself was most heavily marketed in New York, according to the New England governors' recreational campaign (ibid., 2).
3. One has only to look at the twentieth-century collection of the Museum of Fine Arts, Boston (before the recent acquisition of the Lane collection), to get the point. Boston collectors went as far as Monet and van Gogh but seldom ventured past to Matisse and Picasso. The very active group of Harvard undergraduates who organized avant-garde exhibitions in the 1920s—most importantly Alfred Barr—all graduated and went to New York. Agnes Mongan, who stayed behind, became famous as a curator of old master drawings. Only Chick Austin at the Wadsworth Atheneum in Hartford, Connecticut, in the 1930s, introduced his museum and its audience to much modernist art.
4. In fact, the motifs follow the models established in the advertising of the same period. While advertising copy mentions "charming colonial villages . . . Pilgrims . . . the route of Paul Revere . . . scenes of America's historic and literary greatness," the imagery is almost entirely of healthy outdoor activity—sailing, walking, swimming, and so on (ibid., 11).
5. Lovecraft, "Picture in the House," 121.
6. John Marin to Alfred Stieglitz, Stonington, Deer Isle, Maine, 21 August 1927, in Norman, ed., *Selected Writings of John Marin,* 115.
7. Hartley, "On the Subject of Nativeness," 112.
8. Among many other sources, one might consult Tuchman, *Spiritual in Art.*
9. Alfred Stieglitz, mentor of many of the artists I will be discussing, had an estate near Lake George in upstate New York; had he had a vacation home on Cape Cod or Mount Desert, this story might be different. Only two of the artists he most consistently supported, Marsden Hartley and John Marin, worked much in New England, and Hartley did so only reluctantly.
10. Quoted in Robertson, *Hartley,* 47. See also Hartley, "On the Subject of the Mountain," 136.
11. Strand later said: "I've always had an interest in the things that make a place what it is, which means not exactly like any other place and yet related to other places" (Strand, *Paul Strand,* 23). The critic Paul Rosenfield characterized Marsden Hartley's early still lifes as the characteristic production of a New Englander with such terms as "quaint humorousness . . . extravagant conceits . . . capricious inventions," comparing him to Emily Dickinson (Rosenfield, *Port of New York,* 99). At the same time, one cannot deny that Hartley has painted an iconically tourist image—he was always conscious of his market (see Robertson, *Hartley,* 77, 120).
12. Hartley, "John Marin," 79.
13. See Hartley's 1937 drawings of characteristic objects associated with fishing (Robertson, *Hartley,* 106).
14. Hartley to Adelaide Kuntz, 24 October 1939 (quoted in Hokin, *Pinnacles and Pyramids,* 111). Mount Katahdin is also the spot that the sun shines on first as it rises over the United States, at least according to Ripley's "Believe It or Not!" (see *Selling New* England, 20).
15. Hopper, of course, may be taken as both a realist and a modernist—he is hard to categorize. In the early 1930s, however, he was modern in the eyes of most. Concerning his election to the National Academy of Design, a critic for *The New York Times* wrote: "[This] stronghold of conservatism . . . elect[ed] an artist of the modern school." Not every one agreed. When Hopper was given a retrospective at the Museum of Modern Art in 1933, the critic Ralph Pearson claimed "he was definitely outside the modern school" (Levin, *Hopper,* 242, 252).
16. Puritanism was evidently ubiquitous and almost always tied to a hard-edged character. For example, John Sloan described Gloucester in 1925 as "one of the odd corners of America, built against the puritan landscape, blue-eyed and rocky" (quoted in Holcomb, *Sloan,* 12). And, further afield, William Allen White amusingly describes the consequences of Kansas's Puritan heritage, derived from those who were descendants of New England abolitionists: "The first Kansans, therefore, were crusaders, intellectual and social pioneers . . . which . . . means that Kansas was full of cranks" (White, "Kansas," 2).
17. Hopper's art was associated with puritanism by critics, in part as a way of labeling his "Americanism." "Puritan austerity and nothing in excess," as Helen Appleton Read wrote in 1933. Hopper's own character was decidedly "American" as well, indeed New Englandish. Forbes Watson described him as honest, ungainly, quiet, and slow—the same terms one might apply to a Vermont farmer. Guy Péne du Bois made the connection more exactly: Hopper "turned the Puritan in him into a purist, turned moral rigours into stylistic precisions" (Levin, *Hopper,* 253, 254, 381).
18. Hartley, *Poems,* 153.
19. Dorothy Canfield Fisher, for example, tried to characterize the states as people and described Vermont as "a tall, powerful man, with thick gray hair, rough outdoor clothes, a sinewy axman's hand and arm, a humorous, candid, shrewd mouth and a weather-beaten face from which look out the most quietly fearless eyes ever set in any man's head . . . the quaint, strong, unspoiled personality is tinctured to its last fiber by an unenvious satisfaction with plain ways" (Fisher, "Vermont," 44–45).
20. Robert Herrick, in his essay on Maine in *These United States,* paid particular attention to the "rude white" farmhouses and the "fishermen's houses along the coast . . . equally white and graceless" (Herrick, "Maine," 124).
21. Henry McBride, *The Dial,* 1921 (quoted in Fahlman, *Pennsylvania Modern,* 44). *After Sir Christopher Wren* (1920) is the work that most prominently centers on the steeple of a church in Gloucester; the painting was also called *New England.*

22. Bernstein, *Meyerowitz*, 53.
23. Marling says that in the 1920s in these art colonies: "What to paint . . . now took a back seat to questions of style—how to paint . . . many modernists ceased to rely on picturesque local scenes for their topical focus. Blanche Lazelle['s] paintings do not readily reveal her reasons for joining the Cape Cod art colony." She adds: "During the heyday of the Model-T, almost every group activity conceived by artists, regardless of rationale, drummed up tourism" (Marling, "Woodstock," n.p.).
24. How else to explain Gloucester's Pilgrim monument, erected in 1907, a tower in a Siennese Renaissance style? See George Ault's *Provincetown #1* (1923) for a painting that incongruously places the monument where one would expect a lighthouse.
25. Virtually all the essays in Gruening, ed., *These United States,* dwell on the racial makeup of the individual states, some quite obsessively. John Macy's chapter on Massachusetts is framed by the sight of an Irish priest at a Harvard commencement, singing "Fair Harvard," a song with the line: "Till the stock of the Puritans die" (Macy, "Massachusetts," 228). For a bleak assessment of racial questions in the period, see Robinson, "Racial Minorities."
26. Bernstein, *Meyerowitz*, 30. Actually, the Portuguese is *"gaivota."*
27. One might recall here, too, Hopper's models for his painting *Cape Cod Evening:* "In the woman I am trying to get the broad, strong-jawed face and blond hair of a Finnish type which there are many on Cape Cod. The man is a dark-haired Yankee" (quoted in Levin, *Hopper: A Catalogue Raisonné,* 3:48).
28. Honoring the lively sense of female intellectualism so celebrated in New England culture, Bernstein turns on its head the genre conventions for depicting a group of women together: this is no gossiping quilting bee but an evening of intense and interesting conversation.
29. Bernstein, *Meyerowitz*, 31.
30. Quoted in Luhan, *Movers and Shakers,* 3:488.
31. As Gloucester is described in the reviews of William Meyerowitz's exhibitions in the *Art Digest* 16, no. 13 (1 April 1942): 24; see also *Art Digest* 14, no. 14 (15 April 1940): 16.
32. Davis, *Davis,* 25.
33. Lockett, "Provincetown," 54–55.
34. Field, *Technique of Oil Painting and Other Essays,* 58.
35. Lockett, "Provincetown," 49–50.
36. As noted earlier, much of this sense of New England's stunted, antimodern character derived from—in the eyes of most cultural critics—its Puritan heritage. Van Wyck Brooks claimed this inheritance could be blamed on their relationship to the land—"The Puritan forefathers lived in perpetual conflict with nature . . . they hated the land they looted"—or on the lack of real friendship, in a "morbid reticence . . . spring[ing] from a deep distrust of human nature." It existed in a "twilight" state, "returned upon itself and look[ing] back across the Atlantic" (Brooks, *Sketches in Criticism,* 127, 170, 214). In 1924 Paul Rosenfield makes the same analysis in connection with Hartley (Rosenfield, *Port of New York,* 94).
37. Quoted by Newhall, *Time in New England,* 153.
38. See *Webster's New International Dictionary,* 2d ed., s.v. "grotesque."
39. Stallybrass and White, *Politics and Poetics of Transgression.*
40. See, for example, on Hawthorne, Davis S. Reynolds, *Beneath the American Renaissance* (Cambridge, Mass.: Harvard University Press, 1988), chap. 9. The fear of degeneracy and inbreeding, so vocally expressed by eugenicists also permeated fiction for a long time without showing up in the visual arts.
41. It is in this sense that New England artists were inspired by the work of Jean-François Millet, as Roger Stein suggests here in chapter 1, "After the War: Constructing a Rural Past."
42. Marin to Stieglitz, 11 September 1921, in Norman, ed., *Selected Writings of John Marin,* 71.
43. See, for example, Bois and Krauss, *Formlessness.*
44. Paul Rosenfield describes Marin as having, even in his most abstract representations, painted the coves and inlets so that those who were familiar with Casco Bay or Stonington could identify them accurately. "And, still, fused with the inscrutable elements of race and place, there pulses in every one of Marin's spurts the tempo of the modern world" (Rosenfield, *Port of New York,* 162).
45. One might contrast this with the heroic vision of fishing life to be found in federally subsidized murals, like Paul Sample's *Apponaug Fishermen* (1942).
46. Speaking of another industrial city scene, Hirsch described his first reaction to the United States after returning from World War I. Instead of the open vitality he expected from reading Whitman and Emerson, he found it ugly and cramped, a "megapolitania" (quoted in Friedman, *Precisionist View in American Art,* 34–35). In a surprising fashion, Homer's *Morning Bell* (1872) is not dissimilar in its juxtaposition of a little farm building on one side of the canvas and the slightly decayed factory on the other. For a similar vision to Hirsch's, see Oscar Bluemner's *Walls of New England* (1935).
47. Troyen and Hinsler, *Sheeler,* 68. Karen Lucic discusses Sheeler's ambivalence toward industry in the 1940s in Lucic, *Sheeler,* chap. 4.
48. See John Macy's word-portrait of a typical Massachusetts town, with one or two nice houses, a factory district, a "native" shopkeeper being put out of business by a Greek or Italian grocer, a good church "thanks to Wren and a defunct race of carpenters who built both churches and ships . . . the soldier's monument is a fright," and the trees on the common in danger of dying (Macy, "Massachusetts," 242).
49. There is a profound interest in the Civil War during the 1930s; instances appear in surprising places in the oeuvre of these artists, from Hopper's only two historical paintings (of Union soldiers resting) to Hartley's portraits of Lincoln (inspired, no doubt, by Carl Sandburg's biographies).
50. This painting by Guglielmi is one of several, including *Odd Fellows Hall* (1934), *Connecticut Autumn* (1937), and *Town Square* (ca. 1933–34), that depict empty, threadbare, slightly ominous small-town New England settings. *Land of Canaan* (1934) plays more overtly on the contrast between

the industrial smokestack in the rear and the barren houses in the foreground. An unlocated painting called *New England* (1936?) might almost be the sequel: a half-ruined farmhouse with a man sprawled on his back in the field and a woman standing silently in the middle of her ruined home (reproduced in Baker, *Guglielmi*, 15).

51. *Selling New England,* 19.
52. The piece is created from something appropriately both local and exotic. The wood is Borneo mahogany, bought from an old ship's carpenter who had obtained it forty years before (see Wingert, *Sculpture of William Zorach,* n.p.).
53. Even artists dedicated to a more representational style tackled the subject, as in Leon Kroll's series of women stretched out on the rocks above the water, like *Blanche Reading* (1932). Milton Avery plays on these associations in a slightly disturbing portrait of his daughter on the beach, *Artist's Daughter by the Sea* (1943).
54. For *Bather with Cigarette* (1924), see Jane Myers and Tom Wolf, *The Shores of a Dream: Yasuo Kuniyoshi's Early Work in America* (Fort Worth, Tex.: Amon Carter Museum, 1996), 10.
55. These adjectives may be compared to those used by Rosenfield when he connected Marsden Hartley to Emily Dickinson, in their apparent similarity as untutored New England originals. See this chapter, note 11.
56. As early as 1924 Rosenfield had identified the "mournfulness" and "mordancy" of Hartley's paintings as well as their "fantastic and extravagant and capricious" qualities as a product of his New England background. The Dark Landscapes were a "cry of hunger and resentment and anguish . . . their cruel white forms crowding and crushing the central wretched, bending one" (Rosenfield, *Port of New York,* 97).
57. "Farmhouses are more frequently placed on high ground in Maine than in other New England States, as if to survey the approach of possibly hostile strangers" (Herrick, "Maine," 124).
58. Hartley to Rebecca Strand, September 1930, Marsden Hartley Papers, Archives of American Art, Smithsonian Institution; Hartley to Stieglitz, 25 February 1929, Alfred Stieglitz Papers, Beinecke Library, Yale University.
59. Hartley was born in 1877 in Lewiston, Maine, a town that in 1871, as Brown and Nissenbaum note in their historic overview to this publication, was eighty percent French Canadian.
60. Newhall, *Strand,* n.p.
61. Strand, in his introduction to *Time in New England,* touches on all the standard images and tropes. At the heart of his project is his sense that "New England was a battleground where intolerance and tolerance faced each other over religious minorities, over trials for witchcraft, over the abolitionists. . . . The rights of man were here affirmed in 1775 and 1860" (vii). The book itself is dedicated "to the Spirit of New England which lives in all that is free, noble, and courageous in America."
62. Lewis Mumford, "The Brown Decades: Art," *Scribner's* 90, no. 4 (October 1931): 366.
63. See Wheat, *Lawrence.*

Artist Biographies

FRANCES ALLEN (1854 – 1941), MARY ALLEN (1858 – 1941)

The Allen Sisters sought to bring old New England to life by posing and photographing models in colonial costume throughout their adopted hometown of Deerfield, Massachusetts. These images of women churning butter and girls embroidering, as well as landscapes, views of distinguished architecture, and still lifes of relics in the local museum, all contributed to the public image of Deerfield as a uniquely historic environment. So popular was this perception that the sisters were named two of "The Foremost Women Photographers of America" by the *Ladies' Home Journal* in 1902. The Allen sisters did not set out, however, to be photographers; they were trained as teachers. Both attended the State Normal School in Westfield in the 1870s, but were forced to retire when they became hard of hearing. Inherited money enabled Mary and Frances to move to Deerfield in the 1890s, where they turned to "amateur" photography, a pastime then prescribed as a form of therapy. Influenced perhaps by EMMA COLEMAN, a pioneer woman photographer who lived in Deerfield at the time, the Allen sisters began to sell photographs to tourists, printed a series of catalogues, and eventually sold their images to national publications. In this way, the sisters anticipated the mass-market interest in colonial scenes later exploited by WALLACE NUTTING. (TAD)

References

Flynt, McGowan, and Miller, *Gathered and Preserved*, 4–5, 10–11, 39, 50, 53; Meyer, ed., *Inspiring Reform*, 149, 192–93, 206; Naomi Rosenblum, *A History of Women Photographers* (New York: Abbeville, 1994), 60–61, 291–92, 333.

CLIFFORD ASHLEY (1881 – 1947)

Ashley set out to document a dying industry when he accompanied the bark *Sunbeam* on a three-month whaling voyage out of New Bedford, Massachusetts, in 1904. The artist, a descendant of an old whaling family, exposed over three hundred negatives of the well-worn vessel and its foreign-born crew as it was fitted out and at work on the high seas. Ashley chronicled this adventure in 1906 when he wrote and illustrated "The Blubber Hunters" for *Harper's Monthly Magazine*. A talented young man, Ashley was born in New Bedford and began his education at the Eric Pape School of Art in Boston. In 1901 he studied with HENRY J. PECK and N. C. WYETH at the artist colony of Annisquam, near Gloucester, Massachusetts. The following year he and Wyeth traveled to Wilmington, Delaware, to study with HOWARD PYLE, the patriarch of the Brandywine School. The mature Ashley was a prolific artist and writer. He authored two major books, *The Yankee Whaler* (Boston, 1926) and *Ashley's Book of Knots* (Garden City, New York, 1944), and contributed illustrations to *Century Magazine*, *Hampton's Metropolitan*, and *The Saturday Evening Post*. (TAD)

References

Clifford Ashley, *The Yankee Whaler* (Boston: Houghton Mifflin Company. The Riverside Press, 1938); Dorothy Brewington, *Dictionary of Marine Artists* (Salem, Mass. and Mystic, Conn.: Peabody Museum of Salem and Mystic Seaport Museum, 1982), 16; Elton Hall, *Sperm Whaling from New Bedford: Clifford W. Ashley's Photographs of Bark* Sunbeam *in 1904* (New Bedford, Mass.: Old Dartmouth Historical Society, 1982).

GEORGE AULT (1891 – 1948)

Ault was brought up in England and came late to an appreciation of his American origins. After training at University College School in London, the Slade School, and St. John's Wood School of Art, his painting style was described as an Anglicized version of impressionism. But when he returned to America in 1911 he began to paint New York night scenes and architectural subjects in a spare, modernist style. This caused his father, an academic painter, to stop supporting him. In the 1920s, on vacation in Provincetown, he painted the local scenery in oils and watercolors. These works were shown at a local gallery and in New York. In the early 1930s he worked on

New Deal art projects, gradually severing most of his ties with the art market. He moved to Woodstock, New York, in 1937, but avoided life in the art colony there. A nearby barn, which he painted three times, was a favorite subject, symbolizing for him a dying, agrarian way of life in the Catskills. In this sense his work echoed, from his own modernist viewpoint, the preservationist themes of many New England artists. Ault's life, plagued by illness, depression, and poverty, ended with his suicide in 1948. (JKM)

References
Louise Ault, *Artist in Woodstock. George Ault: The Independent Years* (Philadelphia: Dorance & Company, 1978); Susan Lubowsky, *George Ault* (Whitney Museum of American Art, New York, 1988); Tom Wolf et al., *Woodstock's Art Heritage: The Permanent Collection of the Woodstock Artists Association* (Woodstock, N.Y.: Overlook Press, 1987), 50–51.

HENRY BACON (1839 – 1912)
Growing up in Haverhill, Massachusetts, Bacon witnessed first-hand the changes wrought by industrialization and urbanization on the New England landscape. First settled in 1640, Haverhill was one of the oldest towns in the Commonwealth. By the time of the Civil War, however, it was a center of the shoe-making industry in America and well on its way to becoming a mill city. From this urban environment Bacon marched off to fight with the Thirteenth Massachusetts Infantry. After his army service, Bacon traveled to Paris to study painting at the École des Beaux Arts. Unlike his peers, however, who returned to the states after an encounter with impressionism, Bacon remained abroad for the majority of his career, painting conservative historical genre scenes and pictures of the exotic Middle East. Dissimilar in subject matter, Bacon's paintings share a moralizing tone and a pervasive nostalgia for a primitive, pre-industrial past. Bacon's American subjects proved to be highly popular and his magnum opus, *The Boston Boys and General Gage, 1775*, was exhibited in Memorial Hall at the 1876 Centennial Exposition in Philadelphia. (MN & TAD)

References
Dimock Gallery, *Victorian Sentiment and American History Painting: Henry Bacon's* The Boston Boys and General Gage, 1775 (Washington, D.C.: George Washington University, 1996); Patricia Hills, *The Painter's America: Rural and Urban Life, 1810–1910* (New York: Praeger Publishers, 1974), 100, 141; H. Barbara Weinberg, *The Lure of Paris: Nineteenth-Century American Painters and Their French Teachers* (New York: Abbeville Press, 1991), 138–144.

THOMAS BALL (1819 – 1911)
Ball rose to prominence as the growing United States sought to commemorate its civic heroes in public spaces as well as in the home. Although he is best known for his larger-than-life equestrian statue of George Washington in the Boston Public Garden, Ball was also one of the first American sculptors to patent and cast in bronze affordable domestic statuary. He made a career of portraying statesmen and historical figures, rendered in a naturalistic style somewhere between the inexpensive, moralizing sculpture groups cast in plaster by JOHN ROGERS and the high-style neoclassical marbles of Thomas Crawford and Hiram Powers. Ball was born in Charlestown, Massachusetts. The son of a house and sign painter, he served a brief apprenticeship with the Boston engraver Abel Brown before opening his own studio as a miniaturist and portrait painter. Soon after, Ball gave up his easel, distracted by a romantic disappointment and, according to legend, transferred his attention to a lump of clay. He found his calling and relocated to Italy. Although Ball made periodic trips back to the states, and his work was included in such major exhibitions as the 1893 World's Columbian Exposition in Chicago, he remained an expatriate until 1897, when he moved to Montclair, New Jersey. (MN)

References
Greenthal, Kozol, and Ramirez, *American Figurative Sculpture*, 35–38; Wayne Craven, *Sculpture in America* (New York: Thomas Crowell Company, 1968), 219–28; Jennifer Gordon, *Cast in the Shadow: Models for Public Sculpture in America* (Williamstown, Mass.: Sterling and Francine Clark Art Institute, 1985), 13–18.

GEORGE BELLOWS (1882 – 1925)
George Bellows and ROCKWELL KENT had much in common—their age, training under Robert Henri, approach to nature, and love of Monhegan Island, Maine. But Bellows ranged more widely for subject matter, painting "modern" subjects such as boxing matches, construction sites, tenement life, and the new urban spectacle of skyscrapers at night, as well as many portraits. He produced over 170 lithographs of a variety of subjects, often for publication in periodicals such as *The Masses*. Bellows's feeling for New England seacoast life was kindled by childhood summers spent in Sag Harbor, Long Island, and a grandfather's reminiscences of whaling off Montauk. Beginning in 1911, he spent five of the next six summers in Maine, claiming that it was "the most wonderful country ever modeled by the hand of the master architect." He eventually conflated his own family with the fishing folk of Monhegan, inserting himself and his wife and daughter in his two versions of *Fisherman's Family* (1914–15 and 1923). In his short life, Bellows found time not only to produce a considerable body of work, but also to experiment with several new compositional systems and color theories. Along with this interest in what was

new, he shared with other artists in this book an interest in the past, painting traditional subjects and often dressing his portrait subjects in old-fashioned clothes. (JKM)

References
Jane Myers and Linda Ayers, *George Bellows, The Artist and His Lithographs, 1916–1924* (Fort Worth, Tex.: Amon Carter Museum, 1988); Michael Quick, Jane Myers, Marianne Doezema, and Franklin Kelly, *The Paintings of George Bellows* (New York: Harry N. Abrams, 1992); Rebecca Zurier, Robert W. Snyder, and Virginia Mecklenburg, *Metropolitan Lives. The Ashcan Artists and Their New York* (Washington, D.C.: National Museum of American Art, 1995), 81–86.

GERRIT BENEKER (1882 – 1934)
Beneker is known for his paintings of industrial workers—for a time he had a studio in a Cleveland steel mill—and saw himself as a champion of the working man and America's industrial growth. Encouraged by his Dutch immigrant father, he studied at the Chicago Art Institute and the Art Student's League in New York. There he became fascinated with the construction he saw around him, painting men at work, as well as the building of the Brooklyn Bridge, which he could see from his studio. When he moved to the newly founded Provincetown art colony in 1913 to work with Charles Hawthorne, Beneker transferred his interest in urban laborers to those on the Cape. A Provincetown waterfront character served as his model for his famous Liberty Loan poster, produced when Beneker worked for the navy during World War I. Commissioned in the 1920s to paint portraits of the workers at the Hydraulic Pressed Steel Company in Cleveland and at the General Electric Company in Schenectady, he brought to his art a sense of dignity laborers were denied in assembly-line production, depicting in a heroic manner their performance of ordinary tasks. He was also interested in the craft of labor; as an employee of the same company, he saw himself as a craftsman working alongside other craftsmen. His Provincetown works were done in the same social realist style he practiced in Cleveland. He returned to paint in Provincetown when he could, and retired to Truro, but continued to lecture and exhibit. (JKM)

References
Beneker, New York Public Library Artists File, Microfiche B318 C5; *Gerrit A. Beneker (1882–1934). Painter of Modern Industry* (Boston:Vose Galleries of Boston, Inc., n.d.).

FRANK WESTON BENSON (1862 – 1951)
Benson was one of upper-class Boston's most admired painters. His early portraits and paintings of Beacon Hill drawing rooms quietly merge present and past for a group with deep reservations about modern life. Later, with more dash and brilliance, he set women and children against bright summer landscapes, yet still safely within traditional New England boundaries. The artist himself was no stranger to the region's history or the landscape of summer. Benson was born and schooled in Salem, Massachusetts, a community with a unique sense of history. He studied for three years at the School of the Museum of Fine Arts under OTTO GRUNDMANN, then traveled to Paris in 1883 and enrolled at the Académie Julian, along with fellow Bostonian EDMUND TARBELL. Returning to Boston, Benson painted portraits and small interior scenes, frequently exhibiting at prestigious local art organizations, such as the Boston Art Club and the St. Botolph Club. Growing ever more successful, the artist and his family began to summer on North Haven, Maine, eventually buying a house on the island in 1906. On North Haven, Benson turned away from portraiture, preferring to depict his wife and children enjoying the warm sun and coastal breezes. (MN & TAD)

References
Bedford, *Frank W. Benson*; *Frank W. Benson: A Retrospective* (New York: Berry Hill Galleries, 1989); Fairbrother, *The Bostonians*, 68, 69, 199.

CARROLL THAYER BERRY (1886 – 1978)
The prints and wood engravings of Maine harbors, lighthouses, coasts, and landmarks that won Berry popular success were the products of the second half of his life. His early career combined his interests in engineering and commercial design, and took him far from New England. Born in New Gloucester (near Portland, Maine), Berry earned a degree in naval architecture at the University of Michigan. He moved back to Boston to work as a mechanical draftsman, taking art classes at night. Later, while working on the construction of the Panama Canal, he contracted malaria. During his recuperation in the United States, he studied at The Pennsylvania Academy of Fine Arts, which led to a commission from the government to paint large murals commemorating the building of the canal. After several years working in New York and Chicago as a commercial artist and interior designer, and after front line service in World War I, he returned to Wiscasset, Maine, in 1934 with his second wife, Janet Scott, an illustrator. Berry had begun making woodblock prints in the 1930s. On America's entry into World War II, he became a draftsman at Camden Shipping Company, and moved to Rockport to be closer to his work. It was in a studio overlooking Rockport harbor that he began his most successful printmaking enterprise. Both local people and tourists admired his woodblocks and color wood engravings of local quarries, ports, and landscapes. He struck as many prints as would sell—in some cases over 375 for one image. His last works, one of which shows a Maine village floating

like a heavenly city above a jagged array of skyscrapers, reveal his fear of nuclear holocaust—an anxiety heightened, no doubt, by the construction of a nuclear powerplant in his idyllic Yankee town. (JKM)

References

Elwyn Dearborn, *Carroll Thayer Berry: Downeast Printmaker* (Camden, Maine: DownEast Books, ca. 1983); Elwyn Dearborn, "The Down-east Printmaker. Carroll Thayer Berry," *Journal of the Print World* (spring 1983): 14–15; Lewis D. Hammel, "The Romantic World of Carroll Thayer Berry," *DownEast Magazine* (May 1983): 32–37.

GEORGE HENRY BOUGHTON (1833 – 1905)

Boughton's historical scenes were drawn from a variety of sources—Dutch peasant life, eighteenth-century England, and Knickerbocker New York. His American credentials, however, rest on paintings of seventeenth-century Puritan subjects, especially those taken from the poems of Henry Wadsworth Longfellow, and on a youth (1834 to 1861) spent in Albany and New York City. Boughton was born on a farm in Norwich, England, and, after his American sojourn, went to France. He studied with pupils of Thomas Couture in the late 1850s, from whom he learned to paint small Barbizon-style pastoral scenes. In the early 1860s he moved to London, still working in a Barbizon manner, but varying his output with allegorical paintings of peasant life. He later abandoned these for larger history and figure paintings, the latter reminiscent of James McNeill Whistler, which he frequently exhibited on both sides of the Atlantic—at the National Academy of Design in New York and the Royal Academy of Art in London. Both American and British writers praised Boughton's ideal views of the past, and patrons in both countries responded with similar enthusiasm. (MN)

References

Alfred Lys Baldry, "George Henry Boughton: His Life and His Work," *The Art Annual* 29 (Christmas issue of *Art Journal*, 1904); Huntington and Pyne, *The Quest for Unity*, 49–53, 89–90; Richard J. Koke, *American Landscape and Genre Paintings in the New-York Historical Society*, vol. 1 (New York: The New-York Historical Society, in association with G. K. Hall, Boston, 1982), 74–79.

EDWIN HOWLAND BLASHFIELD (1848 – 1936)

Born in New York and groomed for a career in engineering, Blashfield studied at Boston Latin School, Harvard College, and Massachusetts Institute of Technology (MIT). While at MIT, his mother, an artist, sent some of his drawings to the French academic painter Jean Léon Gérôme, whose interest convinced Blashfield's father to allow his son to pursue a career in art. He studied in Paris with the French history and portrait painter Léon Bonnat from 1867 to 1870 and, interrupted by the Franco-Prussian war, from 1874 to 1880. During the interregnum, he traveled in Europe and returned to New York, where he painted genre pictures. He settled in New York in 1881, producing paintings and illustrations for *St. Nicholas Magazine* and for books, and decorating private homes. Not until 1892, at the request of Frank Millet, whom he had met during a stay in Broadway, England, did he begin the large mural painting at the World's Columbian Exposition for which he became well known. The patriotism evident in his public commissions for state capitols and court houses took the form of triumphal, classicizing allegories. He continued to paint large murals for public and private commissions, including the Library of Congress and the Appellate Division Courthouse in New York, until his beaux-arts style was no longer in favor. He closed his studio in 1933, when Public Works of Art Project muralists were using a less decorative style, harsher colors, and dissenting political themes. (JKM & MN)

References

Leonard N. Amico, *The Mural Decorations of Edwin Howland Blashfield (1848–1936)* (Williamstown, Mass.: Sterling and Francine Clark Art Institute, 1978), 1–10; Doreen Bolger Burke, *American Painting in the Metropolitan Museum of Art. Vol III: A Catalogue of Works by Artists Born between 1846 and 1864* (New York: Metropolitan Museum of Art, 1980), 67–70; Huntington and Pyne, *The Quest for Unity*, 87–88.

ALFRED THOMPSON BRICHER (1837 – 1908)

During a fifty-year career, Bricher made a comfortable living from his work but was rarely praised by critics. Born in Portsmouth, New Hampshire, he grew up in Newburyport, Massachusetts, and by 1851 was working in Boston. He became a professional painter in 1858, after meeting Charles Temple Dix and William Stanley Haseltine while sketching at Mount Desert, Maine. The following year he had his own studio in Newburyport. During the 1860s, Bricher made pictures for L. Prang and Company's print catalogue; like many New England artists of this period, he sought to bring his work before a wider public. In 1868 he married and moved his studio to New York, but over the next decades spent a great deal of time traveling, primarily sketching seascapes up and down the Atlantic coast. Most of his summer trips were to the New England states. On these trips he made landscape studies that were later transformed into oils and luminous watercolors. He was particularly impressed with Grand Manan Island off the Maine coast in the Bay of Fundy, whose rugged cliffs and surrounding sea he drew and painted for seventeen years. (JKM)

References

Brown, *Alfred Thompson Bricher*; Alexandra W. Rollins, ed., *Treasures of State: Fine and Decorative Arts in the Diplomatic Reception Rooms of the U.S. Department of State* (New York: Harry N. Abrams, 1991; Bricher entry by William Kloss), 456–57; Workman, *The Eden of America*, 55–58.

JENNIE BROWNSCOMBE (1850 – 1936)

Brownscombe's best-known painting, *The First Thanksgiving at Plymouth* (1914), a scene in which Pilgrims and Indians celebrate this historic feast together, can be understood as part of the pageantry movement of the early twentieth century. Many towns reclaimed a past by staging dramatic and patriotic renderings of local and national history. Brownscombe herself was a descendant of an early Boston settler and a member of both the Historic and Scenic Preservation Society and the Daughters of the American Revolution. A native of Honesdale, Pennsylvania, she was first a school teacher. Later she trained as an artist in New York City at the Cooper Union's School of Design for Women and at the National Academy of Design (NAD), and was a founding member of the Art Students League. By the early 1870s she was working both as a graphic artist for a number of magazines, including *Harper's Monthly*, and as a painter of genre scenes, which were exhibited at the NAD every year through the 1870s and 80s. In her later years she turned primarily to historical paintings of the Pilgrims, of Washington and the Revolution, and to other colonial costume pieces. Over one hundred of these were copyrighted and reproduced in graphic versions that are still available, and can be seen in schoolrooms, banks, and other public spaces. (JKM & RBS)

References

Ahrens, "Jennie Brownscombe": 25–29.

JOHN HENRY BUFFORD (1810 – 1870)

Bufford was the first employer and art teacher of WINSLOW HOMER, but was also a prolific lithographer and competitor of Nathaniel Currier. Homer's fame as an artist and Currier's successful publishing firm, which became Currier and Ives, overshadow Bufford's legacy as a commercial illustrator of books and sheet music. Nevertheless, he was a popular and successful artist in his day. He also made drawings of disasters, a precursor to the newspaper photograph. Born in Portsmouth, New Hampshire, Bufford apprenticed in Boston and, by 1835, moved to New York, where he opened a lithography business. By 1840, he had returned to Boston and formed a partnership with his brother-in-law in a new lithographic printing firm, for which he did most of the drawing. The business, with and without his brother-in-law as partner, thrived until the late 1860s, when photolithography became a widely available, less expensive alternative. As an engraver, Bufford was dedicated to replicating faithfully the work of other artists. His own work after 1840, however, took on a sketchy, shorthand quality. With tastes already beginning to shift toward a photographic naturalism, he gradually withdrew from the drafting side of his business and hired younger artists to carry on in his place. (JKM)

References

David Tatham, *John Henry Bufford: American Lithographer* (Worcester, Mass.: American Antiquarian Society). Reprinted from *Proceedings of the American Antiquarian Society* 86, pt. I (April 1976).

DENNIS MILLER BUNKER (1861 – 1890)

Though he was born in New York, Bunker's portraits and landscapes appealed in particular to a Boston public that was steeped in the past. His portraits, somber in palette and traditional in composition, respected the reserved taste of the community. His landscapes, painted mainly in Brittany, Nantucket, and Medfield, Massachusetts, were more experimental; their bold colors and brushwork provide a high-key version of a beautiful old New England. These contrasting styles mirror the contradictions in Bunker's own life. Although trained in the academic tradition at the Académie Julian and the École des Beaux Arts in Paris, he witnessed the change that occurred in French painting during the 1880s. Through contact with artists such as ABBOTT THAYER and, eventually, JOHN SINGER SARGENT, Bunker became familiar with the latest impressionist techniques. He returned to America in 1885, settling in Boston. During this period, the old "city upon a hill" was rapidly expanding its colonial shoreline to include filled land in the Back Bay. Laid out on parallel boulevards in the manner of modern Paris, this new and fashionable section of the city culminated in the cultural center of Copley Square. Bunker lived in this area, and participated in social activities at the Tavern Club and St. Botolph Club, and became a friend of some of Boston's most prominent, yet avant-garde, families, notably Mr. and Mrs. Jack Gardner. (MN)

References

Fairbrother, *The Bostonians*, 48–50, 202–3; Erica Hirshler, *Dennis Miller Bunker: American Impressionist* (Boston: Museum of Fine Arts, 1994); Hirshler, *Dennis Miller Bunker and His Circle*.

JULIA MARGARET CAMERON (1815 – 1879)

The photographic portraits that Julia Margaret Cameron did of Henry Wadsworth Longfellow and James T. Fields at her home at Freshwater, on the Isle of Wight, illuminate the close ties between the American poet and Fields, his Boston publisher, and the British cultural community of which they were a part. Fields was also the American publisher of Alfred Lord Tennyson, Cameron's close friend and neighbor at Freshwater. It was Longfellow's visit to Tennyson in the summer of 1868 that prompted Cameron's image. Cameron was born in Calcutta, educated in France, and married to a distinguished jurist, who retired to England in 1848. Her photographic career only began in 1864, but she quickly attained prominence as a portraitist of distinguished literary, artistic, and scientific men and women who inhabited her social world. She is known, as well, as an allegorist and idealizer of women, depicted in tableaux vivants and dramatic renderings of works such as Tennyson's "Idylls of the King." (MN & RBS)

References
Helmut Gernsheim, *Julia Margaret Cameron: Her Life and Photographic Work* (Millerton, N.Y.: Aperture, 1975); Joanne Lukitsh, *Cameron: Her Work and Career* (Rochester, N.Y.: International Museum of Photography at George Eastman House, 1986); Mike Weaver, *Julia Margaret Cameron, 1815–1879* (London: Herbert Press, 1984).

JAMES WELLS CHAMPNEY (1843 – 1903)

Service in the Civil War interrupted Champney's early career with the Boston engraving firm of Bricker and Russell. When the artist contracted malaria, however, he was discharged from the service and found work as a drawing instructor at the Young Ladies Seminary of Dr. Dio Lewis in Lexington, Massachusetts. There, Champney met and married Elizabeth Williams, the daughter of Free-State abolitionists and temperance advocates who emigrated westward from Deerfield, Massachusetts before the war. Inheriting the family homestead, she and her artist-husband moved to Deerfield in 1876 when Champney was appointed professor of art at Smith College. The Champneys settled into the historic Williams homestead and made a number of important and telling changes. They added a studio wing to the old framed house (now called "Elmsted") and embellished the structure by grafting on window trim, a gambrel-roofed ell, and the doorway from Alexander Hamilton's house in New York City. Champney, like so many of his generation, "updated" his house by looking to the past and including architectural fragments from historic houses. Champney's views of old New England, executed in this colonial retreat, struck a resonant chord in post-war America, and led to exhibitions of his work at the 1876 Centennial Exposition in Philadelphia and the 1893 World's Columbian Exposition in Chicago. Champney was also a prolific illustrator. His work can be found in popular journals such as *Scribner's Monthly*. (TAD)

References
Monkhouse et al., *James Wells Champney*.

CHASE BRASS AND COPPER COMPANY (1876 – 1945)

Located in Waterbury, the heart of Connecticut's "Brass Valley," the Chase Brass and Copper Company was founded in 1876 to produce a wide variety of prosaic goods such as pins, buttons, and umbrella hardware. The company had evolved into a major producer of building supplies by the turn of the century and supplied copper pipe for the home and thin-wall tubing for industrial use. When the stock market crashed in 1929, however, Chase was left with a large surplus of raw materials. To reduce stock on hand, company vice president Rodney Chase quickly turned to the housewares market, engaging a series of well-known industrial designers from New York City to make use of warehoused copper tubing. The designers, Russell Wright, ROCKWELL KENT, Walter Von Nessen, and Ruth Gerth adopted the streamlined aesthetic of the era to create useful and attractive objects, such as coffee sets, cocktail shakers, and candlesticks. A strong historical influence, however, can be identified in Chase "specialties" catalogs, showing modern designs juxtaposed with "Puritan" candle-snuffers and "Salem" candlesticks. Chase housewares were, in part, indebted to designs of the past, while being intended for the home of the future. (TAD)

References
Karen Davis [Lucic], *At Home in Manhattan: Modern Decorative Arts, 1925 to the Depression* (New Haven: Yale University Art Gallery, 1983), 67, 77, 105, 114; Denenberg, "Chase Chrome"; "Machinal Moulds Metal," *Interior Architecture and Decoration* 37 (December 1931): 274–75.

FRANCIS COLBURN (1909 – 1984)

Born and raised in Vermont, Colburn specialized in painting scenes of his native state. After graduating from the University of Vermont, he studied at the Art Students League in New York and then with STEFAN HIRSCH at Bennington College. For many years he was the only artist on the faculty of his alma mater. He took an active interest in developing the art department and in encouraging the university's Fleming Museum to build a collection of works by local artists. Although his modernist style reshaped the familiar New England landscape, Colburn's work also evokes its past; he called some of his works "nostalgia" or "memory" pieces. As he stated, "I can-

not help but be nostalgic about things; the very nature of the scenery is nostalgic to me." But unlike many painters who depicted only a vanished past, Colburn also focused on Vermont industry, its quarries and sawmills. In his later years he adopted a straightforward style of painting, but his early works most often demonstrate the wit for which Colburn was known—skewing the Vermont of postcards and tourist propaganda in order to make a personal statement. It was an approach appreciated by his neighbors, who were the main collectors of his work. (JKM)

References
Francis Colburn, Exhibition of Paintings (New York: Knoedler Galleries, Nov. 23–Dec. 12, 1942). Essay by Genevieve Taggard, "I see Vermont/ Old, wild and new"; Ildiko Heffernan, ed., *Francis Colburn: This I Remember* (Burlington, Vt.: Robert Hull Fleming Museum, University of Vermont, 1984); University of Vermont press release, 1942.

EMMA COLEMAN (1853 – 1942)
Emma Coleman was one of a group of late-nineteenth-century New England women, frequently with colonial family heritages, who used sharp and meticulously focused photographs to capture rural and often historical views of old New England. These images were exhibited at art clubs in Boston, Paris, and elsewhere, and used to illustrate accounts of preservation projects in books and magazines. Coleman's aesthetic models were the painters of Barbizon landscapes, the French region that she visited during her travels in the 1870s. Her friend, the painter Susan Minot Lane, had worked with William Morris Hunt, who in turn had been trained directly by the Barbizon leader Jean François Millet. Coleman's life partner was the historian and preservationist C. Alice Baker, whom she posed carrying out rural chores in staged reenactments of colonial life. Both image and text were instrumental in conserving local history at Deerfield, Massachusetts, and in the Piscataqua region. Among Coleman's collaborative projects was a series of photographs for a limited edition of Sarah Orne Jewett's *Deephaven*. (JKM & RBS)

References
Giffen and Murphy, eds., *"A Noble and Dignified Stream"*; Susan Mahnke, *Looking Back: Images of New England, 1860–1930* (Dublin, N.H.: Yankee, 1982); Ellie Reichlin, "Emma Lewis Coleman: Photographer in the Barbizon Mood, 1880–1940" (Society for the Preservation of New England Antiquities, 1982, typescript).

HOWARD COOK (1901 – 1980)
Cook, a native of Springfield, Massachusetts, learned printmaking from Joseph Pennell at the Art Students League in the early 1920s. He subsequently traveled widely, including a trip to Maine in the summer of 1926. The magazine *Forum* printed his woodcuts from the New England stay and then sent Cook to New Mexico to provide illustrative "atmosphere" for its publication of Willa Cather's *Death Comes for the Archbishop*. From then on, he was fascinated by the Southwest. Cook continued to travel, learning lithography in Paris and exhibiting his work in New York. From the late 1920s to the early 1930s, he and his wife lived primarily in New York, where ongoing construction in the city was a major subject of his art. In 1939, the couple settled in New Mexico and Cook took up mural painting. His later work in oils, pastels, watercolors, and graphics won him critical acclaim. His career was curtailed after he contracted multiple sclerosis, but he continued to receive honors and prizes and to take part in exhibitions. (JKM)

References
Betty and Douglas Duffy, *The Graphic Work of Howard Cook, A Catalogue Raisonné* (Bethesda, Md.: Bethesda Art Gallery, 1984), 15–27; *Modernist Themes in New Mexico: Works by Early Modernist Painters* (Santa Fe, N.M.: Gerald Peters Gallery, 1989), 20–23.

ALLAN ROHAN CRITE (born 1910)
Brought up in Boston, Crite received his art training at the School of the Museum of Fine Arts and earned a Bachelor of Arts degree at the Harvard University Extension School in 1968. He worked for most of his life as an illustrator in the Planning Department of the Boston Naval Shipyards, retiring in 1976, but continued to paint at the same time. His work has been widely exhibited and well received in Boston, where a square is named after him. Crite's early paintings depict the daily life of Boston's African-American community, a community that was to be transformed in the following decade by urban renewal and housing projects. According to the artist, he sought to show viewers the "real Negro" as opposed to the "Harlem" or "jazz Negro," that was created by white people. In his later paintings, magic-realist visions in which a black Virgin and Child ride on public transportation or float above the city streets, Crite used a bright palette rather than the more somber tones of his "neighborhood paintings." Compared with these earlier paintings, the religious works offer a message of hope and deliverance. During the 1950s Crite lectured on liturgical art and wrote and illustrated books with theological themes telling "the story of man through the black figure" (Athenaeum brochure). Crite's most recent exhibition was at the Boston Athenaeum in 1997. (JKM)

References

Allan Crite's Boston. Paintings, Watercolors, and Drawings in the Collection of the Boston Athenaeum (Boston Athenaeum, 1997); Artist's typescript "Commentary on early 1950s," illustrated. National Museum of American Art vertical files, 1970s; Artist's typescript of his diary of the 1930s and observations about the black artist in 1930s Boston, illustrated. National Museum of American Art vertical files, 1975.

LOUISE DAHL-WOLFE (1895 – 1989)

Born in San Francisco and trained there in painting, interior design, and photography, Dahl-Wolfe did not decide on a career in photography until the late 1920s. She experimented with a succession of styles, from a California version of pictorialism to the documentary lens she trained on Tennessee mountain people. But not until moving to New York in 1933 did she find her role as a fashion photographer. For over twenty years (1936–58), she worked for *Harper's Bazaar*, which, along with *Vanity Fair*, was the trend-setting fashion magazine of that era. She preferred to photograph models out of their "gilded cage," that is, out of the studio, in settings that were chic and cosmopolitan, though more offbeat than usual. When she turned to portrait subjects—artists, writers, and society women—she did the same. Her female subjects, therefore, usually have the status of competent, worldly women, whether seated in a Paris salon or skiing in Vermont. New England, of course, was not her usual beat; she brought unaccustomed glamour to its rural image. But that may have been what the area needed to catch on as a center for recreational skiing. By the 1940s, Dahl-Wolfe was at the top of her profession, as influential in her own way as many of the people she photographed. She maintained her high standing until 1960, when she concluded that art had given way to commerce in fashion photography, and she chose to retire. (WHT)

References

Louise Dahl-Wolfe, *A Photographer's Scrapbook* (New York: St. Martin's/Marek, 1984); Sally Eauclaire, *Louise Dahl-Wolfe: A Retrospective Exhibition* (Washington, D.C.: The National Museum of Women in the Arts, 1987); Nancy Hall-Duncan, *The History of Fashion Photography* (New York: Alpine Book Company, 1979), 225.

CYRUS E. DALLIN (1861 – 1944)

Born in Springville, Utah, surrounded by the vast praries of the West, Dallin's beginnings seem far removed from the Anglo settlement of New England. His abiding respect for the past, however, would bring the artist to represent with dignity and respect both the native tribes and the early colonists of the United States. Dallin's art training began in Boston in 1880, in the studio of sculptor Truman Bartlett, during which time he also worked in a terra cotta factory. After two years he opened his own studio, modeling portraits and an equestrian statue of Paul Revere. In 1888, with some success behind him, he went to Paris, where he studied with Henri Chapu at the Académie Julian. He also spent time at Buffalo Bill's Wild West Show, which came to Paris in 1889, sketching costumes and accessories of Native American participants. Many of these would serve as studies for a series of four equestrian statues of Native Americans. Dallin began the series before he returned to Boston in the early 1890s, and completed the final one, *Appeal to the Great Spirit*, in 1908. Late in life, Dallin executed ideal images of colonial life — commemorative plaques and figures in Pilgrim dress. (MN)

References

Kent Ahrens, *Cyrus E. Dallin: His Small Bronzes and Plasters* (Corning, N.Y.: Rockwell Museum, 1995); Wayne Craven, *Sculpture in America* (New York: Thomas Y. Crowell, 1986), 527–31; Rell G. Francis, *Cyrus E. Dallin: Let Justice Be Done* (Springville, Utah: Springville Museum of Art, 1976).

STUART DAVIS (1892 – 1964)

Stuart Davis's anti-establishment view of life was informed by that of his parents, who both trained at The Pennsylvania Academy of the Fine Arts. His family and their bohemian circle of friends were instrumental in forming his progressive social views. An intense interest in "Americanness"— understood in terms of his Philadelphia background as well as a commercial and working-class present—formed a part of these views. Perhaps surprising to us, in an article in *The Soil* (an early avant-garde magazine) Davis listed an appreciation of colonial architecture as a proper subject for "young, robust . . . daring" American art, a viewpoint Davis recalled enthusiastically at the end of his life. Davis first went to Gloucester in 1915 with other artists working for the radical magazine *The Masses*, and in subsequent years he spent most summers there. He referred to himself as an "addict of the New England coast," but his modernist eye made him look at typical New England subjects with a combination of humor and irony. Masts of old fishing schooners, for example, are seen among fish processing plants, gas pumps, and commercial signs. Despite critics' applause, steady exhibitions, and early patronage from Gertrude Vanderbilt Whitney, Davis had trouble selling his work and only began to make a comfortable living in the 1950s. Nevertheless, his continually evolving approach to both urban and rural subjects, and his active pursuit of artists' rights, kept him at the forefront of the modernist movement. (JKM)

References
Patricia Hills, *Stuart Davis* (New York: Harry N. Abrams, 1996); Philip Rylands, ed., *Stuart Davis* (Milan: Electra, and the Solomon R. Guggenheim Foundation, 1997); Lowery Stokes Sims et al., *Stuart Davis, American Painter* (New York: Metropolitan Museum of Art, 1991).

JOSEPH RODEFER DECAMP (1858 – 1923)

DeCamp's paintings speak volumes about New England society at the turn of the century. Like other painters of the Boston school, De Camp's male figures are strong and self-assured; his females, delicate, introspective, and frequently involved in genteel pastimes, such as reading, crocheting, or playing musical instruments. His landscapes, bright coastal scenes and autumnal woods, provide a regional backdrop for the performance of these traditional gender roles in what was a rapidly changing world. Born and raised in Cincinnati, Ohio, DeCamp was quickly accepted in Boston society despite his midwestern roots. He settled in his adopted city in 1884, after studying in Munich with Frank Duveneck, and held teaching positions at Wellesley College and the Museum School of the Museum of Fine Arts. By 1890 DeCamp had become a major figure in Boston artistic circles, with praise accorded to both his portraits and landscape paintings. His work was included in the 1893 World's Columbian Exposition in Chicago, and he frequently exhibited in Boston at the St. Botolph Club and nationally with the Society of American Artists, and, later, with "The Ten." DeCamp's paintings, particularly those of young women in elegant and understated interiors, define old New England as enduring, exquisite, feminine, and genteel. (MN & TAD)

References
Laurene Buckley, "Joseph DeCamp," in William H. Gerdts et al., *Ten American Painters* (New York: Spanierman Gallery, 1990), 147–49; Buckley, *Joseph De Camp*; Fairbrother, *The Bostonians*, 205–6.

ADOLPH DEHN (1895 – 1968)

Dehn's satirical prints of European and New York scenes were the product of an unconventional Minnesota upbringing and an iconoclastic eye. The son of a feminist, socialist mother and an atheist, anarchist father, he was not destined for a quiet life. He studied at the Minneapolis Art Institute and the Art Students League in New York, after which he was imprisoned as a conscientious objector during World War I. On his release Dehn took odd jobs and made his way to Europe, where his work as a magazine illustrator supported him and his Russian immigrant wife in their travels. While in Europe Dehn was a critical observer of the social scene, especially in Vienna and Berlin, and a light-hearted painter of park scenes and landscapes. In 1930, after his return from Europe, his work, on both European and New York subjects, was shown at the Weyhe Gallery in New York City. The critical response was good, but sales were only moderate. In the mid-1930s, Dehn began to paint watercolor landscapes, which proved immensely popular. As a result, new commercial opportunities opened, including travels through the United States, Mexico, and Venezuela. His fame led to offers to teach and then to work for the Navy during World War II. Throughout the forties, fifties, and sixties, Dehn and his wife traveled around the world, doing commercial work and lithography. His work became less satirical and more fanciful, and he experimented with new graphic techniques. He died of a heart attack in 1968 while planning new trips, beginning a book, and organizing a retrospective. (JKM)

References
Richard W. Cox, "Adolf Dehn: The Life," in Jocelyn Pang Lumsdine and Thomas O'Sullivan, *The Prints of Adolf Dehn: A Catalogue Raisonné* (St. Paul, Minn.: Minnesota Historical Society Press, 1987), 1–25; *Nature and Human Nature: The Art of Adolph Dehn* (Baton Rouge, La.: Louisiana Arts and Science Center, 1995), 7–11; *Watercolors and Drawings of Adolf Dehn (1895–1968)* (New York: Hirschl and Adler Galleries, Inc., 1986), intro.

JACK DELANO (1914–1997)

A talented painter and musician as well as photographer, Delano started his career with Roy Stryker at the Farm Security Administration (FSA), and stayed on when, in 1941, the unit was taken over by the Office of War Information. His photographs of New England were done mainly for the latter, so the message they convey is not necessarily one of Depression-era America. More often they celebrate the land and portray a nation unified behind the war effort. Shots of New England range from tourist highlights to milltowns, in which factories produce for a wartime economy. Delano was born in Kiev, came to America when he was nine, and, though his parents had little to spare, managed to receive a degree from The Pennsylvania Academy of the Fine Arts. His first major portfolio, photographs of Polish miners taken in the coal fields west of Philadelphia, caught the attention of PAUL STRAND, who recommended Delano to Stryker. Delano was hired in 1940. Not long after he was sent to the Virgin Islands and Puerto Rico to record the conditions of rural workers. After the war, he and his wife settled in Puerto Rico. Over the next four decades, they played a major role in the island's cultural life, encouraging artists, musicians, and craftpersons to investigate their local heritage. (WHT)

References

Jack Delano, *Puerto Rico Mio: Four Decades of Change* (Washington, D.C.: Smithsonian Institution Press, 1990); Stewart Doty, *Arcadian Hard Times: The Farm Security Administration in Maine's St. John Valley, 1940–43* (Orono: University of Maine Press, 1991); *Nueva Luz* 3, no.4 (1992; issue devoted to Delano's photographs of Puerto Rico).

CHARLES DEMUTH (1883 – 1935)

Demuth was born to a prosperous, well-established Lancaster, Pennsylvania, family, but lameness from a hip disease contracted in childhood and his early ambivalence about his homosexuality combined to form an outsider self-image. As a child, Demuth took art lessons and later attended the Drexel Institute of Technology. Even though some members of his family were amateur artists, the Demuths were convinced that their son would fare better professionally as a commercial artist. Demuth's teachers at Drexel, however, encouraged him to transfer to The Pennsylvania Academy of the Fine Arts. Trips to Europe during and after his five years at the academy (in 1907 and 1912–14) exposed Demuth to the vanguard art that was to influence his own style. When he returned to America, he divided his time among New York, Lancaster, and New England seaside resorts, where he spent his summers. In New York he exhibited first with Charles Daniel and later with Alfred Stieglitz, while pursuing a bohemian lifestyle. It was during his New England summers, particularly in Provincetown under the influence of MARSDEN HARTLEY, that he developed the precisionist style for which he is known. After a serious illness in 1921, diagnosed as diabetes, Demuth never again enjoyed good health. From then on, he painted primarily in watercolor and tempera. His last works were Provincetown beach scenes. (JKM)

References

Fahlman, *Pennsylvania Modern*; Barbara Haskell, *Charles Demuth* (New York: Whitney Museum of American Art, 1987); Jonathan Weinberg, *Speaking for Vice: Homosexuality in the Art of Charles Demuth, Marsden Hartley, and the First American Avant-Garde* (New Haven: Yale University Press, 1993).

THOMAS WILMER DEWING (1851 – 1938)

The timeless nature of Dewing's landscapes stands in sharp contrast to the ever-increasing pace of modern life in New England. Verdant, mysterious, and peopled with attractive, classically dressed women, Dewing's paintings provided fixed points of truth and beauty for a turn-of-the-century generation fearing the great changes in American culture wrought by immigration, industrialization, and urbanization. Dewing's father worked in a paper mill, suffered financial ruin, and died an alcoholic, yet he descended from one of the first families of seventeenth-century New England. Despite modest circumstances, Dewing studied at the Lowell Institute in his native Boston and traveled to Paris, where he enrolled at the Académie Julian in 1876. Returning to Boston, he taught at the newly opened Museum School at the Museum of Fine Arts before moving, like so many writers and artists of his generation, to New York City. Living in New York, Dewing sought refuge from the vicissitudes of his new environment by returning annually, from 1885 to 1905, to the artists's colony at Cornish, New Hampshire. In Cornish, he perfected the misty, dream-like aesthetic that he used to depict a beautiful past. (TAD)

References

William H. Gerdts et al., *Ten American Painters* (New York: Spanierman Gallery, 1990), 99–101; Hobbs, *The Art of Thomas Wilmer Dewing*; Pyne, *Art and the Higher Life*, 145–48, 148–51, 152–57, 203–4.

ARTHUR WESLEY DOW (1857 – 1922)

Often remembered only as Georgia O'Keeffe's teacher, Dow was an important artist and educator who helped bring a modern image of New England to the national stage. He was born in Ipswich, Massachusetts, and enjoyed an impressive New England ancestry, but like many of his contemporaries, including CHILDE HASSAM and WILLARD METCALF, his immediate family lived in reduced circumstances. After teaching elementary school for several years and saving his salary, Dow traveled to Paris to study in life classes at the Académie Julian and to Brittany for seven months of plein-air landscape painting. After returning to Boston, he fell under the spell of the Far East and became a leading advocate of Japanese design principles and color theory. Dow contributed articles on Far Eastern art and aesthetics to journals such as *Camera Notes*, *The Delineator*, and *International Studio,* and authored the highly influential art manual *Composition* (1899). He also began an impressive teaching career, launching the Ipswich Summer School of Art (1891), and going on to the Pratt Institute (1895–1904), and to the Art Students League (1897–1903). His career culminated in 1904 with the directorship of the Fine Arts Department at the Columbia University Teachers College. (TAD)

References

Nancy E. Green, *Arthur Wesley Dow and His Influence* (Ithaca, N.Y.: Herbert F. Johnson Museum of Art, Cornell University, 1990); Meyer, ed., *Inspiring Reform*, 27–28, 145–46, 155–56, 212; Frederick C. Moffatt, *Arthur Wesley Dow (1857–1922)* (Washington, D.C.: Smithsonian Institution Press for the National Collection of Fine Arts, 1977).

JOHN WHETTEN EHNINGER (1827 – 1889)

Ehninger came from an old Knickerbocker family. After graduating from Columbia College in 1847, he went to Paris and Düsseldorf, studying with Thomas Couture and Emanuel Leutze. Ehninger began his career as both an illustrator and painter, and by the late 1850s had developed a photographic process to make book illustrations from his drawings and those of other artists. A set of his drawings, photographed by Matthew Brady, were used to illustrate Longfellow's "Courtship of Miles Standish." Another set appeared in an American edition of Tennyson's "Idylls of the King." Ehninger's genre paintings, done mostly in New York City, were post-Civil War renditions of charming country folk in idealized New England and Southern plantation settings. Later on, apparently discontented with urban life, Ehninger moved to Saratoga Springs, New York. In the late nineteenth century, and well into the twentieth, Ehninger's paintings—paeans to disappearing agricultural folkways—were thought to be faithful depictions of the places and people represented. In 1940, *Yankee* magazine used some of these works to illustrate childhood reminiscences of a contemporary woman. (JKM)

References
Lois Marie Fink, National Museum of American Art Curatorial Files, 1980; *M. & M. Karolik Collection of American Watercolors and Drawings* (Boston: Museum of Fine Arts, 1962), 150; "'October' and 'Old Kentucky Home.' John Whetten Ehninger, 1827–1889. N.A. 1860," *The Old Print Shop Portfolio* 4 (October 1943): 30–31; Henry T. Tuckerman, *Book of the Artists, American Artist Life* (New York: James F. Carr, 1967), 461–64.

CHANSONETTA STANLEY EMMONS (1858 – 1937)

Emmons grew up in Kingfield, Maine (population 800 in 1900), which was founded by one of her ancestors. Her interest in photography began when she took drawing lessons from her brother F. E., the photographer who invented the photographic dry plate. She taught art in Boston for a time, but after her husband's early death in 1898 she turned more to photography. In 1900 she studied painting with William Preston Phelps, who was also a photographer, and gradually she began to consider photography her life's work. She and her daughter, Dorothy, lived in Newton, outside Boston, and summered in Kingfield, where she found her photographic subjects, primarily young children, elderly people, and farm life. Emmons knew firsthand of Maine farms that had been deserted in pursuit of a better life in the West; she knew the economic hardship caused when rural ports were closed in favor of those closer to urban railheads. The lambent quality of light and frequent appearance of older people in her photos indicates her awareness of the passing of an era. Her attachment to the old ways is revealed in images showing workers engaged in such activities as rug weaving, which was already being done in mills. The town's own industry, the manufacture of wooden buckets, rakes, and handles for farm implements, never appears in Emmons's photos. Although she was deaf from the 1920s on, to augment her income she began giving lantern slide shows to women's groups and other civic organizations extolling "the beauties and glories of rural New England," with her daughter narrating and answering questions—ever the champion of a mid-nineteenth-century view of New England (Péladeau,14). (JKM)

References
Meyer, ed., *Inspiring Reform*, 213; Péladeau, *Chansonetta*, 7–15; Naomi Rosenblum, *A History of Woman Photographers* (New York: Abbeville, 1994), 301–2.

DANIEL CHESTER FRENCH (1850 – 1931)

French was born in Exeter, New Hampshire, and raised in Cambridge and Concord, Massachusetts, the twin literary capitals of old New England. Home to such major writers as Henry Wadsworth Longfellow, Ralph Waldo Emerson, and the Alcott family, the romantic tales spun in (and about) these historic communities held sway over French and the nation for the rest of the nineteenth century. French's later portrayals of strong, dignified, historical figures seem an ideal complement to such communities. The setting and characters of literary Concord had a very direct influence on the young sculptor. Abigail May Alcott was his first art teacher and French came to prominence with his statue of the *Minute Man*, a work commissioned by the town in 1873. Although President Grant, James Russell Lowell, Emerson, and Longfellow attended the dedication, the sculptor himself was absent, having left in 1874 to pursue his studies in Italy. French worked overseas in the studio of THOMAS BALL for two years and returned to America where, until his death in 1931, he executed allegorical and historical figures for public spaces and portrait statues for private consumption. His work graces public buildings, parks, and gardens from Boston to Nebraska. (MN)

References
Wayne Craven, *Sculpture in America* (New York: Thomas Y. Crowell Company, 1968), 392–406; Richman, *Daniel Chester French: An American Sculptor.*

JOHN ORNE JOHNSON FROST (1852 – 1929)

Frost was the son of a Marblehead, Massachusetts, shoemaker and the youngest of eleven children. At the age of sixteen he began one of several fishing expeditions to the Grand Banks. His primary career, however, was on land as a restaurant manager for his father-in-law, and later as a restaurant owner. It was only at the age of seventy, after the destruction of his restaurant and much of the town by fire, a severe illness, and the suicide of his wife, that he decided to take up painting. The impetus for Frost's art appears to have been the same that motivated him to write letters to the local newspaper about his life and to keep a scrapbook: to preserve the town's history. His works depict the early history of Marblehead, Revolutionary and Civil War events, and his own memories. He also made sculptures of fish, fishing paraphernalia, ships, and Marblehead buildings. Only two exhibitions of Frost's work were presented during his lifetime—one in his backyard museum (a collection of artifacts and Indian relics he thought would enhance the historical significance of the paintings) and another in a Marblehead hardware store. He also tried to sell his views of the town at a photography shop. Although none of these efforts were successful, he kept on working. Frost was described as a true Yankee: "gritty, adamantine and unyielding in his purpose to hew to the line he knew to be right" (Katz, 34). A preservationist before the movement began, he was less interesting to his neighbors than to tourists, who thought him a character and were fascinated by his stories. (JKM)

References
American Painting and Folk Art by J.O.J. Frost of Marblehead and George E. Lothrop of Roxbury from the Collection of Betty and Albert L. Carpenter (New York: Parke-Bernet Galleries, 1971); Katz, "J.O.J. Frost."

IGNAZ GAUGENGIGL (1855 – 1932)

Born in Bavaria, Gaugengigl settled in Boston in 1879, where he worked as a portrait and genre painter. His artistic pedigree, which included study at Munich's Royal Academy as well as in England and Paris, made him popular with Boston's elite. *The Boston Sunday Herald* remarked that his small, old-world costume pieces were "at home amid elegant surroundings, and . . . exert an influence of refined mirth" (Downes, 17). He exhibited at the old-guard St. Botolph Club (headed by Francis Parkman and John Lowell), and taught at the Boston Art Club (in addition to giving private lessons to students such as CHILDE HASSAM.) Gaugengigl's most productive years were the last decades of the nineteenth century and the first of the twentieth. During that period he painted numerous old-fashioned interiors and portraits of prominent Bostonians. Like similar pictures by FRANK BENSON, EDMUND TARBELL, and JOHN SINGER SARGENT, they show elegant, beautifully dressed men and women in well-appointed drawing rooms; the note of luxury and social privilege is unmistakable. (JKM)

References
American Impressionism / Recent Acquisitions: Spring 1997 (New York: Adelson Galleries, Inc., 1977), fig. 5; William Howe Downes, ed., *Gaugengigl: His Life and Works* (Boston: John A. Lowell & Co., 1883); Fairbrother, *The Bostonians*, 208.

GEORGE CHRISTIAN GEBELEIN (1878 – 1945)

"I am interested in the [John Coney] brazier," wrote one of Gebelein's forward-thinking customers about a piece of silver modeled after the work of a seventeenth-century silversmith, "[c]an I use sterno with it?" An innocent, but telling, question, for the Bavarian-born "successor to Paul Revere" made a career out of straddling the centuries, reproducing early American silver for his contemporary patrons. Although Gebelein was trained by the major firms of Goodnow & Jenks and Tiffany & Company at the close of the nineteenth century, he eventually adopted the ideology of the Arts and Crafts movement, eschewed mass-production, and joined the Handicraft Shop in Boston in 1903. The Handicraft Shop, run by the Society of Arts and Crafts in Boston, served as a conduit for silver and leather goods produced by its members. Gebelein soon outgrew this cooperative venture, however, and in 1907 he established his own shop "at the foot of Beacon Hill" in partnership with David Mason Little, an amateur silversmith and descendant of an old Boston family. Gebelein's position as a much-loved member of Boston's twentieth-century artisan community stands in sharp contrast to that of another German immigrant, IGNAZ GAUGENGIGL, who declared allegiance to the Kaiser during World War I and became persona non grata among arbiters of old New England taste. (TAD)

References
Alexandra Deutsch, "George Christian Gebelein: The Craft and Business of A 'Modern Paul Revere'" (master's thesis, University of Delaware-Winterthur Program in Early American Culture, 1995); Wendy Kaplan, *The Art That is Life: The Arts and Crafts Movement in America, 1875–1920* (Boston: Museum of Fine Arts, 1987), 178–81, 270; Margaretha Gebelein Leighton, *George Christian Gebelein, Boston Silversmith, 1878–1945* (Lunenburg, Vt.: The Stinehour Press, 1976).

ABBOTT FULLER GRAVES (1859 – 1936)

A descendant on his mother's side of the first physician of Plymouth Colony, Graves grew up in Plymouth, Massachusetts. His familiarity with New England architecture and knowledge of horticulture, acquired while working for a florist, were put to good use in his numerous paintings of

doorways and gardens of colonial houses. Although he was briefly enrolled at the Massachusetts Institute of Technology, his formal artistic training did not begin until 1884, when he went to Paris and studied with Georges Jeannin, a painter of floral still lifes. In Paris he shared a room with EDMUND TARBELL, who was to become a lifelong friend. By the 1880s he had opened a studio in Boston where his first student was Montie Aldrich, whom he would soon marry. In 1885 he was asked to teach still-life and flower painting at the Cowles Art School in Boston. He returned to Europe with his wife in 1887 and studied for three years at the Académie Julian in Paris, exhibiting at the Salon each year and decorating a Parisian hotel. After Paris, Graves settled in Kennebunkport, Maine, building a house there in 1906. Kennebunkport's gardens and cottages provided fertile references for popular paintings of an old-fashioned, rural New England. While his friends painted "wild, modern atrocities," as he termed contemporary art, he continued to execute charming New England scenes, although by the 1920s he was living primarily in New York. He continued, however, to exhibit in Kennebunkport and Boston. (JKM)

References
Joyce Butler, *Abbott Fuller Graves. 1859–1936* (Kennebunk, Maine: The Brick Store Museum, 1979); Peters and Lukehart, eds., *Visions of Home*, 110; Fairbrother, *The Bostonians*, 209.

EMIL OTTO GRUNDMANN (1844 – 1890)
Grundmann is best known as a teacher of Boston School painters. The first director of the School of the Museum of Fine Arts, Boston, he taught drawing and painting there from 1876 until his death fourteen years later. Born in Meissen, Germany, he trained at the Dresden Academy and in Antwerp and Düsseldorf. Grundmann's successful career as a portrait and genre painter brought him to the attention of Frank Millet, who met him when he was a student at the Antwerp Academy. Millet recruited Grundmann for the Museum School. During his first summer in America, Grundmann visited the White Mountains of New Hampshire as a guest of his friends and patrons the Reverend and Mrs. Robert Cassie Waterston, who owned a summer "cottage" in Whitefield. His paintings seek to integrate the old-world style he taught at the Museum School with the values of rural life celebrated by his New England patrons and fellow tourists. (JKM)

References
"The Art Museum School's Great Loss," *The Art Amateur* 23, no. 5 (October 1890): 83; Fairbrother, *The Bostonians*, 209; Research files, Brown and Corbin Fine Art, Lincoln, Mass., 1997.

O. LOUIS GUGLIELMI (1906 – 1956)
Guglielmi's early childhood was spent in Milan and Geneva. When he was eight his parents (his father was a musician) brought him to the United States. They settled in Harlem. Guglielmi began to attend night classes at the National Academy of Design in 1920, while still attending high school. By 1923 he was a full-time student at the Academy, where he remained until 1926. He met GREGORIO PRESTOPINO in a life drawing class and the two first shared an unheated studio, and later moved to better accommodations. The years after he left school were financially difficult, but the depression proved to be an ideological watershed for him; he found its economic devastation a great stimulus to art. Guglielmi went to New England in 1932, the first of eleven summers he spent at the MacDowell Colony in Peterborough, New Hampshire. Because of his new commitment to social causes, he viewed this year as the beginning of his life as an artist. During summers in New Hampshire, he found both the solitude and social interaction that "helps to form and give direction to our rising native culture" (Baker, 5), a characterization that echoed the MacDowells's stated purpose when establishing their colony in the first decade of the century. They hoped to unite New England's inspirational beauty with an understanding of the region as the foundation of American culture. (JKM)

References
Baker, *O. Louis Guglielmi*; *Community of Creativity/ A Century of MacDowell Colony Artists* (Manchester, N.H.: Currier Gallery of Art, 1996); *O. Louis Guglielmi: The Complete Precisionist* (New York: Nordness Gallery, 1961).

MARSDEN HARTLEY (1877 – 1943)
Born in Lewiston, Maine, Hartley embarked on a lifelong search for family after his own dissolved in his youth with the early death of his mother and his father's remarriage. When Hartley was twelve years old, his father and stepmother left the boy with his older sister for four years. He was an introspective and isolated child, and these traits, in addition to his homosexuality, were a source of tension all his life. Hartley's attachment to the landscape of Maine was an important element of his painting career. Simultaneously attracted and depressed by the scenery, he returned every summer during the years he studied in New York (first with William Merritt Chase and then at the less expensive National Academy of Design) and lived there with his father and stepmother during his twenties and thirties. Hartley's early pictures, aggressively brushed impressionist landscapes painted in North Lovell, reveal his efforts to find his own style. His first critical success came with an exhibition at Alfred Stieglitz's 291 Gallery in New York in 1909. Subsequent years were spent painting in Europe, New York, New Mexico, New Hampshire, Mexico, Bermuda, and Nova Scotia. At the end of his career, Hartley returned to Maine, whose wild landscape he considered unique and whose people, he believed, "practiced

values of directness and trust." His later Maine paintings were to some degree a means of resolving his artistic and personal struggles. He invested the landscape, particularly Mount Katahdin and the shore, with a spiritual significance informed by his belief in the transcendentalism of Whitman and Emerson. He experienced a degree of success in the early 1940s, when several museums acquired his work. (JKM)

References
Donna Cassidy, "'On the Subject of Nativeness': Marsden Hartley and New England Regionalism," *Winterthur Portfolio* 29 (winter 1994): 227–45; Robertson, *Marsden Hartley*; Jonathan Weinberg, *Speaking for Vice: Homosexuality in the Art of Charles Demuth, Marsden Hartley, and the First American Avant-Garde* (New Haven: Yale University Press, 1993).

CHILDE HASSAM (1859 – 1935)
Frederick Childe Hassam, the scion of an old New England family (his surname is a corruption of Horsham), grew up in the upper-middle-class suburb of Dorchester, Massachusetts. His father, a Boston merchant and hardware store owner, collected Americana well before this hobby became a popular pastime. He passed this interest in history along to his son. It is telling that the future artist first dabbled with a brush while sitting in the old coach that carried the Marquis de Lafayette through New England on his triumphal tour in 1824–25! Hassam, like many of his fellow artists, traveled to Europe for instruction in the 1880s and eventually settled in New York. Exposed to the full measure of urban hustle and bustle, Hassam returned to the past as often as he could and during the last forty years of his life traveled from one historic summer resort to the next, painting picturesque villages and towns throughout New England. The past is therefore a living presence in Hassam's art. While his village scenes may appear quaint, they are also active statements about the importance of traditional New England values and institutions in an era of great change. (TAD)

References
David Park Curry, *Childe Hassam: An Island Garden Revisited* (New York: W. W. Norton in association with the Denver Art Museum, 1990); Hiesinger, *Childe Hassam*; Weinberg, Burke, and Curry, *American Impressionism and Realism*, 5, 21, 71, 350.

CHARLES HAWTHORNE (1872 – 1930)
Hawthorne had lifelong ties to the New England coast and its commerce. He was born in Richmond, center of the Maine shipbuilding and ice industries, and his father was captain of a trading ship. During the summer of 1896 Hawthorne studied with William Merritt Chase at his Shinnecock school, while living in a fisherman's storage shack. It was his attachment to the sea, according to his son, that led Hawthorne to choose Provincetown three years later as the location for his own school, the Cape Cod School of Art. He painted in Holland for a year and studied art in Italy for two years beginning in 1906, thereafter establishing a pattern, with few exceptions, of wintering in New York and spending summers in Provincetown. Much of Hawthorne's career was directed to teaching—at the National Academy of Design, the Art Students League, the Art Institute of Chicago, and other schools. Widely credited with establishing Provincetown as an artists's colony, he taught there for thirty years, using as models the local landscape and people. His paintings focused not on the struggle and hardships of seafaring life but on more peaceful, domestic aspects of that life. Despite the critics's view of his paintings as sentimental, his work was popular with collectors. By the time of his death, Hawthorne's success had enabled him to own homes and studios in Provincetown and New York, as well as a house in Bermuda. (JKM)

References
Hawthorne Retrospective (Provincetown, Mass.: Chrysler Art Museum of Provincetown, 1961), 5–16; Elizabeth McCausland, *Charles W. Hawthorne, an American Figure Painter* (New York: American Artists Group, Inc., 1947); *The Paintings of Charles Hawthorne* (Storrs, Conn.: The University of Connecticut Museum of Art, 1968).

ALDRO HIBBARD (1886 – 1972)
Hibbard grew up in Falmouth, Massachusetts, and was trained at the Massachusetts Normal Art School, under JOSEPH DECAMP, and at the Boston Museum School, under EDMUND TARBELL. He traveled through Europe in 1913 and 1914. Several exhibitions in Boston after his return established his reputation, and he began annual sojourns to the mountains and the shore. Vermont and Rockport, Massachusetts, as Hibbard's principal painting locations, constituted a "complete" New England, at least for those who purchased his work from 1915 through 1965. As one might expect, spending winters in Jamaica, Vermont, he specialized in snow scenes, featuring activities such as logging and maple sugar gathering. He discovered Rockport in 1919, not long after he had begun painting in Vermont. He established a summer school there, which quickly grew into a Rockport institution. For the next thirty years he taught artists and amateurs alike to see the Massachusetts coast as a familiar, old-fashioned place—as quintessentially New England as snow-covered Vermont. (WHT)

References

John L. Cooley, *A.T. Hibbard: Artist in Two Worlds* (Concord, N.H.: Rumford Press, 1968); Fairbrother, *The Bostonians*, 131, 213; William H. Gerdts, *Art across America: Two Centuries of Regional Painting, 1710–1920* (New York: Abbeville Press, 1994), 3:46–47, 71.

THOMAS HILL (1829 – 1908)

Thomas Hill and his brother Edward crisscrossed the continent, building artistic careers on the new tourism made possible by railroad access to the grand scenery of the White Mountains of New Hampshire and the Yosemite Valley in California. Both were born in England, came to the United States in 1844, and began careers as carriage and furniture painters. Thomas married in Boston and moved with his wife and first child to Philadelphia in 1853 to attend The Pennsylvania Academy of the Fine Arts. He began painting White Mountain landscapes the next year, but continued decorating furniture until he moved to California in 1861 to improve his health. Edward joined him briefly in San Francisco, but returned to Boston a year later to start his own painting career. Thomas studied in Paris with Barbizon painters for two years, but spent the next five years in New England, and then moved permanently to California in 1871. Interest in western scenery increased after the Civil War, especially among easterners. Pictures of the Yosemite Valley, and lithographs made after them by LOUIS PRANG & COMPANY secured Thomas's fame and fostered a market in Boston for his large White Mountain landscapes as well. Back in San Francisco, Thomas sought patrons enriched by the recently completed transcontinental railroad. Although he lived in the West for the rest of his life and kept a studio in the Yosemite Valley, he returned to the East five times to paint in the White Mountains. (JKM)

References

Marjorie Dakin Arkelian, *Thomas Hill: The Grand View* (Oakland: The Oakland Museum of Art, 1980); Donald D. Keyes, "Perceptions of the White Mountains: A General Survey," in *The White Mountains, Place and Perceptions*; McGrath and MacAdam, "*A Sweet Foretaste of Heaven.*"

STEFAN HIRSCH (1899 – 1964)

The child of Americans living in Nuremberg, Germany, Hirsch was educated at the University of Zurich. When he came to New York in 1919, he met the painter Hamilton Easter Field, with whom he studied, as did YASUO KUNIYOSHI and ROBERT LAURENT, during summers in Ogunquit, Maine. Hirsch subsequently became a founder and exhibitor at the avant-garde Salons of America (an alternative to the Society of Independent Artists) and an instructor in the art departments at Bennington College in Vermont and Bard College in upstate New York. Although Hirsch was represented in the collections of many museums, including The Metropolitan Museum of Art, the Museum of Modern Art, the Whitney Museum of American Art, and the Corcoran Gallery of Art, reviewers during the 1930s and 1940s found his work difficult to characterize. By the time of his death they called it "thoroughly modern, without being extreme" (*New York Times*, September 30, 1964). Although the subject of his paintings varied widely— Mexican landscapes, barnyard scenes, ruins, portraits, and the circus—Hirsch often painted scenes that represent the transition from rural to industrial life. (JKM)

References

Abraham A. Davidson, *Early American Modernist Painting, 1910–1935* (New York: Harper & Row, 1981), intro., 220; *Index of Twentieth-Century Artists* 2, no. 7(April 1935; New York: College Art Association, 1935), 104; *Modernism at the Salons of America 1922–1936* (New York: Richard York Gallery, 1995).

WINSLOW HOMER (1836 – 1910)

No single artist represented as many different old New Englands as did Winslow Homer. An illustrator, watercolorist, marine and landscape painter, Homer's vision of his native region enjoyed great currency in his lifetime and influenced countless others, both before and after his death. His path to greatness, like so many other painters of the period, led directly out of a work-a-day middle-class background. Homer's father owned a hardware store in Boston and his mother was an accomplished watercolorist. The younger Homer took a job with JOHN HENRY BUFFORD and, like JAMES WELLS CHAMPNEY, the future artist seemed destined for a career as an illustrator. In 1859, however, Homer moved to New York City and began taking classes at the National Academy of Design. He came to popular attention during the Civil War as a sketch artist for *Harper's Weekly* and his oil paintings of wartime scenes secured his place as a major American talent. He was elected to the National Academy in 1866. Homer traveled to Paris that year and upon his return focused his art on nostalgic scenes of rural life, including one-room school houses, children at play, country stores, and an old wooden mill. In 1881 and 1882, he lived in Cullercoats, an English fishing village on the North Sea coast. Homer relocated to Prout's Neck, Maine, and, for the remainder of his life, dedicated himself primarily to painting the rugged people and landscape of the Atlantic coastline. (TAD)

References

Burns, *Inventing the Modern Artist*, 187–220; Cikovsky and Kelly, *Winslow Homer*; Robertson, *Reckoning with Winslow Homer*.

EDWARD HOPPER (1882 – 1967)

Hopper was born in Nyack, New York, to a businessman and a housewife who encouraged his early drawing talent. In deference to his parents's wishes, Hopper began to study for a career as a commercial artist at the New York School of Illustrating, but soon followed his own inclination toward fine art, transferring to the New York School of Art. He studied there with Robert Henri. Jo Nivison, whom Hopper would later marry, was also enrolled at the school. Early in his career Hopper was described as a "Puritan" by his friend the painter Guy Pène du Bois. He equated the term with Hopper's purist style but also with personal moral rigor and Americanness, a description Hopper enthusiastically accepted (Levin, *Hopper*, 239). In a review of his first retrospective in 1933, Hopper's work was said to fulfill the "requirements of what was meant by racial quality in American art. Puritan austerity and nothing in excess . . . above all independence of thought and spirit" (Levin, *Hopper*, 253). Undoubtedly his New England subjects contributed to this view. At Jo's suggestion he began painting watercolors, as well as oils, of Gloucester streets, Maine and Massachusetts lighthouses, and Cape Cod landscapes. Although the couple lived in New York City, they traveled around New England every summer, finally building a house and studio in Truro on Cape Cod. (JKM)

References
Levin, *Edward Hopper*; Gail Levin, *Edward Hopper: The Art and the Artist* (New York: W.W. Norton, in association with the Whitney Museum of American Art, 1980); Carl Little, *Edward Hopper's New England* (New York: Chameleon Books, Inc., 1993).

ALFRED CORNELIUS HOWLAND (1838 – 1909)

Alfred Howland was descended from seven generations of New Englanders, the first of whom came as an indentured servant on the *Mayflower*. Howland's grandfather settled in Walpole, New Hampshire, where Howland grew up in a Greek Revival house that his builder-father had constructed. The son began his training as a lithographer in Boston in 1857, went to Düsseldorf in 1859 to study at the Royal Academy as well as privately, and then to Paris to work with Emile Lambinet and the Barbizon painters. He returned to live in Boston, spending ten summers in Williamstown, Massachusetts. Best known for his genre paintings, Howland also executed landscapes and portraits, or a combination of all three, as in *The Old Yale Fence* (1889–90), which contains portraits of numerous Yale sportsmen lounging against a fence with the campus in the background. He derived his style from Camille Corot, Theodore Rousseau, and Jean François Millet, all of whom were his friends, adapting some of their approaches to painting light and nature to his New England subjects. Howland's paintings invariably focused on the rustic New England countryside and its inhabitants, depicting farmers, Fourth of July paraders in their old-fashioned clothing, and rearranging locally identifiable buildings to suit his boyhood memories. (JKM)

References
William Nathaniel Banks, "Alfred Cornelius Howland: The Education of an Artist," *The Magazine Antiques* 110 (July 1976): 160–75; Charles de Kay, "Alfred C. Howland, N.A.," *American Art Galleries* (February 16–17, 1910); Howland Family Papers, Yale University Library.

GEORGE INNESS (1825 – 1894)

Inness was born in New York City and grew up on a farm in Newark, New Jersey. His minimal art training consisted of time spent with an itinerant artist, John Jesse Barker (who had studied with Thomas Sully), and a year's apprenticeship to a map engraver. In 1844 he began exhibiting in New York, and later spent a month working with the landscape painter Regis Gignoux. During most of his life, he kept a studio in New York. Although he claimed that his concentration was limited by his "fearful nervous disease"—epilepsy—by 1860 he was considered "a man of unquestionable genius" (Cikovsky and Quick, 20). At the outbreak of the Civil War, lacking the good health to enlist, he offered bounties to those who did and painted uplifting allegorical landscapes. During the same years, Swedenborgianism would significantly influence his art and life. So would residence in New England. In 1860 he moved to Medfield, Massachusetts, where he spent four years painting pastoral scenes in the fresh air in an effort to restore his health. He returned during the summer of 1875, living at the Kearsarge House at the base of the White Mountains. He painted several landscapes of the mountain, but concentrated on atmospheric effects rather than the grandeur of the scenery, which most previous artists had emphasized. During two subsequent summers on Nantucket (1879 and 1883) Inness's style softened further, approaching the tonalist harmonies that prevailed in his late work. (JKM)

References
Nicolai Cikovsky, Jr., and Michael Quick, *George Inness* (Los Angeles: Los Angeles County Museum of Art, 1985); *George Inness: Presence of the Unseen* (Montclair, N.J.: Montclair Art Museum, 1994); Leo G. Mazow, "George Inness: Problems in Antimodernism" (Ph.D. diss., University of North Carolina at Chapel Hill, 1996).

EASTMAN JOHNSON (1824 – 1906)

Born in Lovell, Maine, Johnson moved to Washington, D.C., in 1845, when his father accepted a major clerkship in the Navy Department. Eastman established his portrait career by drawing members of the Maine legislature and U.S. Senators. More formal training commenced at the Royal Academy in Düsseldorf and with history painter Emanuel Leutze. This was followed by four years in The Hague, the offer of an appointment as court painter to William III of Holland, and a few months with Thomas Couture in Paris in 1855. Johnson subsequently became a successful portrait and genre painter in New York, as distinguished as many of his patrons. In addition to painting New York subjects, Johnson established a studio on Nantucket, shortly after his marriage in 1870, where he lived and worked during summers over the course of thirty years. His paintings of island cranberry harvests and maple sugar gathering in Maine transformed these familiar scenes into fine and popular art, creating a national awareness of extant but vanishing rural life in these New England places. The popularity of Johnson's scenes of rural labor in New England marks them as part of the widespread impulse to assign values identified with New England—independence, resourcefulness, devotion to hard work—to the entire nation. (JKM)

References

Hills, *Eastman Johnson*; Simpson, Mills, and Hills, *Eastman Johnson*; Lesley Carol Wright, "Men Making Meaning in Nineteenth-Century American Genre Painting, 1860–1900" (Ph.D. diss., Stanford University, 1993).

ROCKWELL KENT (1882 – 1971)

Painter, author, navigator, and aggressive social reformer, Kent was born in Tarrytown, New York, into an upper-middle-class family whose values he soon found stifling. He studied architecture at Columbia University but abandoned that career after a summer working with William Merritt Chase, who encouraged him to apply for a scholarship to the New York School of Art. Kent's teachers included Robert Henri, Kenneth Hayes Miller, and ABBOTT HANDERSON THAYER. Through Henri, Kent saw the grittiness of urban life, causing him to reevaluate the genteel circumstances in which he had been raised. It was Thayer who introduced Kent to Monhegan Island off the coast of Maine, where he was to live from 1905 to 1910. Captivated by its scenery, he worked there as a carpenter and lobsterman to earn enough to allow him time to paint, living the life of his subjects, the "toilers of the sea." Kent admired the values of those who lived in the wilder parts of New England, believing their way of life exemplified his ideas of Christian socialism in which poverty and hard work were high goals. He found even New Hampshire too bucolic, compared to life on Monhegan. He moved on to ever wilder surroundings—Greenland, Newfoundland, and Alaska—searching, he said, not for "picturesque material," but for "happiness and peace of mind." He found both, for a time, in northern New England. (JKM)

References

Glenn C. Peck, *Rockwell Kent, George Bellows, Leon Kroll* (New York: Allison Gallery, 1991); David Traxel, *An American Saga, The Life and Times of Rockwell Kent* (New York: Harper & Row, 1980); Richard V. West, Fridolf Johnson, and Dan Burne Jones, *"An Enkindled Eye": The Paintings of Rockwell Kent* (Santa Barbara, Calif.: Santa Barbara Museum of Art, 1985), 9–25.

BENJAMIN WEST KILBURN (1827 – 1909)

The Kilburn brothers were seventh-generation New Englanders. Benjamin was an outdoorsman, fond of hunting and mountain climbing, and his choice of career—promoting the New England scenery through which he had tramped all his life—seems fitting. He and his younger brother Edward worked with their father in the family foundry and machine shop in Littleton, New Hampshire, until the early 1860s, when both took up photography. In 1865 the brothers established a stereophotographic publishing company in their hometown, with Benjamin taking the pictures and Edward meticulously developing them. Edward left the firm in 1875. Its successor, B. W. Kilburn & Co., produced an average of three thousand stereographs per day, which were sold for $2.00 to $2.50 a dozen. In its forty-five year history, the company produced over 2,000 views of northern New Hampshire, pioneered the concept of door-to-door sales of pictures, and by 1890 was employing photographers to take views all over the world. Kilburn's popular pictures structured nature as a work of art, informing tourists how and from what vantage point they should look at particular sites in order to derive the greatest benefit. (JKM)

References

Donald D. Keyes, "Perceptions of the White Mountains: A General Survey," in *The White Mountains: Place and Perceptions*, 41–59; William F. Robinson, *A Certain Slant of Light: The First Hundred Years of New England Photography* (Boston: New York Graphic Society, 1980), 73–76; Southall, "White Mountain Stereographs," 97–108.

YASUO KUNIYOSHI (1889 – 1953)

Kuniyoshi emigrated from Japan to America in 1906. Poor and unable to speak English, he sought adventure and employment, planning to return home once he had achieved prosperity. But after a visit to Japan in 1931, he realized he had become thoroughly at home in America and remained here for the rest of his life, developing a great affinity for New England.

Kuniyoshi's ten-year apprenticeship as an artist included three years at the Los Angeles School of Art and Design, which he attended at night after picking fruit during the day, brief stays at the National Academy of Design, the Henri School, and the Independent School, where he met and befriended STUART DAVIS, and four years at the Art Students League. His first patron, Hamilton Easter Field, gave Kuniyoshi and his first wife, artist Katherine Schmidt, a stipend on which to live in New York as well as a studio in Ogunquit, Maine, where they spent ten summers. The American primitive art and artifacts Kuniyoshi saw there for the first time and soon began to collect had a strong influence on his art. Maine scenery was also a primary force in his artistic development. "That severe landscape and simple New England buildings were my God," he wrote. "Whenever I did anything, I used to make up that type of scenery somewhere in the picture" (Lubowsky, 23). In later life, Kuniyoshi taught at the Art Students League, fought for artists's rights, and was a leader in American art organizations. (JKM)

References
Lloyd Goodrich, "Yasuo Kuniyoshi 1889–1953," in *Yasuo Kuniyoshi* (New York: Whitney Museum of American Art at Philip Morris, 1986); Susan Lubowsky, "From Naiveté to Maturity: 1906–1939," in *Yasuo Kuniyoshi* (Tokyo, Japan: Tokyo Art Museum, 1989), 22–29; Jane Myers and Tom Wolf, *The Shores of a Dream: Yasuo Kuniyoshi's Early Work in America* (Fort Worth, Tex.: Amon Carter Museum, 1996).

ROBERT LAURENT (1890 – 1961)
Laurent was born in Brittany, the grandson of a fisherman and a weaver. He and his parents were invited to come to America by Hamilton Easter Field, who had gone to their village to paint. He became their American host for three years, as well as Laurent's lifelong friend, second father, and teacher. After briefly returning to France with his family, Laurent accompanied Field to Rome in 1907, where he began his art training. He also studied drawing at the British Academy and carving as an apprentice to a framemaker. Returning with Field to America in 1910, Laurent began making frames for CHILDE HASSAM and Robert Henri, and subsequently graduated to carving reliefs. When Field died in 1922, he left his entire estate, including his property at Ogunquit, Maine, to Laurent and his wife and child. They spent summers there until Laurent retired to Cape Neddick, Maine. By the 1940s, Laurent had executed several large public sculptures and his work in wood, alabaster, and aluminum was widely exhibited. He taught sculpture at the Ogunquit School from 1911 to 1961, served as a visiting instructor at Vassar, Goucher College, and the Corcoran School of Art, and became a professor of art at Indiana University in 1942. (JKM)

References
Laurent: Fifty Years of Sculpture (Bloomington, Ind.: Department of Fine Arts, Indiana University, 1961); *The Robert Laurent Memorial Exhibition 1972–1973* (Durham, N.H.: University of New Hampshire, 1972); Roberta Tarbell, *Robert Laurent and American Figurative Sculpture 1910–1960* (Chicago: The David and Alfred Smart Museum of Art, 1994).

JACOB LAWRENCE (born 1917)
Lawrence was born in Atlantic City, New Jersey, after his parents had moved north from Virginia and South Carolina. Following another move to Easton, Pennsylvania, his parents separated and his mother moved with Lawrence and his brother and sister to Philadelphia. In 1927, unable to support them, she placed the children in foster homes until she was able to settle in Harlem with them three years later, when Lawrence was thirteen. His own rootless youth combined with his interest in African-American history made the movement of fugitive slaves and freed black people an ongoing theme of his art. Lawrence's art education began in New York when he designed masks in a school program in Harlem run by Charles Alston, with whom he continued to study while in high school and in WPA art workshops beginning in 1932. In Alston's studio during the 1930s, he met many of the luminaries of the Harlem Renaissance, as well as his future wife, the painter Gwendolyn Knight. According to Lawrence, the purpose of his social realist art was to narrate the history of African Americans and to lift them out of economic slavery (Wheat, 40). His use of the series format—devoted to subjects such as Frederick Douglas, Harriet Tubman, and "The Migration of the Negro"—represents his most direct effort to accomplish this goal.(JKM)

References
Elizabeth Hutton Turner, ed., *Jacob Lawrence: The Migration Series* (Washington, D.C.: The Phillips Collection, 1993); Ellen Harkins Wheat, *Jacob Lawrence, American Painter* (Seattle and London: University of Washington Press, 1986); Wheat, *Jacob Lawrence*.

EDMONIA LEWIS (1845 – 1911?)
Early connections with members of the abolitionist movement in Boston brought Lewis, a sculptor of African-American and Native American descent, the professional support needed to launch her career. She began her art education as a college preparatory student at Oberlin (the first college in the country to admit both women and African Americans) with the academic practice of copying from antique models. After a difficult three years she was forced to leave

without graduating because of the taunting and prejudice of her classmates. In 1863, with a letter of introduction from William Lloyd Garrison, she moved to Boston where she worked with the sculptor Edward A. Brackett, learning to make portrait busts and small, clay portrait reliefs. With the support of the leading abolitionists of the day, such as Lydia Maria Child and Ann Whitney, and proceeds earned from the sale of plaster copies of her portrait bust of Colonel Robert Gould Shaw, Lewis sailed to Rome. She made occasional trips back to Boston and to San Francisco, Philadelphia, and Chicago to sell and exhibit her work, some of which was based on the poetry of Longfellow. (JKM & MN)

References
Romare Bearden and Harry Henderson, *A History of African-American Artists from 1792 to the Present* (New York: Pantheon Books, 1993), 54–77; Kirsten Buick, "The Ideal Works of Edmonia Lewis: Invoking and Inverting Autobiography," *American Art* 9, no. 2 (summer 1995): 5–19; Burgard, "Edmonia Lewis and Henry Wadsworth Longfellow."

WILLIAM HENRY LIPPINCOTT (1849 – 1920)
Lippincott was born in Philadelphia and trained at The Pennsylvania Academy of the Fine Arts, but began professional life as a commercial artist. He was an illustrator and scene designer, a specialty he pursued even after becoming an acclaimed painter. In 1874 Lippincott went to Paris. He stayed eight years, while he studied with Léon Bonnat, spent one or more summers in Brittany, and exhibited at the annual Paris salons. In 1882 he returned to New York, established a studio, and began painting portraits, genre scenes, and landscapes. He also taught at the National Academy of Design. Several of his paintings are set at his summer home and studio on Nantucket. Like his stage designs, these interiors, furnished in a colonial revival style, construct an ideal domestic world. In both his interior and exterior genre scenes Lippincott shows women in genteel pursuits, such as drawing and playing the piano. He was also fond of painting children in rustic surroundings, perhaps transferring his recollections of Brittany to the equally old-fashioned atmosphere of Nantucket. (JKM)

References
Caitlin McQuade, "The Depiction of Social Space in 'Childish Thoughts': A Material Cultural Analysis of a Painting" (master's thesis, University of Delaware, 1991); New York Public Library Artists Files; Sellin, *Americans in Brittany and Normandy*, 147.

ANGELO LUALDI (life dates unknown)
Little is known about Lualdi beyond the fact that he carved furniture and religious statuary in Cambridge, Massachusetts, in the early twentieth century. From 1916 to 1920, the Boston City Directory lists his studio in Tremont Street and his factory across the river in Cambridge. In 1915 A. Piatt Andrew, a local philanthropist and congressman, commissioned him to carve a statue for the restored Our Lady of Good Voyage Portuguese Church in Gloucester. Lualdi later established a gallery on Newbury Street in Boston, where he sold Italian antiques, such as heavy walnut furniture dating from the sixteenth and seventeenth centuries, and ecclesiastical objects in iron, marble, and wood, which he imported from Florence. A brochure for his antiques business, which appears to date from the 1920s, stresses the authenticity of his merchandise and his familiarity with traditional craft techniques. As a sculptor and antiques dealer, Lualdi successfully marketed his old world heritage to a tradition-minded Boston. (JKM)

References
Biographical Files, Library and Archives, Society for the Preservation of New England Antiquities, Boston, Mass.; Renaissance Galleries advertising brochure, n.d. [?1920s].

LUIGI LUCIONI (1900 – 1988)
Lucioni's biography has overtones of the classic immigrant's tale. His parents came to this country from Molnate, a small Italian town near the Swiss border, in 1911. They settled in Union City, New Jersey, where his father took up his trade as a cooper, and Luigi, after several years of school, and while working in an engraving house, continued the art lessons he had begun in Italy. He studied, in succession, at Cooper Union, at the National Academy of Design, and at the Tiffany Foundation in Oyster Bay, Long Island. At the last, JOHN SLOAN, Kenneth Hayes Miller, Gifford Beal, and CHILDE HASSAM taught classes. Success soon followed, with a show at Ferargil Galleries, the receipt of several medals, and the sale of a still life to the Metropolitan Museum. The sale, in turn, led Lucioni to Vermont and a commission from Mrs. J. Watson Webb, co-founder of the Shelburne Museum. Rural Vermont reminded him of northern Italy, but by then the two had perhaps become conflated in Lucioni's mind in a more meaningful way. The hills of Vermont struck a home chord because they also signified certain "American" values that were important to him. The act of painting rural Vermont, therefore, became a way of reinforcing those values, and, not incidentally, of marking his achievement in this country. In 1939, Lucioni bought a farmhouse and barn near Manchester Depot. The latter he turned into a studio, where he continued to paint and make etchings of the surrounding countryside for the next fifty years. (WHT)

References
Stuart P. Embury, *The Etchings of Luigi Lucioni: A Catalogue Raisonné* (Jacob North, 1984); Saunders, Westbrook, and Graff, *Celebrating Vermont*, 190–91; The Shelburne Museum, *The Shelburne Museum Proudly Presents the Painting Life of Luigi Lucioni* (Shelburne, Vermont, 1968).

JOHN MARIN (1870 – 1953)

Marin's career as an artist got off to a slow start: he was almost thirty when he undertook formal art training. He had been a draftsman, however, since his early days while living in New Jersey with the grandparents, aunts, and uncles who raised him after his mother's death. In 1899, after spending six unsuccessful years pursuing a career in architecture, Marin studied for two years at The Pennsylvania Academy of the Fine Arts and a year at the Art Students League, then went to Paris in 1905 for five years. There Edward Steichen saw some of Marin's watercolors, which he showed to Alfred Stieglitz. Stieglitz's exhibition of Marin's work in New York was the beginning of his lifelong role as Marin's dealer and patron, and of Marin's long and acclaimed art career. Marin considered himself schooled more by nature than by any instructor (Fine, 27) and generally sketched out-of-doors. From 1914 until his death, he worked part of almost every year in Maine, often finishing the work in New York, or, later, in his winter studio in New Jersey. He bought a house at Cape Split, Maine, in 1934, and a lobster boat in which to reach surrounding islands. There and in the Berkshires and White Mountains, he produced energetic, abstract oils, watercolors, and etchings of the New England scenery he loved. (JKM)

References
Ruth E. Fine, *John Marin* (New York: Abbeville Press, 1990); Sheldon Reich, *John Marin, A Stylistic Analysis and Catalogue Raisonné* (Tucson, Ariz.: University of Arizona Press, 1970); Robert Louis Sanstrom, "John Marin's Paintings of the Maine Seacoast" (Ph.D. diss., New York University, 1969).

WILLARD LEROY METCALF (1858 – 1925)

Unlike CHILDE HASSAM, whose closely framed studies of picturesque old houses resemble craggy ancestral portraits, Metcalf stood back from his subject and carefully selected architectural and geographic features that projected a pastoral view of old New England. His trademark subjects—church steeples, farms, and small towns nestled in panoramic autumnal landscapes—literally and figuratively "fixed" upper-class anxieties about change and disorder in an era of rapid immigration, industrialization, and urbanization. Ironically, Metcalf was born in Lowell, Massachusetts, the milltown that became synonymous with modern New England. He apprenticed with the painter George Loring Brown from 1875 to 1876, but soon became interested in spiritualism, rebelled against Brown's classical tastes, and moved on to the newly formed Museum School of the Museum of Fine Arts, Boston (1877–78). Metcalf's principle instructors at the MFA were the painter OTTO GRUNDMANN and anatomist William Rimmer. Metcalf worked in a toned-down palate, when compared with French impressionists, and created visually and thematically accessible images for his well-to-do patrons. He exhibited frequently, as one of "The Ten" and solo in major New York galleries. Popularity did not provide personal stability, however. Metcalf went through his career as a peripatetic, wandering from one New England watering hole to the next. Thrice divorced and often impecunious, Metcalf painted landscapes that depict a harmony absent from his personal life. (TAD)

References
William Gerdts, *American Impressionism* (New York: Abbeville Press, 1984), 176–78, 194–99, 303–4; Pyne, *Art and the Higher Life*, 269–71, 273–74, 287–90; Elizabeth de Veer and Richard J. Boyle, *Sunlight and Shadow: The Life and Art of Willard Metcalf* (New York: Abbeville Press, 1987).

ANNA MARIE ROBERTSON MOSES (1860 – 1961)

Grandma Moses appeared, the critic John Canaday wrote in 1967, at a time when the art public assumed that "primitive" art was something that came "spontaneously from the heart, from an instinctively directed talent . . . that could be trusted as genuine." Indeed, the kind of honest, unadorned life Grandma Moses lived would seem to be a prelude to artistic candor. Born in a small town in New York in 1860, she was just old enough when President Lincoln died to remember the black bunting wrapped around the pillars of the local store. At the age of twelve, she left home to serve as a housekeeper for more prosperous local families. Marriage, childbearing, and dawn-to-dusk farm work followed, until her husband died in 1927. Then she began to paint—untouched, as it were, by art lessons, by the staggering changes the nation had undergone during her adult life, by anything other than a need to be productive in her old age. "If I hadn't started painting," she once said, "I would have raised chickens." And yet, we can now observe, Grandma Moses' work falls neatly into a 1930s genre of celebrating rural life. The innocent, homespun world she portrays may have alluded to life around Eagle Bridge, New York, the small town on the New York–Vermont border that was her final home, but today we are more likely to see her work as an earnest exercise in wish fulfillment. Such pictures of wholesome rural life, ordered and colored with engaging naiveté, are often a complex guide to the less than perfect world that lies outside the frame. (WHT)

References

Kallir, *Grandma Moses*; Kallir, *Art and Life of Grandma Moses*; National Gallery of Art, *Grandma Moses: Anna Mary Robertson Moses (1860–1961)* (Washington, D.C., 1979).

HENRY MOSLER (1841 – 1920)

Gustave Mosler brought his family, including young Henry, to the United States in 1849. The Moslers, like many of their fellow German Jews, escaped the political unrest in their homeland that followed the revolutions of 1848 by settling in Midwestern communities, in this case Cincinnati, Ohio. There, the Moslers became leaders in their community and eventually developed a national reputation based on the family business—the manufacture of safes. Henry Mosler studied in Cincinnati with portrait and genre painter James Beard for two years and covered the Western theater of the Civil War as an artist-correspondent for *Harper's Monthly*. He studied for three years in Düsseldorf and Paris before returning home to begin his career. In 1874, Mosler again traveled to Paris, but remained for twenty years this time and developed a reputation for his paintings of Breton peasant life. Mosler's final homecoming to his adopted country came in 1894. In that year he set up a studio in New York City and turned his attention to historical genre with the same eye for detail that marked his earlier work. Paintings such as *Pilgrims Grace* (the painting that won the artist life membership to the National Arts Club of New York) and *Quilting Bee* draw upon Mosler's Breton experiences to create a realistic vision of the preindustrial past for modern America. (MN & TAD)

References

Barbara Gilbert, *Henry Mosler Rediscovered: A Nineteenth-Century American-Jewish Artist* (Los Angeles: Skirball Cultural Center and Museum, 1995); Barbara Gilbert, "Henry Mosler Rediscovered: A Nineteenth-Century American Jewish Artist," *American Art Review* 8, no. 3 (June–August 1996): 96–100; Natalie Spassky, *American Painting in the Metropolitan Museum of Art of Art. Vol II: A Catalogue of Works by Artists Born between 1816–1845*, ed. Kathleen Lurs (New York: Metropolitan Museum of Art, 1980), 563–65.

CARL MYDANS (born 1907)

In 1936, at the age of 29, Carl Mydans' Farm Security Administration (FSA) career was already over. He went to work in November of that year for *Life* magazine, the first issue of which had not yet reached the newsstands, and was almost immediately sent to Hollywood, where he must have felt a long way from the down-and-out areas of the country he had been photographing during the previous year. As a *Life* photographer, Mydans went on to cover World War II in both Europe and Asia. He is best known for his photograph of General Douglas MacArthur wading ashore at Luzon in 1945, but equally impressive are shots Mydans made in a Japanese prison camp in Manila in 1944, where earlier in the war, he too had been interned. He was also present at the ceremonies on board the USS Missouri in September 1945, when the Japanese surrendered to the United States. Mydans' photography career seems to have developed from his patriotic beliefs (he is first-generation American) and an interest in journalism, which he studied at Boston University. After graduation (1930), he moved to New York, attended photography classes at the Brooklyn Academy of Arts and Sciences, and joined the FSA in 1935. He was one of the first photographers Roy Stryker hired for his new unit. Mydans was mainly active in the Southwest, but on occasional forays into New England he portrayed either stock Yankee scenes, such as horse trading, or abandoned farm houses and depleted land. (WHT)

References

Robert E. Hood, *12 at War: Great Photographers under Fire* (New York: Putnam, 1967), 80–93; Carl Mydans, *More Than Meets the Eye* (New York: Harper & Brothers, 1959); Carl Mydans and Philip B. Kunhardt, Jr., *Carl Mydans, Photojournalist* (New York: Harry N. Abrams, 1985).

WALLACE NUTTING (1861 – 1941)

The name "Wallace Nutting" appeared as a trademark throughout middle-class American homes before World War II. The man behind the name, a former Congregational minister turned entrepreneur developed his hobby—photography—into a colonial-revival business venture that sold hand-tinted photographs, reproduction furniture, and illustrated books on the picturesque villages and customs of New England. Nutting's images of rustic life and historical tableaux struck a resonant chord in the early twentieth century, and were a commercial success. He invested the proceeds in the purchase and restoration of five old buildings in three New England states that became known as the "Chain of Colonial Houses." Not only did these serve as settings for his popular photographs, but as museum houses they catered to the evolving industry of automobile tourism. Nutting gathered an extensive collection of seventeenth- and eighteenth-century decorative arts to furnish the houses and, in the late teens, began reproducing furniture based on these models. As an author, he developed an even larger audience with a subsequent series of travel books (the States Beautiful) for historically minded tourists and a number of volumes on American decorative arts for collectors. Of the latter, the three-volume *Furniture Treasury* and *Furniture of the Pilgrim Century* became standard reference works in the field. Nutting's publishing efforts continued the pattern of expansion that led the retired minister to eventually control a minor business empire based on the idea and image of old New England. (TAD)

References

Barendson, "Wallace Nutting," 187–212; Wallace Nutting, *Wallace Nutting's Biography* (Framingham, Mass.: Old America Company, 1936); Woods, "Viewing Colonial America," 67–86.

MAXFIELD PARRISH (1870 – 1966)

Parrish's career, from the beginning to the very end, seems to represent an escape from all aspects of modernism. As a promising young illustrator, he left Philadelphia, and direct access to a number of firms that had begun to publish his work, to settle in Plainfield, New Hampshire (near Cornish). There he designed and built, on a hillside covered with ancient oaks, an old-fashioned New England "cottage." Over the years, the cottage grew to considerable size, each addition calculated to take advantage of the unique site Parrish had chosen. But an apparently escapist narrative becomes more complex when one discovers, at the heart of this cottage, an elaborate, up-to-date machine shop, where Parrish spent many hours producing the structural and decorative items that went into making his new home look old. At "The Oaks," as he called his New Hampshire home, Parrish also produced popular magazine and book illustrations and commercial advertisements. Among these was a series of New England landscapes begun in the 1930s. They look like dreamscapes, with iridescent colors and neatly arranged topography. But as calendar images, which most of them were, they delivered an appealing version of old New England to a wide-ranging middle-class audience. Parrish's ancestors were prominent in both Pennsylvania and Maryland. He grew up in Philadelphia, attended Haverford College for three years, and then studied at The Pennsylvania Academy of the Fine Arts (1892–94) under Robert Vonnoh and Thomas Anshutz. Success came soon after, with publishers willing to pay higher and higher fees for his illustrations. He eventually became known as the "businessman with a brush." (WHT)

References

Brandywine River Museum, *Maxfield Parrish: Master of Make-believe* (Chadds Ford, Penn.: Brandywine River Museum, 1974); Laurence S. Cutler and Judy Goffman, *Maxfield Parrish* (New York: The American Illustrators Gallery and Bison Books, 1993); Ludwig, *Maxfield Parrish*.

WILLIAM MCGREGOR PAXTON (1869 – 1941)

The women in Paxton's finely detailed interiors, from dowagers and schoolgirls to servants, helped define idealized female roles for upper-class New Englanders at the turn of the century. Calm, introspective, and bathed in quiet light, Paxton's figures provide a striking contrast to the working-class female subjects of New York's Ashcan School. Whereas the well-to-do Boston women read, drink tea, and regard fine things in their quiet homes (while their servants quietly keep house), New York women are seen promenading down bustling streets, flirting openly, and readily catching the eye of passing strangers. Both, however, demand the attention of the viewer: Paxton's women project a compelling but reserved, sensual languor; Ashcan women are depicted as open and engaging. As an image maker, Paxton was keenly aware of the social conventions of upper-class Boston, even though he was raised in less privileged circumstances. The son of a suburban caterer, he attended the Cowles Art School on scholarship before making the pilgrimage to Paris to study at the École des Beaux-Arts (with Gérôme) and the Académie Julian. Like so many of his Boston School colleagues, Paxton was able to use his artistic ability and finely tuned social antennae to achieve a prominence in New England cultural circles that belies his middle-class origins. (TAD)

References

Fairbrother, *The Bostonians*, 221; Ellen W. Lee et al., *William McGregor Paxton, N. A., 1869–1941* (Indianapolis: Indianapolis Museum of Art, 1978), 13–44; O'Leary, *At Beck and Call*, 210–16, 225–28, 243–48, 257–60.

HENRY J. PECK (1880 – 1964?)

Born in Galesburg, Illinois, Peck studied at the Rhode Island School of Design with Eric Pape, and at HOWARD PYLE's school in Philadelphia. He also worked as a painter, illustrator, etcher, and writer in Warren, Rhode Island. By 1929 he had a studio in New York and was living in Providence. Peck's illustrations appeared in early issues of *Harper's Weekly*, *Collier's*, and *Scribner's Monthly*, and when accompanied by stories and poetry, in *The Delineator*, *Century*, and *Country Life*. These illustrations sometimes celebrated innovations in early twentieth-century American life, such as the automobile, the airplane, and rural free delivery. Peck's marine paintings—New England fishermen navigating a none-too-friendly ocean—were a different matter. They encouraged viewers to see Yankee enterprise as a preparation for modern industrial life. (JKM)

References

National Museum of American Art/National Portrait Gallery Library vertical files; New York Public Library Artist's File; Peabody Essex Museum, Salem, Massachusetts, curatorial files; *Who Was Who in American Art*, ed. Peter Hastings Falk (Madison, Conn.: Soundview Press, 1985), 476.

LOUIS PRANG (1824 – 1909), L. PRANG & COMPANY (1860 – 1897)

Louis Prang was born in Breslau (now called Wroclaw, a part of Poland) and as a young man worked in his father's calico-printing business. Forced to leave Germany during the 1848 Revolution, he found employment at printing companies in New York and Boston. Then in 1856 he formed a partnership with a Boston lithographic printer, Julius Mayer. In 1860 Prang bought out Mayer and prospered during the Civil War, making maps of battles, scenes of military life, and portraits of Union Army officers. He went on to publish album cards, greeting cards, games, series on birds and flowers, and toy books, in addition to fulfilling his dream of fine-art publishing, reproducing the works of well-known artists such as WINSLOW HOMER, EASTMAN JOHNSON, ALFRED T. BRICHER, and THOMAS HILL. Prang's chromolithographic process—reproduction in oil colors—brought color-printed advertising into common use and pictures of old New England into a wide range of American homes. He set high standards for his reproductions, insisting on color and textural quality that duplicated the original image. He was able to achieve those standards with technology not previously used in the industry. Even before the perfection of the chromolithograph, Prang's lithographs of New England towns made from 1855 to 1865 had helped satisfy a demand for art in the home and had made New England a more popular destination for tourists. (JKM)

References
Larry Freeman, *Louis Prang: Color Lithographer/Giant of a Man* (Watkins Glen, N.Y.: Century House, 1971); Peter Marzio, *The Democratic Art: Chromolithography 1840–1900: Pictures for a Nineteenth-Century America* (Boston: David R. Godine, in association with the Amon Carter Museum of Western Art, Fort Worth, Tex., 1979); Katharine Morrison McClinton, *The Chromolithographs of Louis Prang* (New York: Crown Publishers, Inc., 1973).

GREGORIO PRESTOPINO (1907 – 1984)

Born in New York's "Little Italy," Prestopino followed the educational path typical of many immigrant children: elementary school and then a few years at a vocational high school. After having pursued such a path, in which he attempted to learn sign painting, he left school at the age of fourteen. At another fixture of immigrant life, the settlement house, he was introduced to the fine arts, winning a scholarship to the National Academy of Design. There he was a student of CHARLES HAWTHORNE and became acquainted with the work of the Ashcan School painters. After his studies he established a studio in New York and began painting the life he saw around him. A series of stays at the MacDowell Colony in Peterborough, New Hampshire, beginning in the summer of 1934, had a marked influence on his work. He spent eight summers in residence there, during one of which he met his wife, Elizabeth. Along with depictions of working-class city dwellers, he now began painting scenes that embodied "small town individualism and egalitarianism" (*Community*, 31). During the 1960s and '70s, Prestopino actively supported the civil rights and antiwar movements, donating the sales of his art and designs to benefit these causes. His later work moved away from the figure and toward abstraction. (JKM)

References
Archives of American Art, Edward and Marian MacDowell files, microfilm; *Community of Creativity/A Century of MacDowell Colony Artists* (Manchester, N.H.:Currier Gallery of Art, 1996); *Five Artists from the 1930s and 1940s* (New York: Midtown Galleries, 1988), 8 – 9; *Prestopino* (New York: Nordness Gallery, 1960).

HOWARD PYLE (1853 – 1911)

"I may say to you in confidence," wrote Howard Pyle in 1912, "that even to this very day I still like the pictures you can find in books better than wall pictures." The statement can be understood as Pyle's way of endorsing strong narrative content in a work of art, but it also helps to explain why, in a career spanning thirty-five years, he produced 3,300 published illustrations, half of which appeared in magazine articles and books he had written. Pyle was born in Wilmington, Delaware, and remained there, with occasional time spent in New York, for the rest of his life. Seven generations of his family had lived in the nearby Brandywine Valley. Most were Quakers, although Pyle was raised as a Swedenborgian. His education more or less kept pace with his drawing skills; he simultaneously read and drew his way through history and literature. His art training ended with a stint in 1869 at The Pennsylvania Academy of the Fine Arts, and commercial success followed almost immediately, with illustrations that began to appear everywhere—in *Harper's Monthly*, *Collier's*, the *Saturday Evening Post*, and in books whose subjects ranged from medieval legends and children's tales to life in colonial America. Teaching preoccupied Pyle from 1894 on; a formidable line of students, including N. C. WYETH, passed through his classrooms. Like their master, they were keenly aware of the new printing techniques of the era, which helped them bring their work before the public with unprecedented fidelity. (MN)

References
Howard Pyle: Diversity in Depth (Wilmington: Delaware Art Museum, 1973); *Howard Pyle: The Artist, His Legacy* (Wilmington: Delaware Art Museum, 1987); Henry Pitz, *Howard Pyle: Writer, Illustrator, Founder of the Brandywine School* (New York: Clarkson N. Potter, 1975).

PHILIP REISMAN (1904 – 1992)

When he was four years old, Reisman fled Polish pogroms with his mother and three siblings to join his father and two older brothers in New York. Because the family was poor, his father discouraged his early ambition to be an artist. Undeterred, Reisman dropped out of high school after six months to study at the Art Students League. By working at odd jobs he was able to take classes there for six years. His early paintings were candid, crowded scenes of the life he saw around him on the Lower East Side of New York: butchers, carters, peddlers, and homeless men in the Bowery. His first one-man show in 1932 was a critical success. In 1944 Reisman spent a summer on Cape Ann and became fascinated with the fishing industry in nearby Gloucester. Sketches for his painting *Mackerel Machine* were made at a Gloucester processing plant where mackerel were canned for the army. Reisman saw a connection between the lives of men engaged in the struggle to make a living from the sea and those of city dwellers trying to survive in an often hostile environment. He continued painting into his eighties. His intention, he said, was "to carry on the humanist point of view" (Bush, 96). (JKM)

References

George D. Bianco, *The Prints of Philip Reisman* (Bedford, N.Y.: Bedford Press, 1992); Bush, *Philip Reisman*.

THEODORE ROBINSON (1852 – 1896)

Robinson was instrumental in bringing new styles of painting from the old world to help the new world look at its past. Trained at the National Academy of Design in New York City (1874) and by Émile Carolus-Duran and Jean Léon Gérôme at the École des Beaux-Arts in Paris (1876–77), the Vermont-born artist at first seemed destined for a career as a traditional academic painter. This tidy trajectory was altered in 1887, however, when Robinson began to travel about the French countryside and discovered the artist colonies at Barbizon and Giverny. Although Robinson moved to Giverny in 1888 and became a disciple of Claude Monet, the leading French impressionist, he maintained his interest in the human form and his figural landscapes owe much to Barbizon-school painters such as Jean François Millet. Robinson brought this hybrid style back to New York City in 1892. Subsequent artistic travels took him to his native Vermont, as well as to Boston and to popular watering holes such as Greenwich and Cos Cob, Connecticut. With the narrative emphasis of an academician, Barbizon concern for rugged simplicity, and the bold brushwork and lighter palette of an impressionist, Robinson met with critical and commercial success in his homeland and abroad before his untimely death in 1896. (TAD)

References

Bev Harrington, ed., *The Figural Images of Theodore Robinson: American Impressionist* (Oshkosh, Wis.: Paine Art Center and Arboretum, 1987); Sona Johnston, *Theodore Robinson, 1852–1896* (Baltimore: The Baltimore Museum of Art, 1973); Weinberg, Burke, and Curry, *American Impressionism*, 55–59.

NORMAN ROCKWELL (1894 – 1978)

The approach to Rockwell's home in Arlington, Vermont, where he lived from 1939 until he moved to Stockbridge, Massachusetts, was accented by a covered bridge built in 1852. Thus, a rural past, and the emblems of small-town life that appear in many of his paintings, were never far from his easel. In fact, his Arlington neighbors posed for *Freedom of Speech*, the best known of his "Four Freedoms" paintings. Knowing this, one might assume that Rockwell's New England paintings are close copies of life in Arlington (or Stockbridge), but that was not the case. Rockwell was, as his many self-portraits reveal, a great believer in deception. With unerring skill, he recast major national events to play on a traditional small-town stage, thus toning down the more disturbing aspects of the depression, World War II, rapid urbanization, integration, and the numerous social changes that followed. But that enabled Rockwell, who saw himself as an illustrator, to address a much wider audience. Born in New York, into a family that could offer him little support, Rockwell left high school in his sophomore year to enroll at the Art Students League. Seven years later he painted his first *Saturday Evening Post* cover, which launched a remarkable career, much of which (the next forty-seven years) was devoted to painting more *Post* covers. (WHT)

References

Thomas Buechner, *Norman Rockwell, a Sixty-Year Retrospective* (New York: Harry N. Abrams, 1972); Judy Goffman, Davide Faccioli, and Manuela Teatini, eds., *Norman Rockwell* (Milan: Electa, 1990); Laurie Moffatt, *Norman Rockwell, a Definitive Catalogue* (Stockbridge, Mass.: The Norman Rockwell Museum, distributed by the University Press of New England, 1986).

JOHN ROGERS (1829 – 1904)

So popular were Rogers' plaster statuary groups in the decades after the Civil War that George Armstrong Custer carried one as a symbol of Eastern culture while campaigning on the Western frontier. Known as the "people's sculptor," Rogers mass-produced his designs, casting the original model many times over. His most popular groups reached editions of up to 20,000. His subjects were taken from popular literature, such as Longfellow's *Tales of the Wayside Inn*, and provided conversation pieces for the middle-class Victorian parlor. In this way, Rogers made real the

myths and symbols of old New England for thousands of Americans across the country. Like FRANK BENSON, Rogers was born into a merchant family in Salem, Massachusetts. His great-grandfather was Elias Hasket Derby, one of the young republic's first millionaires. His father's financial reverses, however, forced Rogers to postpone an artistic career and train, after schooling in the graphic arts at Boston English High School, as a mechanic for the Amoskeag Machine Shop in Manchester, New Hampshire. Rogers followed the rails west and settled in Hannibal, Missouri, where he worked as a railroad mechanic in the 1850s. The Depression of 1857 forced him back to Massachusetts where he began sculpting. The success he realized in 1859 when he exhibited the first of his "Checker Players" statuettes continued until the turn of the century. (MN & TAD)

References
Wayne Craven, *Sculpture in America* (Newark: University of Delaware Press, 1984), 357–66; Huntington and Pyne, *The Quest for Unity*, 68–70; Wallace, *John Rogers*.

LOUISE ROSSKAM (born 1910)
Rosskam was born in Philadelphia to Hungarian immigrant parents. Her father, a bank president, who had helped other immigrants bring family members to America, suffered financially during the depression. Still, Louise attended the University of Pennsylvania in pre-med, one of three areas of study open to women at the time. When she met her husband, painter and photographer Edwin Rosskam, she took up photography. During her marriage, Rosskam and her husband worked together on projects, including several for the Farm Security Administration (FSA). Her work in New England was one of the few solo projects she undertook until her husband's death in 1984. Rosskam made her New England photographs while participating in a social program during the late 1930s and early 1940s requiring city and country dwellers to exchange places. Staying for two months with a farmer and his wife in Bristol, Vermont, Rosskam photographed it and nearby towns, selecting subjects that interested her. Roy Stryker, head of the FSA's historical section, who had admired her other photographic essays, requested these images for the permanent FSA files. Several of her aerial views of Vermont towns were taken from a Piper Cub with the door removed. Rosskam, leaning far out of the cockpit, was supported only by her seat belt. (JKM)

References
Author's conversations with Rosskam, 23–24 October, 1997; Andrea Fisher, *Let Us Now Praise Famous Women* (London: Pandora, 1987), 9–10, 37, 51; Steven W. Plattner, *Roy Stryker: U.S.A., 1943–1950* (Austin: University of Texas Press, 1983).

ARTHUR ROTHSTEIN (born 1915)
Rothstein's most famous photograph, a scene of an Oklahoma dust storm through which a farmer and his two sons struggle to return to their ramshackle home, has a social message very different from his pictures of New England. The latter depict a less hostile world. Bucolic farms, maintained by traditional agricultural methods, are one aspect of Rothstein's New England; another is working-class life, with its own special kind of camaraderie and leisure-time activities. A pre-med student at Columbia University in 1935, but also a camera enthusiast, Rothstein opted for photography when, shortly before graduation, funds for medical school did not materialize. He joined Roy Stryker's photo documentation unit of the Farm Security Administration, traveling widely to make memorable images of depression-era America. In 1940, he went to work for *Look* magazine. Except for a stint with the Office of War Information during World War II, he remained at *Look* until 1972, after 1946 as director of photography. He subsequently became an editor at *Parade* magazine. During his long career, he also served on the faculty at the Columbia University School of Journalism and the Newhouse School of Public Communication at Syracuse University. (WHT)

References
Arthur Rothstein, *The Depression Years as Photographed by Arthur Rothstein* (New York: Dover Publications, 1978); Arthur Rothstein, *Arthur Rothstein: Words and Pictures* (New York: American Photographic Book Publishing Company, 1979); Arthur Rothstein, *Arthur Rothstein's America in Photographs, 1930–1980* (New York: Dover Publications, 1984).

AUGUSTUS SAINT-GAUDENS (1848 – 1907)
Saint-Gaudens's life story is the classic, but rarely realized, dream of the American immigrant. Born to an Irish shoemaker and his wife shortly before their relocation to New York in 1848, he began his artistic career as a cameo cutter. By 1867 the young Saint-Gaudens showed such promise that his father sent him to Paris to study with the academic sculptor François Jouffroy. From that date until the early 1880s, he moved back and forth between New York and Europe, supporting himself through portrait busts and cameos. During this period he also began to obtain commissions for public monuments. In 1885, Saint Gaudens bought a farm in Cornish, New Hampshire, and settled permanently in the United States. His residence served as both home and studio, as well as one of the principal gathering places of the noted local art colony, which included the painters THOMAS WILMER DEWING and ABBOTT HANDERSON THAYER. During the summer months this select group of artists, musicians, and actors came to Cornish, seek-

ing inspiration from the New Hampshire countryside and interaction with one another. The art produced by the self-described "choice spirits" of Cornish helped define New England as a landscape of history and myth for an equally select group of patrons. (MN & TAD)

References
Wayne Craven, *Sculpture in America* (New York: Thomas Crowell Company, 1968), 373–92; Dryfhout, *The Work of Augustus Saint-Gaudens*; Kathryn Greenthal, *Augustus Saint-Gaudens, Master Sculptor* (New York: Metropolitan Museum of Art, 1985).

PAUL SAMPLE (1896 – 1974)
Sample's attempt to impose a Thomas Hart Benton/GRANT WOOD brand of Midwestern regionalism on New England seems to have been at once affirmative and upbeat, and singularly touched with irony. None of his 1930s paintings of Vermont rural life are without a note of discord, based perhaps on his own mild suspicion of small-town social customs. His New England roots were never deep until late in his career. After a peripatetic childhood, four years at Dartmouth College, and a bout with tuberculosis, he settled in Los Angeles (1925), where he received artistic training (and inspiration) from artists as varied as Stanton MacDonald-Wright and David Alfaro Siqueiros. He also taught painting at the University of Southern California. During these same years, Sample and his wife Sylvia frequently visited Sylvia's parents in Vermont. The visits led to some of Sample's best-known paintings. In 1938, his career on the rise, Sample was appointed artist-in-residence at Dartmouth. After World War II, mural commissions and sketching trips across the country occupied much of his time. (WHT)

References
Paula F. Glick, "The Murals of Paul Sample" (master's thesis, The George Washington University, Washington, D.C., 1981); John T. Haletsky, *Paul Sample: Ivy League Regionalist* (Coral Gables, Fla.: The Lowe Art Museum, University of Miami, 1984); McGrath and Glick, *Paul Sample*.

JOHN SINGER SARGENT (1856 – 1925)
Sargent, born in Italy to American parents and educated in Germany and France, possessed a keen eye for regional social conventions. As the premier society portrait painter of his day, Sargent instinctively knew what pose, attire, and mood to suggest in London, New York, or Boston. His English subjects have an air of pomp and splendor, New Yorkers have a cosmopolitan appearance, and Boston subjects often look a bit more serious, as if ancestral responsibilities rested on their shoulders. Sargent's understanding of old New England imagery may well have been learned over time; his father, the surgeon FitzWilliam Sargent, descended from a prominent Gloucester, Massachusetts, family. The Sargents relocated to Europe in 1854 and raised their children as peripatetic members of an international elite. John Singer attended schools in Florence and Dresden before entering the atelier of Carolus-Duran and the École des Beaux Arts in 1874. Academic training equipped Sargent with narrative conventions that he adjusted for class and local color in his portraits, yet his lively brushwork was up-to-date, even forward-looking. This unique style secured several commissions for Sargent on his first visit to Boston in 1887. By 1890 his reputation was such that the trustees of the Boston Public Library selected the painter to decorate the interior of the institution's new McKim, Mead, and White building in Copley Square. (MN & TAD)

References
Trevor Fairbrother, *John Singer Sargent* (New York: Abrams, 1994); Patricia Hills, *John Singer Sargent* (New York: Abrams, 1986); David McKibbin, *Sargent's Boston* (Boston: Museum of Fine Arts, 1956).

ALICE SCHILLE (1869 – 1955)
Schille was one of six children born to a prosperous Columbus, Ohio, family. She attended the Columbus Art School and then moved to New York in 1897 to study at the Art Students League. She also enrolled in William Merritt Chase's New York School of Art, and in her second year in New York spent the summer at his Shinnecock Hills school. In 1902 she traveled to Europe with another Chase student, Ella Hergesheimer. Schille studied in Madrid and at the Académie Colarossi in Paris. While there she exhibited five paintings at the Paris Salon. After returning to America, she showed her work at The Pennsylvania Academy of the Fine Arts. She began to teach at the Columbus Art School in 1904, painting in Europe during the summers. Unable to travel abroad during World War I, Schille spent her summers in Gloucester, Massachusetts, making bright, post-impressionist watercolors of town and beach. Schille taught at the Columbus Art School until 1948, continued to travel, and won prizes for works made in New Mexico, Mexico, North Africa, and Guatemala. (JKM)

References
Alice Schille Watercolors (Columbus, Ohio: Keny Galleries, 1991); *Lyrical Colorist/ Alice Schille 1869–1955* (Columbus, Ohio: Keny and Johnson Gallery, 1988); Wells, *Alice Schille*.

CHARLES SHEELER (1883 – 1965)

Sheeler was born in Philadelphia, the only child of a steamship company employee and his wife. After three years at the School of Industrial Art, he enrolled at The Pennsylvania Academy of the Fine Arts, where he studied with William Merritt Chase, taking two summer tours to Europe with his class. Although Sheeler wanted to be a fine artist, he made his living as a commercial photographer for many years, taking pictures of new buildings for architects, then of works of art for galleries and dealers in New York. Marius de Zayas promoted Sheeler's photographs as artworks in their own right, and Alfred Stieglitz followed, awarding Sheeler a prize in 1918. Sheeler's homes and their contents, his photographs and paintings, neatly and ironically combined the machine age with the past. The functional quality of American products, from the country's earliest days to Sheeler's own times, was for him a symbol of national pride. He collected American antiques, and his works juxtaposed this collection with the modern and the machine-made—cityscapes, locomotives, ocean liners, and factories themselves, like those along the Merrimack River, built when New England was in its industrial heyday. (JKM)

References

Lucic, *Charles Sheeler and the Cult of the Machine*; *Precisionism in America 1915–1941: Reordering Reality* (Montclair, N.J.: The Montclair Art Museum, 1994); Troyen and Hirshler, *Charles Sheeler*.

JOHN SLOAN (1871 – 1951)

In 1888, having grown up in Philadelphia, Sloan had to leave high school in his senior year when his father's business failed. He took a job as a cashier with a book and print dealer and found he was able to sell the greeting cards and copies of etchings by Rembrandt and Dürer that he had made. His subsequent training consisted of commercial artwork—calendars, illustrations, and greeting cards—and an evening class in drawing at The Pennsylvania Academy of the Fine Arts taught by Thomas Anshutz. Sloan began his career as an illustrator for newspapers and magazines, a profession that had attracted other future Ashcan painters then living in Philadelphia. When they—Henri, Luks, Glackens, and Shinn—moved to New York, Sloan followed, improved his oil technique, and was soon a full-fledged, exhibiting member of the Ashcan group. In Gloucester for only five summers (1914–18), Sloan painted primarily landscapes and seascapes, but a total of almost 300 works—more than in the preceding twenty-four years of his career. These summers gave Sloan an opportunity to explore approaches to painting that he had not had the time or resources to explore while earning a living as an illustrator. Just as many saw New England as a touchstone for the founding ideas of the nation, the region served as a source of renewed creativity for Sloan. (JKM)

References

John Sloan: The Gloucester Years (New York: Kraushaar Galleries, Inc., 1994); Rowland Elzea, *John Sloan's Oil Paintings: A Catalogue Raisonné* (Newark: University of Delaware Press, 1991); Rowland Elzea and Elizabeth Hawkes, *John Sloan: Spectator of Life* (Wilmington: Delaware Art Museum, 1988).

CHARLOTTE STERNBERG (born 1920)

Sternberg was born and grew up in Meriden, Connecticut, close to where she still lives and works. In both her commercial art and portraiture, New England has always been a favorite subject. She was trained at the Yale School of Fine Arts, graduating in 1942 with a preference for working in egg tempera. During World War II Sternberg made portrait sketches of convalescing servicemen and in 1961 she was commissioned to paint a portrait of President Dwight Eisenhower. Her later work, highly detailed scenes of idyllic American farmsteads and towns, has been extensively reproduced for calendars and for the American Artists Group "Christmas card" series. (JKM)

References

Author's conversation with the artist, December, 1997; New York Public Library Artist Files; The 1994 Charlottesville Calendar (Delafield, Wis.: Lang Graphics).

PAUL STRAND (1890 – 1976)

A writer and filmmaker as well as photographer, Paul Strand was born in New York. His family sent him at age fourteen to the progressive Ethical Culture School, where he took a course in photography from Louis Hine. Hine introduced him to the Photo-Secession group and to Alfred Stieglitz, who became, for a while, a friend and mentor. After several odd jobs, including work in a slaughterhouse, and a two-month stay in Europe, Strand became a commercial photographer in 1911. Strand's education, the influence of Stieglitz and the "291" exhibitions, as well as his political experiences—he moved to France in the 1950s to flee McCarthyism—combined to create his view of the importance of human agency in the world. New England, in particular, was an ideological touchstone for him. Writing of the region's attraction, and its historical role in protecting the rights of man, he stated: "From the very start, New England was a battleground

where intolerance and tolerance faced each other. . . . I was led to try to find in present-day New England images of nature and architecture and faces of people that were either part of or related in feeling to its great tradition" (Newhall, 1950). Strand's Maine and Vermont photographs were an attempt to record a place that he believed embodied the core values of New England and, therefore, of the nation. (JKM)

References

Catherine Duncan, *Paul Strand: The World on My Doorstep: An Intimate Portrait* (New York: Aperture, 1994); Sarah Greenough, *Paul Strand, An American Vision* (Washington, D.C.: National Gallery of Art, 1990), 31–49; Paul Strand, *Essays on His Life and Work*, ed. Maren Stange (New York: Aperture, 1990); Newhall, *Time in New England*.

CLEMENT NYE SWIFT (1846 – 1918)

Swift was born and educated in Massachusetts, and spent half of his career in France. On the advice of local artist Thomas Hewes Hinckley, he went to Paris in 1867 to copy paintings in the Louvre and to work in the ateliers of Adolphe Yvon and Henri Harpignies. He moved to Brittany in 1870, and became an authority on Breton customs and lore. The genre pieces he painted of the seafaring people of Brittany (which he exhibited at Paris Salons from 1872 to 1881) and the stories he wrote about them while living in the artist colony at Pont Aven established the direction his work would take when he returned to Massachusetts in 1882. In the landscape around New Bedford, similar to parts of Brittany, he painted local farms and fishing scenes and wrote poetry about life on whaling ships. Swift's work demonstrates his uneasy relationship with the new technologies entering American life. In one of his later, elegiac paintings a fisherman sits near a ruined, beached boat on the Massachusetts shore, with the smoke stacks of New Bedford in the background. Although Swift made use of the new medium of photography, his carefully posed scenes served only as templates for later paintings. (JKM)

References

Mary Jean Blasdale, *Artists of New Bedford: A Biographical Dictionary* (New Bedford: Old Dartmouth Historical Society, 1990), 182–83; Michael Jacobs, *The Good and Simple Life / Artist Colonies in Europe and America* (Oxford, England: Phaidon Press, 1985), 42–62; Sellin, *Americans in Brittany and Normandy*, 141.

EDMUND C. TARBELL (1862 – 1938)

Edmund Tarbell's remarkable New Hampshire summer home is emblematic of the painter and his art. Just as the artist's paintings draw upon traditional styles and motifs to construct an image of genteel New England, Tarbell's house blended the old and the new to create a rarefied atmosphere of history and domesticity. On canvas, Tarbell repeatedly depicted modern life in terms of the past, arranging his female subjects in quiet interiors, surrounded by icons of New England's glorious past, such as gate-leg tables, Chippendale chairs, and incense jars. Tarbell's sitters read, knit, and drink tea as if in a historical vacuum. At home, in the fashionable summer colony of New Castle on the Piscataqua River near Portsmouth, Tarbell re-created the same atmosphere. Starting with a modest nineteenth-century farmhouse, he tripled its size and used architectural fragments from earlier buildings to provide the new house and garden with historical ambience. Tarbell's arrival in New Castle marked his ascension to the very highest circles of New England society. Of old Yankee stock himself, he could trace his lineage back to 1638. This pedigree served the artist in his rise from a country boyhood in West Groton, Massachusetts, to school in Boston and Paris, and finally to his position as the leading arbiter of taste for genteel New England. Considered the dean of Boston school painters (dubbed "Tarbellites" in 1897 by the critic Sadakichi Hartmann), Tarbell taught at the School of the Museum of Fine Arts from 1889 until 1912, imparting his vision of a graceful past to a generation of Bostonians. (TAD)

References

Fairbrother, *The Bostonians*; Giffen and Murphy, *"A Noble and Dignified Stream,"* 131–33; Pyne, *Art and the Higher Life*, 211–15.

ABBOTT HANDERSON THAYER (1849 – 1921)

Thayer's unusual Dublin, New Hampshire, house speaks volumes about the painter. Built in 1888 on land provided by Mary Amory Greene, a direct descendant of the colonial portraitist John Singleton Copley, the two-story building sported several screened-in porches and was surrounded by a number of sleeping huts—small lean-to structures that broke down the barriers of traditional Victorian domestic space and encouraged a rustic, almost wild atmosphere. The unruly house and unusual artist were not without their contradictions. To the right of the front door, mounted on a bracket, stood a copy of DANIEL CHESTER FRENCH's famous bust of Ralph Waldo Emerson—a symbol of the intellectual rigor expected of family and guests. Thayer was the patriarch of an extended family of blood relations, servants, and models who became year-round residents of Dublin in 1901. His career had begun much earlier, first as an animal painter and then as a student at the National Academy of Design in New York and the École des Beaux Arts in Paris. At the latter, he studied under Jean Léon Gérôme. After Thayer returned from Paris (1879), he began painting ethereal women and children and writing about natural history,

particularly the development of animal coloration. Lost in the wild or in his vision of idealized female form, Thayer sought an alternative to the banality of the modern world. (MN & TAD)

References

Ross Anderson, *Abbott Handerson Thayer* (Syracuse, N.Y.: The Everson Museum of Art, 1982); Alexander Nemerov, "Vanishing Americans: Abbott Thayer, Theodore Roosevelt, and the Attraction of Camouflage," *American Art* 11: 2 (summer 1997): 50–81; Nelson White, *Abbott H. Thayer: Painter and Naturalist* (Hartford: Connecticut Printers, Inc., 1951).

CHARLES YARDLEY TURNER (1850 – 1919)

Turner was primarily a mural painter, with a lifelong interest in early American history. His most important work appears in banks and public buildings, including the Bank of Commerce in New York, City Hall in Philadelphia, the State Capitol in Madison, Wisconsin, and the Hudson County Court House in Jersey City. Early in his career, and between mural commissions, he painted rural genre scenes, landscapes, and literary adaptations of events from colonial history. Born in Baltimore into a Quaker family, Turner received his art training at the Maryland Institute, supplemented by several years at the National Academy of Design in New York. In 1878 he went to Paris, where he studied with Léon Bonnat and the Hungarian muralist Mihaly Munkacsy. A full career followed, as a specialist in literary and historical figure painting, as Frank Millet's assistant in overseeing decorative projects at the World's Columbian Exposition, and, subsequently, as a director of numerous professional art organizations. (MN)

References

James William Pattison, "The Mural Decorations of C.Y. Turner, at Baltimore, Maryland," *International Studio* 24 (January 1905): lvii–lxi; *Revisiting the White City*, 331–32; Cynthia H. Sanford, *Heroes in the Fight for Beauty: The Muralists of the Hudson County Court House* (Jersey City: Jersey City Museum, 1986), 75–79.

J. ALDEN WEIR (1852 – 1919)

"Hollyhocking," Weir's term for embellishing the scenery in his paintings, allowed the artist to realize his vision of a pastoral New England. If a painting needed just the right bit of color to balance the composition or to blot out some unsightly feature, Weir simply added a hollyhock, the most genteel of all New England flora. The practice of "hollyhocking," or taking artistic license, did not run in the family. Weir's father, the painter Robert W. Weir, taught drawing at the United States Military Academy at West Point, a job that stressed topographic precision. The younger Weir learned to draw at his father's knee before traveling to Paris in 1873 to study with Jean Léon Gérôme at the École des Beaux-Arts. This academic training made Weir initially disdainful of impressionism. Purchasing a farm in Branchville, Connecticut, helped bring about a change of heart and a shift in style as Weir took to the outdoors and began experimenting with a lighter palette and broader brushwork. During this period he also became an important leader in the art world, organizing the upstart group known as "The Ten," before moving on to serve in increasingly conservative positions, such as president of the National Academy of Design and trustee of The Metropolitan Museum of Art in New York. As time went on, critics chided Weir for his prosaic style of painting. Weir's answer to these charges: add another hollyhock. (TAD)

References

Doreen Bolger, "J. Alden Weir," in Gerdts, *Ten American Painters* (New York: Spanierman Gallery, 1990), 135–38; Doreen Bolger Burke, *J. Alden Weir: An American Impressionist* (Newark, Del.: University of Delaware Press, An American Art Journal Book, 1983); Hildegard Cummings, Helen K. Fusscas, and Susan G. Larkin, *J. Alden Weir: A Place of His Own* (Storrs, Conn.: William Benton Museum of Art, University of Connecticut at Storrs, 1991).

MARION POST WOLCOTT (1910 – 1990)

A tough, feisty photographer who began freelancing for the Associated Press in 1935, Wolcott has only recently received the attention she deserves. Most of her fairly short career was spent working under Roy Stryker at the Farm Security Administration, following the Stryker formula for "documenting" working-class life across the country during the late 1930s and early 1940s. Her New England pictures are eloquent examples of that formula, merging old and new New Englands into an (almost) comfortable relationship with each other. Her own inclination, after studies at the New School for Social Research in New York and the University of Vienna (she heard Hitler speak in Berlin), was to be more of a social activist, an inclination that occasionally surfaces in her "off duty" pictures. In 1941, with husband Lee Wolcott, she moved to a farm in Virginia. For the next three decades she raised a family, taught school, and traveled with her husband, who joined the Foreign Service after a farming accident. In 1975, she returned to photography, this time specializing in color. She and her husband settled in San Francisco in 1978. (WHT)

References

Hendrickson, *Looking for the Light*; Jack Hurley, *Marion Post Wolcott: A Photographic Journey* (Albuquerque: University of New Mexico Press, 1989); Sally Stein, *Marion Post Wolcott: FSA Photographs* (Carmel, Calif.: The Friends of Photography, 1983).

GRANT WOOD (1891 – 1942)

Wood's brand of Midwestern regionalism has often been seen as a response to his own youth, spent on an Iowa farm and in the town of Cedar Rapids. These years were perhaps idealized when he looked back on them from Chicago and Paris, where he went for artistic training. He returned to Cedar Rapids with a mildly avant-garde direction to his work, which he first applied to decorative arts and design. By 1930, he had developed a distinctive painting style—a kind of meticulous, down-to-earth realism—that he imposed on the Iowa landscape. Wood's compositions, consisting of neatly ordered farms, generously spaced across a wide horizon, led viewers to believe that at the heart of America lay the virtues of agrarian life. Twice Wood ventured into colonial fables, painting the *Midnight Ride of Paul Revere* and then *Parson Weems' Fable*. Both works, done in a tidy realistic style and featuring spacious rolling Iowa landscapes, are noteworthy for their "midwestern" approach to colonial history. (WHT)

References

Corn, *Grant Wood*; Davenport Museum of Art, *Grant Wood: An American Master Revealed* (San Francisco: Pomegranate Art Books, 1995); James M. Dennis, *Grant Wood: A Study in American Art and Culture* (Columbia: University of Missouri Press, 1986).

THOMAS WATERMAN WOOD (1823 – 1903)

Wood grew up in the new town of Montpelier, Vermont. As a young man he worked in his father's cabinet shop. His art education was largely self-acquired: at first he painted signs, made patent drawings for inventors, and attempted some portraits. He may have also studied with Chester Harding in 1846 and 1847, and later he worked in Düsseldorf. By 1852 he had opened a studio in New York, continuing his portrait practice, and had built a summer home overlooking Montpelier. After a year in Europe in 1857, he moved to the South and began to do the genre pieces for which he is best known: popular conceptions of democratic America, lauding unpretentious, rural ways. He continued to paint these subjects after moving back to New York in 1866. Wood was elected to the National Academy of Design in 1871 and served as president for eight years. He continued to spend summers in Montpelier and late in life founded and donated his collection to the Wood Art Gallery in the town. (JKM)

References

Catalogue of the Pictures in the Art Gallery in Montpelier (Montpelier, Vt.: Capital City Press, 1913, first published 1897), 9–19; Leslie A. Hasker and J. Kevin Graffagnino, "Thomas Waterman Wood and the Image of Nineteenth-Century America," *Antiques* (November 1980): 1030–42; William C. Lipke, "The Readable Image: Thomas Waterman Wood and Popular Genre," in *Thomas Waterman Wood, PNA, 1823–1903* (Montpelier, Vt.: Wood Art Gallery, 1972), 13–58.

NEWELL CONVERS WYETH (1882 – 1945)

In 1912 Theodore Roosevelt sent a brief note to Wyeth, complimenting him on the vigorous character of his work. "I am stirred to stronger manhood every time I read it," Wyeth told a friend. His career might well be understood as an extension of that remark. From illustrations of the Civil War to scenes of the Maine coast, Wyeth portrayed people and events that defined an aggressively masculine (and Anglo-Saxon) idea of America during the first four decades of the twentieth century. Born in then rural Needham, Massachusetts, to a family of colonial ancestry, Wyeth grew up with a lively interest in the past and became the patriarch of a remarkable clan of painters that includes son Andrew and grandson Jamie. The elder Wyeth's early taste for medieval legends and western adventures eventually led him to HOWARD PYLE's studio, where in a short time he became a skillful illustrator. The first of his many *Saturday Evening Post* covers appeared in 1903. In the early 1920s Wyeth purchased a house in Port Clyde, Maine, attracted by the rugged coast and sturdy fisherman who lived nearby. Each summer he returned to Port Clyde, painting the local scene through the eyes of one determined to reconnect his life to those of the local residents. (MN)

References

Allen and Allen, *N. C. Wyeth*; James H. Duff, *An American Vision: Three Generations of Wyeth Art: N. C. Wyeth, Andrew Wyeth, James Wyeth* (Boston: Little, Brown, 1987); David Michaelis, *N. C. Wyeth: A Biography* (New York: Knopf, 1998); Christine B. Podmaniczky, *N. C. Wyeth: Experiment and Invention, 1925–1935* (Chadds Ford, Penn.: Brandywine River Museum, 1995).

MARGUERITE ZORACH (1887 – 1968)

Reviews of the landmark 1913 Armory Show mention the work of only one Zorach, Marguerite. Today, however, Marguerite Thompson Zorach's reputation is largely overshadowed by that of her sculptor husband, William. And yet the attention Marguerite attracted should come as no surprise. She was an early exponent of modernism in America, employing the bold colors of the Fauves (a group of radical French painters) with the striking, and controversial, forms of cubism. Marguerite's modernist credentials were impeccable. An acquaintance of Pablo Picasso and the expatriate Gertrude Stein, she attended La Palette, a school of "post-impressionists," and exhibited at the Salon d'Automne and the Société des Artistes Indépendants. She married William in 1912, returned to the United States, and together they began summering in New England. After several restless seasons in New Hampshire and Provincetown, Massachusetts, the Zorachs pur-

chased a farm in Robinhood Cove near Stonington, Maine. Marguerite continued to paint, but she also turned her attention to fiber art in the form of embroidery and batik. Through the use of these traditional materials, Zorach articulated her uniquely modern vision of old New England. (TAD)

References

Marilyn Hoffman, *Marguerite and William Zorach: The Cubist Years, 1915–1918* (Manchester, N.H.: The Currier Gallery of Art, 1987); Roberta K. Tarbell, *Marguerite Zorach: The Early Years, 1908–1920* (Washington, D.C.: The National Collection of Fine Arts, 1973); Roberta K. Tarbell, *William and Marguerite Zorach: The Maine Years* (Rockland, Maine: William A. Farnsworth Library and Art Museum, 1979).

WILLIAM ZORACH (1889 – 1966)

Not until 1917, well into a career as a lithographer and painter, did Zorach take up sculpture. His earliest works appear to have followed his painting style, a kind of angular cubism that in the third dimension reinforced the "primitive" style of his carving. Most works of this period resemble African or medieval sculpture. But soon after he took his lead from an aesthetic of direct carving, allowing the material in which he was working to guide him toward an artistic solution. By the 1930s, sculpture in stone, mostly of human figures, constituted Zorach's major output. Zorach was the son of a Lithuanian immigrant who settled in Cleveland. He was trained at the Cleveland School of Art as a lithographer, then studied painting in Paris in 1910 and 1911. Four of his works were accepted at the Salon d'Automne in the latter year. He continued to paint, especially in watercolor, during summers spent at Robinhood Cove near Stonington, Maine. The subjects he chose, coastal views of Penobscot Bay, suggest a link to the animals he carved from the granite that lined the shores of the bay. Both watercolors and sculpture were meant to evoke a spirit of place, the former by representing the liquid atmosphere that merged sky and water, the latter as an expression of the enduring character of the Maine coast. During the late 1930s and early 1940s, Zorach worked on commission for the Fine Arts section of the Treasury Department, which presided over the decoration of federal buildings in Washington and post offices in regional cities and towns. The post office program fostered an awareness of national government in local communities; individual projects, however, focused not on "official art" but on local history, commerce, and industry. (WHT)

References

John I. H. Baur, *William Zorach* (New York: Frederick A. Praeger for the Whitney Museum, 1959); Park and Markowitz, *Democratic Vistas*, 53, 54; Roberta Tarbell, *William and Marguerite Zorach: The Maine Years* (Rockland, Maine.: William H. Farnsworth Library and Art Museum, 1980).

Thomas Andrew Denenberg

Judith K. Maxwell

Martha M. Norton

Roger B. Stein

William H. Truettner

References

Listed here are sources cited in abbreviated form in the chapter endnotes and in the Artist Biographies.

Abbott, Charles D. *Howard Pyle: A Chronicle*. Introduction by N. C. Wyeth. New York: Harper, 1925.

Abbott, Katherine M. *Old Paths and Legends of New England*. 1903. New York: Putnam's, 1909.

Adams, Henry. *The Education of Henry Adams*. Boston: Houghton Mifflin, 1918.

Ahrens, Kent. "Jennie Brownscombe: American History Painter." *Women's Art Journal* 1, no. 2 (fall 1980–winter 1981): 25–29.

Aldrich, Thomas Bailey. *The Writing of Thomas Bailey Aldrich: Poems*. Boston: Houghton Mifflin, 1911.

Allan Crite's Boston: Paintings, Watercolors, and Drawings in the Collection of the Boston Athenaeum. Boston: Boston Athenaeum, 1997.

Allen, Douglas, and Douglas Allen, Jr. *N. C. Wyeth: The Collected Paintings, Illustrations, and Murals*. New York: Crown, 1972.

American Impressionism, Recent Acquisitions: Spring 1997. New York: Adelson Galleries, 1997.

Anderson, Jeffrey W. "A Season in Lyme: Life among the Artists." In *En Plein Air: The Art Colonies at East Hampton and Old Lyme, 1880–1930*. Old Lyme, Conn.: Florence Griswold Museum, 1989.

Axelrod, Alan, ed. *The Colonial Revival in America*. Introduction by Kenneth Ames. New York: Norton for the Henry Francis du Pont Winterthur Museum, 1985.

Baker, John. *O. Louis Guglielmi*. New Brunswick, N.J.: Rutgers University Art Gallery, 1980.

Barendson, Joyce P. "Wallace Nutting, an American Tastemaker: The Picture and Beyond." *Winterthur Portfolio* 18 (summer–autumn 1983): 187–212.

Barron, Hal. *Those Who Stayed Behind: Rural Society in Nineteenth-Century New England*. Cambridge: Cambridge University Press, 1984.

Bartlett, William Henry. *The Pilgrim Fathers; or, the Founders of New England in the Reign of James the First*. London: Arthur Hall, Virtue, 1853.

Bedford, Faith Andrews. *Frank W. Benson: American Impressionist*. New York: Rizzoli, 1994.

Bernstein, Theresa. *William Meyerowitz: The Artist Speaks*. Philadelphia: Art Alliance, 1986.

Birchfield, James D. *Thomas Satterwhite Noble, 1835–1907*. Lexington: University of Kentucky Art Museum, 1988.

Bois, Yves Alain, and Rosalind E. Krauss. *Formlessness: A User's Guide*. New York: Zone Books, 1997.

Bradford, William. *Of Plymouth Plantation, 1620–1647*. Edited by Samuel Eliot Morison. New York: Knopf, 1953.

Braithwaite, Deborah Willis. *Van Der Zee: Photographer, 1886–1983*. New York: Abrams, 1993.

Brooks, Van Wyck. *The Flowering of New England, 1815–1865*. New York: Modern Library, 1936.

————. *Sketches in Criticism*. New York: Dutton, 1932.

Brown, Dona. "Accidental Tourists: Visitors to the Mount Mansfield Summit House in the Late Nineteenth Century." *Vermont History* 65 (summer–fall 1997): 117–30.

————. *Inventing New England: Regional Tourism in the Nineteenth Century*. Washington, D.C.: Smithsonian Institution Press, 1995.

————. "Purchasing the Past: Summer People and the Transformation of the Piscataqua Region in the Nineteenth Century." In *"A Noble and Dignified Stream": The Piscataqua Region in the*

Colonial Revival, 1860–1930, edited by Sarah L. Giffen and Kevin D. Murphy. York, Maine: Old York Historical Society, 1992.

Brown, Jeffrey R. *Alfred Thompson Bricher, 1837–1908*. Indianapolis: Indianapolis Museum of Art, 1974.

Buckley, Laurene. *Joseph DeCamp: Master Painter of the Boston School*. New York: Prestel, 1995.

Buell, Lawrence. *New England Literary Culture: From Revolution through Renaissance*. Cambridge: Cambridge University Press, 1986.

Burgard, Timothy Anglin. "Edmonia Lewis and Henry Wadsworth Longfellow: Images and Identities." *Harvard University Art Museums Gallery Series*, no. 14 (1995): 2–21.

Burke, Doreen Bolger, et al. *In Pursuit of Beauty: Americans and the Aesthetic Movement*. New York: Metropolitan Museum of Art, 1986.

Burke, Mary Alice Heekin. *Elizabeth Nourse, 1859–1938: A Salon Career*. Washington, D.C.: National Museum of American Art and the Smithsonian Institution Press, 1983.

Burns, Sarah. *Inventing the Modern Artist: Art and Culture in Gilded Age America*. New Haven: Yale University Press, 1996.

————. *Pastoral Inventions: Rural Life in Nineteenth-Century American Art and Culture*. Philadelphia: Temple University Press, 1989.

Bush, Martin H. *Philip Reisman: People Are His Passion*. Wichita, Kans.: Edwin A. Ulrich Museum of Art, Wichita State University, 1986.

Charvat, William. *The Profession of Authorship in America, 1800–1870*. Columbus: Ohio State University Press, 1964.

Cikovsky, Nicolai, and Franklin Kelly. *Winslow Homer*. Washington, D.C.: National Gallery of Art, 1995.

Connecticut and American Impressionism.
 Storrs, Conn.: William Benton Museum
 of Art, 1980.

Connolly, James. *Book of the Gloucester
 Fishermen.* New York: Doyle, 1927.

Cook, Clarence. *The House Beautiful.* 1881.
 New York: Dover, 1995.

Corn, Wanda. *Grant Wood: The Regionalist
 Vision.* Minneapolis: Minneapolis
 Institute of Arts, 1983.

Crane, Charles Edward. *Let Me Show You
 Vermont.* Introduction by Dorothy
 Canfield Fisher. New York: Knopf, 1937.

Cunningham, John T. "Historian on the
 Double." *American Heritage* (June 1968):
 54–64ff.

Curry, David Park. *James McNeill Whistler at
 the Freer Gallery of Art.* Washington, D.C.:
 Freer Gallery of Art in association with
 Norton, 1984.

Danbom, David. *The Resisted Revolution:
 Urban America and the Industrialization of
 Agriculture, 1900–1930.* Ames: Iowa State
 University Press, 1979.

Davis, John. "Eastman Johnson's *Negro Life
 at the South* and Urban Slavery in
 Washington, D.C." *Art Bulletin* 80
 (March 1998): 67–92.

Davis, Stuart. *Stuart Davis.* Edited by Diane
 Kelder. New York: Praeger, 1971.

Denenberg, Thomas Andrew. "Chase
 Chrome: Poor Man's Sterling for the
 Modern Era." Paper presented at the
 Henry Francis du Pont Winterthur
 Museum, October 1995.

_____. "Consumed by the Past: Ideology
 and Craft in 'Old' New England." Paper
 presented at the annual meeting of the
 American Studies Association, Washing-
 ton, D.C., October 1997.

_____. "Pilgrims and Progressives: The
 Colonial Vision of Joseph Everett
 Chandler, Restoration Architect." Paper
 presented at the annual meeting of the
 Society of Architectural Historians,
 Seattle, April 1995.

Denny, George V. "'Town Meeting Tonight':
 The Revival of a Great American
 Institution." *Atlantic Monthly* (September
 1942): 69.

Docherty, Linda J. "Model Families: The
 Domesticated Studio Pictures of William
 Merritt Chase and Edmund C. Tarbell."
 In *Not at Home: The Suppression of
 Domesticity in Modern Art and Architecture,*
 edited by Christopher Reed. London:
 Thames & Hudson, 1996.

Drake, Samuel Gardner. *Annals of Witchcraft
 in New England.* 1869. New York: Blom,
 1967.

_____. *The Witchcraft Delusion.* Roxbury,
 Mass., 1866.

Dryfhout, John H. *The Work of Augustus
 Saint-Gaudens.* Hanover, N.H.: University
 Press of New England, 1982.

Earle, Alice Morse. *China Collecting in
 America.* New York: Scribner's, 1892.

_____. *Costume of Colonial Times.* New
 York: Scribner's, 1894.

_____. *Customs and Fashions in Old New
 England.* New York: Scribner's, 1894.

_____. *Home Life in Colonial Days.* New
 York: MacMillan, 1899.

_____. *Sabbath in Puritan New England.*
 New York: Scribner's, 1891.

_____. *Two Centuries of Costume in
 America, 1620–1820.* New York:
 Macmillan, 1903.

Edwards, Lee M. *Domestic Bliss: Family Life in
 American Painting, 1840–1910.* Yonkers,
 N.Y.: Hudson River Museum, 1986.

Emmet, Alan. *So Fine a Prospect: Historic New
 England Gardens.* Hanover, N.H.:
 University Press of New England, 1996.

Eno, Jr., Arthur L. *Cotton Was King: A
 History of Lowell.* Lowell, Mass.: Lowell
 Historical Society, 1976.

Fahlman, Betsy. *Pennsylvania Modern: Charles
 Demuth of Lancaster.* Philadelphia:
 Philadelphia Museum of Art, 1983.

Fairbrother, Trevor J. *The Bostonians: Painters
 of an Elegant Age, 1870–1930.* Boston:
 Museum of Fine Arts, 1986.

Federal Writers' Project of the Works
 Progress Administration in the New
 England States. *Here's New England! A
 Guide to Vacationland.* Boston: Houghton
 Mifflin, 1937.

Federal Writers' Project of the Works
 Progress Administration of Massachu-
 setts.
 *Massachusetts: A Guide to Its Places and
 People.* Boston: Houghton Mifflin, 1937.

Federal Writers' Project of the Works
 Progress Administration of Vermont.
 *Vermont: A Guide to the Green Mountain
 State.* Boston: Houghton Mifflin, 1937.

Field, Hamilton Easter. *The Technique of Oil
 Painting and Other Essays.* Brooklyn:
 Ardsley House, 1913.

Fisher, Dorothy Canfield. *Bonfire.* New York:
 Harcourt, Brace, 1933.

_____. *Vermont Tradition: The Biography of
 an Outlook on Life.* Boston: Little, Brown,
 1953.

_____. "Vermont: Our Rich Little Poor
 State." In *These United States: A Sympo-
 sium,* edited by Ernest Gruening, 44–55.
 New York: Boni & Liveright, 1923.

Fleischhauer, Carl, and Beverly W. Brannan,
 eds. *Documenting America, 1935–1943.*
 Berkeley: University of California Press,
 1988.

Flynt, Henry N., and Samuel Chamberlain.
 *Frontier of Freedom: The Soul and Substance
 of America Portrayed in One Extraordinary
 Village, Old Deerfield.* New York: Hastings
 House, 1952.

Flynt, Suzanne L., Susan McGowan, and
 Amelia F. Miller. *Gathered and Preserved.*
 Deerfield, Mass.: Pocumtuck Valley
 Memorial Association, 1991.

Forbes, Allan, and Ralph M. Eastman.
 Taverns and Stagecoaches of New England.
 Boston: State Street Trust, 1954.

Forbes, Esther. *Paul Revere and the World He
 Lived In.* Boston: Houghton Mifflin,
 1942.

Fox, Richard Wrightman. "Epitaph for
 Middletown: Robert S. Lynd and the
 Analysis of Consumer Culture." In *The
 Culture of Consumption: Critical Essays in
 American History, 1880–1980,* edited by
 Richard Wrightman Fox and T. J. Jackson
 Lears. New York: Pantheon, 1983.

Friedman, Martin L. *The Precisionist View in
 American Art.* Minneapolis: Walker Art
 Center, 1960.

Frye, Melinda Young. "The Beginning of the
 Period Room in American Museums:
 Charles P. Wilcomb's Colonial Kitchens,
 1896, 1906, 1910." In *The Colonial
 Revival in America,* edited by Alan
 Axelrod. Introduction by Kenneth Ames.
 New York: Norton for the Henry Francis
 du Pont Winterthur Museum, 1985.

Gabriel, Ralph Henry. *Toilers of Land and
 Sea.* Vol. 3 of *The Pageant of America: A
 Pictorial History of the United States,* edited
 by Ralph Henry Gabriel. New Haven:
 Yale University Press, 1926.

Gabriel, Ralph Henry, ed. *The Pageant of
 America.* 15 vols. New Haven: Yale
 University Press, 1925–29.

[Gale]. *Currier and Ives: A Catalogue Raisonné.*
 Introduction by Bernard F. Reilly. 2 vols.
 Detroit: Gale Research, 1984.

Gallagher, Nancy. "Henry Perkins and the
 Vermont Eugenics Movement." Master's
 thesis, University of Vermont, 1955.

Garrett, Edmund H. *Romance & Reality of the
 Puritan Coast.* Boston: Little, Brown,
 1897.
_____. *Three Heroines of New England
 Romance.* Boston: Little, Brown, 1894.

Gerdts, William H. *Masterworks of American
 Impressionism.* New York: Abrams for
 Thyssen-Bornemisza Foundation, 1990.

_____. "The Ten: A Critical Chronol-
 ogy." *Ten American Painters.* New York:
 Spanierman Gallery, 1990.

Giffen, Sarah L., and Kevin D. Murphy, eds. *"A Noble and Dignified Stream": The Piscataqua Region in the Colonial Revival, 1860–1930.* York, Maine: Old York Historical Society, 1992.

Gilbert, Barbara C. *Henry Mosler Rediscovered: A Nineteenth-Century American-Jewish Artist.* Los Angeles: Skirball Museum, 1995.

Glassberg, David. *American Historical Pageantry: The Uses of Tradition in the Early Twentieth Century.* Chapel Hill: University of North Carolina Press, 1990.

Gould, John. *New England Town Meeting: Safeguard of Democracy.* Brattleboro, Vt.: Stephen Daye, 1940.

Graffagnino, J. Kevin. "Arcadia in New England: Divergent Visions of a Changing Vermont, 1850–1920." In Richard H. Saunders, Virginia A. Westbrook, Nancy Price Graff, *Celebrating Vermont: Myths and Realities.* Middlebury, Vt.: Middlebury College Museum of Art, 1991.

Green, Harvey. "Looking Backward to the Future: The Colonial Revival and American Culture." In *Creating a Dignified Past: Museums and the Colonial Revival,* edited by Geoffrey L. Rossano. Savage, Md.: Roman & Littlefield, 1991.

———."Popular Science and Political Thought Converge: Colonial Survival Becomes Colonial Revival, 1830–1910." *Journal of American Culture* 6 (winter 1983): 3–24.

Greenthal, Kathryn, Paula M. Kozol, and Jan Seidler Ramirez. *American Figurative Sculpture in the Museum of Fine Arts, Boston.* Boston: Museum of Fine Arts, 1986; distributed by Northeastern University Press.

A Group of Fifty New England Colonial Homes, from the Designs of Miles Standish Richmond, Architect. Boston: Metropolitan Federal Savings and Loan Association [ca. 1938].

Gruening, Ernest, ed. *These United States: A Symposium.* New York: Boni & Liveright, 1923.

Halter, Marilyn. *Between Race and Ethnicity: Cape Verdean American Immigrants, 1860–1965.* Urbana: University of Illinois Press, 1993.

Harris, Neil, and Martina Roudabush Norelli. *Art, Design, and the Modern Corporation.* Washington, D.C.: National Museum of American Art, 1985.

Hart, Albert Bushnell. "The Pilgrims: Who They Were, What They Were, and Why They Came to America." *Mentor* 8, serial no. 213 (1923): 1–35.

Hartley, Marsden. *The Collected Poems of Marsden Hartley, 1904–1943.* Edited by Gail R. Scott. Santa Rosa, Calif.: Black Sparrow, 1987.

———. "John Marin." 1928. In *On Art,* edited by Gail R. Scott. New York: Horizon, 1982.

———. "On the Subject of the Mountain." 1932. In Jeanne Hokin, *Pinnacles and Pyramids: The Art of Marsden Hartley.* Albuquerque: University of New Mexico Press, 1993.

———. "On the Subject of Nativeness— A Tribute to Maine." 1937. In *On Art,* edited by Gail R. Scott. New York: Horizon, 1982.

Hathaway, Richard. "Men against Stone: Work, Technology, and Health in the Granite Industry." In *Celebrating a Century of Granite Art.* Montpelier: T. W. Wood Art Gallery at the Vermont College Arts Center, 1989.

Hemingway, Andrew. *Philip Reisman's Etchings: Printmaking and Politics in New York, 1926–1933.* London: University College Press, 1966.

Hendrickson, Paul. *Looking for the Light: The Hidden Life and Art of Marion Post Wolcott.* New York: Knopf, 1992.

Henri, Robert. *The Art Spirit.* 1923. Philadelphia: Lippincott, 1960.

Herrick, Robert. "Maine: Down East." In *These United States: A Symposium,* edited by Ernest Gruening, 118–26. New York: Boni & Liveright, 1923.

Hiesinger, Ulrich. *Childe Hassam: American Impressionist.* New York: Prestel for Jordan-Volpe Gallery, 1994.

Hills, Patricia. *Eastman Johnson.* New York: Clarkson Potter for Whitney Museum of American Art, 1972.

Hirshler, Erica E. *Dennis Miller Bunker and His Circle.* Boston: Isabella Stewart Gardner Museum, 1995.

Hobbs, Susan. *The Art of Thomas Wilmer Dewing: Beauty Reconfigured.* Brooklyn: Brooklyn Museum, 1996.

Hobsbawm, Eric, and Terence Ranger, eds. *The Invention of Tradition.* Cambridge: Cambridge University Press, 1983.

Hokin, Jeanne. *Pinnacles and Pyramids: The Art of Marsden Hartley.* Albuquerque: University of New Mexico Press, 1993.

Holcomb, Grant. *John Sloan: The Gloucester Years.* Springfield, Mass.: Museum of Fine Arts, 1980.

Hooper, Marion. *Life along the Connecticut River.* Brattleboro, Vt.: Stephen Daye, 1939.

Huntington, David, and Kathleen Pyne. *The Quest for Unity: American Art between World's Fairs, 1876–1893.* Detroit: Detroit Institute of Art, 1983.

Hurley, F. Jack. *Portrait of a Decade: Roy Stryker and the Development of Documentary Photography in the Thirties.* Baton Rouge: Louisiana State University Press, 1974.

Jacobs, Harriet Brent. *Incidents in the Life of a Slave Girl.* 1861. Edited by Jean Fagan Yellin. Cambridge: Harvard University Press, 1987.

James, Henry. *The American Scene.* 1907. Bloomington: Indiana University Press, 1968.

Jewett, Sarah Orne. *Deephaven.* 1893. Illustrated by Charles Wood Lowry and Marcia Oaks Woodbury. Portsmouth, N.H.: Peter Randall for Old Berwick Historical Society, 1993.

Judd, Richard A., Edwin A. Churchill, and Joel W. Eastman, eds. *Maine: The Pine Tree State from Prehistory to the Present.* Orono: University of Maine Press, 1994.

Judd, Richard Munson. *The New Deal in Vermont, Its Impact and Aftermath.* New York: Garland, 1979.

Kallir, Jane. *Grandma Moses: The Artist behind the Myth.* New York: Clarkson Potter for Galerie St. Etienne, 1982.

Kallir, Otto. *Art and the Life of Grandma Moses.* New York: Gallery of Modern Art, 1969.

Katz, Martha B. "J. O. J. Frost: Marblehead Artist." Master's thesis, State University of New York, Oneonta, 1971.

Kammen, Michael. *Mystic Chords of Memory: The Transformation of Tradition in American Culture.* New York: Knopf, 1991.

Kelly, Franklin. "A Process of Change." In Nicolai Cikovsky and Franklin Kelly, *Winslow Homer.* Washington, D.C.: National Gallery of Art, 1995.

Kent, Rockwell. *It's Me, O Lord: The Autobiography of Rockwell Kent.* 1955. New York: Da Capo, 1977.

Keyes, Donald D. *The White Mountains: Place and Perceptions.* Hanover, N.H.: University Press of New England, 1980.

Kornhauser, Elizabeth Mankin. *American Paintings before 1945 in the Wadsworth Atheneum.* New Haven: Yale University Press, 1996.

Lears, T. J. Jackson. *No Place of Grace: Antimodernism and the Transformation of American Culture, 1880–1920.* New York: Pantheon, 1981.

Lessard, Suzannah. *The Architect of Desire: Beauty and Danger in the Stanford White Family.* New York: Dial, 1996.

Leuchtenburg, William C. *Franklin D. Roosevelt and the New Deal, 1932–1940.* New York: Harper & Row, 1963.

Levin, Gail. *Edward Hopper.* New York: Knopf, 1995.

————. *Edward Hopper: A Catalogue Raisonné.* New York: Norton, 1995.

Levine, Laurence W. "Hollywood's Washington: Film Images of National Politics during the Great Depression." *Prospects: An Annual of American Cultural Studies* 10 (1985): 189.

Lindgren, James. *Preserving Historic New England: Preservation, Progressivism, and the Remaking of Memory.* New York: Oxford University Press, 1995.

Lockett, Elizabeth. "Provincetown." *The Arts* 10, no. 1 (July 1926): 49–55.

Longfellow, Henry Wadsworth. *Complete Poetical Works.* Cambridge edition. Boston: Houghton, Mifflin, 1893.

Lorentz, Pare. *FDR's Moviemaker: Memories and Scripts.* Reno: University of Nevada Press, 1992.

Lossing, Benson J. *Pictorial Field-Book of the Revolution.* 1850. Freeport, N.Y.: Books for Libraries, 1969.

Lovecraft, H. P. "The Picture in the House." 1922. In *The Dunwich Horror and Others,* 121–29. Sauk City, Wisc.: Arkham House, 1963.

Lublin, Mary. *American Selections, 1850–1950.* New York: Jordan-Volpe Gallery, 1992.

Lucic, Karen. *Charles Sheeler and the Cult of the Machine.* Cambridge: Harvard University Press, 1991.

Ludwig, Coy. *Maxfield Parrish.* New York: Watson-Guptill, 1973.

Luhan, Mabel Dodge. *Movers and Shakers.* Vol. 3 of *Intimate Memories.* New York: Harcourt, Brace, 1936.

Lynd, Robert S., and Helen Merrell Lynd. *Middletown.* New York: Harcourt, Brace, 1929.

Macy, John. "Massachusetts: A Roman Conquest." In *These United States: A Symposium,* edited by Ernest Gruening, 228–44. New York: Boni & Liveright, 1923.

Marcus, Lois Goldreich. "The Shaw Memorial by Saint-Gaudens: A History Painting in Bronze." *Winterthur Portfolio* 14 (spring 1979): 1–24.

Marling, Karal Ann. *George Washington Slept Here: Colonial Revivals and American Culture, 1876–1986.* Cambridge: Harvard University Press, 1988.

————. "Woodstock: An American Art Colony." Poughkeepsie, N.Y.: Vassar College Art Gallery, 1977.

Marquand, John. *The Late George Apley.* Boston: Little, Brown, 1937.

Marx, Leo. *The Machine in the Garden: Technology and the Pastoral Ideal in America.* New York: Oxford University Press, 1964.

Mather, Jr., Frank Jewett. *American Spirit in Art.* New Haven: Yale University Press, 1927.

Matthiessen, F. O. *American Renaissance: Art and Expression in the Age of Emerson and Whitman.* New York: Oxford University Press, 1941.

McBride, Henry. *The Flow of Art: Essays and Criticisms of Henry McBride.* Edited by Daniel Catton Rich. 1947. New York: Atheneum, 1975.

McGowan, Susan, and Amelia F. Miller. *Family and Landscape: Deerfield Homelots from 1671.* Deerfield, Mass.: Pocumtuck Valley Memorial Association, 1996.

McGrath, Robert L., and Paul F. Glick. *Paul Sample: Painter of the American Scene.* Hanover, N.H.: Hood Museum of Art, Dartmouth College, 1988.

McGrath, Robert L., and Barbara J. MacAdam. *"A Sweet Foretaste of Heaven": Artists in the White Mountains, 1830–1930.* Hanover, N.H.: University Press of New England, 1988.

Meixner, Laura L. *French Realist Painting and the Critique of American Society, 1865–1900.* New York: Cambridge University Press, 1995.

Merseyside County Council. *American Artists in Europe, 1800–1900.* Liverpool: Walker Art Gallery, 1976–77.

Meyer, Marilee Boyd, ed. *Inspiring Reform: Boston's Arts and Crafts Movement.* Wellesley, Mass.: Wellesley College Museum, 1997.

Miller, Marla R., and Anne Digan Lanning. "'Common Parlors': Woman and the Recreation of Community Identity in Deerfield, Massachusetts, 1870–1920." *Gender and History* 6 (November 1994): 439.

Monkhouse, Christopher P. "The Spinning Wheel as Artifact, Symbol, and Source of Design." *Nineteenth Century* 8, nos. 3–4 (1982): 154–72.

Monkhouse, Christopher P., et al. *James Wells Champney, 1843–1903.* Deerfield, Mass.: Hilson Gallery, Deerfield Academy, 1965.

Montgomery, M. R. *In Search of L. L. Bean.* New York: New American Library, 1985.

Morgan, Charles H. *George Bellows, Painter of America.* New York: Reynal, 1965.

Mumford, Lewis. *The Golden Day: A Study of American Literature and Culture.* 1926. Boston: Beacon, 1953.

Naus, Laura. "Their Own Labor, Their Thought, and Good Taste: The Restoration of Frary House." Paper prepared for Historic Deerfield Summer Fellowship Program, Henry N. Flynt Library, Historic Deerfield, Inc., 1987.

Nevins, Winfield S. "Summer Days on the North Shore." *New England Magazine* 11 (September 1891): 17–37.

Newhall, Nancy. *Paul Strand: Photographs, 1915–1945.* New York: Museum of Modern Art, 1945.

————. *Time in New England.* With photographs by Paul Strand. New York: Oxford University Press, 1950.

New-York Historical Society. *American Landscape and Genre Paintings in the New-York Historical Society: A Catalogue of the Collection, including Historical, Narrative, and Marine Art.* Compiled by Richard Koke. Boston: G. K. Hall for New-York Historical Society, 1982.

Nicoll, Jessica F. *Allure of the Maine Coast: Robert Henri and His Circle, 1903–1918.* Portland, Maine: Portland Museum of Art, 1995.

Norman, Dorothy, ed. *The Selected Writings of John Marin.* New York: Pellegrini & Cudahy, 1949.

Nutting, Wallace. *Massachusetts Beautiful.* Framingham, Mass.: Old America Company, 1922.

————. *Wallace Nutting's Biography.* Framingham, Mass.: Old America, 1936.

Nylander, Jane. *Our Old Snug Fireside: Images of the New England Home, 1760–1860.* New York: Knopf, 1994.

O'Leary, Elizabeth L. *At Beck and Call: The Representation of Domestic Servants in Nineteenth-Century American Painting.* Washington, D.C.: Smithsonian Institution Press, 1996.

Openo, Woodard D. "Artistic Circles and Summer Colonies." In *"A Noble and Dignified Stream": The Piscataqua Region in the Colonial Revival, 1860–1930,* edited by Sarah L. Giffen and Kevin D. Murphy. York, Maine: Old York Historical Society, 1992.

Park, Marlene, and Gerald E. Markowitz. *Democratic Vistas: Post Offices and Public Art in the New Deal.* Philadelphia: Temple University Press, 1984.

Peggy Bacon: Personalities and Places. Washington, D.C.: National Collection of Fine Arts, 1975.

Péladeau, Marius B. *Chansonetta: The Life and Photographs of Chansonetta Stanley Emmons, 1858–1937.* Waldoboro: Maine Antiques Digest, 1977.

Peters, Lisa N., and Peter M. Lukehart, eds. *Visions of Home: American Impressionist Images of Suburban Leisure and Country Comfort.* Carlisle, Pa.: Trout Gallery, Dickinson College, 1997.

Pickard, Samuel T. *Whittier-Land: A Handbook of North Essex.* Boston: Houghton Mifflin, 1904.

Poggioli, Renato. *The Oaten Flute: Essays on Pastoral Poetry and the Pastoral Ideal.* Cambridge: Harvard University Press, 1975.

Prevots, Naima. *American Pageantry: A Movement for Art and Democracy.* Ann Arbor, Mich.: UMI Research Press, 1990.

Proctor, Nancy. "Travelling between the Borders of Gender and Nationality: Nineteenth-Century American Women Artists in Rome." *Prospero* 2 (1995): 46–55.

Pyne, Kathleen. *Art and the Higher Life: Painting and Evolutionary Thought in Late Nineteenth-Century America.* Austin: University of Texas Press, 1996.

Quinn, Vernon. *Beautiful America.* New York: Stokes, 1923.

Rainey, Sue. *Creating "Picturesque America": Monument to the Natural and Cultural Landscape.* Nashville, Tenn.: Vanderbilt University Press, 1994.

Rainey, Sue, and Roger B. Stein. *Shaping the Landscape Image, 1865–1910: John Douglas Woodward.* Charlottesville, Va.: Bayly Art Museum, 1997.

Rebora, Carrie, and Paul Staiti. *John Singleton Copley in America.* New York: Metropolitan Museum of Art, 1995.

Revisiting the White City: American Art at the 1893 World's Fair. Washington, D.C.: National Museum of American Art and National Portrait Gallery, Smithsonian Institution, 1993; distributed by the University Press of New England.

Rhoads, William B. "The Colonial Revival and the Americanization of Immigrants." In *The Colonial Revival in America,* edited by Alan Axelrod. Introduction by Kenneth Ames. New York: Norton for the Henry Francis du Pont Winterthur Museum, 1985.

Richman, Michael. "Daniel Chester French." In *Metamorphoses in Nineteenth-Century Sculpture,* edited by Jeanne L. Wasserman and Arthur Beale. Cambridge: Fogg Art Museum, 1975.

_____. *Daniel Chester French: An American Sculptor.* New York: Metropolitan Museum of Art for the National Trust for Historic Preservation, 1976.

Robertson, Bruce. *Marsden Hartley.* New York: Abrams, 1995.

_____. *Reckoning with Winslow Homer: His Late Paintings and Their Influence.* Cleveland: Cleveland Museum of Art, 1995.

Robinson, Albert G. *Old New England Doorways.* New York: Scribner's, 1920.

Robinson, Geriod Tanquary. "Racial Minorities." In Harold E. Stearns, *Civilization in the United States.* New York: Harcourt, Brace, 1922.

Rockwell, Norman. *My Adventures as an Illustrator.* Garden City, N.Y.: Doubleday, 1960.

Rosenfield, Paul. *The Port of New York.* New York: Harcourt, Brace, 1924.

Roth, Rodris. "The New England or 'Olde Tyme' Kitchen Exhibit at Nineteenth-Century Fairs." In *The Colonial Revival in America,* edited by Alan Axelrod. Introduction by Kenneth Ames. New York: Norton for the Henry Francis du Pont Winterthur Museum, 1985.

Rourke, Constance. *American Humor.* New York: Harcourt, Brace, 1931.

_____. *Davy Crockett.* New York: Harcourt, Brace, 1934.

_____. *The Roots of American Culture.* New York: Harcourt, Brace & World, 1942.

Saint-Gaudens, Homer, ed. *The Reminiscences of Augustus Saint-Gaudens.* 2 vols. New York: Century, 1913.

Saunders, Richard. *John Smibert.* New Haven: Yale University Press, 1995.

Saunders, Richard H., Virginia A. Westbrook, and Nancy Price Graff. *Celebrating Vermont: Myths and Realities.* Middlebury, Vt.: Middlebury College Museum of Art, 1991.

Sellin, David. *Americans in Brittany and Normandy, 1860–1910.* Phoenix: Phoenix Art Museum, 1982.

Selling New England, 1935–36: The New England Governor's Joint New England Recreational Advertising Campaign, under Direction of the New England Council (Boston, 1936).

Sewall, Abbie. *Message through Time: The Photographs of Emma D. Sewall, 1836–1919.* Gardiner, Maine: Harpswell, 1989.

Sharp, Lewis I. *John Quincy Adams Ward: Dean of American Sculpture.* Newark: University of Delaware Press, 1985.

Sheldon, George W. *American Painters.* New York: Appleton, 1879.

Sichel, Kim. *Black Boston: Documentary Photography and the African American Experience.* Boston: Boston University Art Gallery, 1994.

Simon, Linda. *Thornton Wilder: His World.* Garden City, N.Y.: Doubleday, 1979.

Simpson, Marc. "Reconstructing the Golden Age: American Artists in Broadway, Worcestershire, 1885–1889." Ph.D. diss., Yale University, 1993.

Simpson, Marc, Andrea Henderson, and Sally Mills. *Expressions of Place: The Art of William Stanley Haseltine.* San Francisco: Fine Arts Museums of San Francisco, 1992.

Simpson, Marc, Sally Mills, and Patricia Hills. *Eastman Johnson: The Cranberry Harvest, Island of Nantucket.* San Diego: Timken Art Gallery, 1990.

Smith-Rosenberg, Carroll. *Disorderly Conduct: Visions of Gender in Victorian America.* New York: Oxford University Press, 1986.

Snyder, Robert L. *Pare Lorentz and the Documentary Film.* Norman: University of Oklahoma Press, 1968.

Solomon, Barbara H., ed. *Short Fiction of Sarah Orne Jewett and Mary Wilkins Freeman.* New York: Signet, 1979.

Southall, Thomas. "White Mountain Stereographs and the Development of a Collective Vision." In *Point of View: The Stereograph in America—A Cultural History,* edited by Edward L. Earle. Rochester, N.Y.: Visual Studies Workshop/GANYS, 1979.

Springer, Haskell, ed. *America and the Sea: A Literary History.* Athens: University of Georgia Press, 1995.

Stallybrass, Peter, and Allon White. *The Politics and Poetics of Transgression.* Ithaca, N.Y.: Cornell University Press, 1986.

Stange, Maren. "The Record Itself: Farm Security Administration Photography and the Transformation of Rural Life." In Peter Daniel et al., *Official Images: New Deal Photography.* Washington, D.C.: Smithsonian Institution Press, 1987.

Stebbins, Jr., Theodore E. *The Lure of Italy: American Artists and the Italian Experience, 1760–1914.* Boston: Museum of Fine Arts, 1992.

Stein, Roger B. "Picture and Text: The Literary World of Winslow Homer." In *Winslow Homer: A Symposium,* edited by Nicolai Cikovsky. Washington, D.C.: National Gallery of Art, 1990.

_____. "Portfolio." In *America and the Sea: A Literary History,* edited by Haskell Springer. Athens: University of Georgia Press, 1995.

_____. "Realism and Beyond." In *America and the Sea: A Literary History,* edited by Haskell Springer. Athens: University of Georgia Press, 1995.

Steiner, Michael C. "Regionalism in the Great Depression." *Geographical Review* 73 (October 1983): 432–34.

Stilgoe, John R. *Borderland: Origins of the American Suburb, 1820–1913.* New Haven: Yale University Press, 1984.

Stillinger, Elizabeth. *Historic Deerfield: A Portrait of Early America.* New York: Dutton, 1992.

Strahan, Edward [pseud. Earl Shinn], ed. *Art Treasures of America.* 3 vols. Philadelphia: Barrie, 1879–82.

Strand, Paul. *Paul Strand: Sixty Years of Photographs.* Millerton, N.Y.: Aperture, 1976.

Sturges, Hollister, ed. *The Rural Vision: France and America in the Late Nineteenth Century.* Omaha, Neb.: Joslyn Art Museum, 1987.

Thaxter, Celia. *Among the Isles of Shoals.* Boston: Osgood, 1873.

Thistlethwaite, Mark. *The Image of George Washington.* New York: Garland, 1979.

Tragard, Louise, and Patricia E. Hart. *A Century of Color, 1886–1986: Ogunquit, Maine's Art Colony.* Ogunquit, Maine: Barn Gallery Associates, 1986.

Troyen, Carol. *The Great Boston Collectors.* Boston: Museum of Fine Arts, 1984.

Troyen, Carol, and Erica Hirshler. *Charles Sheeler: Paintings and Drawings.* Boston: Little, Brown, 1987.

Tryon, Warren S., and William Charvat. *The Cost Books of Ticknor & Fields and Their Predecessors, 1832–1858.* New York: Bibliographical Society of America, 1949.

Tuchman, Maurice. *Spiritual in Art: Abstract Painting, 1890–1985.* Los Angeles: Los Angeles County Museum of Art, 1986.

Tuckerman, Henry T. *Book of the Artist: American Artist Life.* New York: Putnam, 1867.

Van Dyke, John C. *American Painting and Its Tradition.* New York: Scribner's, 1920.

Van Hook, Bailey. *Angels of Art: Women and Art in American Society.* University Park: Pennsylvania State University Press, 1996.

Van Tassel, David J. "Benson J. Lossing: Pen and Pencil Historian." *American Quarterly* 6 (spring 1954): 32–44.

Victorian Sentiment and American History Painting: Henry Bacon's "The Boston Boys and General Gage, 1775." Washington, D.C.: Dimock Gallery, George Washington University, 1995.

Wallace, David. *John Rogers: The People's Sculptor.* Middletown, Conn.: Wesleyan University Press, 1967.

Weinberg, H. Barbara, Doreen Bolger, and David Park Curry. *American Impressionism and Realism: The Painting of Modern Life, 1885–1915.* New York: Metropolitan Museum of Art, 1994.

Wells, Gary. *Alice Schille: The New England Years, 1915–1918.* Columbus, Ohio: Keny and Johnson Gallery, 1989.

Wharton, Anne Hollingsworth. *Through Colonial Doorways.* Philadelphia: Lippincott, 1893.

Wharton, Edith, and Ogden Codman, Jr. *The Decoration of Houses.* 1897. New York: Norton, 1997.

Wheat, Ellen Harkins. *Jacob Lawrence: The Frederick Douglass and Harriet Tubman Series of 1938–1940.* Hampton, Va.: Hampton University Art Museum, 1991.

White, William Allen. "Kansas: A Puritan Survival." In *These United States: A Symposium,* edited by Ernest Gruening, 1–12. New York: Boni & Liveright, 1923.

Whitefield, Edwin. *The Homes of Our Forefathers.* Boston: Williams, 1879.

Whitehill, Walter Muir. *Boston: A Topographical History.* Cambridge: Harvard University Press, 1963.

Whiteside, Clara Walker. *Touring New England: On the Trail of the Yankee.* Philadelphia: University of Pennsylvania Press, 1926.

Wick [Reaves], Wendy C. *George Washington: An American Icon.* Washington, D.C.: Smithsonian Institution Traveling Exhibition Service and National Portrait Gallery, 1982.

Wilder, Thornton. *Our Town: A Play in Three Acts.* 1938. (Reprinted, New York: Harper & Row, 1985).

Wilkie, Richard W., and Jack Tager, eds. *Historical Atlas of Massachusetts.* Amherst: University of Massachusetts Press, 1991.

Williams, Stanley Thomas. *The American Spirit in Letters.* Vol. 6 of *The Pageant of America: A Pictorial History of the United States,* edited by Ralph Henry Gabriel. New Haven: Yale University Press, 1926.

Williams, Susan Reynolds. "In the Garden of New England: Alice Morse Earle and the History of Domestic Life." Ph.D. diss., University of Delaware, 1992.

Williams, William Carlos. *In the American Grain.* 1925. New York: New Directions, 1956.

Wills, Garry. *Cincinnatus: George Washington and the Enlightenment.* Garden City, N.Y.: Doubleday, 1984.

Wingert, Paul Stover. *Sculpture of William Zorach.* New York: Pitman, 1938.

Winship, Michael. *American Literary Publishing in the Mid-Nineteenth Century: The Business of Ticknor & Fields.* Cambridge and New York: Cambridge University Press, 1995.

Wood, Grant. *Revolt against the City.* Iowa City: Clio, 1935.

Wood, William, and Ralph Henry Gabriel. *The Winning of Freedom.* Vol. 11 of *The Pageant of America: A Pictorial History of the United States,* edited by Ralph Henry Gabriel. New Haven: Yale University Press, 1926.

Woods, Marianne Berger. "Viewing Colonial America through the Lens of Wallace Nutting." *American Art* 8 (spring 1994): 67–86.

Workman, Robert G. *The Eden of America.* Providence: Museum of Art, Rhode Island School of Design, 1986.

Wright, Richardson, ed. *House & Garden's Book of Houses.* New York: Nast, 1920.

Wyeth, Betsy James, ed. *The Wyeths: The Letters of N. C. Wyeth, 1901–1945.* Boston: Gambit, 1971.

Young, Alexander. *Chronicles of the Pilgrim Fathers.* 1841. (Reprinted, New York: Da Capo, 1971).

Zusy, Catherine. "Against Overwork and Sweating, Against the Apotheosis of Cheap and Shoddy: The Arts and Crafts Movement in Deerfield, 1896–1941." Paper prepared for Historic Deerfield Summer Fellowship Program, Henry N. Flynt Library, Historic Deerfield, Inc., 1981.

Index

The typefaces used in this book include Arrus, Gill Sans, and Seagull. Arrus was designed by Richard Lipton for Bitstream Inc. and was first released in 1991. Arrus is based on Lipton's own hand-lettered calligraphic alphabets that draw their influence from classic inscriptional forms. Gill Sans was designed by Eric Gill, essayist, typographer, stone carver, and wood engraver. It is one of the most balanced and well-designed sans-serif fonts of the modern era. It was originally designed for the Monotype Corporation in 1929, although its first appearance was as a hand-lettered sign done for Douglass Cleverdon's bookshop in Bristol, England, in 1926. The typeface owes much to a sans-serif type Gill's teacher, Edward Johnston, designed in 1916 for the London Underground Railway.